Savoir-faire

Editorial Direction by Béatrice Vignals,
Stéphane Melchior-Durand, with Bernadette Fric
Overviews by Sylvie Bourrat
Designed by Jean-Philippe Gauvin
Layout by Chantal Guézet
Picture Research by Béatrice Petit, with Sabrina Rozet
English edition:
Translated from the French by Louise Guiney
Edited by Philippa Brinkworth-Glover and Christine Schultz-Touge
Typesetting by Octavo Editions, Paris
Color origination by Bussière S. A., France
Printed by Mame Imprimeurs, France

Flammarion
26, rue Racine
75006 Paris

**Front jacket, left to right, top to bottom:**
Burnishing with agate at the Manufacture Nationale de Sèvres © C.C.;
Sealing perfume bottles at Chanel © C.C./Valéry Assénat/Chanel; Harvest at
Château Lafite-Rothschild © VU/Jean-Luc Chapin; Chanel workshops, Paris, haute couture,
November 1993 © VU/Agnès Bonnot; Mauboussin. The jeweler's craft ©
C.C./Mauboussin/M. Fernandez; Brazing a solid silver piece at Puiforcat © C.C./Erwan
Lemarchand (Studio Arcadia); Olla tureen in the form of a cabbage, c. 1750.
Strasburg, Manufacture de Joseph Hannong. © Musée des Arts Décoratifs,
Paris/photo L. Sully-Jaulmes; François Desportes, *Still life with peaches, figs and a
brace of pheasants* (detail), 1735 © RMN; Working on a photo-plate in the engraving
workshops at Gandit; Saddle-stitching on a "Monogram" suitcase at Louis Vuitton
© C.C./Louis Vuitton; "Sauterelles" vase 1912, blown, mouled, patinated, white glass,
Lalique, © C.C.; Bellhop at the Hôtel de Crillon © VU/Paulo Nozolino/Crillon.

ISBN: 2-08013-552-X
Numéro d'édition: 1024
Dépôt légal: October 1995

# GREAT TRADITIONS IN FRENCH ELEGANCE

*Pierre Rival • François Baudot*

Flammarion

Comité Colbert

## ACKNOWLEDGMENTS

The concept for this book was formulated by the Comité Colbert, working in co-operation with Flammarion to produce a definitive reference source which describes the various areas of craftsmanship representing the great French traditions.

First and foremost, Pierre Rival would like to thank Bernadette Fric and Liesbeth Moreaux of the Comité Colbert for guiding him through the luxury industry, and for the diplomacy with which they introduced him to its inner circles. This complex book could not have been completed without the help of Béatrice Vignals and Stéphane Melchior-Durand, who read over the manuscript; Sylvie Bourrat, who edited the chronology; and Béatrice Petit who compiled the written and pictorial documentation. Lastly, the author wishes to express his special appreciation to Flammarion editors Delphine Le Cesne and Suzanne Tise, who invited him to carry out the project and encouraged him at every step of the way.

The publisher wishes to express special thanks to Yvonne Brunhammer, Sün Evrard, and, Olivier Gagnère, who provided valuable assistance for the chapters on "Crystal," "Leather," and "Faience and Porcelain" respectively.

Many thanks also to Jean-Pierre Gauvin, responsible for the graphic design of the book; Xiao Fan Ru, who did the Chinese ideogram calligraphy for the "Faience and Porcelain" chapter and Pauline Guiraud who designed all the chapter headings.

*Flammarion and Bussière S. A. (color origination) are both members of the Comité Colbert.*

# Contents

# Preface

France is universally renowned for the peerless artistry represented by its venerable crafts tradition. This national resource was first recognized by Louis XI, and later harnessed by statesman Jean Baptiste Colbert, who supported the creation of manufacturing facilities and the export of their products. When the bourgeoisie began to accumulate wealth in the nineteenth century, a new aristocracy based on the luxury trade arose. However, because the respective goals of art and industry differ so widely, their union has always been a stormy one. Human beings have had to be very adroit at controlling the machines they invented; and yet, by working through and beyond periods of dramatic change that have all too often been seen as revolutions, France in our century has succeeded—not without risk—in maintaining its imposing heritage of skills and *savoir-faire*; its exceptional creative environment; and its continuous support for that special art of living which, in a highly competitive world, remains one of the country's most remarkable assets.

Praise for traditional craftsmanship is an oft-heard refrain, but today it is gaining new force as general interest in fine workmanship increases. Not so long ago the future seemed bleak for the world of finely crafted artifacts, but today unique, rare, precious, and delectable "one-of-a-kind" goods and services are being rediscovered and newly appreciated. As the third millennium dawns, these are no longer seen as mere indulgences for the privileged few, but as evidence of a cultural heritage that must not be allowed to disappear. Today, the technology of automation is eliminating routine tasks from the factory floor and threatening the people who perform them. In this context, the trained minds, eyes, and hands of genuine artisans who transmit their skills to succeeding generations have become a foundation on which to build the future; a living promise—as long as men and women are willing and able to sustain it—ensuring that the unique will never be totally displaced by the mass-produced.

The present volume has been arbitrarily divided into nine chapters, each one focusing on the primary materials used in a single craft. It has been written in close cooperation with the Comité Colbert, a 75-member organization representing the ultimate in French luxury goods and services, an elite group whose mission is to promote French traditions and innovations on the five continents of the world. In chapters devoted to gems and precious metals; hotels and gastronomy; crystal; faience and porcelain; fragrance; textiles; *haute couture*; wine; and leather, we tell the long story of products that have no equal anywhere—a story that begins with the humblest apprentice and ends with the most prestigious of France's international outposts. Our

exploration of these renowned firms, and the often unsung individuals responsible for their fame, involved research by a team of reporters, the skill of Pierre Rival's pen, and the keen vision of the young photographers at VU photographic agency, who proved that in their field, as in so many others, a new generation is on the rise.

Because it is abstract rather than tangible, one of our topic's most important aspects—brand-image—will not be discussed extensively in the following pages. Famous names have a strong impact, however, and therefore deserve to be mentioned before we turn our book over to the artisans responsible for each craft. Today, famous brand names and the consummate craftsmanship they represent go hand-in-hand, each supporting the other in the effort to win new markets and attract a new generation of artisans. Finely crafted products need a famous name in order to survive; but famous names without fine craftsmanship behind them are derisory. In combination, however, both expand, gaining recognition and adherents for those firms that draw most deeply from the wellsprings of the French cultural heritage, and enabling them to exert an influence reaching far beyond the limited circles of fortune's favored few. This small circle is not powerful enough to support firms that, although working in the luxury market, must still compete on every battleground. Strategic brand-image projection on the international market has accounted for the extraordinary growth of the French luxury-goods industry over the past decade. This novel phenomenon, expressed through the financial health, capacity for change, and entrepreneurial spirit of the firms in question is the one single factor most likely to guarantee a better future to the artisans described in the following pages.

In this book, three terms recur: "house," which refers to an established and universally recognized firm; "craft," designating the *savoir-faire* of ancient tradition passed on from generation to generation; and "signature," or the unmistakable hallmark of a unique product or service. Together, these terms exemplify the most distinctive features of luxury goods and services rooted in French soil. Our goal in compiling *Savoir-Faire, Great Traditions in French Elegance* has been to offer encouragement to every type of creativity and innovation. Whatever its origin, shape, or form, the spirit of creativity will find no environment more hospitable to its fulfillment than France, the country which for centuries has seen so many skills and talents blossom and bear fruit.

François BAUDOT

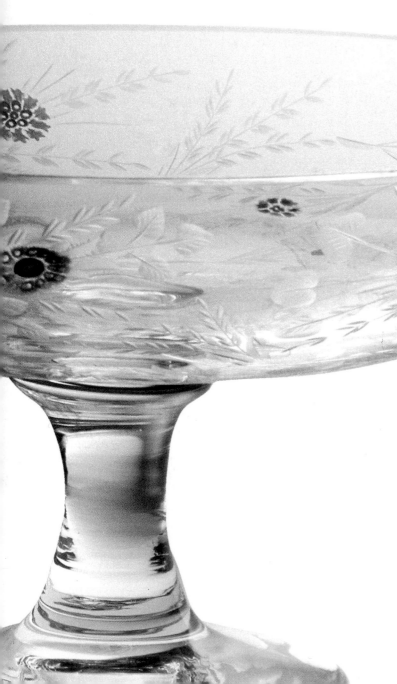

# Crystal

Glass is resonant, fragile, fusible, and most often transparent—so transparent it can even seem invisible. There is no more magical or paradoxical invention than this vitreous substance made of sand, air, and fire. Glass is solid, yet light can pass right through it. It can be shaped by a breath, yet shield against a gale. Glass can magnify images or reduce them; it is formed in fire and gives form to water. Glass seems insubstantial, hiding nothing yet holding all. It can shatter into a thousand pieces or be built into the strongest wall. These magical paradoxes are possible because of technological improvements added over the centuries to the properties—the virtues, as it were—of glass.

The word "glass" is used for a range of extremely diverse products. The respective properties of these products reflect different methods of applying heat to the raw materials they are made from. Glass shares many properties with china, its companion on the dining table, and fine glassware is the mark of a fine household. When we raise a glass to our lips, most of us keenly appreciate the shape, style, and delicacy of a receptacle made from the simplest materials, yet representing the ultimate in craftsmanship. The appeal of most glass lies in its brilliance and fragility. Gold and silver last forever; leather ages gracefully, acquiring a rich patina as it does so; ceramics outlive their users; but the creations of the glass blower are vulnerable to the flick of a fan or the slightest pressure from the hand. The fragility of glass is part of its charm. Today we are able to trace the glass industry back to its origins only because ancient burial customs decreed that household utensils be buried with their owners, and were thus protected from breakage.

Contemporary research dates the oldest glass recipients found in Mesopotamia and Egypt at about 1300 B.C. However, it is the technique of blown glass, invented shortly before the birth of Christ, that constitutes the most important step in the evolution of this craft, since blown glass can be produced in large quantities

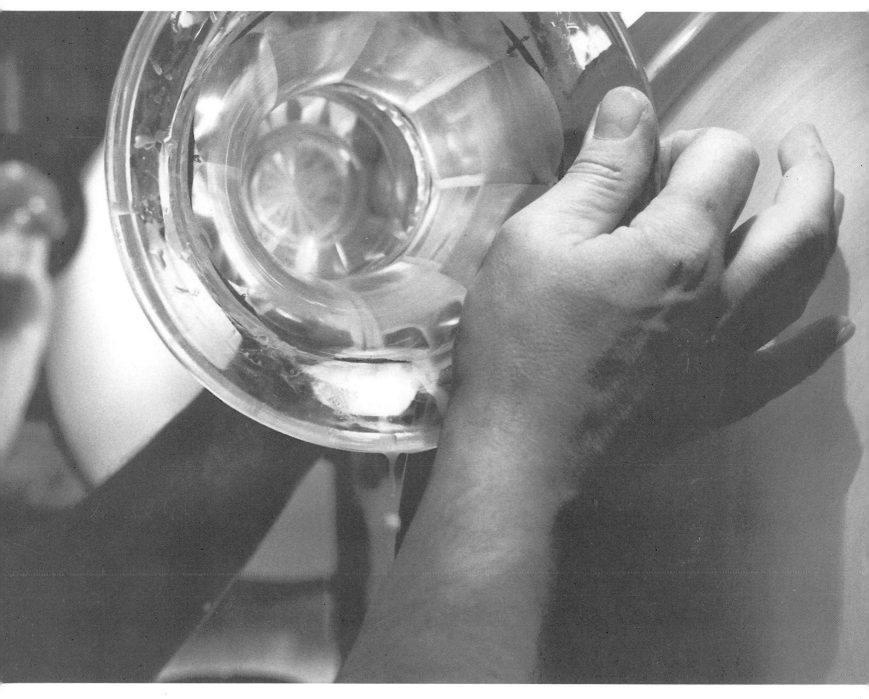

The cutting workshop: *Only a cutter who has attained the rank of master craftsman will have acquired the special skill needed to draw a design on virgin crystal.*

Left: *Footed Botticelli bowl in clear crystal with multicolored millefiori cane inlays and wheel engraved floral decoration. Cristalleries de Saint-Louis.*

*Design by Henri Berger for Eucalyptus vase decorated with leaves. Daum, 1920.*

Right: *Carl Runz and John Gieger, A crystalworks. 1838, lithograph. Musée historique, Vienna. A pot kiln can be seen in the background.*

at relatively low cost. The rare pieces of old glass to have survived into our own time indicate that glassware was more widespread during the Middle Ages than previously supposed, and that it was not used solely for stained-glass windows in churches and cloisters, or in feudal and municipal secular structures. However, the Christian prohibition against placing domestic utensils in graves deprived much medieval glass of a refuge that might have saved it from destruction.

The art of glassmaking continued to develop in Syria, Egypt, Persia, and especially in Venice, which at the fall of Byzantium in 1204 retained the techniques imported from the Orient, establishing a center for them on the island of Murano. Venice subsequently became famous for its glass, exporting two types: an "ordinary" range for everyday use; and an "extraordinary" range for symbolic or purely decorative purposes. Examples of the latter can be found in many fine collections today, and bear witness to the peerless craftsmanship of their time. Bohemia followed Venice as a center of fine glassware, but in France the craft foundered until the eighteenth century, with the exception of the Manufacture Royale de Saint-Gobain, which acquired a substantial market for its large, flat, polished mirrors. It was not until the eve of the French Revolution, when a new English process for adding lead oxide to molten glass was adopted, that France's crystal industry assumed significant proportions. Studded with names such as Saint-Louis, Sèvres, Le Creusot, Vonèche, Baccarat, and Val-Saint-Lambert, French crystal made rapid progress technologically, winning international fame and overwhelming commercial success. Technological advances in glassmaking have continuously expanded the functions of glass in French architecture and construction, from the Grand Palais to the Pyramid of the Louvre.

French glassmakers, especially those of the Nancy School, played a leading role in the art nouveau movement at a time when interior decorator and designer René Lalique was also using glass and crystal in costume jewelry, tableware, and the decorative arts. Meanwhile, the perfume industry was creating its own demand for designer glass. The talents of glassmakers were called upon by the most famous names in perfume for the creation of custom-made bottles that in design and execution could serve as fitting receptacles for the carefully blended ingredients formulated by the perfumers' expert "Noses." Thanks to the intersection of these two creative paths, glassware and perfumery,

name fragrances today afford consumers the dual appeal of exceptional contents bottled in exceptional containers.

Glassmaking and crystal-cutting are two crafts that require particular skill and virtuosity from artisans handling a fragile material that a single awkward movement or imperceptible slip of the hand could irretrievably destroy. Although glass can be opaque or transparent, delicate or sturdy, we tend to associate it with translucence and fragility—two qualities that no doubt account for its eternal appeal.

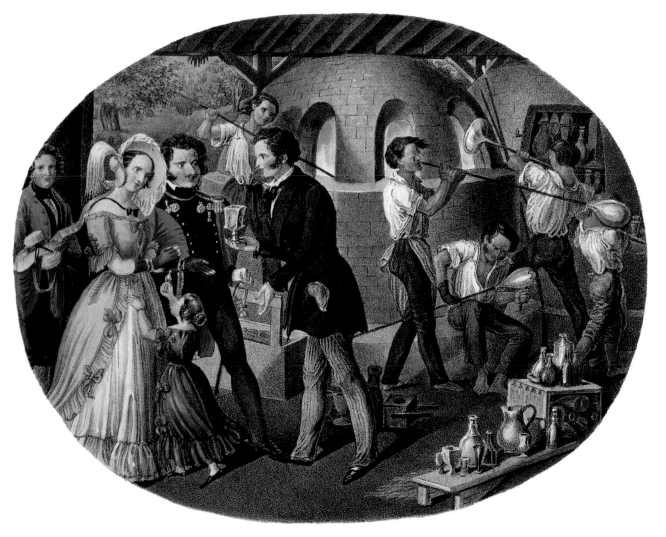

*The gatherer plunges his rod in the pot and brings the exact amount of molten glass required, with no air bubbles or impurities in it.*

Right: *The central hall at Baccarat rebuilt in 1881.*

## "The pot kiln is like a sun"

"The pot kiln is a like a sun radiating sunbeams." This comment by a glass blower at Daum accurately reflects the first impression received on entering a glass factory. Whether at Baccarat, Daum, Lalique, or Saint-Louis, the huge pot kiln is a "bravura piece" in the concert of scenes that greets the eye. The comparison to the sun is apt: as the glassmakers plunge their rods into the clay pots under the arch of the glass kiln and extract the gobs of molten glass; as they rush it to the blowers who then expand and stretch it into the shape of a glass or a vase; and as the smoldering, viscous mass becomes increasingly transparent the farther it travels from the circular kiln; then it becomes clear that this comparison, trite as it may seem, is exact. The pot kiln is the center of this universe. It is round and glowing like the sun and, like the sun, the light and heat it sheds alternate with dark and cold. This is because the pot kiln, which was probably invented in England during the early eighteenth century, is not continuously fired, unlike non-stop modern glass furnaces. Pot kilns are re-fired for each separate batch. The pots are filled with the raw materials, which are gradually heated until they fuse, and then finished during a lengthy process lasting no fewer than thirty-six hours. In former times, when fusion was less well understood than it is today, glassblowers lived near the hearth of the pot kiln. The head glassmaker, or gaffer, would alert them by ringing a bell when a batch of molten glass was ready to be blown. Such a bell can still be seen outside the Baccarat factory to this day. It hangs from a gable of the imposing shed, facing the rows of nineteenth-century workmen's cottages which stand across a large square. The large factory dwarfs the village church below it, eloquently symbolizing the priorities of the industrial age, when time was governed by the factory bell rather than the church bell.

The pot kiln may be a venerable piece of equipment designed a long time ago, but it is still unrivaled in the production of fine crystal tableware and art objects. In the words of Baccarat head glassmaker Denis Mangin: "The modern automatic glass-feeder furnace can produce top-quality glass in large quantities, but it doesn't have the flexibility of the old-fashioned pot kiln. The advantage of the old method is that each separate pot can be filled with a different mixture—different colors, for example, or small batches for individual pieces." "The past has a great future ahead of it," adds Baccarat's hearth foreman Marceau Comte, as he gently revolves a cut-and-engraved, color-overlaid "Collection of the Tsar" Rhine wineglass in his hand. Indeed, in luxury crystal making, perhaps more than in any other

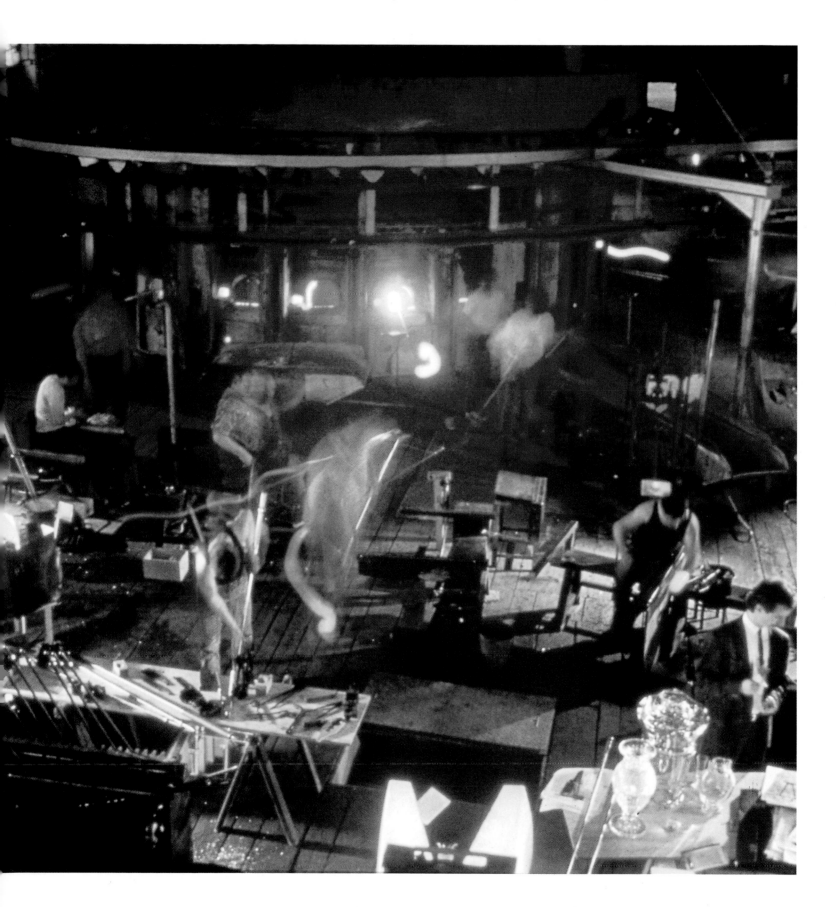

### Color overlay

*Molten crystal is almost infinitely flexible and ductile, a property exploited by glassmakers to create pieces made from layers of colored crystal only a fraction of a millimeter thick.*

*To create overlaid glass, the glassmaker first uses his blowpipe to gather a large gob of transparent molten crystal. He then manipulates it with a rod called a pontil (or punty), while blowing through his pipe until the gob balloons into a sphere. An assistant dabs a small gob of colored molten crystal on to this sphere, which is then passed to the head glassblower, or gaffer. The gaffer uses his own pontil*

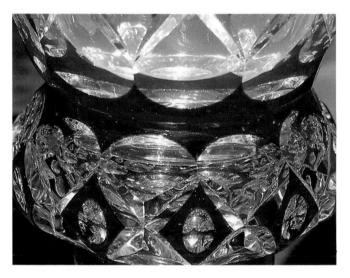

*to extend the drop of colored crystal until it has completely covered the transparent balloon with a thin film of colored glass. He then works the sphere into an elongated cylinder, the parison, now completely overlaid with a layer of color no more than one or two millimeters thick.*

*Next, the glassblower uses his pontil to pierce a small opening in the layered glass, and places another gob of transparent glass into it. The new gob is then blown and stretched from within the parison until the outer, colored layer is no more than a few tenths of a millimeter thick.*

craft, the combination of ancient techniques and ancestral skills with modern design and contemporary art stands as a striking proof of continued vitality.

The survival of the pot kiln is an outstanding symbol of this vitality, one that deserves to be investigated more fully before turning to the art of the glassblowers themselves. For example, all fine glassmakers also produce the pots for their kilns. This means that every great glass factory has its own pottery shop.

### The pottery

The pottery at Daum is a peaceful area presided over by Jean-Jacques Yung. Here, the heat and light of the pot kiln and the frantic bustle of the glassblowers seem to belong to an entirely different world. That world is completely dependent on this one, however, since here the terracotta furnace pots are made that will hold molten glass heated to temperatures of up to fifteen hundred degrees Celsius. Yung supervises both the manufacture of the pots and their installation, which is the most spectacular operation conducted in this factory. The fire in the kiln is not extinguished as old pots are replaced with new ones. As the furnace blazes away, all eyes turn to Yung, who stands "on the firing line" in the center of the forehearth, directing the insertion of the new pots. This is Yung's moment of glory—his reward for long, lonely months spent in the pottery shop, separated from the day-to-day excitement of the hearth.

The pottery shop is isolated from the rest of the factory because the terracotta melting-pots require a closed, protected atmosphere with a controlled humidity level of eighty percent. The pots are made from blended clay that is exceptionally refractory, or heat-resistant. Yung uses a blend of soils from Normandy and Provins containing fifty percent raw earth and fifty percent fire clay. This blend is baked at a temperature of thirteen hundred degrees until it hardens. It is then pulverized, sifted, and stored in cellars for six months to rest and settle. If any air still remains in the pulverized baked clay after is has been allowed to settle, a vacuum pump is used to extract it.

To shape the pots, the potter first cuts a base approximately three and a half inches thick from the prepared clay. He then rolls more clay into a tubular circle, presses it around the rim of the base, and gently works and raises it until a dome-shaped pot has been formed. The completed pots must then be seasoned. They are stored for a few months at room temperature, then in a slightly warmer room, and then in a hot room known as the drying room. "Our practice,"

explains Jean-Jacques Yung, "is to age pots for two years before installing them in the kiln."

When the pots are ready to be installed under the pot arch, they are subjected to a final one-week seasoning at temperatures rising gradually to thirteen hundred degrees. The final seasoning ensures that new pots placed in a kiln operating continuously at a temperature of fourteen hundred degrees will not break on exposure to the heat.

When the great day finally arrives, the glassmakers don fireproof asbestos clothing, break into the front of the kiln with crowbars, and extract the old pot. The new, pre-seasoned pot is then inserted in its place, and the area around the neck of the pot is walled in with heat-resistant bricks. Throughout the entire operation, the kiln continues to generate fifteen hundred to sixteen hundred degrees of heat from its source.

### From sand into crystal

Heat is the catalyst which causes the raw materials inside the melting-pots to fuse into crystal. These raw materials consist of sand (fifty percent), potash (between twenty and thirty-eight percent), and lead oxide (between twelve and thirty percent). Lead is the ingredient that gives crystal its characteristic weight, resonance, brilliance, density and high refraction index. The term "full crystal" can only be applied to glass with a lead oxide content of at least twenty-four percent. The composition of plain glass is different: sixty percent sand, twenty percent soda, and twenty percent lime. This combination of ingredients makes glass lighter, less resonant, and less brilliant than crystal, and gives it a much lower refraction index. Cullet, or waste crystal, is sometimes added to the mixture to accelerate fusion, which occurs at a temperature of about fifteen hundred degrees.

The formula for crystal was discovered early in the seventeenth century by an Englishman named George Ravenscroft, and it remained a kind of secret alchemy until the introduction of international standards specifying the exact amounts of lead oxide that crystal must contain and the exact interior light-refraction index it must register. However, even today some secrets remain, since all fine glassmakers cling jealously to special methods or "gimmicks" unknown to their competitors. Some examples of these are the Baccarat formula for making solid red crystal and Daum's method of making glass paste; Lalique's sanding and polishing methods; and the techniques used at Saint-Louis to produce colored glass, crystal-ceramics, and layered-glass paperweights.

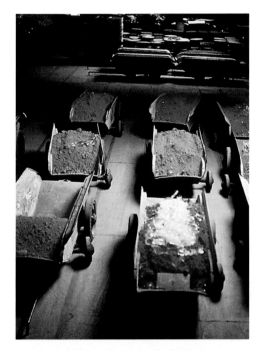

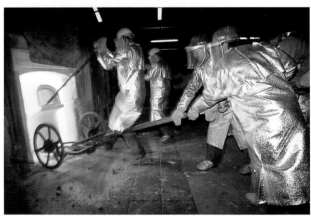

*Lalique. Changing the kiln pot. The glassmakers, wearing fireproof asbestos clothing, break the front of the kiln with crowbars and extract the old pot. The new pot, after undergoing a final one-week seasoning in temperatures gradually rising to thirteen hundred degrees, is inserted in its place.*
Top: *Baccarat. The raw materials are transported in trucks to the pot kilns: sand (fifty percent), potash (twenty percent) and lead oxide (thirty percent). The latter gives crystal its weight, resonance, density and above all its high refraction index.*

Left: *Beveled Paris vase lined with red crystal. Model created in 1960 by Cristalleries de Saint-Louis.*

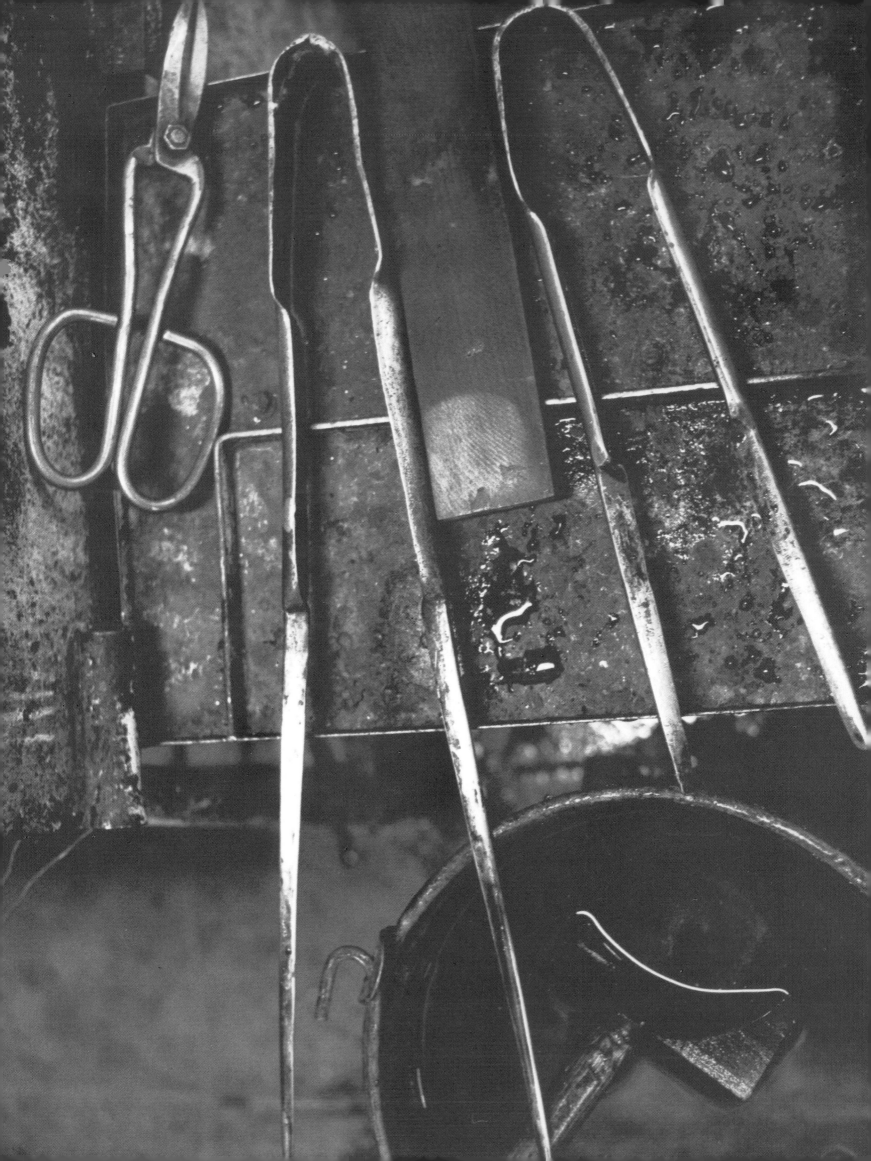

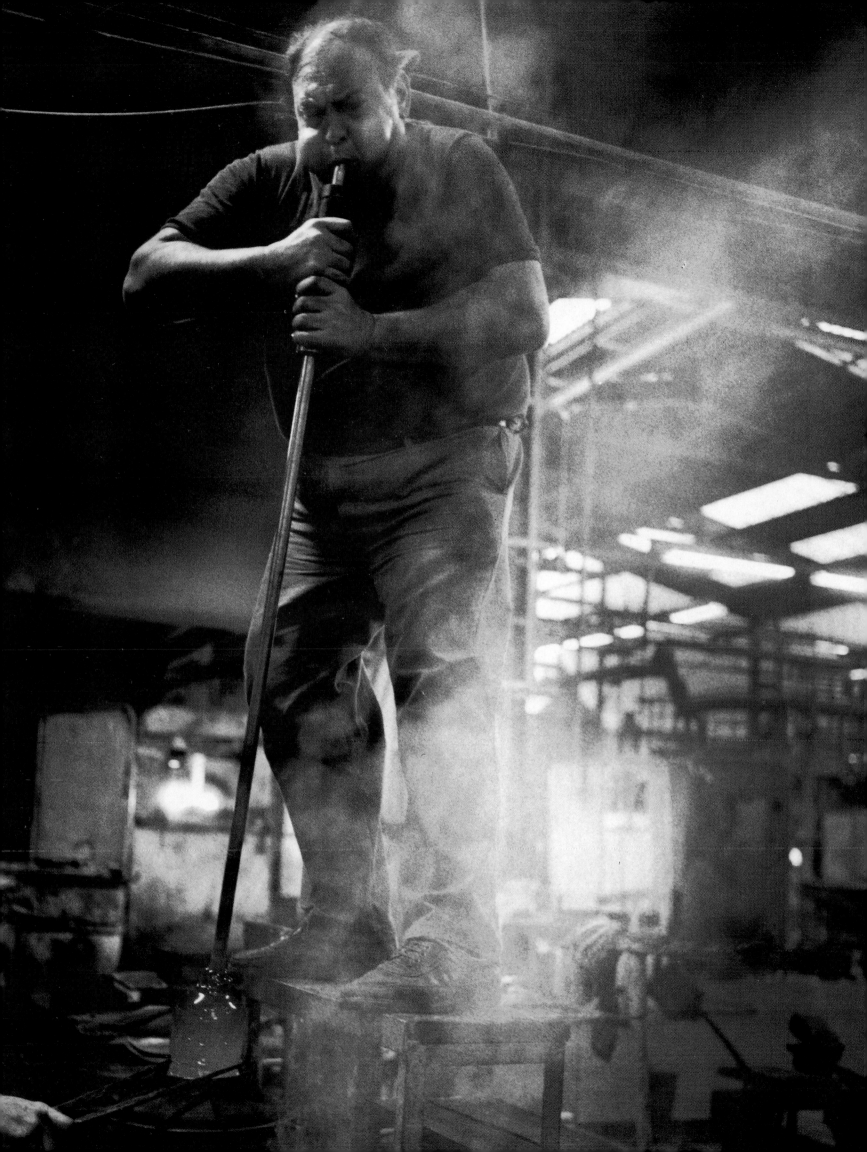

The word "alchemy" also suggests the initiation of novices, and the glassmaking craft does indeed involve a process of initiation. Glassmakers still cherish the venerable guild spirit and traditional hierarchies in which each worker, from raw apprentice to experienced master glassblower, knows his place. All glassmakers are aware of belonging to an aristocracy in which titles are won by merit, "under fire."

The scene at the forehearth of a crystal pot kiln appears chaotic at first, but this is an illusion, as is the impression of danger. The gatherers rush back and forth with gobs of molten glass hanging from the tips of their gathering rods, but they are sure-footed and adroit. Visitors are carefully piloted to strategic positions from which they can observe the work of the gatherers and glassblowers, whose dexterity is a guarantee of safety. Every gesture within this deceptively chaotic scene is executed with great precision.

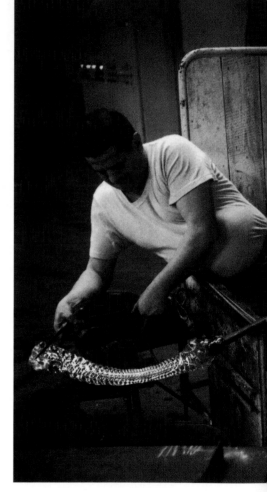

THE GATHERER • It takes no less than four glassblowers to produce a single goblet, but the relative importance of their separate functions is not immediately obvious. For example, one might be excused for assuming that the gatherer plunging his blow-pipe into the pot and extracting the gob of molten glass is the most important member of the team, but he is actually only the fourth blower, at the bottom rung of the hierarchy. His task—gathering the glass from the furnace and blowing through his tubular rod until the gob balloons out and adheres only to the outer rim of the blow-pipe— is a spectacular one, however. To the outside observer, this man is emblematic, a living symbol of his craft. His task is crucial, as Marceau Comte acknowledges when he says: "A good gatherer brings you exactly the amount of molten glass you need, with no air bubbles or impurities in it. A good gatherer's gob of glass is

*Molten Baccarat crystal: glowing, red crystal which gradually becomes transparent after it is removed from the circular kiln.*

Preceding double page: *The glassblower's tools. He uses pliers to hold the piece, lengthen the stem of a glass and modify shapes. He uses shears to cut the substance down to the exact size, and to widen and refine the edges.*
Right: *The glassblower who first blows through the tubular rod can be seen as an emblematic person, the living symbol of glassmaking.*

perfect. He doesn't mess around with it"—which apparently is all too easy to do—"by turning the rod too fast, or by not plunging it deep enough into the pot, and so on." The list of possible "errors" on the part of the gatherer, as opposed to "flaws" in the original composition of the material, is a long and daunting one.

THE GLASSBLOWER • The rod is now passed from the gatherer, or fourth blower, to the third blower. His task is to blow the balloon-shaped gather into a tubular-shaped parison, or blank, which

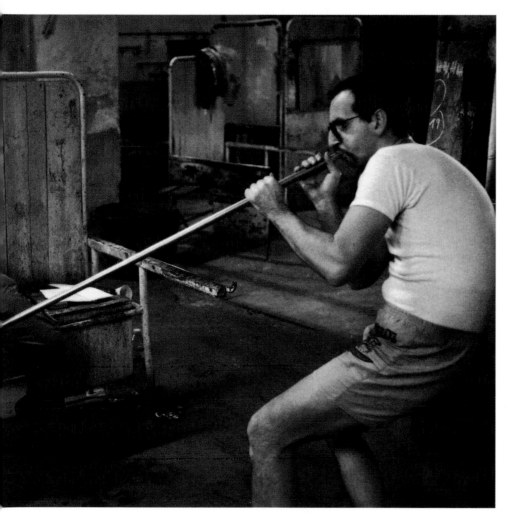

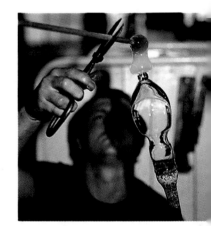

*The shaping of the stem of a goblet at Saint-Louis. The gatherer places a gob of molten glass on the parison and then the first blower pulls and shears to size. Center:* Creating the cabled arm of a light-fitting. This delicate operation requires a perfect synchrony of actions. The first blower creates the right thickness of the piece while it is still attached to the parison, while simultaneously, the second blower pulls and twists it to create the cabled effect.

will form the actual body of the crystal goblet. At this stage, blowing technique becomes as important as handling the rod, since the expanded gob of glass must now be made to conform as nearly as possible to the desired model. Final form is given to the cooling crystal either by placing it in a parison mold, or by rolling it with a large spoon-shaped mallet. But here again, the blower's most spectacular movements are not necessarily either the most difficult or the most complex.

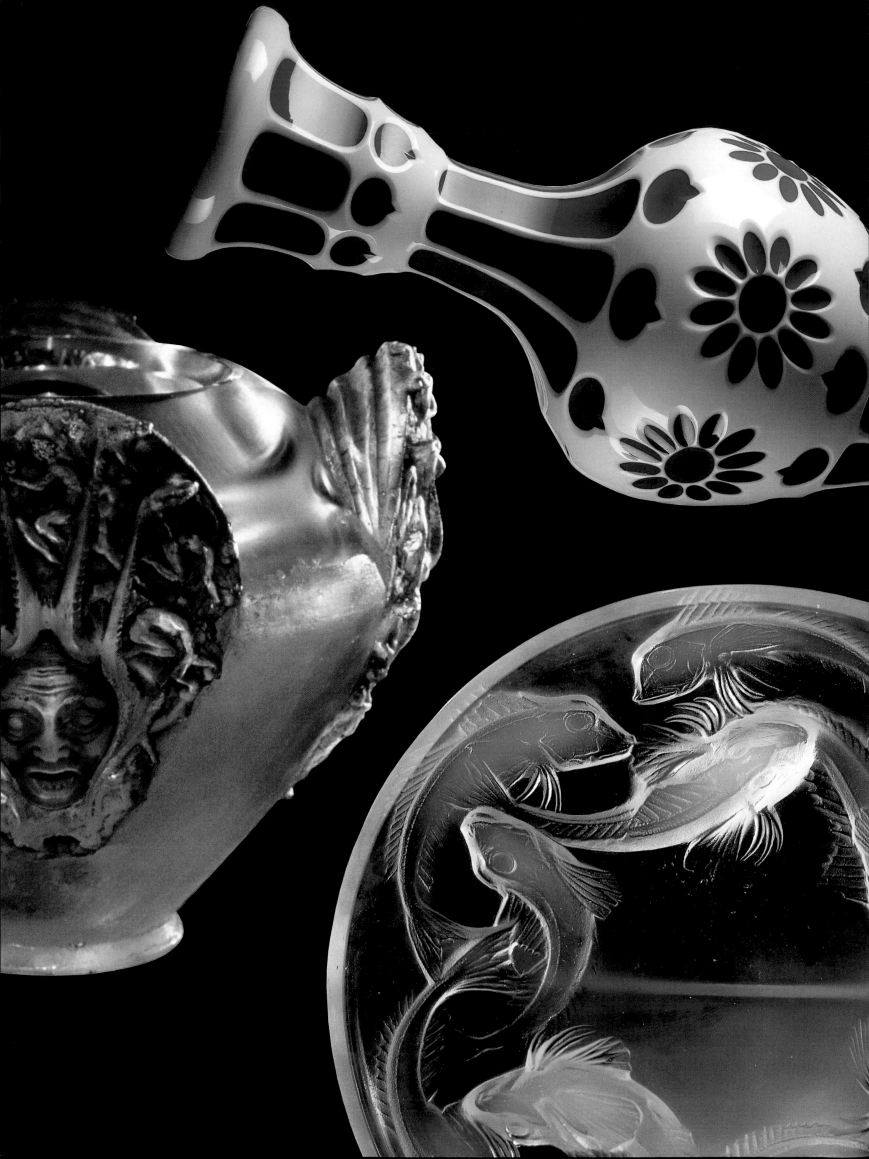

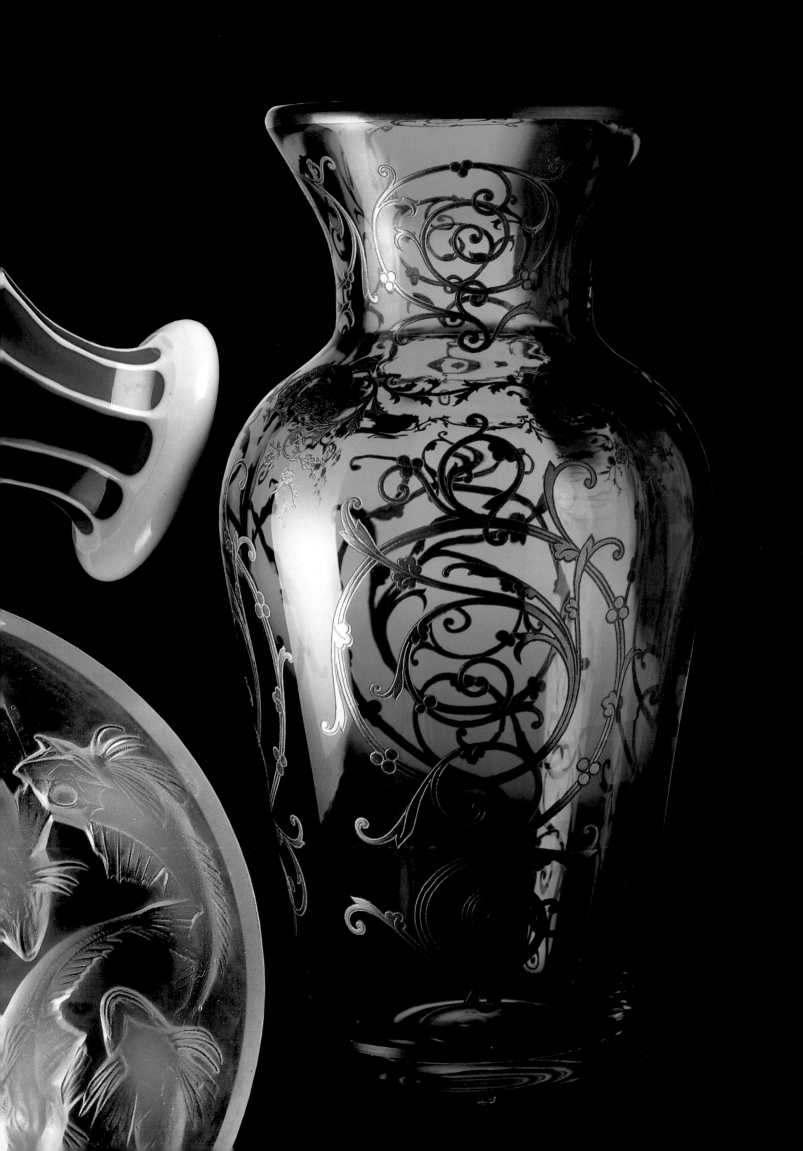

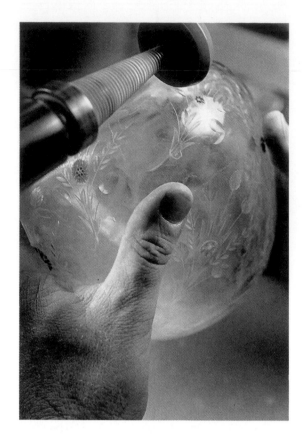

*Lapidary tools caress the crystal almost imperceptibly with a gentle rustling sound, further attenuated by the continuous stream of water flowing over the area of the piece being worked.*

Preceding double page
Left: *"Four Gorgons" vase, Lalique, 1913. Patinated blown glass, molded by the lost-wax process. Calouste Gulbenkian Museum, Lisbon.*
Top: *Louis II of Bavaria vase. Cristalleries de Saint-Louis, reproduction of a piece dating from 1850 in blue double enamel.*
Right: *Guillaume Apollinaire vase. Cristalleries de Saint-Louis, reproduction of a piece dating from 1850. Turquoise decorated with gold.*
Below: *Large decorative dish with molded fish design, created by Lalique in 1925. Opaline glass.*

The best glassblowers are those able to blow the gob into a shape as close as possible to that of the parison mold. They are "men who can make glass do what they want it to." The parison's thickness, or what glass blowers call its "strength," is as important as its shape, and this varies according to how the finished goblet will be cut or engraved. As the third blower revolves his blow-pipe, he uses an iron blade to thicken or thin the parison as required.

The rod is now passed directly to the first blower, a man seated at the center of the forehearth, absorbed in a task that may seem undramatic to an outsider but is actually the most delicate of all: this is why he is ranked first in the hierarchy. His task is to shape the goblet's stem, which can only be done by someone with exceptional dexterity, and only after long experience. The gatherer, or fourth blower, places a small gob of molten glass on the parison. Since the exact amount of crystal needed can vary considerably depending on the goblet's final design, the first blower will evaluate the gob with a practiced eye and shear it down to size if necessary. He then smooths the gob of glass, flattens it or shapes it into a cone, reheats it where it is attached to the base of the parison, and then manipulates it with metal pliers until it forms a stem identical to the model. The first blower checks the stem's dimensions with his callipers and then passes the rod to the second blower, who uses a pair of castanet-like paddles to shape the stem's base from a final gob of molten glass brought to him by the gatherer.

A finished, undecorated crystal goblet is a perfect example of the glassblower's art at its purest. At this stage, form is all: cutters and engravers will later add a crowning virtuoso touch to the goblet, but their art depends for its total effect on the quality and purity of its medium, which is the work of the master glassblower.

FROM MOLTEN HEAT TO CRYSTALLINE COLD • Located far from the fiery pot kiln and bustling forehearth are the "cold" workshops, an area of tranquil work-benches all of which receive the benefit of generous skylights. This is a watery realm as well, since cooling streams flow continuously over the grinding wheels which are used to cut the crystal. Here blank crystal goblets undergo the metamorphosis which will transform them into costly works of art. Although at first sight the cold workshops may appear more banal and less dramatically Promethean than the furnace shed, they boast teams of master craftsmen who have made Baccarat, Daum, Lalique, and Saint-Louis the leading holders of *Meilleur Ouvrier de France* awards. This coveted title is given to skilled artisans in recognition of a work that is outstanding of its kind, and that faithfully

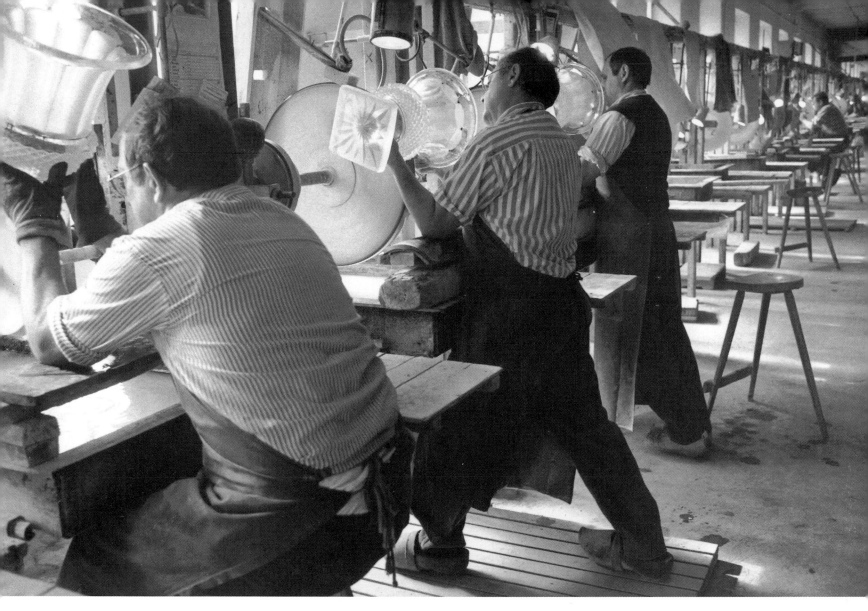

represents the traditional guild spirit. However, in the field of crystal cutting and engraving, a *Meilleur Ouvrier de France* award is only the first step in a journey as long as formal medical studies, a comparison which speaks volumes for the difficulty of this particular craft.

CUTTING • Gérard Beylstein is a master cutter with Baccarat who entered the *Meilleur Ouvrier de France* competition when he was still a novice craftsman. During those early years he was sent to work with various glassmakers, where he learned the rudiments of a craft he now claims he only truly mastered several years later. When he received the *Meilleur Ouvrier de France* award, he was given the position of pupil under a system whereby two artisans—a master craftsman and a novice—work as a team. The master is thereby able to pass on his own unique skills and experience to the younger man. Although Gérard Beylstein was already an accomplished glasscutter, as a novice on this two-man team he was still unable to execute the most difficult task of all, which is drawing the design on the glass. Glasscutters work from an underlying design that has been sketched on to the goblet, and the expert who draws it must not only have

*In the cutting workshop: myriad designs such as beveled lines, lozenges, stars and teardrops are engraved on to the crystal by means of etching points in sandstone, pumice stone and corundum engraving wheels.*

Following double page
Paperweights
Top: *"Viala" collection paperweights, limited edition of 250 pieces. Inlaid flowers on a blue ground. Cristalleries de Saint-Louis.*
Left: *Millefiori "Persian" paperweight, 1990, limited edition of 600 pieces. Cristalleries de Saint-Louis.*
Bottom: *"Eclosion" paperweight, 1994, limited edition of 150 pieces. Small filigree pedestal and inlaid raised formal bouquet. Cristalleries de Saint-Louis.*
Right: *"Gingham" overlay with inlaid raised formal bouquet. Limited edition of 50 pieces, 1989. Cristalleries de Saint-Louis.*
Glass paste at Daum
Left: *Making an elastomer mold.*
Below: *The plaster molds are filled with cullet (waste glass).*
Right: *The base of the "Cactus" bowl by Hilton McConnico being extracted from the plaster mold.*

# Paperweights

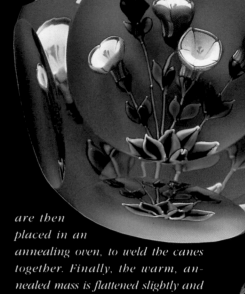

In French, the name sulfure (crystal-ceramic) is often mistakenly applied to all ornamental glass paperweights. Perhaps even the writer Colette was misled: she was a collector of "these tiny petrified gardens, these multicolored tours de force, these almost edible candies"—symbols of the mysterious processes of glass production.

## Millefiori

Millefiori paperweights, known to the Egyptians and Romans and revived in sixteenth-century Venice, were revived once again in 1845 by glassmakers Saint-Louis, Baccarat, and Clichy. Millefiori are made by assembling sectioned, multicolored "canes." These complex compositions are still fascinating today by virtue of their variety and transparency.

The first step in constructing millefiori is the fusion in the pot kiln of separate batches of colored glass in small pots. The glassblower then gathers gobs of first one color and then another on the end of his rod. The first color will be the center of the millefiori cane, with the second color forming a ring around it. Sometimes a third color is added around the second one. Next, two glassmakers, each wielding a rod, pull and stretch the concentric rings of glass into a cane measuring up to fifty feet long and only a fraction of an inch in diameter. When the canes cool and harden, they are cut into small sections, or "candies," each with a multicolored surface. The artistic sensibility of the glassmaker comes into play at this point, when he arranges his choice of sectioned canes on a steel or cast-iron disk. The disks are then placed in an annealing oven, to weld the canes together. Finally, the warm, annealed mass is flattened slightly and covered with a parison, or hollow blank, of clear crystal.

Many variations are possible in assembling the canes. For filigree and lace designs, clear crystal is combined in the center of the disk with "torsades" or white enamel canes that have been stretched and twisted. Decorative motifs of greater complexity, such as stars, cloverleafs, and animals, are made in metal molds.

## Formal bouquets

Another type of paperweight contains formal bouquets. These also require artistic sensibility from the craftsman wielding blowpipe, rod, and shears in order to model canes and threads of crystal into floral bouquets and miscellaneous decorative motifs, and then covering them with a parison of clear crystal.

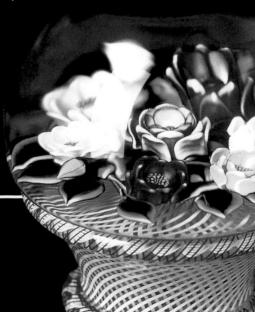

# Glass paste

## Sulfures or crystal-ceramics

Crystal ceramics are round paperweights in which the decorative element is a raised figurine, or cameo, made from ceramic paste pressed in a plaster mold and then covered with a transparent crystal dome. The first French cameo paperweights were manufactured in the thirteenth century by regional artisans, some of whose work can be seen today at the Sèvres Museum. This art was subsequently revived in the middle of the nineteenth century by the great glassmakers

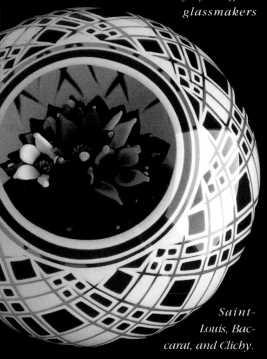

Saint-Louis, Baccarat, and Clichy.

## Overlays

The last paperweight category is the "overlay," a term designating a sphere covered with double or triple layers of enamel glazing. When the sphere is cut through, the different layers of glazing become visible. The first layer is usually white, and the second red, yellow, green, or blue. Overlays sometimes also contain a central motif such as a millefiori or cameo.

Paperweights are unpretentious little objects with no real function. They first became popular in France with the advent of the printed postage stamp and regular, universal mail delivery. Today paperweights are sought after primarily by collectors.

At Daum, the process of molding glass paste resembles sculpture-casting more than glassblowing. This is because the classic lost-wax method is used to make the plaster molds into which molten glass is poured.

The design for the piece is first drawn on paper. Using this sketch as a guide, a detailed model is made from clay. Liquid elastomer is then poured over the clay model and allowed to dry. When the clay model is removed, it leaves an exact, detailed imprint in the flexible elastomer. Hot wax is then poured into this elastomer mold and allowed to harden. The mold is peeled off and the hardened wax trimmed, resulting in an exact wax replica of the original clay model. In the final step, the wax replica is covered with heat-resistant plaster and baked in

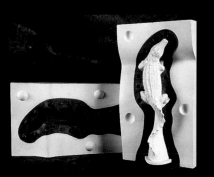

a special oven. The plaster hardens and the wax inside it melts away, leaving a rigid, heat-resistant plaster mold that can then be filled with molten glass.

The plaster mold is filled with cullet (waste glass) in the desired color and placed in a furnace heated to a temperature of one thousand

degrees. The heat is progressively decreased over a period of several days until the cooled mold can be removed from the furnace and broken, and the molded glass piece removed.

This is still not the end of the process, however. At this stage, the glass piece is unpolished and still contains the sprues, or branches of glass that in molten form flowed through the air vents in the mold. The sprues are cut off, and the glass is machine-finished by the master cutter, who virtually sculpts it into its final form,

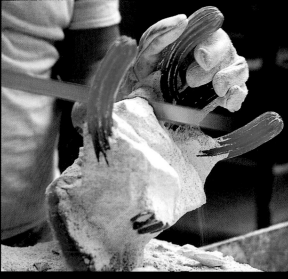

since the surfaces he finishes and polishes are curved rather than geometric as they are for crystal.

These pieces are unique for two reasons: first, because even multiples of the same model are individually finished; and, second, because no two batches of the colored cullet used to make the molten glass are exactly the same. There is no such thing as mass production here.

## René Lalique

The life and work of René Lalique can be divided into two successive phases: that of the poet–artisan, inventor of "modern jewelry," and that of the industrialist who pioneered complex glassmaking techniques that diversified and expanded the ways in which this material is used.

Lalique was trained as a jeweler, and he devoted his early career to the creation of innovative pieces inspired by nature and the imagination of the symbolist movement. During this period, Lalique renounced the rare and costly gems traditionally used for jewelry in favor of materials with more expressive potential: gold and enamel, for their colors; opals and moonstones, for their symbolic associations; and carved ivory and rock crystal, for their organic connotations. To all of these he added glass, which he exploited for maximum effect by tinting it, modeling it like cameos, and using it in place of gems. In 1898 he acquired the Clairefontaine estate, near Rambouillet. There he built his own glassworks, where he manufactured jewelry, the door panels for his house on the Cours la Reine, and fine hollowware (vases, goblets, bowls, and chalices) featuring the same decorative motifs as his jewelry—pine trees, wheat sheaves, and grape vines. These early twentieth-century pieces are from Lalique's first period, when his goal was to incorporate glass into jewelry. During his second period, he concentrated on glass alone.

There may possibly have been a connection between the death of Lalique's wife in 1909 and his renunciation of jewelry design; on the other hand, the fascination glass exerted on his imagination following his initial experiments with it was perhaps all the incentive he needed to establish his own glassworks. Be that as it may, Lalique's fledgling industrial venture began its life with a commission from François Coty for the manufacture of

perfume bottles, which were decorated with the motifs already used for jewelry, and with sinuous female figures clad in classical draperies. For these bottles he invented refined tech-

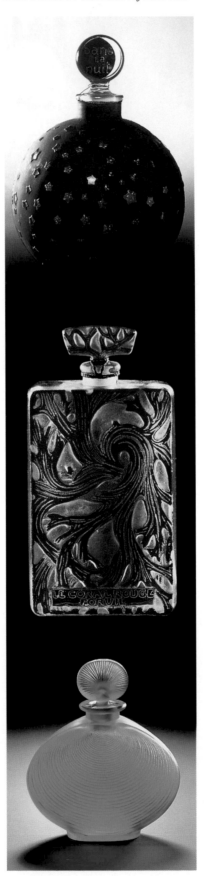

nical procedures combining manual artistry with machine technology. In 1909 Lalique registered a patent for a "glass-molding process applicable to the manufacture of bottles, decanters, and narrow-necked vases." This was followed in 1911 by another patent for a technique "combining glass-blowing and press-molding." Vases and other glass objects manufactured according to these processes were produced in limited series. All required meticulous finishing, acid-etched frosting, along with buffing, patinating, or enameling.

Lalique also became interested in glass tableware, an area in which there had been no significant innovation since the end of the eighteenth century. When the First World War ended, he continued his experiments at a new factory in Wingen-sur-Moder near Saverne, which formed part of the recently recovered French provinces.

The Lalique pavilion at the 1925 Decorative Arts Exhibition demonstrated the full scope of René Lalique's accomplishments as a glassmaker.

In addition to models produced in extremely limited series using the combination blown-glass and lost-wax mold technique, Lalique also manufactured a virtually unlimited series of vases, bottles, bowls, tableware, toiletry accessories, and lighting fixtures. These were ornamented with friezes; processions of neoclassical and neo-Hellenic figures; the stylized floral and vegetal motifs typical of the period; and birds and insects in white, opalescent, or colored glass. His industrial capacity appeared limitless, and he expanded his operations to include fountains and the decoration of public and ecclesiastical structures, transatlantic liners, railway trains, and cars.

After his death on 1 May 1945, the torch of Lalique & Cie was passed on to the founder's son, Marc Lalique.

*Yvonne Brunhammer*

the skill of a master craftsman, but also the sensibility of an artist. With only a scale blueprint to guide him, he uses gold and black wax crayons, etching points, and compasses to draw the chosen design on the crystal piece. The design is then cut into the crystal with grinding wheels that vary from approximately one to fifteen inches in diameter, in inverse proportion to the length of the line to be cut. When the piece has been squared off and the design sketched on to it, the cutter then incises it by running the grinding wheels over the lines. "You dig right into the glass," says Gérard Beylstein, with the confident smile of a man who knows exactly what he is doing.

A SUBTLE HIERARCHY • The task of drawing designs on the crystal is therefore never entrusted to an apprentice, or even to a craftsman who has earned a *Meilleur Ouvrier de France* award. Only a cutter who has attained the rank of master craftsman will have acquired the special skill needed to draw a design on virgin crystal. Executed with a diamond grinding wheel, the actual cutting of the crystal—into a multitude of beveled lines, lozenges, cameos, and rosettes straight from some figure-skater's dream—is totally dependent on the quality of the underlying drawing, which may seem cursory but is actually extremely intricate.

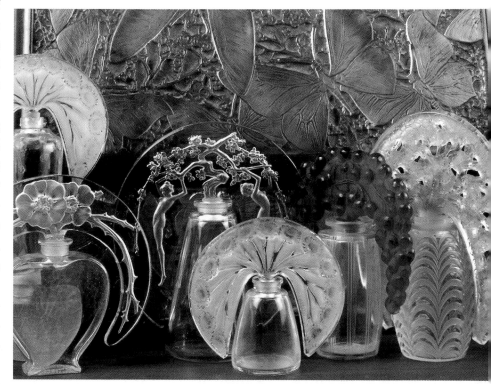

Even this is not the whole story, however. The title of "master craftsman" recognizes not just virtuoso technique and extraordinary manual dexterity, but also exceptional artistic judgment. The master craftsman is a role model first, and a teacher second: he stands as an ideal for apprentices beginning to learn their craft, and novices perfecting theirs, in an atmosphere of reverence which recalls the medieval guilds.

ENGRAVING • Baccarat's master engraver Guy Calinois contemplates the fabulous "chimera" pitcher he has copied from a piece originally designed for the 1878 Paris World's Fair. For his own engraving, he works from a photograph of the original. Calinois has followed this pitcher's progress closely, from the moment the first gob of glass left the pot kiln, to the shaping of the parison and neck by the head glassblower. The first attempt to form the neck resulted in an ordinary funnel shape, so Calinois cut a detailed stencil of his mythical beast's head, and returned to the kiln with it. There, under his supervision, the glassblowers reheated the glass,

*Set of perfume bottles designed
by René Lalique between 1913 and 1920.*

Left, from top to bottom:
*"Dans la Nuit" cobalt blue perfume
bottle with enameled star decoration,
Worth, 1925.
The "Red Coral" perfume bottle created
for Forvil in 1925. Blown, molded,
enameled plain glass.
"Telline" perfume bottle, 1920. Patinated,
blown, molded plain glass with color
overlay and molded, pressed stopper.*

adjusted the neck opening, shaped the beast's muzzle and ears, and attached the pitcher's handle and base. The final version now stands before Calinois in a state of virgin transparency, waiting to be finished. Each scale on the beast's belly and every little decorative arabesque must be separately engraved, and the eyes polished until they sparkle with life. As already noted, designs executed by a glasscutter with a diamond grinding-wheel are basically geometric. The glass-engraver, on the other hand, uses tiny lapidary tools to create designs that can be infinitely varied and extremely complex: curves that are wild and extravagant or subtle and delicate; details that are minute and elegant. When the engraver has completed the design, the piece is then polished to produce matt, semi-matt, and brilliant effects that exploit the many nuances of the crystal itself.

The tiny lapidary tools caress the crystal almost imperceptibly with a stroke that is infinitely gentle compared with the incisive "bite" of the glasscutter's grinding-wheel. A cool stream of water flows continuously over the area of the piece being worked. As night begins to fall, the engraver concentrates all his attention on the piece, taking advantage of the natural light—so essential to his task—which still filters through the skylight overhead. The diamond bit of the lapidary tool leaves a film of gray dust on the crystal, momentarily dimming its brilliance. When he has completed his pitcher, Guy Calinois will take it to the acid-etcher to be dipped for thirty to forty seconds in an acid bath. This will dissolve the film of crystal dust and reveal the engraver's sculpture in all its crystalline glory. The chimera pitcher is major topic of conversation at the factory, a joint effort for which every one on the team feels responsibility and pride.

Guy Calinois, meanwhile, exercises his many skills not only inside the engraving shop, but outside as well. Serving as an ambassador-at-large for fine crystal, he travels to Hong Kong, Dubai, and New York, and is known to the Japanese as a "living national monument." Calinois is one of the few men still alive who is capable of passing on his art to the younger generation. A diligent apprentice sits at a neighboring workbench. With a nod in his direction, Calinois alludes to the initiatory journey every guild member must make before attaining master status, and sums up this itinerary as it applies to the apprentice engraver: "He won't have to travel from site to site all over France the way artisans in other trades do. His Tour de France will be just like mine—a journey from skill to skill, right here in the factory."

*Cutting a glass goblet stem. Cristalleries de Saint-Louis.*
Right: *A master glasscutter at work. Cristalleries de Saint-Louis.*
Top: *"Tommy" service, 1928. Cristalleries de Saint-Louis.*
Below and previous page: *Plate of technical drawings by Joseph Bleicher, 1933. Cristalleries de Saint-Louis.*

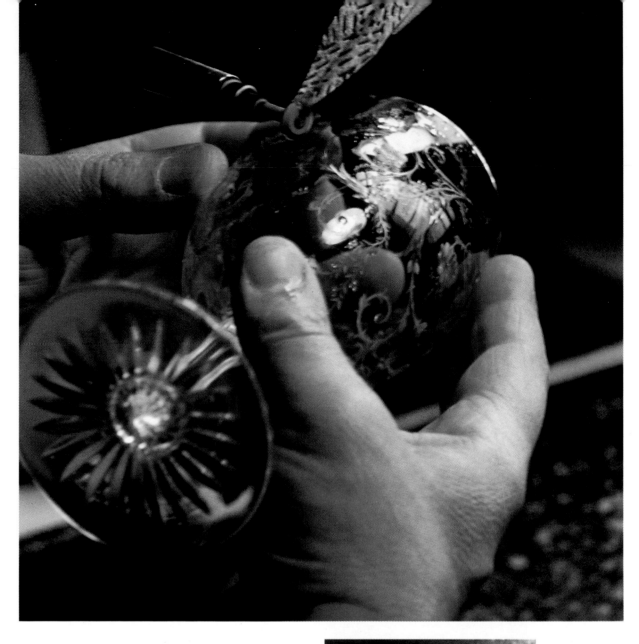

Engraving process involving a corundum
wheel cooled by a continuous stream
of water. Baccarat.
Right: *Acid engraving process :
the design is copied on to the glass using
bitumen and tissue paper. When the piece is
dipped into an acid bath the design
is etched on to the crystal.*

Following double page
*Osias Beert*, Still Life with Oysters, *(detail)
seventeenth century. Prado, Madrid.
Right: Phalsburg glasses, bowl and
luncheon plate. Lalique, 1924.*

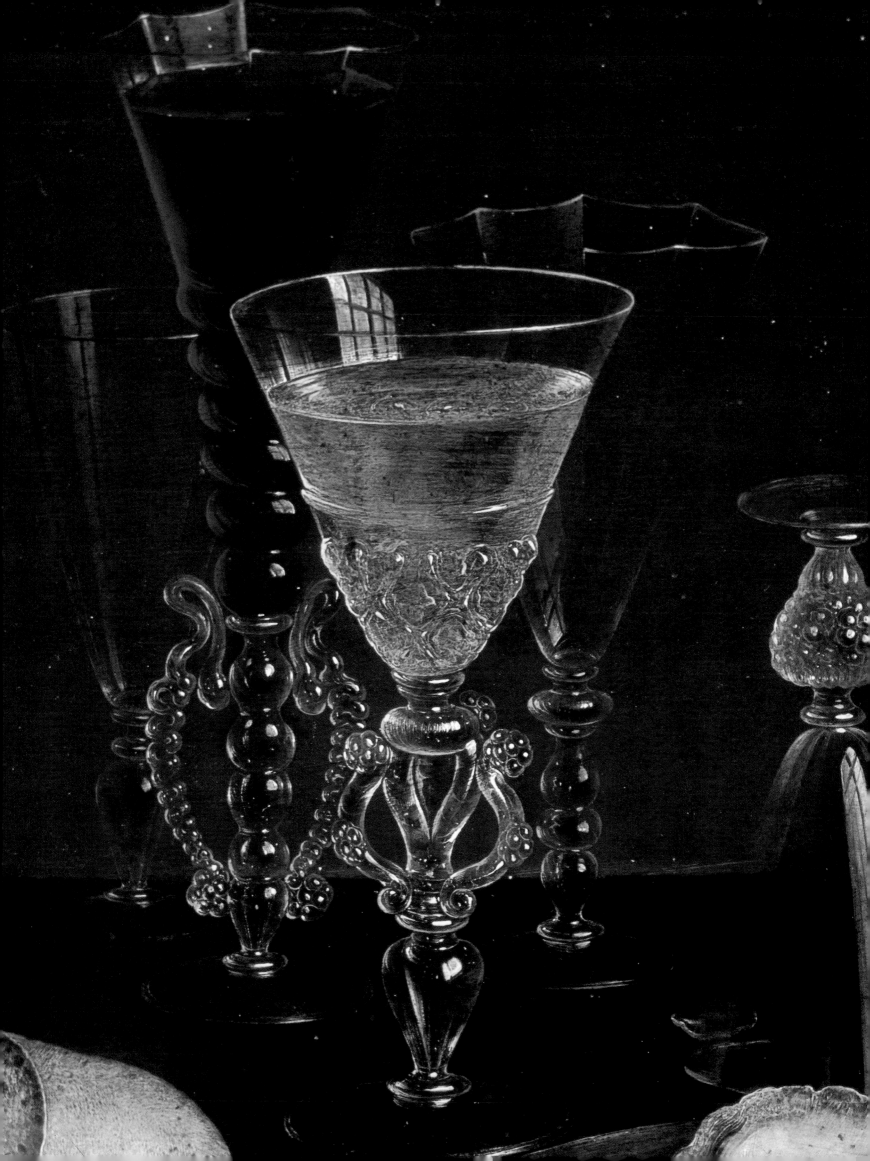

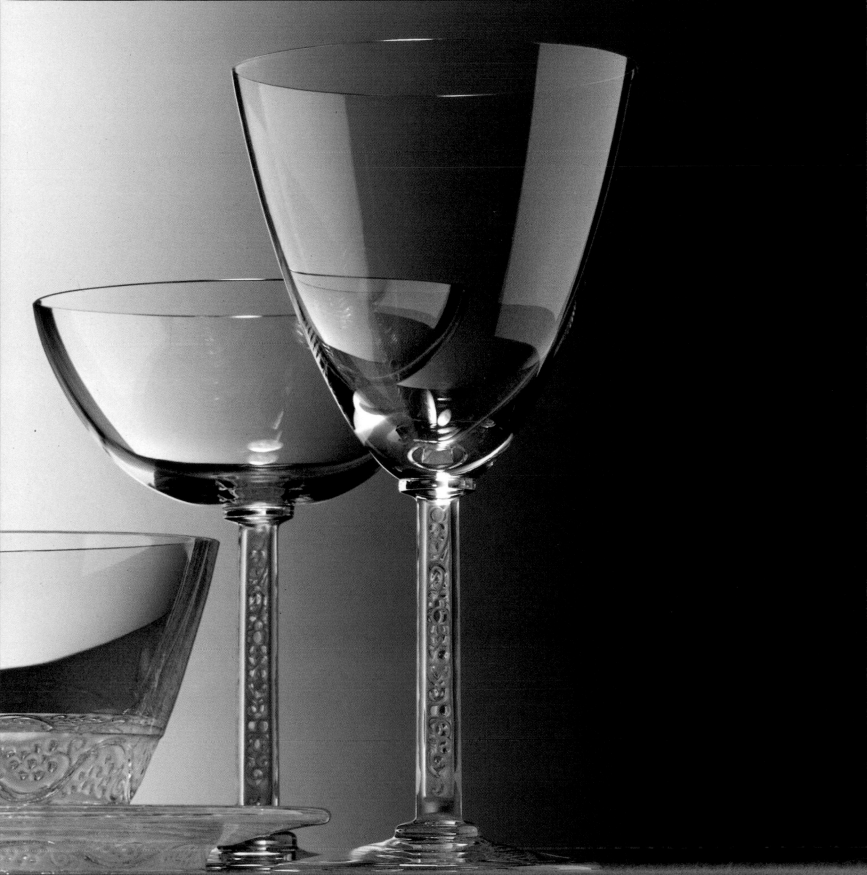

### Third millennium B.C.

The first glass vessels were made by attaching a sand, earth, and straw mold to the end of a rod and plunging it into liquid glass, or coating it with a molten filament. The surface was then polished and the mold extracted.

### Antiquity

It was not until the first century A.D. that the blow-pipe, probably invented by the Phoenicians, enabled blown glass to be produced, marking the birth of an actual glass industry.

### The Middle Ages and the Renaissance

In the Middle Ages, glass continued to be produced from soda ash in the countries south of the Alps, whereas in the north glassmakers started to use potash, extracted from wood ash, as a flux.

The latter was more malleable and enabled the Venetian glassmakers, who had settled on the island of Murano at the end of the thirteenth century, to produce audacious forms enhanced with sophisticated decorations, such as enameled or painted glass, "milk-white" glass, diamond-engraved glass,

and filigree glass. In the fifteenth century they produced a fine, transparent glass resembling rock crystal, known as *cristallo*.

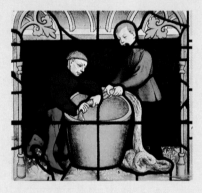

All this glassware was exported, then copied throughout Europe, and until the end of the seventeenth century Venice maintained its monopoly in the sector of luxury glassware.

### The seventeenth century

Bohemian glassmakers succeeded in improving the potash-based composition and became renowned for the particular quality of their glass, known as Bohemian crystal. Although not as fine as *cristallo,* it was harder, thus giving a fuller range to their engraving talents.

**Bohemian Glass**: The birthplace of Bohemian glassware is situated in the mountainous region of the Bohemian Forest, where, due an abundance of wood, silica and potash, glass manufacture became one of the fundamental factors of the area's economy. The industry developed because of the monastic influence, the discovery of silver mines and their subsequent development that brought workers to the region. The eighteenth century marked the golden age of Bohemian glass, at the expense of Venice, the Bohemian technique being characterized by deep cutting, which intensified light refraction.

**English crystal**: In 1615, in order to combat deforestation, an English decree banned the use of wood-fired furnaces. Coal firing, however, had two major inconveniences: first the fumes blackened the glass and second, fusion took longer. To counteract these problems, George **Ravenscroft** (1618–1681) added a new lead monoxide-based flux which lowered the fusion temperature. In 1673 he took out a patent "for the manufacture of a particular type of crystalline glass resembling rock crystal." The perfecting of this process took nearly a century and the brilliant new glass with its much higher refraction index was crystal.

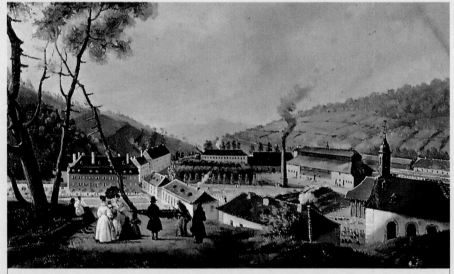

*La verrerie royale de Saint-Louis*, *founded under the patronage of Louis XV in 1767, was the first French glassmaker to manufacture crystal in 1781, and in 1829 it was given the name of Cristalleries de Saint-Louis. Renowned for the quality of its cut glass and color mastery, it introduced pressure molding, filigree painting, and layered glass, thus producing the first paperweights in 1845. Subsequently it specialized in sets of colored glassware and gold-leaf decoration.*

### French glass and crystal in the eighteenth century

In order to take advantage of its forestry resources and limit imports of Venetian and Bohemian glass, France developed its own glass production.

### The nineteenth century

At the beginning of the century many glass-makers turned to manufacturing objects in

*Baccarat: The Baccarat glassworks, founded in 1764 and subsequently renamed the Sainte-Anne glassworks, was bought by **Aimé Gabriel d'Artigues** in 1816. He installed the first crystal furnace, and in 1819, changed the name to Compagnie des Cristalleries de Baccarat. The crystal-works, specializing in chandeliers, produced the first colored crystal in 1839, as well as objects in opaline crystal and subsequently under Napoleon III, began manufacturing perfume bottles for celebrated per-fumers. The working conditions, even in 1827, were exemplary. Today Baccarat perpetuates its exceptional chandelier tradition.*

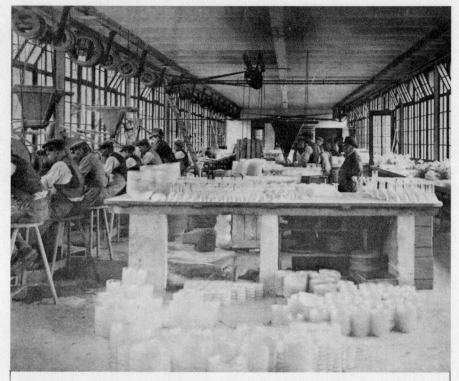

**Lalique. From the chandelier to the perfume bottle.** *As of 1913, René Lalique (1860–1945) specialized in glassware, turning towards an industrial production of original creations of perfume bottles and vases. Experiments with iridescent, satin-finished, and opalescent colors characterized his work. As early as 1918 he expressed his creativity in ornamental and decorative glass while also developing tableware.*

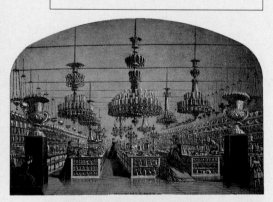

*Gallé and Daum Emile Gallé (1846–1904) played a decisive role in the propagation of art nouveau and of the influence of the Nancy School. His work, as regards materials and forms, testifies to his considerable research and his mastery of techniques, such as in depth decoration, inlaying, and the application of surface enamel. He drew most of his inspiration from the plant register.*
*Antonin Daum, (1864–1930) and Emile Gallé diversified glass art by introducing intercalary decoration, powdered glass, wheel or acid-etched glass, pâte de verre and form orna-mentation. He figured as a pioneer in the creation of lamps in decorated glass.*

cut and engraved crystal. To satisfy the needs of the middle-class clientele and their new lifestyle, table crystal became more varied. Each guest now used several glasses for wine and water, including a champagne flute. Very soon the whole of Europe was placing orders with the French crystalworks.

### The end of the nineteenth century

The revival of *pâte de verre* or glass paste: At the turn of the century, art nouveau artists took little interest in transparent crystal.

### The twentieth century

Apart from a few spectacular orders like that in 1934 for one hundred thousand pieces of Daum crystal tableware and René Lalique lamps to adorn the ocean liner *Normandie*, it was not until the end of the Second World War that crystal production came back into its own.

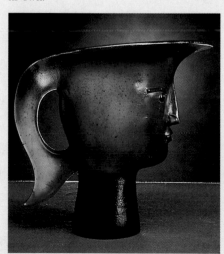

# *Faïence and Porcel*

All ceramics, including faience (earthenware) and porcelain, are produced by exposing earth to fire. The shapes given to ceramic pieces reflect a long tradition during which they have varied very little and then only very gradually. This is a slow-moving craft and a domestic one in a sense, since most of its products—plates, vases, platters, cups—are made to be used, particularly on the table. When people gather round a table, they tend to respect time-honored customs. Olivier Gagnère is a designer of interiors and furniture, and of objects made from metal, glass, and clay. He

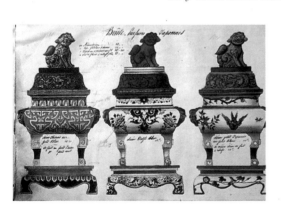

is past-master at injecting domesticated originality unobtrusively and modestly into the relatively constraining mold of custom and tradition. Gagnère is one of the few people who have succeeded in working from within to develop a craft that is itself as vulnerable as its fragile artifacts of

baked clay. Here he gives an interview on his work.

**François Baudot: How is new design introduced into the field of ceramics?**
*Olivier Gagnère: Household china is like a tool, its smallest components honed by centuries of use. Introducing fundamental modifications into a plate or cup would therefore be presumptuous. However, tableware also has its purely esthetic aspect in terms of both ornament and color. Then again, pieces intended for purely decorative purposes certainly allow much more leeway in design. Few people purchase gravy boats and soup tureens today, but many are attracted by non-functional decorative pieces if they are sufficiently appealing. Large decorative ceramics fall outside the province of the typical "bridal register" piece, and can be appreciated in the same way as painting and sculpture.*

**F.B. What is an original designer's function within such a relatively stable craft?**
*O.G. More stable than ever before, as a matter of fact, thanks to modern technology. Today's quality standards are amazingly consistent—sometimes at the expense of a certain charm, however. Makers of fine china all have their own*

history, style, and traditions. These must be thoroughly mastered in order to achieve, through modern means, the element of magic associated with antique pieces. A practiced eye is the most important factor at every stage in design and manufacture. Modern equipment is so sophisticated, it is tempting to let the machine make all the decisions. Designers seeking to express their own ideas must also develop a very close working relationship with manufacturers. This type of cooperation is essential for solving problems, and also for overcoming fixed ideas generated by the weight of the past.

**F.B. How are new pieces and new product lines designed?**
*O.G. In my case, the first step is my own personal desire for something new. The second step is to make a plaster cast for the mold. Since the main body of the design will probably outlive the decoration, we use stencils for the latter. Next we submit the design to the artisans who will execute it. This is always a source of great satisfaction, since these people possess astonishing skills and I find it a pleasure to put them to the test. The manufacture of porcelain is a relatively lengthy process. When a piece has been molded, it is subjected*

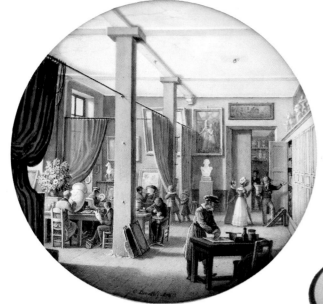

# ain

to an initial, or biscuit, firing. It is then glazed, painted or hand-gilded, and fired again. The second firing is longer, and lasts about thirty hours. When it is completed, the porcelain must be cooled very gradually to prevent cracking. The sum of these operations can span several days, and designers must be humble and patient while waiting to see the final result of their efforts. The thing I especially enjoy, when working with major houses such as Bernardaud, is being able to draw on a tradition that lends credibility to my innovative approach.

**F.B. How do you view the designer's role?**

*O.G. To me, there is absolutely no difference between an* objet d'art *and a painting or a sculpture. My own approach is the same, in any case. The important thing is the emotion stimulated by the creative act. There is no such thing as "modern"—the very word is* passé. *Contemporary style reflects an amalgam of coexisting movements, with no fixed dogma, no hard line. The designer is a person attempting to keep a steady hand on the tiller in a sea of contradictions and contrasts. The goal is to strike just the right balance between past traditions and the present time.*

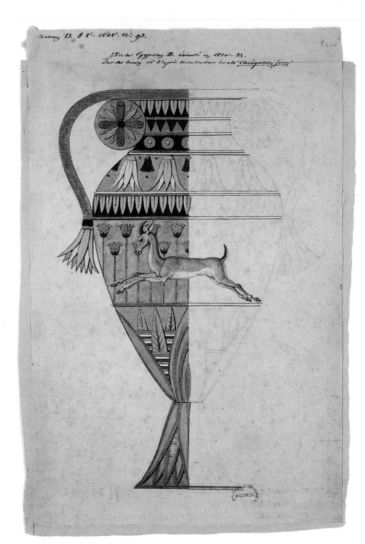

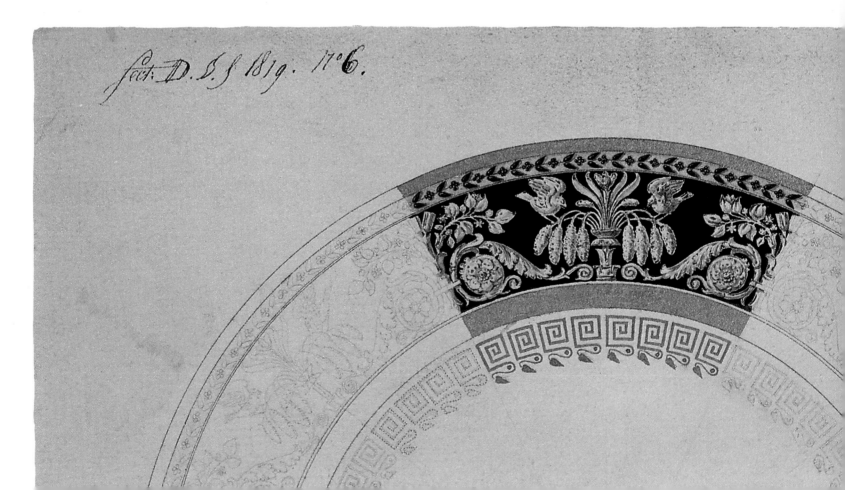

## The ingredients and the method

GIEN'S RECIPE FOR CERAMIC PASTE • At the Faïenceries de Gien, founded in the early nineteenth century, raw ceramic clay is heaped in piles between the posts supporting the roof of the storage shed, settles noiselessly against the cement walls, and lies cold and inert in trenches dug by giant excavating machines. Each pile's respective properties can be identified by a gamut of colors ranging from purest white through solid gray to deepest black.

The hard paste used for producing Gien faience has always been mixed at the factory itself, and chief engineer Denis Caraty likes to begin visitors' tours at this somewhat isolated spot—the warehouse in which the raw materials are stored. He scoops up some of the raw earth and, as he kneads it with a practiced hand and lets the pebbly gray material run through his fingers, he talks about it: "This is clay from Tournon-Saint-Martin. It will turn white when it's fired, because there's very little iron oxide in it." Caraty moves on, planting his foot on a grainy, yellowish pile. "This is sand from the Loire. It contains a little kaolin and lots of sodium and potash. It's a highly feldspathic sand which we use to strengthen the paste—it's our glue, as it were." Further along stands a pile of kaolin from Brittany. Our host invites us to touch it. "It's just like chalk, isn't it?" he comments, rolling a large lump of it between his fingers. "But notice how soft and oily it is. Kaolin results from the decomposition of granitic rock and, unlike some other clay soils that are shifted over time and acquire impurities, kaolin remains exactly where it was formed and stays pure. That's why it's so white." As he reverently returns the lump to its pile, Caraty concludes, "Kaolin is the aristocrat of ceramic clays."

As if to illustrate this last point, Denis Caraty now examines a pile of black clay from the Marne which is clearly filled with organic impurities. "However," he notes, "it will turn white when it's fired. I don't worry much about the color of the raw clay. The only thing we care about is how it will look when it comes out of the kiln. Clay doesn't show its true color until after it's been fired."

These imposing piles of raw clay will eventually be mixed with water, in proportions that remain more or less secret and vary according to the maker. The water goes into the mixing machines first, along with North Sea pebbles that clatter resoundingly as the mixer turns. "Large, round, black pebbles," says

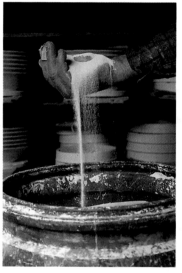

*Quartz, feldspar and kaolin are mixed with water in proportions that remain more or less secret and vary according to the production sites.*
Left: *Faïencerie de Gien. Painting and sketching. Extract from* Aux grandes usines françaises *by Turgan, 1867.*
Top: *Drawing for an Egyptian-style vase B created in 1830 from the drawings and according to the specifications of M. Champollion Jeune. Manufacture Nationale de Sèvres.*
Bottom: *Design for the Liliacé service, 1819, Manufacture Nationale de Sèvres.*

Preceding double page
Left: *Project for a perfume burner, c. 1875, Faïencerie de Gien.*
Top: *Detail of a plate from a service of the Arts industriels representing the decorating workshop at the Manufacture Nationale de Sèvres, 1823. Musée National de Céramique, Sèvres.*
Right: *Ithaque and Lipari services by Olivier Gagnère for Bernardaud.*

高
山
嶺
土

Denis Caraty, holding one out to his guest, "made of chalcedony, a type of silex. The pebbles help pulverize the clay, but the smoothness of the final paste will depend on the speed at which the mixer turns."

Culinary metaphors crop up repeatedly, as if there were some secret relationship between ceramics and cuisine—a similar way of measuring ingredients, blending them, baking them, and "serving" them. Pointing to a row of huge storage vats Caraty concludes: "These pulverized ingredients eventually produce a high-quality ceramic paste." The next step is to extract excess moisture by placing the mixture in a horizontal press that forces out the water and transforms it into slabs of paste. The paste is then kneaded to extract air. If any air is allowed to remain in the paste, it will form air bubbles or cracks when the paste is fired. The final step is forming the paste into tubular rolls. It is from these rolls of ceramic paste that Gien porcelain is shaped.

### Limoges kaolin

Porcelain owes its white color and translucence to a clay called kaolin (from *kao-ling*, a Chinese word for "high hill," the name of the spot where it was first discovered), which had been known in China since the Han dynasty, and was brought to Italy in the thirteenth century by Marco Polo. The earliest known European kaolin deposits are in Saxony, and their discovery led to the invention of a hard-paste clay by Johann Friedrich Böttger of Meissen in 1709. Meanwhile, a number of French porcelain makers, including Sèvres, developed the soft-paste, or artificial porcelain method, in which powdered glass is used as a substitute for the feldspathic rock of true porcelain.

The 1767 discovery of kaolin deposits at Saint-Yrieix, near Limoges, marked the beginning of the hard-paste porcelain industry in France. Limoges earned its title as the capital of fine French porcelain with the creation of its Manufacture Royale, and the development of numerous small, private factories in the region.

Today, the basic formula for hard paste is no longer a secret, and porcelain makers have joined forces in order to set quality standards for their products. However, each firm still jealousy guards its own "recipe" for the exact proportions of each ingredient. Furthermore, although mixing the raw materials has now become a standardized process, the resulting hard paste can vary in unpredictable ways. "These lumps of clay were formed millions of years ago," points out Gérard Gautron, ceramics engineer

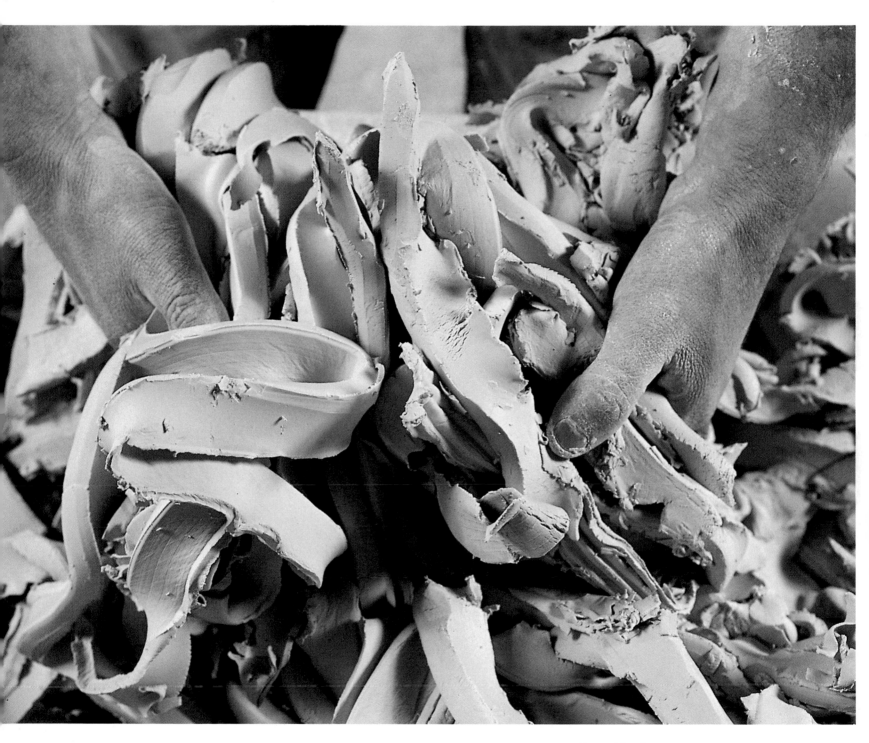

*Paste residue after gauging operation.
Bernardaud.*

Left: *Chinese ideograms of the
word kao-ling.*

at Bernardaud, "and they aren't necessarily all identical." Variations in water quality can also be a factor. When the hard paste is mixed with additional water to make liquid slip, the density and viscosity of the mixture can be affected by the water quality, sometimes resulting in flaws that appear only after the finished piece has been fired. When this happens, single pieces and sometimes an entire series must be rejected as substandard.

## The molding workshop

Another key area in any porcelain factory is the molding workshop. This is where the plaster molds are made that will later be filled with liquid slip or hard paste for the production of finished objects ranging from plates to elaborate formal pieces. Bernardaud's head modeler, Christian Brunet, works from the designer's drawing to fashion a "fired-size" scale model. He will then use this as the basis for executing a "clay-size" model, which will be about one-sixth larger in order to allow for shrinkage during firing. Thus, for a finished plate measuring ten inches in diameter, the clay-size model will measure approximately eleven and a half inches. Brunet then makes four or five plaster masters, or exact replicas, of the clay-size model. He uses these masters as blocks for shaping the final molds into which solid clay paste will be pressed, or liquid slip poured. In a variant of the process, molds can also be used as templates for machine-turning on a lathe. In all cases, the master molder's task is to exploit the full potential of his material while achieving the kind of exemplary piece that depends on the skills of a true craftsman.

CASTING AND PRESSING • Casting is the process of forming a ceramic object by pouring liquid slip into a dry plaster mold. The slip is poured into thirty or forty production molds made from a single master mold, and then placed on a carousel, a large revolving tray known as the "mold wheel." Each of the molds stands on a pivotal axis that acts as a centrifuge for the paste, which must be kept in continuous motion so that no lumps form. As the plaster mold absorbs moisture from the slip, a layer of clay builds up on its inner surface. When sufficient clay adheres to the mold, the surplus slip is poured off and the clay allowed to dry. When it hardens and shrinks from the sides of the mold, it is removed. The molded piece is now ready to be fired in the kiln.

Template pressing is used for flat ware of all sizes, and the bodies of hollow pieces minus appendages such as handles. For plates, the mold for the interior of the piece is placed on a central

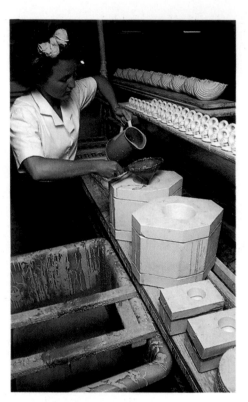

*Pouring slip into plaster molds. Faïencerie de Gien.*

Right: *The molding workshop at Bernardaud where the plaster molds are made which will serve for the production of finished objects.*

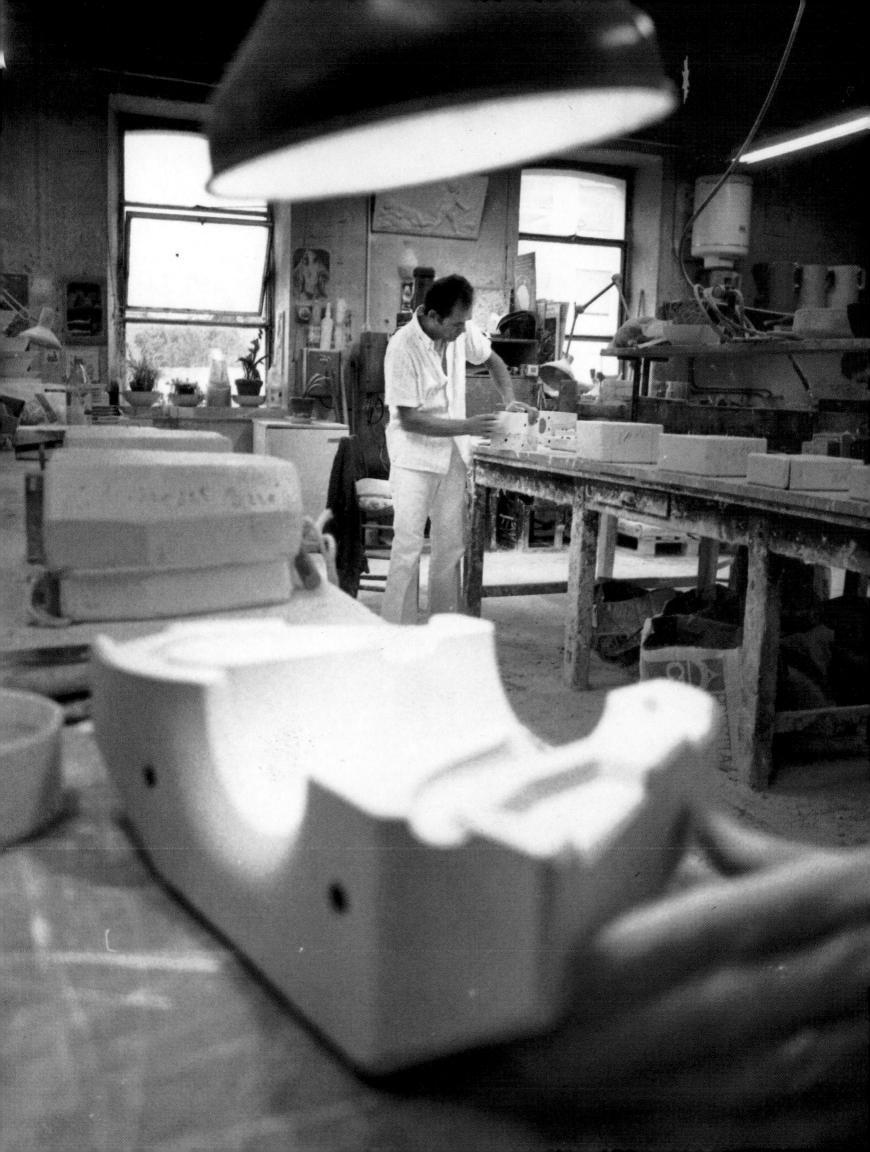

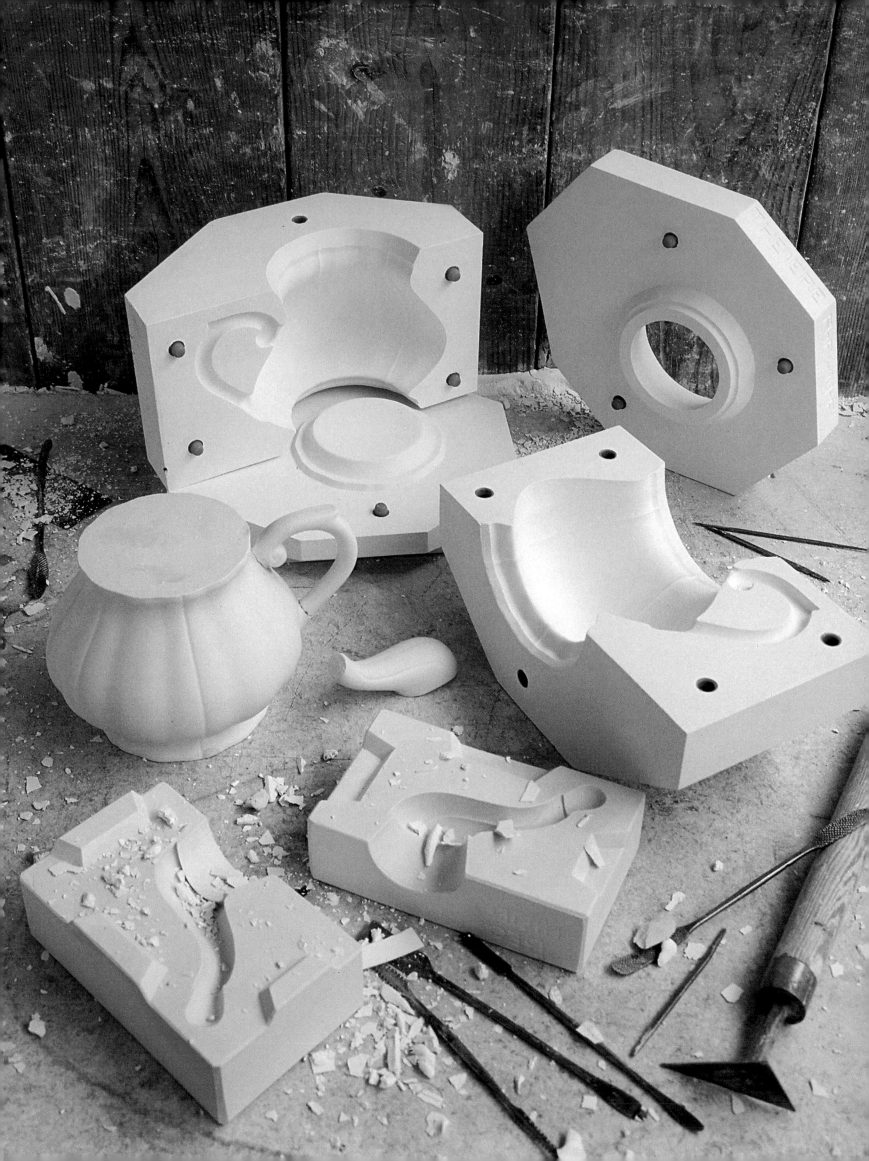

revolving ring, and a thick slab of semi-hardened paste cut in tubular sections pressed down on to it and flattened with a steel template. The paste-filled molds are then placed on a sling or belt that moves them into a dryer for fifteen to thirty minutes. When the pieces are dry, they are removed from the molds by vacuum suction and wiped with a damp sponge before firing.

CLAY NEVER FORGETS • Daniel Chaumeton, foreman of the molding workshop at Robert Haviland & C. Parlon, shows off his

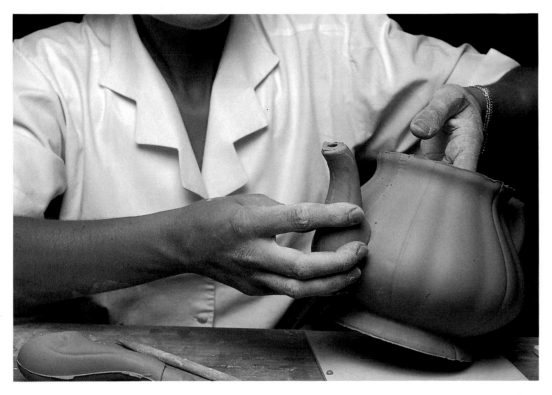

latest creation: a water-lily coffee-cup with relief decoration inside and outside, and a handle which instead of being attached by both ends to the outside of the cup, curves over the top and is attached to the inside. Handles and lips are usually molded separately and then luted (attached with liquid slip) to the piece in order to strengthen them. Unique pieces—and their handles—are never pressed, but always molded and removed from their molds by hand. "What you have to bear in mind," explains Daniel Chaumeton, "is that the paste never forgets anything you do to it. Every bit of pressure you subject it to will affect the way it fires. For example, if you don't remove this cup perfectly vertically from its mold, it will cant slightly to the left. The tilt won't be immediately visible to the naked eye, but it will be aggravated when the piece is fired. This is the kind of delicate task

*Firing at the Faïencerie de Riez-sous-Moustiers. The pieces are stacked one upon the other on the kiln's shelves.*
*Left: The so-called "garnishing" phase when the lip and the handle are attached to the body of the piece with slip. Faïencerie de Gien.*

*Left-hand page: Parts of a teapot unmolded at the Faïencerie de Gien (body and spout). The mold is composed of two or several sections made from a single master mold, also in plaster.*

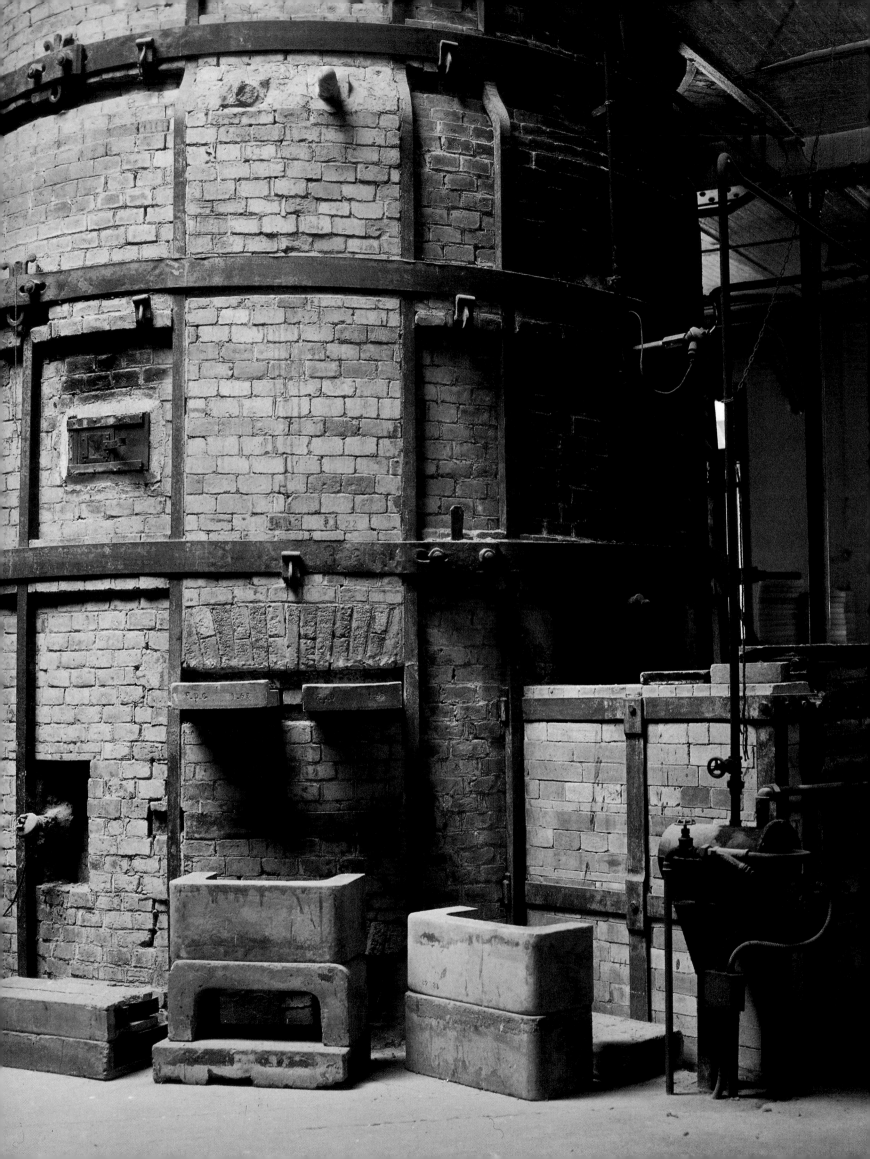

you need real craftsmen for," he adds, taking in the humming workshop around him with a grand gesture.

## Porcelain versus faience: the formula and the firing

Although porcelain is the aristocrat of ceramics, faience, or earthenware, has always been popular with connoisseurs who appreciate the forms and decoration of a material fired at lower temperatures than those required for the vitrification of porcelain. Two factors differentiate earthenware from porcelain. The first is the amount of kaolin in the clay. Both contain some, but porcelain contains much more than earthenware, and it is this that accounts for its distinctive translucence. The second factor is firing temperature.

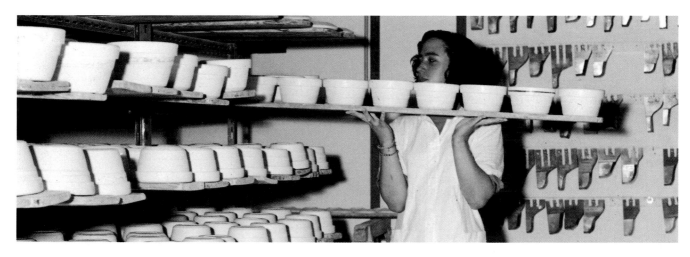

The lower firing temperatures used in the production of earthenware result in pieces that are porous and opaque. The final high firing temperatures used in the production of porcelain, on the other hand, vitrify the kaolin in the paste, resulting in pieces that are non-porous and translucent.

FAIENCE • Molded pieces of unglazed faience are subjected to preliminary firing at temperatures rising to 1,180 degrees Celsius. The fired, unglazed, undecorated pieces are called biscuit ware. Biscuit ware, which has a homespun, somewhat dull, matt surface, is completely hardened and will not deteriorate over time. Some popular examples of this type of ware include the small eighteenth-century "biscuit" figurines—pastoral subjects in a creamy, white color which emphasizes their delicacy.

After the preliminary firing, biscuit ware can then be glazed, overpainted, and refired; or painted, overglazed, and refired.

*A series of cups on display after modeling. In the background the specific tools which correspond to each shape. Robert Haviland & C. Parlon.*

Left: *One of the seven large wood-fired kilns inaugurated in 1876 at the Manufacture Nationale de Sèvres. It was brought back into service in 1990 and can accommodate and fire pieces over six feet in height. The overall firing operations last three weeks. More than fifteen cubic meters of birch wood are used at each firing.*

Antoine d'Albis is triumphant as he holds out pots filled with an orange-colored powder: "I've been trying to achieve that exact shade for over ten years." The man who has finally reached the end of his decade-long quest heads the laboratory at one of the most unusual organizations on earth, the Manufacture de Sèvres. This renowned porcelain maker is an anomaly in today's industrial world, since profit is not its primary goal. As

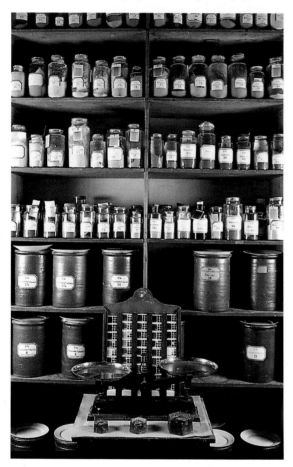

a publicly-owned government institution, Sèvres no longer serves royalty. As an industry, however, no exact value can be placed on what it does; or, rather, what it does cannot be expressed in monetary terms.

As described by Antoine d'Albis, the mission of the Manufacture de Sèvres is truly extraordinary: "We are heirs to the eighteenth-century Manufacture de Sèvres, and our primary mission is to do things exactly as they were done in the eighteenth century. We therefore act as if . . . "

. . . As if there were no outside suppliers of porcelain paste and ceramic pigments; as if wood were still the preferred fuel for kilns; as if no automatic plate-molding machines existed; as if decalcomanias had never been invented and each individual piece had to be decorated by hand; as if gold had to be melted every morning to ensure absolutely pure gilding; as if apprentices needed training in crafts that have virtually disappeared today—burnishing, for example, for which Sèvres trains one or two apprentices every year. Does this make Sèvres a kind of conservatory or museum? No. Sèvres has never ceased being totally contemporary, a timeless institution that has continuously attracted the passionate interest of great artists and designers. When Louis XV placed the near-bankrupt Manufacture de Sèvres under royal protection, he did so at the instigation of Madame de Pompadour, who clearly understood the institution's value as an artistic research laboratory. Twenty years before the German art critic and archaeologist Johann Joachim Winckelmann spearheaded the eighteenth-century neo-classical style, Sèvres had already abandoned the rococo and begun to experiment with designs inspired by neo-romanesque models. The Sèvres tradition of artistic experimentation continues today with plastic and graphic artists—such as Poirier and Ettore Sottsass—who create unique Sèvres pieces exemplifying the vitality of contemporary art.

In his own realm, Antoine d'Albis works patiently in the laboratory, seek-

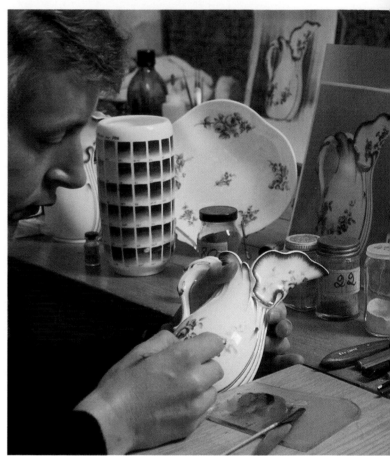

ing the perfect blend of ingredients for recreating traditional colors that were once the secrets of eighteenth-century porcelain makers. "But we definitely intend to publish our results," announces d'Albis with conviction. He has already made public a formula for the soft-paste (or artificial) porcelain that was developed in Europe to compete with imported Chinese hard-paste (true) porcelain made with kaolin. Until the discovery of kaolin deposits in continental Europe, even the Jesuits were unable to plumb the secret of true porcelain.

In the strict sense of the term, the craftsmen employed by the Manufacture de Sèvres are government workers. As such, however, they deserve to be compared with the government officials appointed during China's Celestial Empire, when to hold public office was considered the highest honor to which anyone could aspire; the culmination of a lifetime dedicated to perfection.

PORCELAIN • Porcelain, like earthenware, is also subjected to a preliminary firing, in this case at temperatures of about nine hundred degrees. The purpose of this "biscuiting" is to harden the product and make it porous. After firing, the hardened pieces are individually hand-dipped into the enamel glaze and then placed into saggers, or protective cases made of fire-clay. They are then refired. This second, or "glost," firing is carried out in two stages. First, the kiln temperature is raised to about 1,060. The surplus oxygen burns off all the organic impurities in the clay, and oxidizes any iron remaining in the paste in the form of microscopic iron filings. When the temperature has stabilized throughout the kiln, oxygen levels are diminished, creating a "reducing atmosphere" that provides less oxygen than is needed for the gas to burn, thus causing the oxygen in the iron oxide to be consumed. This occurs at a temperature of approximately 1,280 degrees. The temperature is then raised another hundred degrees and briefly maintained at 1,380 degrees. This short, extremely high-temperature firing hastens vitrification of the feldspar and quartz in the paste, and crystallizes the kaolin. The final result is nonporous, translucent porcelain.

The huge sheds at the new Bernardaud factory in Oradour-sur-Glane would appear soulless indeed were it not for the kilns burning at the core of the plant. These kilns are under the sole supervision of Gérard Gautron, head ceramicist. Gautron is basically a "fire-tamer," since porcelain depends for its inherent properties not only on kaolin, the mineral whose Chinese origins are evident in its name, but also on a delicate process that European craftsmen have developed with great difficulty: the porcelain-firing process. This complicated firing, as explained above, is the main factor in giving porcelain the characteristic hard translucence that is so admirable and so admired.

Even partial mastery of the porcelain-firing process was not achieved until mid twentieth-century technology made possible the production of kilns in which temperatures and gas and oxygen levels could be automatically controlled. Total mastery of these elements remains elusive, however, even today. This is why porcelain plants still employ "sorters" who sit on straight chairs under large windows, with baskets of white porcelain at their feet, using their eyes and ears to check the quality of each separate piece. The women who perform this seemingly anachronistic task are proof that many aspects of white porcelain manufacture have still not been brought entirely under technological control.

## Lithophanes

*At the Bernardaud modeling workshop in Limoges, head modeler Christian Brunet's face lights up as he shows off the lithophanes made from wax prototypes he carved himself. Artistic skills such as his are a basic requirement in all Limoges porcelain factory modeling workshops.*

*Lithophanes are small flat or curved plaques made of biscuit (unglazed) hard-paste porcelain, on which a recessed decorative motif is carved. They are intended to be lit from behind, and the gradations of light transmitted through the raised and*

*recessed portions of the carving give the design a three-dimensional appearance. The process involved in the creation of these pieces originated in the early nineteenth century and was revived by Bernardaud head designer Jean Pierre Hamard, an avid collector of antique specimens that in the past were carved with pastoral and bacchanalian scenes.*

*It takes several days of meticulous labor to carve a lithophane, and the details of the process are jealously guarded by the professional discretion of their proud executor. Watching this craftsman at work one can appreciate the timeless skills which link the modern factory to the workshop of a Renaissance artist.*

*"Bouquet of Roses" lithophane. Bernardaud.*

Left: *Glazing pigment at the Manufacture Nationale de Sèvres.*
Center: *Decorating a water jug at the Manufacture Nationale de Sèvres. The artisan refers to a color chart before applying the pigment.*

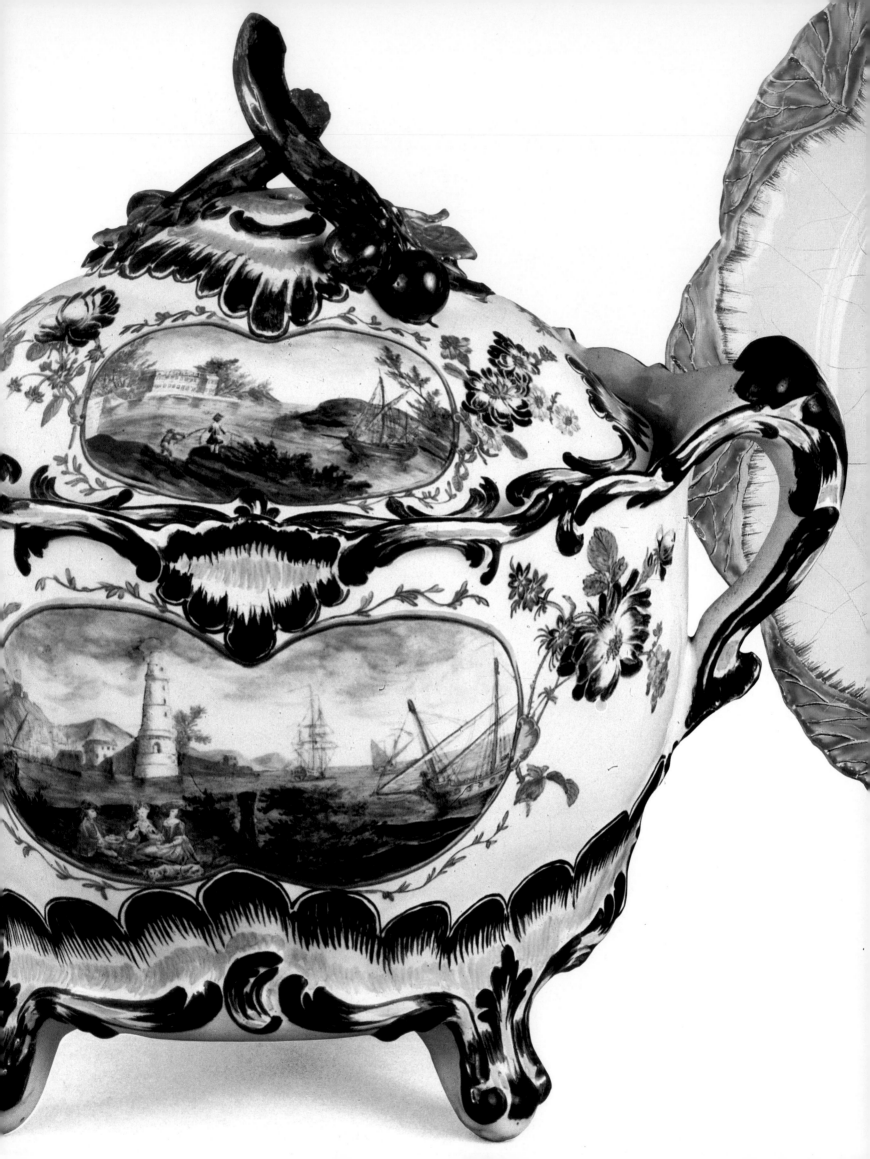

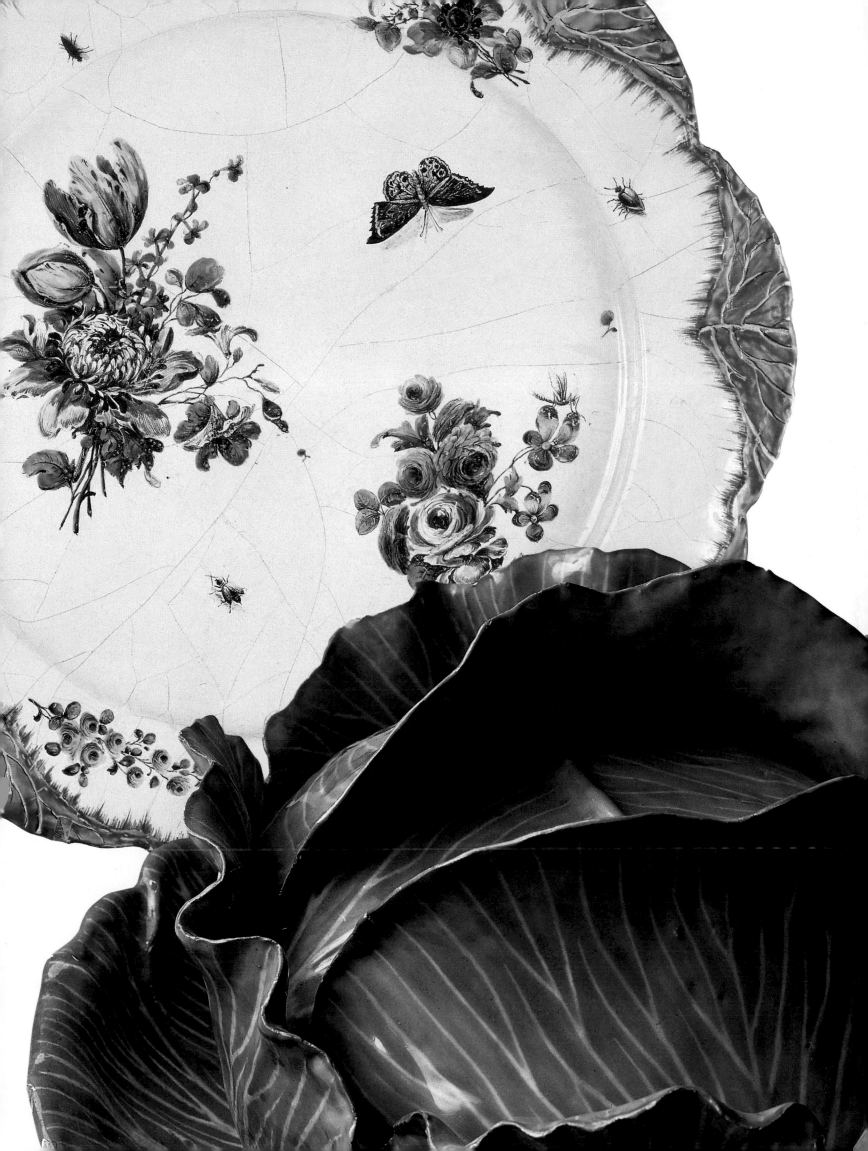

## Decorating techniques

FAIENCE • Biscuit-fired faience, or earthenware, can be hand-painted or decorated by means of silk-screen transfer printing. When a piece has been decorated, it is then dipped in enamel glaze until it is completely covered with a thin film. Both decoration and glaze are permanently fixed by a second, or "glost," firing in a kiln where the temperatures are raised to between 1,060 degrees and 1,080 degrees, the point at which the glaze vitrifies, sealing the colors beneath.

The value of fine earthenware is of course enhanced by quality decoration. At Gien, contemporary decorations reflect current esthetic trends and also the personal inspiration and talents of artists such as Pierre Buraglio, Alain Clément, and Claude Vialat, all of whom combine painterly skills with great manual dexterity. They create a range of familiar objects, in new palettes of colors, that will be the museum pieces of tomorrow.

COPPERPLATE • Gien has preserved a valuable collection of nineteenth-century dry-point copperplate engravings that today constitutes one of the firm's most precious legacies from the past. Over six thousand plates covering the most diverse subjects and backgrounds are still used for stenciling tissue-paper transfers. Hot-printing techniques have not changed for over a century.

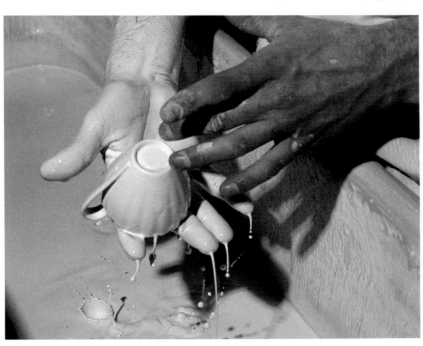

*The enamel bath at Robert Haviland & C. Parlon. Biscuit-fired pieces are hand-dipped in an enamel bath and then placed in fire-clay cases for hard-firing.*

Preceding double page
Left: *Olla tureen. Eighteenth-century Marseille faience.*
Center: *Dish with cabbage-leaf border, 1753, Faïence de Sceaux. Musée des Arts Décoratifs, Paris.*
Right: *Olla tureen in the form of a cabbage, c. 1750. Strasburg, Manufacture de Joseph Hannong. Low-fired faience, polychrome decoration. Musée des Arts Décoratifs, Paris.*

The copper plate is heated, and a mixture of oil and pigment spread over it and then scraped so that it remains only in the grooves of the engraved design. Tissue paper is then placed over the plate and moistened with a special black soap-and-water solution. The water evaporates on contact with the heated plate, and the pigment in the engraved grooves adheres to the soapy residue. The tissue paper is then removed from the copper plate, pressed on to the biscuit-fired piece, and rubbed with a boss, or wool pad, until the design has been transferred. This process is used to reproduce traditional designs at a distance of one hundred to one hundred and fifty years. If colors are added, the bold black outlines of the design keep them from running. The piece is then refired, producing a new earthenware object identical to those used two generations ago.

# Acid gilding

*Porcelain gilding is done entirely by hand, which makes these pieces truly exceptional. Robert Haviland & C. Parlon's cobalt blue Scheberazade dinner service, for example, contains delicately tooled patterns in a swirl of matt, lustrous, and powdered gold that require no less than seven successive firings—not counting extra touch-up firings to correct flaws. Because the materials are so costly, not one single piece can be rejected. Bernardaud's Vergennes, Beauregard, and Chenonceau dinner services also use blue-fired patterns based on techniques developed at Sèvres and later adopted at Limoges. For these pieces, a raised tracing is made of the portion of the design to be etched. The tracing is applied to the piece, which is then covered with Judaean bitumen, a type of pitch. The pitch is spread over the entire piece, leaving only the raised design exposed. The piece is dipped into hydrofluoric acid, which etches the design into the hard porcelain. The acid is washed off and an initial layer of gold applied to the recessed, etched design. The piece is then*

*Sèvres. The gold is given a lengthy buffing with an agate or dog's-tooth burnisher, which makes the gold as lustrous as the porcelain itself.*

*The hundreds of hours required to produce a gilded dinner service are eloquent testimony to the fact that economy is not a consideration, and that consummate opulence is the sole criterion. Here we see an extension into our own time of the eighteenth-century European nobility's determination that nothing less than gold and porcelain should replace the silver of an earlier era on their tables.*

*given a preliminary firing at 900 degrees. A layer of gold is then applied to the raised portion of the design, and the piece is fired again, this time at 860 degrees. After the second firing, the piece is burnished so that the polished raised areas will contrast with the recessed etched design, which remains matt. Burnishing is an ancient process now practiced almost exclusively at*

Left: *Application of Judaean bitumen. Bernardaud.*
Center: *Acid engraving before the application of several coats of gilding. Bernardaud.*
Right: *Detail of a plate with gold inlay on kiln-fired blue. Bernardaud.*

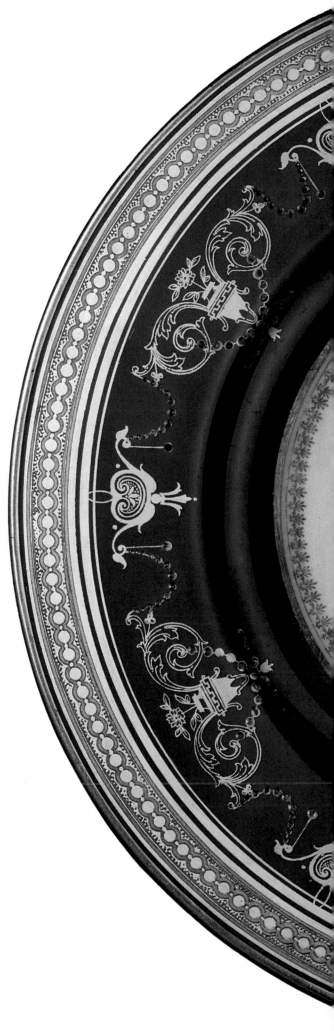

## Sèvres blue

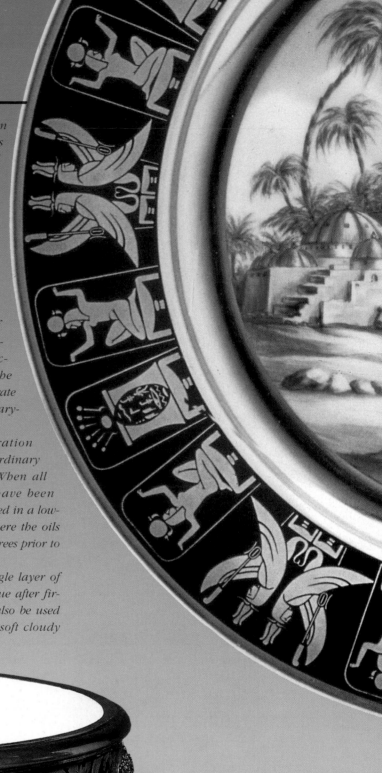

Sèvres blue (bleu de Sèvres) was known as bleu céleste when first developed in 1752. It is a deep shade of blue notable for its inimitable sheen and striking effect under changing light.

The unique quality of Sèvres blue derives from the technical properties of hard-paste (true) porcelain combined with a transparent vitreous glaze. The hard-paste formula still followed today has not changed since the early nineteenth century. A blend of kaolin and chalk, it is particularly suited to treatment with a very fine film of powdered pigment.

The range of approximately one hundred and forty basic pigments used at the Manufacture de Sèvres make it possible to blend virtually all of the special shades used for glazing. Metallic-oxide pigments each react in specific ways to heat, and all must therefore be fired at the precise temperature required for the respective oxide to produce the desired color. Cobalt oxide, for example, which produces its characteristic blue shade at temperatures of about 1,360 degrees Celsius, is ideal for the high-firing process.

Sèvres blue is applied in three successive coats over a colorless fired glaze. The cobalt oxide is thoroughly blended with oil of turpentine to make a blue, semi-liquid paste.

The first coat is spread over the piece with a flat brush, and the second dabbed on with a special brush made of badger-hair. The pointillist brushwork of the second coat ensures that the dabs of color will penetrate the colorless glaze in varying strengths.

This variable penetration accounts for the extraordinary depth of Sèvres blue. When all three coats of color have been applied, the piece is placed in a low-firing "muffle" kiln, where the oils are burnt off at 960 degrees prior to high-firing.

Pieces given only a single layer of pigment are lavender-blue after firing. A single coat can also be used as a base for creating soft cloudy effects.

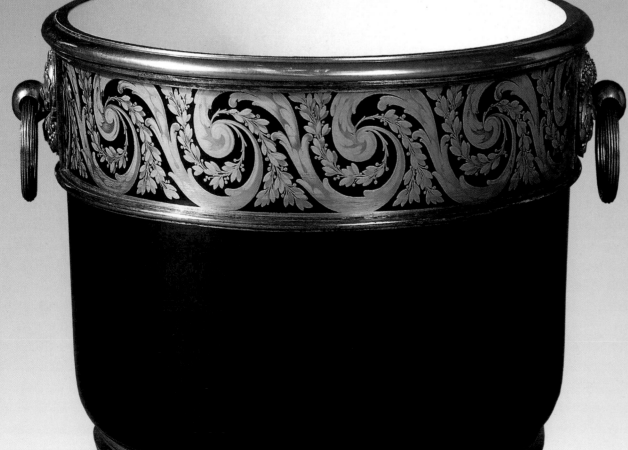

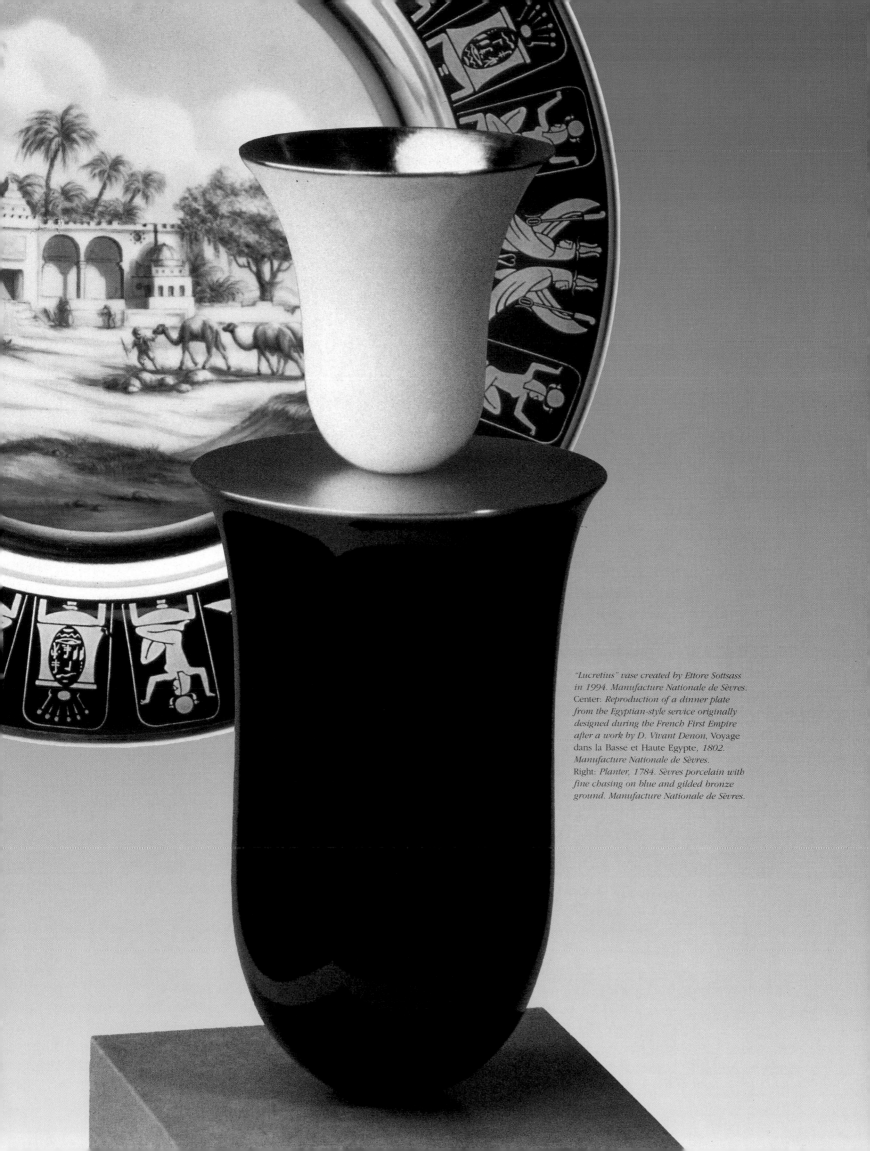

*"Lucretius" vase created by Ettore Sottsass in 1994. Manufacture Nationale de Sèvres.*
Center: *Reproduction of a dinner plate from the Egyptian-style service originally designed during the French First Empire after a work by D. Vivant Denon,* Voyage dans la Basse et Haute Egypte, *1802. Manufacture Nationale de Sèvres.*
Right: Planter, *1784. Sèvres porcelain with fine chasing on blue and gilded bronze ground. Manufacture Nationale de Sèvres.*

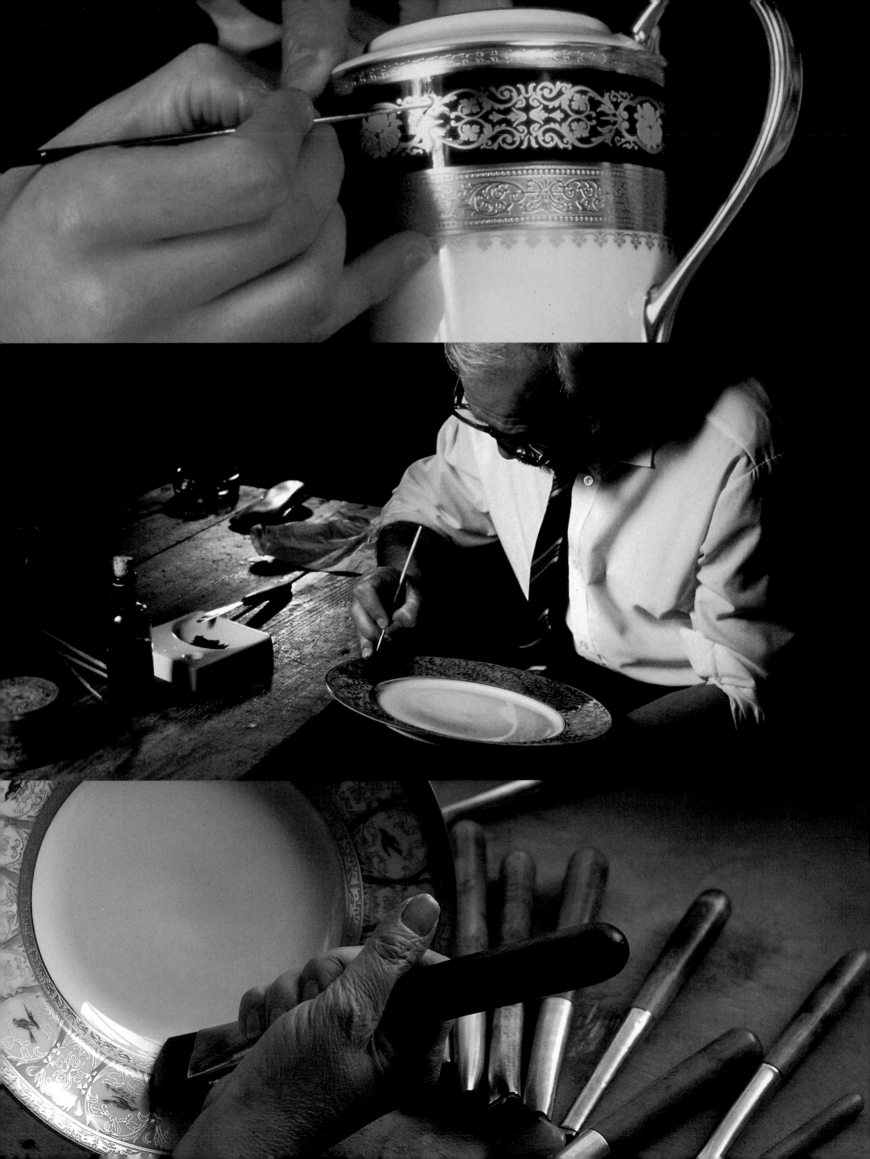

PORCELAIN: LOW-TEMPERATURE AND HIGH-TEMPERATURE FIRING • Ceramic colors are made from pulverized metallic oxides which, when fired at a certain temperature, change color and vitrify. Chrome oxide produces the range of greens, iron oxide the browns, cobalt oxides the blues, and so on. Glazed porcelain is decorated with the appropriate color oxide and refired.

There are two types of firing. Low-firing is conducted at temperatures of only about eight hundred degrees, the point beyond which some metallic oxides, especially the most volatile ones, will run together and destroy the outlines of the design.

High-firing, conducted at temperatures over 1,200 degrees, fuses the enamel glaze with the underglazing, resulting in the glossy surface associated with enamel-glazed porcelain.

In kilns that are not automatically regulated, a system of pyrometric cones is used to register the interior temperature. These pyramidal shapes, called "Seger cones" in Europe and "Orton cones" in North America, have different melting-points. They are placed at a five-degree angle among the pieces being fired. The first pyramid will begin to sag at a temperature of seven hundred and fifty degrees, the second at eight hundred degrees, and the third at eight hundred and fifty degrees. Human skill and experience is also required to adjust the firing temperatures accurately.

CHOOSING THE CORRECT TEMPERATURE FOR FIRING • As Catherine Bergen, head of the Bernardaud decoration archives explains: "Firing temperatures are adjusted to the specific decoration." In the eighteenth century, each color was fired separately. It was only with advances in the chromolithography process, through which several different colors can be fired simultaneously with uniform results, that single firing became possible. Designs are transferred on to the biscuit-fired pieces using silk screens. A separate screen is needed for each color, and as many as twenty-four screens are sometimes used for the transfer of a single design. In recent years, new four-color transfer techniques have made it possible to reproduce the nuances of original designs with greater fidelity. Bernardaud's "Poetry" model, for

*Application of color at Hermès.*

Left, from top to bottom: *Brushwork gilding at Bernardaud. Brushwork gilding at Robert Haviland & C. Parlon. After each application of gold the piece is re-fired. Burnishing at Robert Haviland & C. Parlon. The gold is given a lengthy buffing with an agate or red hematite, making it as lustrous as the porcelain itself.*

example, is a collage of two poems reproduced from two separate media: a standard white page, and a fragile seventh-century Chinese scroll with a nineteenth-century engraving painted on to it by hand. Only four-color printing can accurately reproduce the respective gradations of each separate medium, and only low-firing can protect these delicate subtleties from overdistortion. This is because glaze preserves all of its true gloss when fired at low temperatures. With "on-glaze" or overglaze firing, a wide

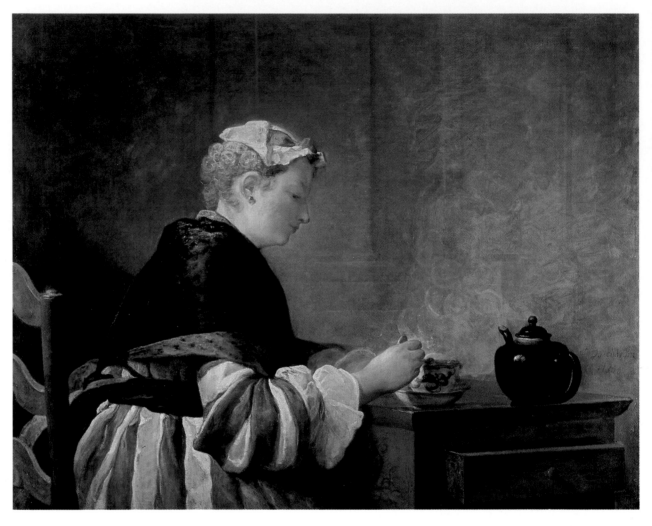

Jean-Siméon Chardin, *Woman taking tea,* 1735 Oil on canvas Hunterian Art Gallery, University of Glasgow.

Right: *Burnishing with agate at the Manufacture Nationale de Sèvres.*

range of colors can be used, but reds and purples are very difficult to work with, since they tend to turn brown or a pale chalky red. Pale shades also suffer at high temperatures: bluish pink turns beige, for example.

Underglazed pieces that have been fired at lower temperatures have a smooth, satiny surface. The finish is hard, glossy, and durable. This type of firing is only suitable for a limited number of colors, primarily the more intense shades such as the

well-known deep ceramic blues. For reds, almost wholly pure pigments such as iron red and cadmium red are used. As Catherine Bergen explains: "Often these pigments cannot be mixed with other colors, since they sometimes absorb them completely during firing." A thorough understanding of pigments and their respective properties is a major factor in the production of subtly hued porcelain.

A ROYAL PRIVILEGE • The need to develop extensive familiarity with glazes and their properties is part of what makes the porcelain industry a noble craft. This nobility reflects the elegance of the product and the aura of mystery that for many centuries surrounded its manufacture. The formula for porcelain came—or was taken—from China, and French porcelain manufacturers operated for many years under royal protection. Today, the classic decorative patterns for Limoges porcelain still exhibit a royal opulence, and every porcelain factory has in its collections several table services designed and decorated for kings and queens, emperors and empresses. Limoges has been the capital of fine French porcelain ever since the nineteenth century, and the craft is still associated with luxury. Although the advancing industrialization of the early twentieth century made Limoges porcelain at one time the product of a large resident working-class population, fierce competition in the town has now eliminated all but those makers traditionally associated with the production of finely crafted porcelain containing great added value. "Crafted" is definitely the word that springs to mind on viewing the Bernardaud and Robert Haviland & C. Parlon factories, which are still located right in the center of the city and employ a team of craftsmen proud of their skills and their work. And they are justly proud of being able to meet the requirements of a fragile material which is continually stretched to its physical limits in a ceaseless quest for the originality that constitutes the most precious asset of contemporary design.

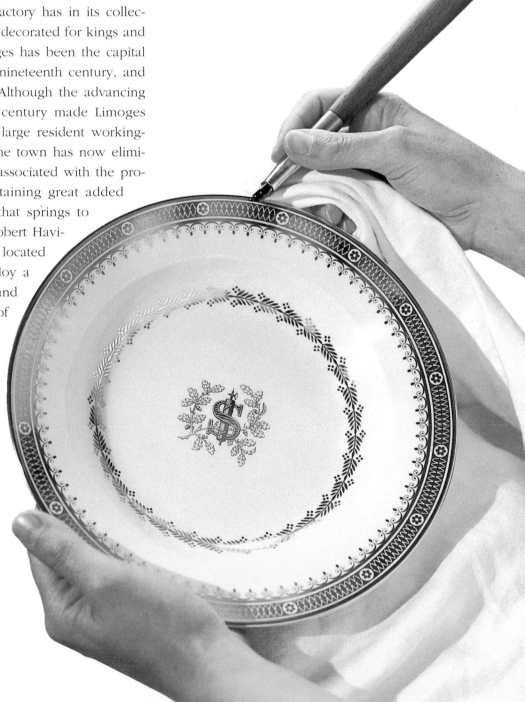

### The spread of faience in the eighth century

Glazed earthenware, or faience (a baked clay mixture covered with an opaque white tin-oxide glaze) was known to the Arabs as early as the eighth century and in Europe it first appeared in Italy and Spain due to Moslem invasions.

### French faience in the sixteenth century

Faience production in France took root in the sixteenth century with centers in Lyon, Rouen, Montpellier, and Nevers. Forms and decoration were inspired by Italian majolica from Faenza and Urbino. The techniques employed were those of high temperature kilns, in which oxides were placed directly on the raw clay and baked together, but as few of the oxides were able to resist the high temperatures required for the clay, the color range was limited to blue from cobalt oxide; violet, brown and black from manganese; green from copper; yellow from antimony; and red ochre from iron.

### The blue faience of the seventeenth century

Until about 1630, forms and decoration were still largely influenced by Italian majolica, producing large, wide-bordered dishes or plates, adorned with grotesques, dolphins, and foliage. Towards the end of the seventeenth century a new style was developed at a pottery in Nevers, inspired by French engravings and contemporary novels, portraying romantic or rustic scenes in polychrome or blue monochrome, whereas under Dutch influence, a taste for the oriental also asserted itself, imposing the use of blue monochrome and widening the decorative repertoire of which the "East India flowers" were a prominent example. During this period, France was seeking to imitate Chinese porcelain which kings and princes had been collecting since the opening of the trade route to India.

*__Chinese porcelain__ Porcelain was discovered by the Chinese while they were seeking to imitate jade. Traditionally it is thought that the discovery dates from 4000 B.C., but we only know with certitude of the existence of Chinese porcelain factories from the sixth century B.C. The first true porcelain probably dates from the early Tang period (618–907), but the main development took place under the Sung dynasty (960–1280), and was pursued during the Yuan dynasty (1280–1368). Chinese porcelain had spread to Asia Minor and it was no doubt due to the Crusades that the first examples of Chinese porcelain were introduced in Europe.*

**Soft-paste porcelain in France**: At the end of the seventeenth century, attempts to imitate Chinese porcelain resulted in the use of the soft-paste method. This artificial porcelain was developed at the Saint-Cloud factory. Although similar to Chinese porcelain in its translucence, it did not possess all of the same qualities—due to the absence of kaolin, modeling is a delicate process. Withdrawal of the paste from the kiln can result in deformations and the very fragile glaze is easily scratched.

### True porcelain in the eighteenth century

In the eighteenth century, porcelain decoration determined that of faience; chinoiserie, rustic scenes, and flowers constituted the main decorative themes. Low temperature kilns, employed as early as 1749, resulted in a wider range of colors and more subtle shades. Very early on forms were inspired by those of precious metalwork and became more diversified to include platters, flower-pot holders, cooling vessels, and ewers, which followed the evolution of styles from rococo to neo-classical.

*__Meissen hard-paste porcelain__ In Europe hard-paste porcelain was discovered by __Friedrich Böttger__ in 1709 at the Royal Saxony factory. The German alchemist produced a new scratch-resistant, translucent porcelain from kaolin found in Aue mixed with Nordhausen calcinated alabaster, heralding the great period of Meissen figures and biscuit ware during the reign of Augustus III from 1730 to 1763.*

**Hard-paste porcelain in France** The discovery of kaolin in Limoges favored the development of prestigious workshops which were influenced by the Sèvres style.

*__La Manufacture de Sèvres__ The Vincennes porcelain factory was opened in 1740. It was transferred to Sèvres in 1756 and, in 1759, acquired by Louis XV, whose mistress, Madame de Pompadour became the patroness of the factory. Thereafter it belonged to the state.*
*The first Sèvres production was a soft-paste porcelain in rococo style. It was characterized by the use of cobalt blue, turquoise, and yellow grounds. Hard-paste porcelain production was initiated after the discovery of kaolin in Saint-Yrieix in 1769. Decorative themes were inspired by the paintings of François Boucher, and by a neo-classical style. It was during this period that the prestigious Sèvres table services made their appearance at all the European courts.*

### French competition in the eighteenth century

The secret of the hard-paste porcelain technique was well guarded. For a long time Sèvres jealously maintained its monopoly and succeeded in eliminating its direct rival, Limoges, despite the latter's proximity to the kaolin deposits. French faience producers also felt threatened and organized their defense.

*__The case of Limoges and Sceaux__ La Manufacture Royale de Limoges was founded in 1771 when kaolin was discovered in Saint-Yrieix. It received the support of __Turgot__, administrator of the province of Limousin, and three years later obtained the patronage of the king's brother, the count of Artois. Limoges production was characterized by sprays of flowers with gold and blue borders. No doubt due to its very assets, Limoges lost its autonomy in 1784, when it was sold to the Manufacture de Sèvres. From then on production developed under the management of __François Alluaud__ who diversified the decorative themes. The French Revolution, however, struck a very severe blow.*
*The Faïencerie de Sceaux, which was founded in 1748, immediately sought to rival Sèvres and Meissen porcelain. In addition to faience, it developed a soft-paste production, which is recognizable by three main decorative themes: floral motifs inspired by Strasburg faience, birds borrowed from the Sèvres style, and landscapes. The patronage of the duchess of Maine never allowed it to rival Vincennes.*

Through collaboration with contemporary artists both factories have succeeded in maintaining high quality in all the artistic and decorative tendencies of the twentieth century. Deck, Guimard, Luce, Ruhlmann, Calder, and Alechinsky have contributed to Sèvres, while Chaplet, Bracquemond, Colonna, de Feure and, more recently, Zofia Rostad, have created for Limoges.

In 1842, **David Haviland**, who was of American origin, opened a workshop for decorative porcelain in Limoges and inaugurated a factory in 1865. The greater part of his production was exported to the United States, where he immediately made a name for himself and was soon supplying the White House. In 1873 he opened a design studio under Bracquemond's management and it was in this studio that Chaplet developed the

*Alexandre Brongniart* (1770–1847) *was the administrator of the Sèvres factory from 1800 to 1847, and with his excellent management of a heritage which had become disorganized and unproductive due to the Revolution, he succeeded in making Sèvres the principal state supplier. The research behind new processes in manufacturing and decoration, the drawing up of the definitive formula for the composition of hardpaste, are all to be attributed to him. His treatise on ceramic arts and the catalogue of the Musée de la Céramique still serve as a reference documents.*

*barbotine* process. Haviland's son, Charles-Edouard, introduced japonaiserie in the decoration of Limoges porcelain.

In 1863, Pierre Guerry, in association with **Rémy Delignière**, opened a factory in Limoges. His production attracted attention at the end-of-the-century World Fairs. He was succeeded by **Léonard Bernardaud**, who developed an original production based on modern techniques. In 1949 he was the first to use the tunnel kiln. The new trends defined by **Van Der Straeten** and **Olivier Gagnère,** and of which the Métropole service is a typical example, characterized the modernity of this establishment's creativity.

Robert Haviland, Charles Field Haviland's grandson, imposed his style at the Decorative Arts Exhibition in 1925 by reworking the décors of the designer Eugène Alluaud.

## The nineteenth century: the boom in industrial crockery

In 1797, Robert **Bray O'Reilly** inaugurated a factory in Creil in the department of Oise, specializing in a fine faience particularly adapted to industrial production methods. The forms were simple and decorated with printed motifs reflecting contemporary fashion. In about 1840 the factory joined with the Montereau faience works.

The Faïencerie de Gien was created in 1822 by an Englishman, **Thomas Hill**. In 1835 he started producing a fine faience, known as "opaque porcelain," which reproduced traditional themes enhanced by color applied with a paintbrush. The collaboration of artists such as Paul **Jusselin** and Ulysse **Bertrand** contributed to a very rich creative production between 1865 and 1900.

# Fragrance

Whether perfume arouses desire, breaks hearts, turns heads, or refreshes the soul, it inevitably leads us by the nose. Furthermore, there is nothing we can do about it. We can close our eyes and cover our ears; we can momentarily stop eating and touching; but we cannot stop breathing. If we live, we breathe; and if we breathe, our noses detect scent. Recognizing scents is a form of memory, and wearing perfume is one way to enjoy our memories physically as we relive them.

Many writers have dealt with scent, but the art of three in particular—Ronsard, Baudelaire, and Proust—underscores the three main ways in which scent makes its impact. Ronsard *perceived* the fragrance of flowers; Baudelaire *enjoyed* it; and Proust *recalled* it. Perception, enjoyment, memory.

Our favorite perfume is like an extension of ourselves lingering on the surface of our skin, and—at first—our loyalty to it is absolute. We defend it passionately and accept it unreservedly, but it eventually escapes us. As time passes and familiarity breeds indifference, our passion wanes and the bottle is pushed to the back of the shelf. We then refer to it somewhat disparagingly, like a discarded lover. But our sense of smell never forgets. Years later, when we happen to come across that bottle of perfume we once defended so passionately and later abandoned, we greet it tenderly, like an old familiar friend. Herein lies the mystery of scent: a tiny drop of perfume can recall the story of a lifetime. And since it is worn to please others, a bottle of perfume contains a few ounces of pleasure that is never purely selfish. In ancient times, smoke from aromatic plants rose over the altars of the gods. Later that odor of sanctity rose again from incense-burners in churches, and joss sticks in Taoist temples.

In the Middle Ages people believed that perfumes could protect them from the plague; physicians wore masks soaked in herbal solutions when they visited the sick and dying. During the terrible epidemics that marked the sixteenth century, people wore pomander balls, spherical ornaments hung from the waist and containing blended fragrances made from amber, musk, rock-rose, lemon, cinnamon, camphor, aloe, rose, sandalwood, and stirax. This olfactory shield may not have been an effective protection against disease, but it did mitigate the stench of open sewers and unwashed bodies. A century later, Madame de Sévigné and Saint-Simon were among those who believed in external applications of Hungary Water as a restorative. This rosemary-based tonic, invented in the fourteenth century, was made by steeping aromatic herbs in alcohol. It was the first true perfume in the modern sense of the term. People of quality with lively curiosities confected their own perfumes at home with the help of reference works such as the *Parfumeur Français*, published by Simon Barbe in Lyon at the end of the seventeenth century. Meanwhile, the French Glovers' and Perfumers' Guild received patents from the king and encouragement from Jean Baptiste Colbert, finance minister during the reign of Louis XIV. The main ingredients in their heavy perfumes were amber, musk, and civet, attenuated by the jasmine, tuberose, rose, and orange-blossom that were already being grown commercially near Grasse. However, since these fragrances were not long-lasting on the skin, men and women applied them to excess, surrounding themselves with clouds of strong scent that vied with the foul odors in the streets and in the corridors of Versailles. Queen Christina of Sweden compared this mingling of overpowering smells to the responsibilities of heading a kingdom: "Those that must bear them grow immune to them."

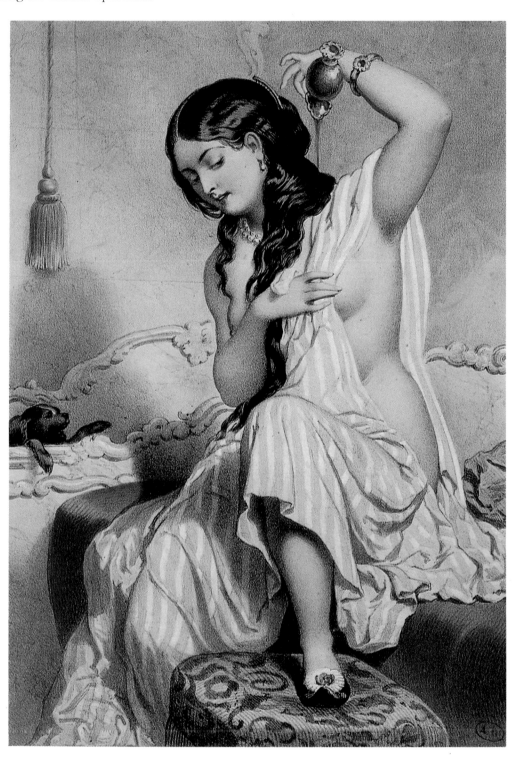

*Woman applying perfume, c. 1860. Engraving. Bibliothèque des Arts Décoratifs, Paris.*

Left: *Jean-Gabriel Domergue, La Garçonne, 1925. Watercolor. Bibliothèque des Arts Décoratifs, Paris.*

During the eighteenth century, greater varieties of perfumes were developed, and fragrances were milder and more consistent. Perfume braziers, pots-pourris, herbal fumigants, bottled fragrances, and scented gloves and handkerchiefs were among the many products marketed by contemporary perfumers. The names of some of these pioneers are still famous today: Lubin, Caron, Houbigant, Pivert, and the astute Jean-Marie Farina, who used an Italian formula based on lemon and bergamot to make the first eau-de-Cologne—a lasting success. The Age of Enlightenment, a sovereign period for the arts of decoration and fashion, witnessed the development of fragrances based on lighter, sweeter floral notes, and bottled in elegant containers that today are much coveted by collectors of glass, porcelain, enamel ware, etc. However, it was not until the nineteenth century that perfume reached a decisive point in its development. This came when chemists began to develop the synthetic fragrances that revolutionized traditional perfume formulae and methods.

In the early years of the nineteenth century, perfumes were still made primarily from a limited range of individual, unblended fragrances. The essential oils of plants and flowers were dissolved in alcohol to create floral and herbal extracts and spirits; these extracts, called "bouquets," were usually sprinkled on handkerchiefs. The men and women of the time followed their own tastes or that of their local perfumer in the choice of fragrances. The "bouquet" concept lasted until 1889, when Aimé Guerlain shattered the old traditions with *Jicky*, generally considered the first modern perfume. *Jicky* is an abstract blend using synthetic fragrances. The formula for it— top secret, of course—is based on two synthetic chemicals, coumarin (the so-called "fern" note) and vanillin (also found in vanilla beans). The development of perfume formulae using synthetic ingredients paved the way for the appearance of the professional "Nose," that master artisan of scent—half scientist, half poet—who, like a couturier, builds fabulous creations where none before existed; and, like an orchestral composer, exploits newly-discovered harmonics to their limit and then surpasses that limit. For example, in the beginning of the twentieth century, six olfactory elements had been successfully extracted from jasmine. Today a total of two hundred fifty have been extracted, and the end is not yet in sight.

In the past, heavy perfumes were associated by respectable society with women of easy virtue. However, with the development of modern perfumes and the increasing liberation of women, this moral distinction has become outmoded. As Coco Chanel once said, "A woman who doesn't wear perfume has no future."

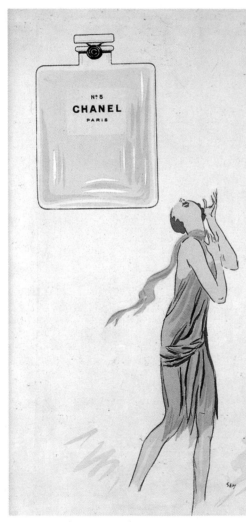

Chanel No. 5 *by Sem, 1921.*

Right: *Antoine Watteau,* Femme assise, *three-color pencil drawing. Pierpont Morgan Library, New York.*

Although perfume remained a novelty for many women up until World War II, it offered them a chance to venture into a world of luxury and refinement from which they had previously been almost totally excluded. This was well-understood by Paul Poiret, who launched the first couturier perfume in 1911 and was promptly followed by Jean Patou in 1925. The movement did not gain real momentum until the end of the war, however, when even more social barriers fell and the great perfumes spread to an ever-widening market. The launch of *Miss Dior* in 1947 sealed the alliance between high fashion and fine perfume.

As perfumes became more democratic, packaging evolved, promotion intensified, and marketing assumed greater importance. Perfume, like cinema, became both an art and a powerful industry. Today, anyone interested in understanding the world of perfume would have to tour factories and advertising agencies as well as gardens and fields. The fact remains, however, that of all luxuries, perfume is the most affordable. This is because its appeal is primarily to the imagination, a psychological gratification based on a minimum of physical stimulation. All of the senses, including the sense of smell, can be overwhelmed by excess, and fragrance must be used sparingly.

Fragrances for both men and women come in many forms: herbal and floral extracts, eaux de parfum, eaux de toilette, and scented toiletries. They have their codes and categories, their secret formulas; they have their special gestures and uses—the dab behind the ear lobes, the quick pressure on a spray, the shake of a few drops on to a handkerchief. There are many ways in which perfume can be worn, many ways to appreciate this fine French luxury product that draws its appeal from fragrance and fragrance alone. But the names it is sold under, whether proper names, brand names, or evocative abstractions, must be packaged. This brings us to the dizzying variety found in perfume bottle design, the second most important factor involved in perfume purchasing decisions. The visual and tactile aspects of a perfume bottle are crucial to the success of its contents. Each bottle is both a miniature sculpture and a status symbol, packaged in an elegant box, beautifully wrapped and tied, and then slipped into an elegant bag. Packaged perfume thus exercises its irresistible appeal like a Russian doll, in a sequence of concentric layers the impact of which is enhanced by the print and film ads and fashion shows that are combined to build promotional campaigns, constantly before the public eye and often publicly acclaimed.

With the development of the ready-to-wear industry and the expansion of the consumer market for fashionable clothing, accessories, and

**Patrick Süskind**
**The Story of a Murderer**

*"For a moment he was so confused that he actually thought he had never in all his life seen anything so beautiful as this girl—although he only caught her from behind in silhouette against the candlelight. He meant, of course, he had never smelled anything so beautiful. But since he knew the smell of humans, knew it a thousandfold, men, women, children, he could not conceive of how such an exquisite scent could be emitted by a human being. Normally human odour was nothing special, or it was ghastly. Children smelled insipid, men urinous, all sour sweat and cheese, women smelled of rancid fat and rotting fish. Totally uninteresting, repulsive—that was how humans smelled*

*. . . And so it happened that for the first time in his life, Grenouille did not trust his nose and had to call on his eyes for assistance if he was to believe what he smelled. This confusion of senses did not last long at all. Actually he required only a moment to convince himself optically—then to abandon himself all the more ruthlessly to olfactory perception. And now he smelled that this was a human being, smelled the sweat of her armpits, the oil of her hair, the fishy odour of her genitals, and smelled it all with the greatest pleasure." (Perfume: the Story of a Murderer, trans. John E. Woods, Harmondsworth: Penguin, 1986.)*

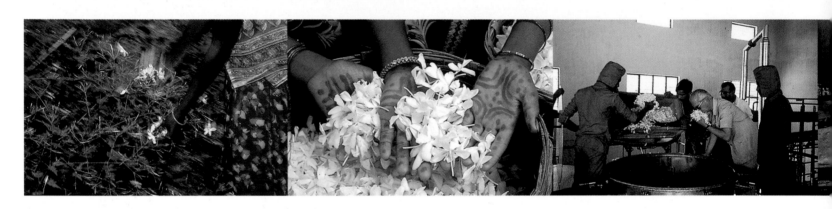

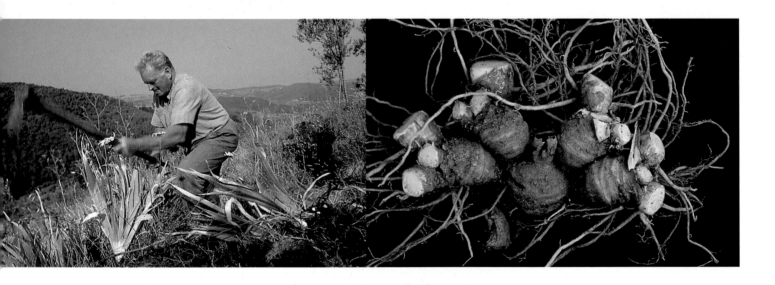

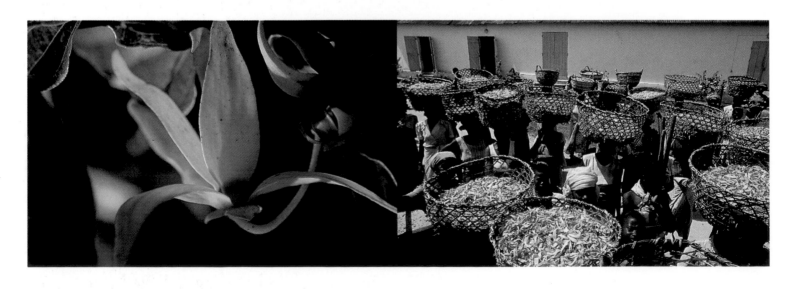

luxury goods, the major names in perfume have considerably widened their consumer base. For both male and female connoisseurs of scent, the daily use of a selected fragrance has become more than a personal statement. Today, it is the automatic final touch to good grooming: a matter of style; a volatile aura lying halfway between body and spirit.

### Finding the right words

The sense of smell is poorly served by the words used to express olfactory experiences. It seems there are not enough words to go around, and of those in use many are far from scientifically exact. This makes it inherently difficult to explain how perfumes are conceived and produced.

Furthermore, the fact that the human brain is divided into two lobes, with olfactory sensation registered in one and memories stored in the other, raises fresh difficulties when attempting both to recall and to identify each facet of the overwhelming amount of received information. As a result, the accepted vocabulary of scent is an inadequate tool for dealing with a limitless wealth of olfactory responses. However, the dramatic expansion of the fragrance industry during recent years has popularized the small vocabulary that has been patiently developed over two centuries, first by perfumers themselves, and then by chemists.

This is why everyone from perfume manufacturers to advertising and marketing specialists, journalists, and consumers, use the same few dozen words to describe all the scents in perfume. If these few words were equal to the task there would be no problem; but, although scent dictionaries do exist (for example the *Classification des Parfums*, edited by the Technical Commission of the French Association of Perfumers), they are further proof of the limitations of human inventiveness.

For practical purposes, the main fragrance types have traditionally been grouped under seven headings, seven itself being a highly symbolic number: citrus, floral, fern, chypre, woody, oriental, and leather. Each group includes endless variations ranging from "chypre citrus-floral" to "chypre-leather" to "woody citrus-floral." It takes a keen nose to distinguish the exact scents these labels refer to, and a keen sense of discrimination to decide when, and if, the same words always refer to the same scent.

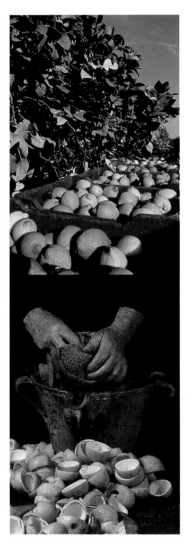

*The harvesting of Sicilian lemons.*

Left-hand page, left to right, top to bottom:
*Harvesting of orange-blossom in Tunisia; Harvesting Indian jasmine; Perfumer Jean-Paul Gaultier inspecting a jasmine crop; Roses harvested for Givenchy perfumes are steeped in a volatile solvent to extract the essences from the blooms; Harvesting Tuscan iris; Harvesting ylang-ylang from the Indian ocean.*

Following double page
Left: *Harvesting vetiver from the Indian ocean. Ground around the foot of a Bourbon vetiver plant being hoed.*
Right: *A bale of violet leaves used in perfumery. Tourettes, Alpes-Maritimes.*

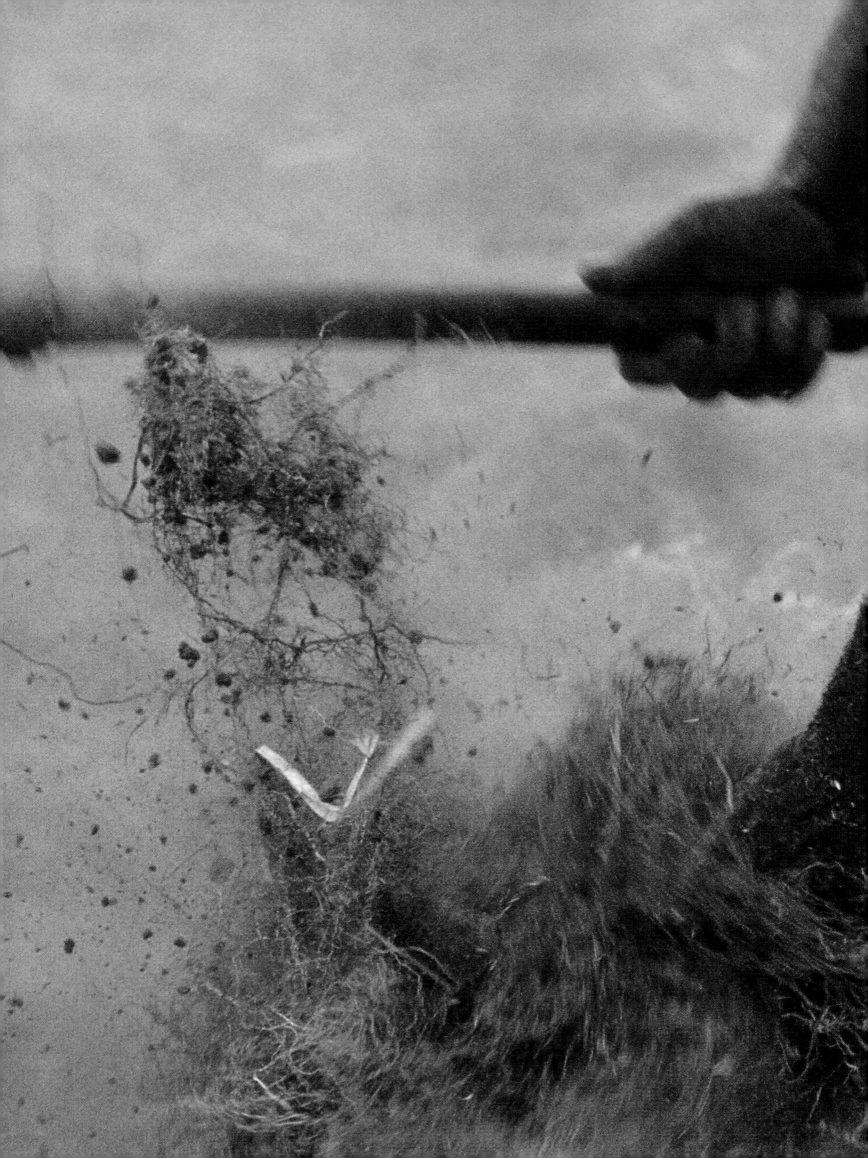

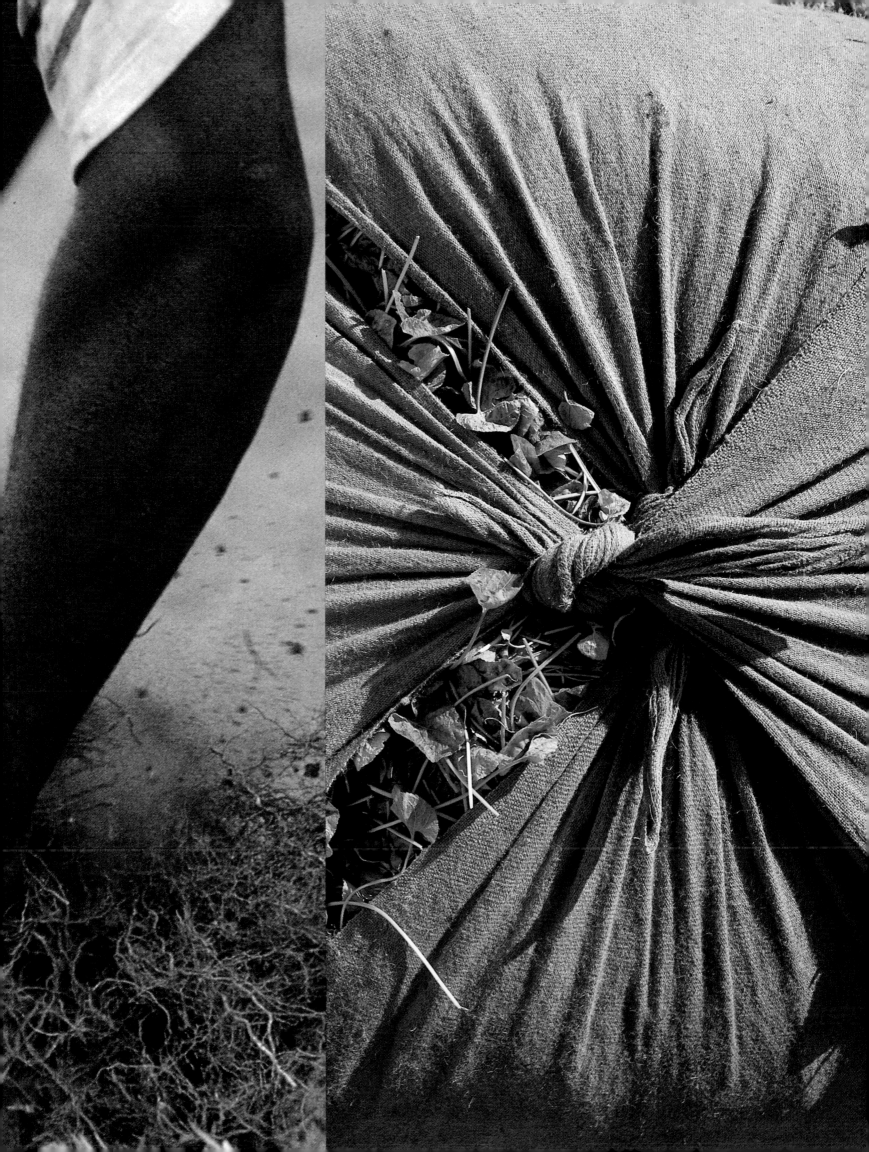

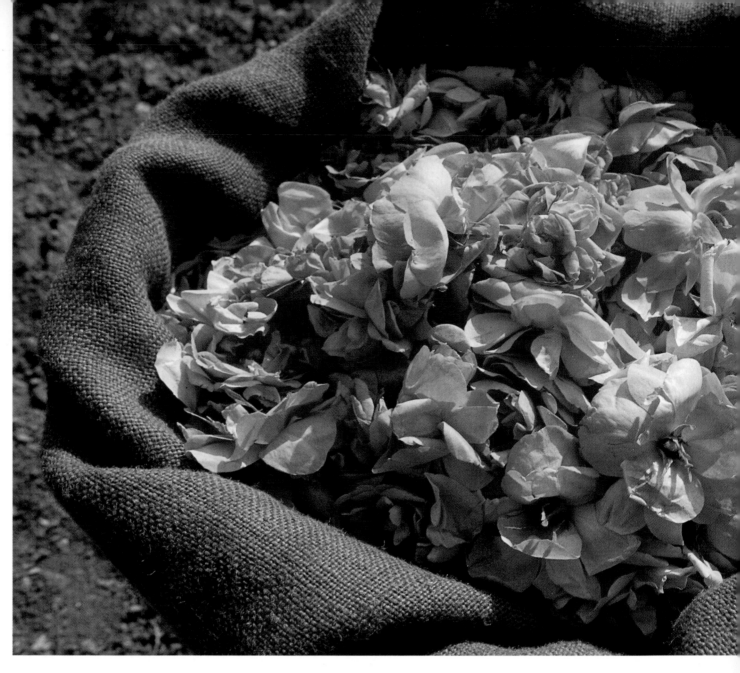

## Grasse

Grasse is still the world's capital of naturally grown herbs and flowers for perfume, but since World War II the city has built on its legendary past, expanding into the processing of imported raw materials as well.

The unique status of Grasse is in jeopardy, because real estate speculation and the cost of raw materials have transformed the region's landscape in order to accommodate the growing industrialization of the fragrance industry. Meanwhile, the six hundred and twenty acres of family-owned land on which jasmine, iris, and centifolia rose are still cultivated have been squeezed back into the hinterland behind Nice.

The availability of pure spring water and an exceptional climate favorable to the cultivation of aromatic plants made sixteenth-century Grasse a major leather-tanning center. Before the area's preeminence as a source of natural floral essences became established, its artisans were already renowned as fine glove-makers with close ties to the apothecary and perfumery trades.

No one has ever been able to determine with certainty whether the incomparable quality of the jasmine grown in Grasse is due to the region's soil or to its sunny climate. The absolute derived from genuine Grasse jasmine is the key ingredient in Chanel N° 5 and sells for over $12,275 per pound, compared with $900 for Moroccan jasmine and $680 for Indian jasmine. Through its exclusive contract with the Mul family, which has produced jasmine for five generations, Chanel controls extraction of virtually all jasmine and rose in the region. This is a unique case, since most cultivated flowers used in perfumery today come from outside France. Some family firms such as Mane, Charabot, and Robertet have

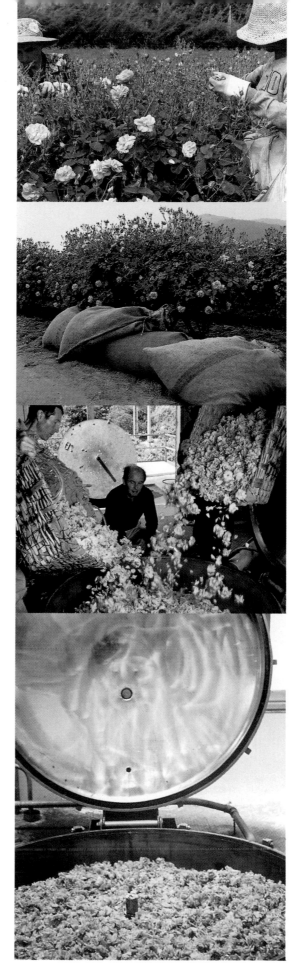

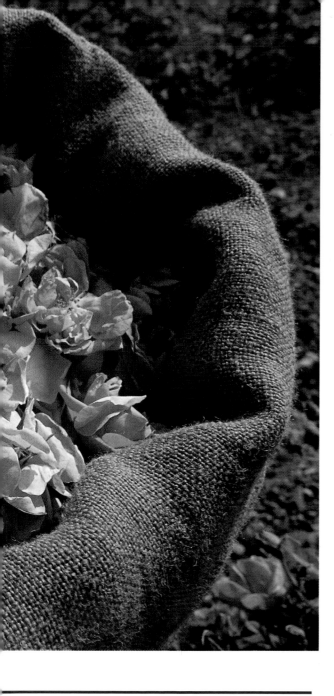

tried to perpetuate the local tradition, but have not been able to avoid diversification into more remunerative products.

These firms are exceptions in a competitive market for fragrance products which is controlled mainly by multinationals, who think more in terms of strategy and productivity than image. Today, food processing accounts for thirty-five percent of Grasse's industry, compared with sixty-five percent for perfume and cosmetics. Other firms, such as Roure, specialize in the manufacture of synthetic fragrances. If Grasse is as successful in the future as it has been in the past, this will surely be due to its ability to adapt to a changing market.

*The May rose or centifolia rose species has been cultivated in Grasse from the outset. At the turn of the century Grasse was the only place in the world where flowers were cultivated exclusively for providing perfume essences. The annual rose harvest takes place in May and only lasts three weeks. Every year, during the season, Chanel perfumer Jacques Polge comes to Grasse to inspect the crop.*
*The roses are steeped in large vats where a volatile solvent extracts the flower essence.*

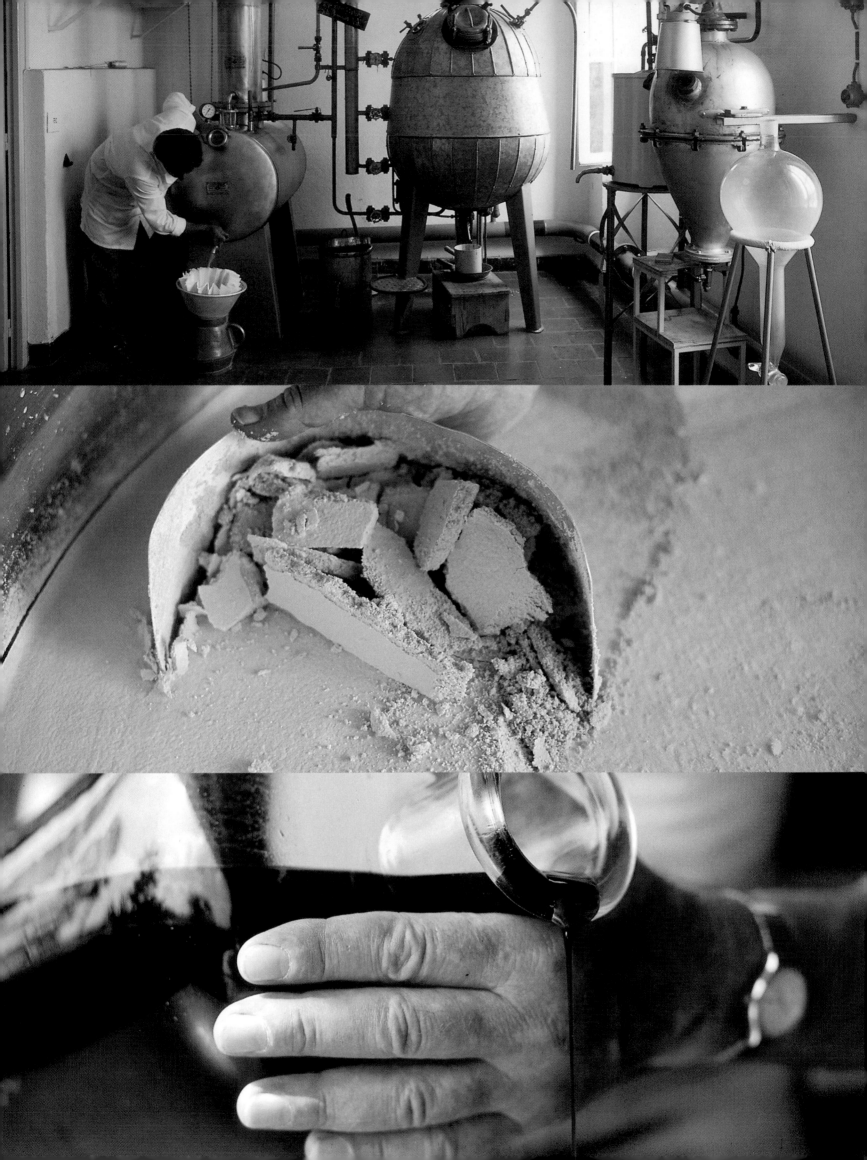

## The ingredients

The most familiar ingredients in perfume—and also often the most costly—are the natural essences obtained from flowers and herbs. Rose, jasmine, and tuberose are the classic scents used in fine perfume. The blooms are harvested by hand between May and September in the South of France and along the French Mediterranean coastline. Extraction plants and distilleries located in Grasse, not far from Nice, process tons of flowers to obtain the pure essences used in the finest perfumes. There are three ways of doing this, depending on the raw materials: solvent extraction, for particularly delicate floral essences; the expression method, for recovering citrus oils from fruit peel; and steam distillation for other plants and herbs.

In the solvent extraction process, the flower petals are placed in vats, volatile solvents (petroleum ether, for example) are added, and the vats are heated. The organic material dissolves, leaving a viscous, sweet-smelling residue in the bottom of the vat. This is known as the "concrete." It takes three hundred and fifty pounds of jasmine petals, for example, to obtain one pound of the concrete.

Further treatment of the concrete yields the final 'absolute,' with which the perfume is made. The concrete is mixed with ninety-per-cent-proof alcohol and then cooled. This produces a gelatinous mixture which is emulsified and then filtered to eliminate the wax, leaving only the alcoholic solution. The solution is then vacuum-distilled to remove the alcohol. The residue from this step is the absolute (representing approximately fifty-five percent of the original concrete) used to manufacture the perfume. It requires some six million flowers to obtain one pound of absolute. Roses, for example, are harvested on a massive scale, and employees of the Grasse distilleries use pitchforks to shovel the blooms into the storage containers.

The absolute obtained from dry materials such as benzoin and galbanum is a gummy resin called "tears." Mosses and lichens from pine and oak produce absolutes similar to those extracted from flowers, but they must be diluted with citrus oils, such as lemon or tangerine, obtained from fruit peel by the expression method. This involves either pressing the peels with sponges, or macerating them mechanically. It takes one ton of lemons to produce five pounds of essential oil.

Herbal plants, such as lavender, rosemary, and thyme, are subjected to traditional steam distillation. In this process, the floral esters are

*The concretes produced by the Molinard perfume house in Grasse, Alpes-Maritimes.*

Left-hand page
Top: *The distillation of the concrete. The perfume industry.*
Center: *Filtrate of beeswax. The Orgeville company in Mougins, Alpes-Maritimes.*
Bottom: *Rose absolute. The Orgeville company in Mougins, Alpes-Maritimes.*

# A visit to the scent archive

For anyone interested in perfume, a visit to the scent archive (osmothèque) is not just a pleasant excursion, it is a pilgrimage. The archive is located in Versailles on premises adjacent to the Institut International des Parfums, the school where all great Noses—past, present and future—are trained. This is not a museum, properly speaking, but a conservatoire of scents founded by the Société française des Parfumeurs de France and containing over one thousand fragrances, from medieval Hungary Water to the most recent creations of the modern fragrance industry.

Guided tours of the scent archive are an experience which might be said to resemble a visit to an art gallery—but a gallery in which visitors remain in comfortable armchairs with their eyes closed. Tours of the archive, usually scheduled on Wednesdays and Saturdays, have been conducted since 1990. Visitors are taken on a journey through the history of perfume, since most of the fragrances "displayed" at the scent archive no longer exist, and have had to be reconstructed from the jealously guarded formulae belonging to the firms that created them. The journey also includes explanations of all the different fragrance classifications developed by specialists working in the field today.

Visitors to the scent archive who follow the perfume classifications attentively will find themselves initiated into the surprisingly mysterious world of perfume. Most people tend to know simply what they like or dislike. But here one has a unique opportunity to learn about perfume's very special properties. Most visitors are women, and all respond enthusiastically to this learning experience. They are eager to know what actually goes into the eau-de-toilette they have always worn, and which is now revealed as a product of human genius comparable to a great painting, sculpture, or work of literature.

The citrus group is the original fragrance family, sometimes called the "Hesperids" in reference to the mythological grove of orange, lemon and bergamot trees where the goddess Hera's golden apples were guarded by nymphs. It is from this group that the first eaux-de-Cologne were made. The fresh, fruity notes of these popular blends served for many years as the mainstay of the perfume industry, under such renowned names as Cologne Extra Vieille by Roger & Gallet, 4711 by Muelhens, and Cologne Impériale, created in 1853 by Guerlain for the Empress Eugénie and packaged in the "imperial bees" bottle. When the great perfumer Edmond Roudnitska created Eau Sauvage for Christian Dior, he revolutionized this citrus fragrance by making it more intense. This development has since been copied for numerous other eaux-de-toilette.

The great family of florals is based on those heady blends of jasmine, lily of the valley, rose, violet, and carnation that evoke the city of Grasse in southern France. Floral fragrances can also feature a single flower, and many famed perfumes beloved by our grandmothers had evocative, single-flower aromas we might find too cloying today. These include Narcisse Noir by Caron (1912); Jasmin de Corse by the great François Coty (1906), who favored this flower because it reminded him of his native isle; and Vera Violetta by Roger & Gallet (1892)—although the latter blend of violet and blackcurrants was also an early pioneer in the use of ionone, a synthetic additive.

As the twentieth century progressed, tastes shifted towards more complex mixtures of scents from different sources. In the floral group, these blends are known as "floral bouquets" and represent the evolution from single-flower scents to blends with no single predominant note. The classic perfumes in this sub-category include Joy by Patou, a blend of jasmine and rose devised by Henri Almeras in 1930, and L'Air du Temps, created by Fabron for Nina Ricci in 1947. Another sub-category is the aldehydic group, the most famous of these being Chanel N° 5 and Lanvin's Arpège. These fragrances are blended with the aldehydes C8, C9, C10, and C12, synthetic molecules which have fruity olfactory properties when blended, despite their initial odor of rancid butter. The value of aldehydes as fragrance fixatives and enhancers was discovered almost accidentally by Ernest Beaux. The fern group includes lavender, geranium, coumarin, and oak moss. Oak moss is the natural product most commonly used in perfume today, but coumarin stamps the fragrances containing it with an

extremely distinctive personality. It was first used in 1882 by Houbigant for Fougère Royale, *the fragrance to which this group owes its name. With the notable exception of Guerlain's famous* Jicky *(1889), which contains another synthetic molecule, vanillin, the fern group is made up largely of fragrances for men:* Moustache *by Rochas, created by Edmond Roudnitska (1949);* Drakkar Noir *by Guy Laroche (1982); and* Tsar *by Van Cleef & Arpels. This is not to say, however, that this group holds no appeal for women—most men's fragrances are destined sooner or later to end up on a woman's skin.*

*The chypre group, like the fern group, also takes its name from a great perfume,* Chypre *by François Coty (1917). This perfume's formula, based on oak moss, rockrose, patchouli, and bergamot, led the way for followers such as* Mitsouko *by Guerlain,* Femme *by Rochas, and* Kouros *by Yves Saint Laurent.*

*A representative of the more intense categories is the woody group, an array of woodland notes created as a tribute to an ideal tree of the perfumer's imagination. Outstanding among these notes are sandalwood, cedar, vetiver root, and patchouli leaf. This family also includes aromatic variants extracted from plants such as thyme, sagebrush, and rosemary; also the distinctive essence of pine and other conifers; plus oriental spice notes such as pepper, nutmeg, and clove.*

*The oriental group is the most exotic, featuring combinations of woody, mossy, and spicy notes with sweet touches of vanilla or balsam, accentuated with the animal odors sometimes used in perfume. Until the recent invention of chemical substitutes, fixatives—which prolong the life of fragrance on the skin while exuding a subtle scent of their own—were mainly of animal origin. Among the best-known are castor, civet, musk, and ambergris, a* secretion formed in the intestine of the sperm whale and collected by fishermen on beaches and in the open sea. Although chemical substitutes have now largely replaced the animal originals, the odor of ambergris is the most sensually satisfying. A single perfume, Guerlain's Shalimar, *epitomizes this group.*

*The last of the seven fragrance groups is leather, which owes everything to another chemical discovery of the late twentieth century, the quinolines. Perfumes in the leather group project a gamey, seasoned note, and were originally intended to replicate the aroma of leather*

*boots worn by Russian cavalry officers. Perfumes in this category include the famed* Tabac Blond *by Caron (1919),* Cuir de Russie *by Chanel (1924), and* Bel Ami *by Hermès (1986). These fragrances combine odors of birch, charcoal, and wood smoke with subsidiary notes that are either floral, or have the honeyed tang of light tobacco.*

*The scent archive provides an entirely new outlook on the colognes and perfumes usually taken for granted. A whole new world is opened up—the invisible world of scent, so all-pervading and so intimate. For, as Marcel Proust once wrote, "Scent is the most lasting form of memory."*

*The elements of the perfume* Cristalle *by Chanel: Bourbon vetiver, bergamot, green mandarin and lemon from Sicily. Drawing by Loustal.*

Left: *Grasse jasmine, May rose and ylang-ylang from the Comoro Islands make up the natural ingredients of* Chanel N° 5. *Drawing by Ruben Alterio.*
Center: *Testing session at the osmothèque.*

### A "Nose" remembers

*The education of a perfumer does not begin with book learning, but with personal experience of the scents from which single and blended fragrances are produced. The first priority is developing the sense of smell; learning the words for describing olfactory perceptions comes later. "When we create a perfume," notes Jean Kerléo, perfumer at Jean Patou, "the most important thing is complete familiarity with all the basic scents and how they interact. I always start by associating each olfactory note with some personal experience or perception. For example, "woody" vetiver root doesn't strike me as woody at all, but earthy. I was brought up in Brittany, and I associate this scent with mildewed potato sacks lying in dank barns."*

*Olfactory perceptions are registered in one lobe of the brain and recalled by the other. Thus memory works by association, connecting the physical perception with mental recollection of the experience—and this is why Noses do not need textbooks for constructing their personal scent "palettes." "As a matter of fact," adds Kerléo modestly, "anyone with a physiologically normal nose could do what we do." Nevertheless, professional Noses must also spend many hours studying all the scent families from which perfume can be made. Jean Kerléo is able to list some fifty of these, plus all the synthetics now flooding the market. The latter pose an additional challenge, since not all of their "perfuming" properties have as yet been exploited.*

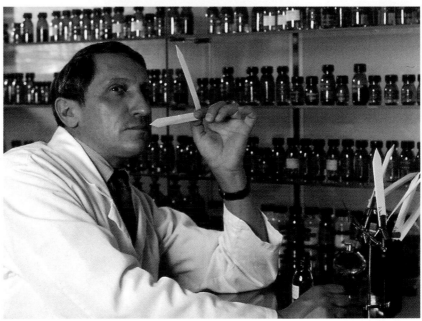

Top: *Jean-Paul Guerlain.*
Top right: *Jean Kerléo, perfumer at Jean Patou.*
Bottom: *The perfume laboratories at Van Cleef & Arpels.*

Right-hand page
*Paul Poiret.* Les parfums de Rosine.

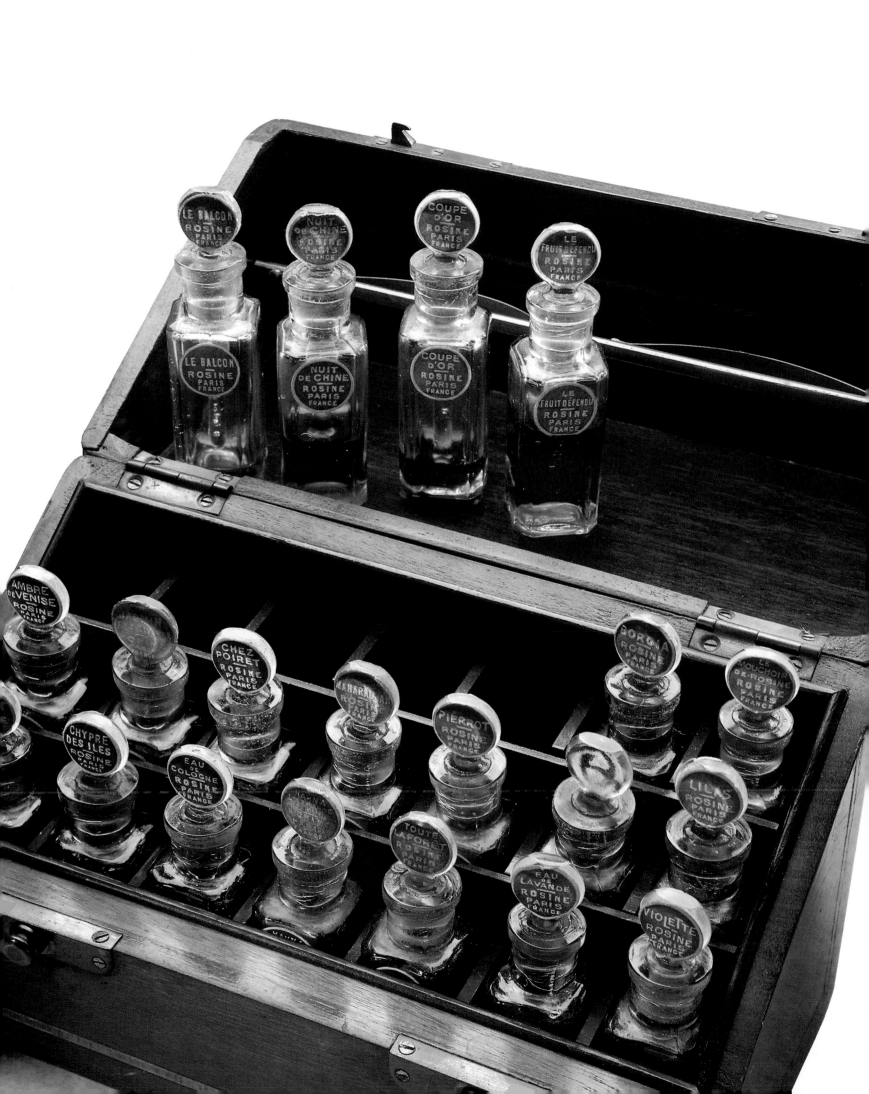

heated, the essence rises and turns into steam, the steam is forced through a cooling coil, and then forms a precipitate of essential oils.

THE MIRACLE OF SYNTHETICS • It is easy to understand from the above why chemists started developing synthetic substitutes for the costly natural ingredients used in perfumery. In fact, synthetics were the catalyst that spurred the growth of the modern perfume industry.

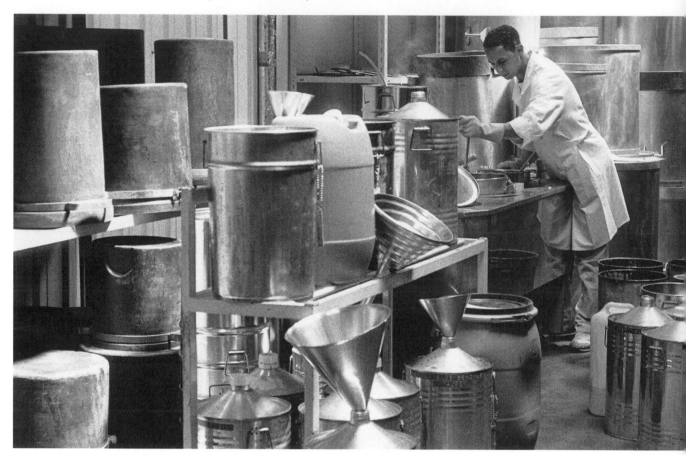

Perfumer Guy Robert explains the origins: "Back in the seventeenth century, the only ingredients used in perfume were orange flower, bergamot, and lemon. Apparently people wanted perfume to smell like orangeade! However, when Jean-Marie Farina invented eau-de-Cologne, he blended these overwhelmingly orange notes with camphorated Hungary Water, a tonic invented for Queen Elizabeth of Hungary. In former times people also used musk, which has a strong, carbolic odor similar to schoolroom ink or bitumen, but which has an interesting effect when applied to the skin."

It was not until about 1850 that scientists began to take a serious interest in the chemical composition of odors. First they analyzed the flowers and plants used in perfumery, isolating the molecules

responsible for their appeal. One example is vanillin, an extract of the vanilla plant which concentrates the latter's odor by fifty to one hundred percent. Chemists today are still analyzing essence of rose: some eight hundred elements have been identified so far, but three hundred more have yet to be isolated. Some of these elements, such as the lactone extracted from a variety of rose called the *Rosa Damascena*, have astonishing properties: an

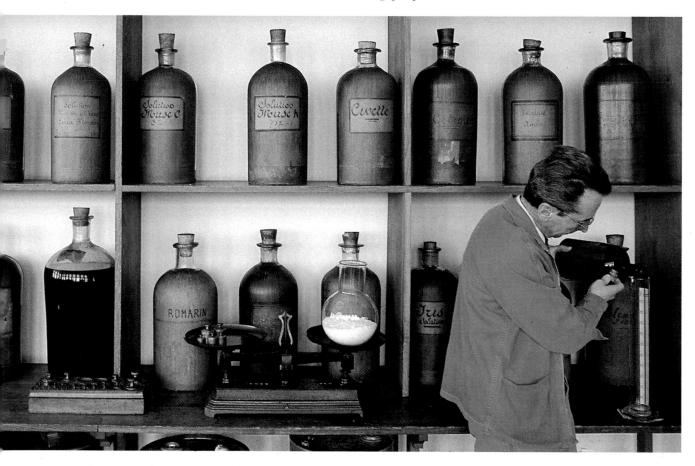

infinitesimal amount added to *Poison* by Christian Dior, for example, accounts for all of that fragrance's unusual appeal. Damascone, which comes from the same rose, is used in *Nahema* by Guerlain. The identification of these elements and more like them offers a host of new possibilities to the perfume industry, although perfumers and public alike are sometimes reluctant to explore them. People are sensitive about scent, and are hesitant about exploring anything too revolutionary.

Research continues, however. Early in the twentieth century experiments were extended to include synthetic products derived from materials such as coal tar, petroleum by-products, acetylene, turpentine, and castor oil. Using the 'cracking' process,

*If it were not for the shelves cluttered with bottles full of roots, gums and dried leaves with strange shapes and names, a perfumer's laboratory could be mistaken for a pharmacist's dispensary.*

Left: *Selection and preparation of the ingredients for perfumed bases. Groupe Robertet, Grasse.*

Top to bottom: *Inspection of the brilliance and transparency of the fragrance. The stainless steel vats at Christian Dior.*

Right: *"Odor extracts". Page from a Guerlain catalogue of the turn of the century.*

Following double page
Left: *Sealing the bottles at Chanel and Hermès. The baudruche (the natural membrane around the stopper) makes the bottle airtight (above). The twisted silk adds refinement, and the wax seal, the final stage, protects it against tampering (below). Right: Perfume bottle and presentation case created by Garouste and Bonetti for Deci-Delà by Nina Ricci, 1994.*

chemists can obtain fragrances with sometimes highly subtle properties. For example, citronella yields hydroxycitronella, a molecule used to synthesize a lily-of-the-valley scent, even though its own odor is totally unlike that of the delicate flower.

THE FORMULA • "A steady stream of new fragrances is coming out of the laboratory," notes Jean Kerléo, "but the perfumer's problem is what to do with them all." His own view is that new scents in perfumery are like seasoning in cooking: "You can have the best ingredients in the world, but if you don't add a little salt and pepper, they'll be too bland." He also believes—in common with many others in the luxury perfume field—that although synthetics enhance natural products, they can never replace them. Since the creation of Guerlain's *Jicky* in 1889, the first perfume to combine synthetics (including vanillin) with a natural essence, all the great perfumers have used synthetics for the extra tang they give to perfume, but none has ever relied on them entirely.

Two fragrances created by two great perfumers tell the story: *Chanel N° 5*, by Ernest Beaux; and Dior's *Eau Sauvage*, by Edmond Roudnitska. *Chanel N° 5* owes its success to the large percentage of natural ingredients in its formula. The quantities of jasmine, rose, tuberose, jonquil, and orange flower make this fragrance virtually the epitome of the truly floral perfume. Nonetheless, it was also the first fragrance to contain aldehydes, synthetics derived from fatty acids. This was a daring innovation, since most perfumers had been reluctant to experiment with these substances which in their natural state smell like rancid butter and candle wax. More recently, *Eau Sauvage*, a blend of citrus and floral notes, earned its success through the addition of a molecule some perfumers refer to as the "miracle product." It is called hedione or methyl dihydrojasmonate, and was isolated, unsurprisingly, by Swiss chemists.

## The art and science of the perfumer

When we step across the threshold of a fragrance laboratory, our eyes are greeted by a scene we might find in a pharmacist's dispensary or a chemical plant. The thermostatically controlled stainless-steel vats are the same, the figures in white coats gliding over the linoleum floor are the same, the obsessive order and spotless cleanliness are the same. The difference is the "fragrance harmonium," a vast keyboard of containers filled with roots, bark, gum resins, and strangely shaped dried leaves. Some of the labels are exotic, some curiously mundane: *Gum of Siam*

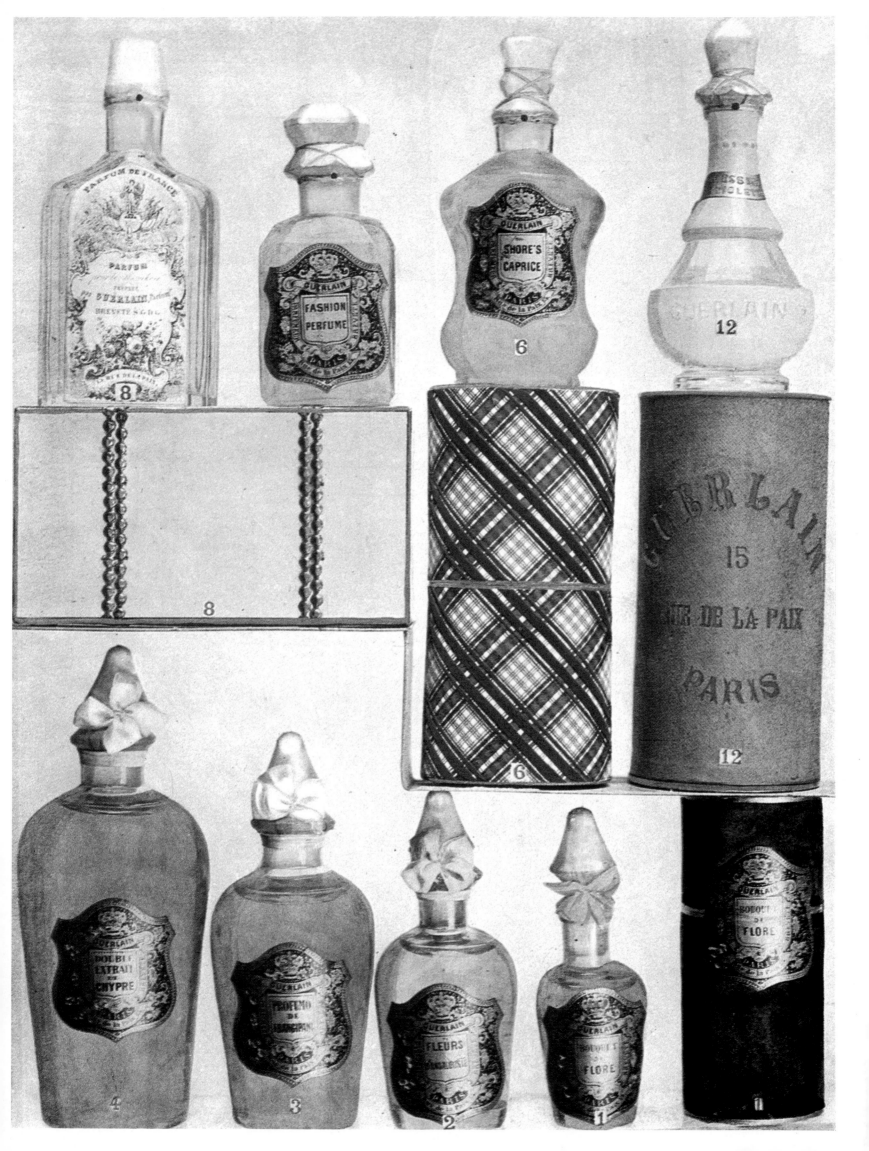

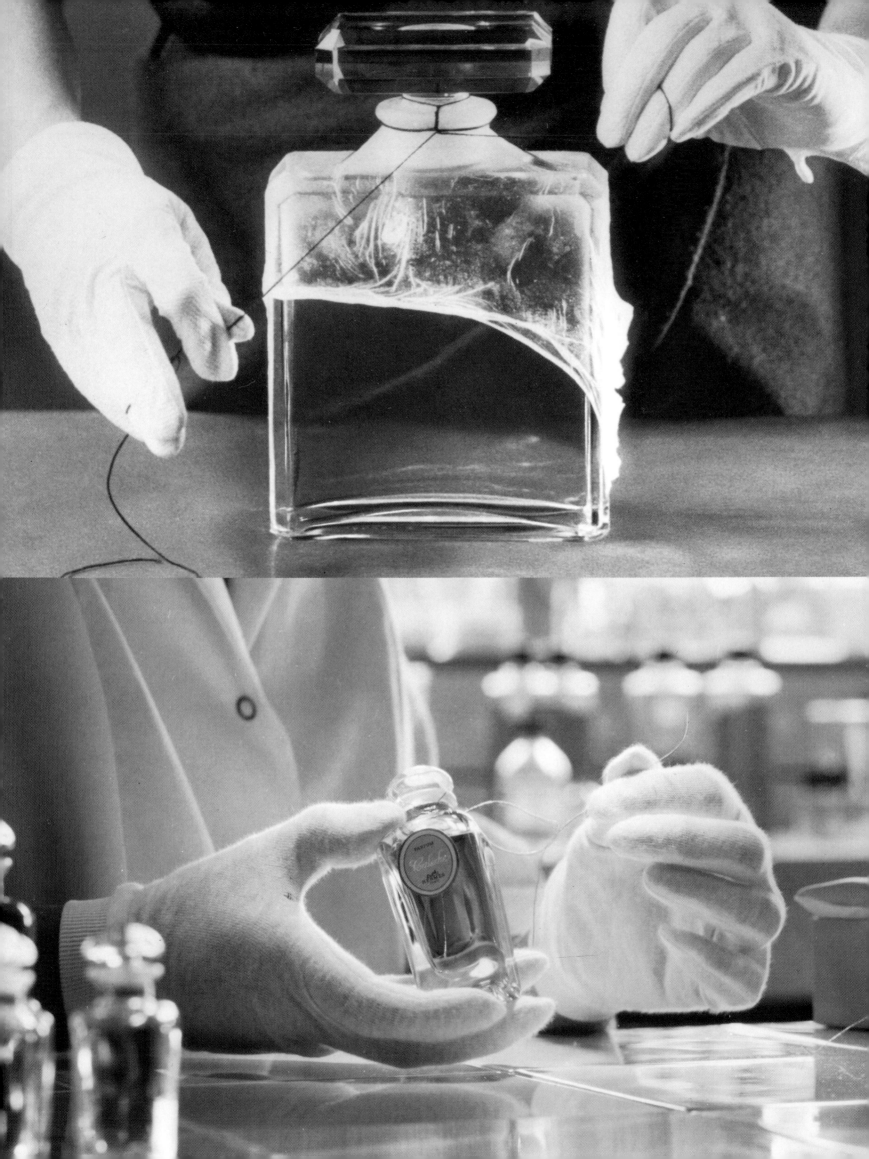

*Benzoin, Bucchu Leaf, Carrot, Celery, Carraway, Fennel, Fenugreek Seeds, Tonka Beans, Whole Cloves, Immortelle Flowers, Oak Moss, Myrrh, Opoponax, Patchouli, Vetiver Root, Bergamot in Oil.* On the counter lie a pile of white cardboard strips for dipping into and inhaling the various essences—the surest sign of all that this is no ordinary laboratory, but the territory of a "Nose."

"PERFUME IS LIKE MUSIC" • Truly great perfumers are people who know all the properties of all the various ingredients, and how to use them. They are also expert in the history of perfumery itself, and in the formulae created before their time. With this background, they are equipped to blend any known scent in elegant, novel, and appealing ways. They also take into account the scent of the skin on which the perfume will be applied, and its effect on the overall impact of the fragrance. This takes a keen olfactory memory, and vast amounts of knowledge, experience, and intuition. The net result is like a musical score—a series of notes combined into chords, harmonies, and symphonies of scent. The material expression of this creative process is also similar to that of the musician. "Perfume is composed just like music," says Guy Robert wryly, "with a piece of paper and a pencil."

SEARCHING THE FOUR CORNERS OF THE GLOBE • In addition to the creation of fragrance, the task of a Nose also involves product management and quality control. As Guy Robert explains, "perfumers do more than just create new blends. They also supervise production and select the raw materials." As supervisor, the Nose inspects every sample of the natural and synthetic products he uses. A product's chemical composition, density, and refractive index can be measured with scientific instruments, but its purely olfactory properties are more elusive. "For example," notes Jean Kerléo, "I've known a chemical product win top marks by every scientific standard, and yet fail the human olfactory test—probably because it was too raw and hadn't matured enough to achieve the note we were looking for."

FROM GRASSE TO INDONESIA • Selection trips take these expert Noses all over the world. They visit patchouli plantations in Indonesia, and jasmine and rose farms in Morocco. They go to Egypt and Tunisia to learn about jasmine and geranium processing, to Réunion and Haiti to find the best vetiver root distilleries. "We don't place any orders while we're there," Kerléo explains, "but we check on the operations and their management, to assess how reliable they'll be as suppliers." The Nose submits his report, and then his firm's buyers act on it.

**From essence to bottle**

*In the cellars of the Nina Ricci plant at Ury, some one hundred and fifty thousand gallons of perfume scheduled for launch on to the market during the year are stored in stainless-steel vats, protected from light, heat, and oxidation. For reasons of hygiene and esthetics, Robert Ricci decided these vats should be raised, and so they stand several feet off the ground.*

*Every half-hour, samples are extracted from the macerating liquid and taken upstairs to be tested for vulnerability to heat and deterioration. The samples are then exposed to ultraviolet rays to test their vulnerability to light. Finally comes the chromatography test: a solution containing a one-milliliter sample of the perfume is sent through a one-hundred-and-fifty-foot column of capillary absorbent. During this journey, the separate ingredients in the perfume form distinct bands or spots on the column, and these are then matched for consistency with the original formula.*

*Batches of the perfume that have passed all their tests are bottled, and the bottles are sent to a spacious, sunny workroom on the uppermost floor to be packaged by the Nina Ricci team.*

*First, a delicate strip of moistened, impermeable organic material is slipped around the stopper. This not only seals the contents, protecting them from exposure to air, but also serves as a guarantee to purchasers that no one has opened the bottle before them. The final touch is a twist of carefully knotted and smoothed gold thread.*

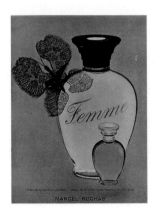

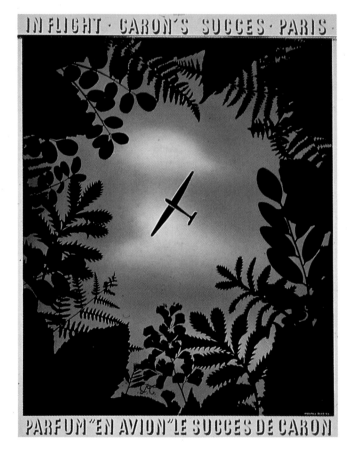

*Poster for* En Avion *by Caron.*
Top: Femme, *a fragrance created in 1944
by Marcel Rochas as a wedding present
for his wife Hélène.*
Top right: *The emblem of the Lanvin house
inspired by Paul Iribe's drawing, 1926.*

This is an elite profession, and today, for better or for worse, most Noses work as freelance consultants to perfume-marketing firms, that subcontract the formulae to outside producers. Noses are thus exchanging their white lab-coats for attaché cases, a trend which reflects the competitive economic environment on which the luxury-product sector depends almost entirely for growth and profits.

In the past, a perfumer such as François Coty could create a new fragrance and then wait two or three years before launching it—taking plenty of time to live with it, asking friends and associates for their opinion, testing its viability and staying power, and organizing special Christmas and New Year's promotions for the new product, calling it merely "François Coty's Mystery Perfume." But those days are gone, and now product development must keep pace with a rapidly changing market.

PRODUCT AND IMAGE • Many marketing people claim that perfume is "mostly image." They are naturally referring to the vast sums of money needed to finance the average promotional campaign for a new fragrance. These sums far outstrip the relatively modest investment required for research and development of the product itself. When Givenchy marketing manager Catherine Guilhem explains what is meant by "image," she describes it as the product's "story." Mass-market products need to tell a story to attract the consumer, and today perfume has become a mass-market consumer product. This means that, through its intrinsic qualities of scent and color, the design of its bottle and packaging, its advertising message, and even its name, it must tell a story about itself that will impress on consumers a vision of prestige, sensuality, youth, beauty, mystery, and vitality.

But there is another story behind the "story," and this one has a moral. Guy Robert, who after fifty years in the perfume business now travels worldwide as a free-lance Nose designing new perfumes, describes the process: "One hundred and fifty perfumes are launched every year, but only once every two or three years will one of them achieve real international success. If a perfume is still performing well after ten years, that means it really does have something special. It's not all in the imagination. Advertising has its limits. It can do a lot, but it can't do everything." Chanel's *N° 5*, Nina Ricci's *L'Air du Temps*, Guerlain's *Shalimar*, Lancôme's *Trésor*, Hermès's *Calèche* and, more recently, Cacharel's *Anaïs Anaïs* and Christian Dior's *Eau Sauvage*, have surged to the fore-

front of the perfume world over the years. Their success lies in the inherent quality of the products themselves.

SPANNING THE GLOBE • Today, a major perfume launch campaign is a global undertaking which costs between twenty and eighty million dollars. The difference between prestige products which are designed to benefit from the parent brand-image, and their more commonplace siblings is a difference in the degree of creative daring, imagination, and originality involved, although the marketing techniques for both can appear very similar. The same focus groups are used to determine the affinity between product and target market; the same brainstorming sessions are convened to decide on color codes for "juice" and packaging, bottle shape, type of advertising campaign, and name, which has to take account of everything this name might suggest in the languages of all the countries where the perfume will be sold.

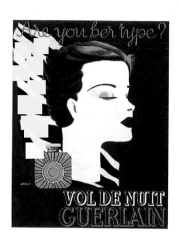

Nevertheless, the single most crucial factor is still the intrinsic quality of the perfume. This depends on formulae that only the greatest Noses are capable of designing; formulae that, when they are successful, far surpass even the most effective "story," or image, and which guarantee long life to the product. Some believe the best way to achieve this elusive standard of quality is simply to follow the old adage: "Look before you leap." This is good advice for an industry that in less than ten years has grown from a tiny clan of some fifteen insiders, to four or five hundred creators of new perfume world-wide.

Caution in the perfume industry is often backed by a firm's desire to maintain its past position, preserve a famous brand image, and protect a reputation rooted in a small but notable number of successes. Yet only a very few firms employ their own Nose and manufacture their own fragrances.

This epitomizes the dilemma of the modern fragrance industry: preserving a distinctive image and respected tradition while also courting the mass market. The answer perhaps lies in the words of Gilles Fuchs, who speaks from experience when describing how European women respond to new perfume: "They're curious, and they'll investigate a product they've seen advertised. But they'll always stay loyal to the perfume they've adopted as their own. A woman who uses *L'Air du Temps* will never use *Poison*, and vice versa. A woman *always* knows which perfume is right for her."

*Gouache illustration by the painter Christian Bérard for* Cœur Joie *by Nina Ricci, 1946.*
Top: Diorissimo *by Christian Dior, 1987. Drawing by Gruau.*
Left: Vol de Nuit *by Guerlain. Poster by Darcy, 1933.*

Following double page
La carte du tendre, *evoking Lancôme fragrances launched between 1933 and 1946. Drawing by E. M. Perot.*

The creation of a new perfume is the fruit of a long gestation period. In the case of Lancôme's Trésor this gestation took four years.

A new perfume must reflect current fashions, which are notoriously fleeting; and yet, if it is to outlive the ephemeral, it must have a distinctive personality of its own. The hardest part is to forecast what the current fashion will be several years in the future; in other words, what the woman of tomorrow will want.

The financial risks are high. With millions of dollars at stake, research and development is geared to producing a perfect congruence between the physical properties of the product, the image it projects, and the overall perception of the brand name.

Lancôme, a renowned French perfumer with a distinguished tradition, decided to reposition its brand image when it expanded its cosmetics business during the 1980s. Lancôme set about crafting a distinctive identity for itself based on a new perfume which was designed to fill the gap between the innovative oriental-type perfumes such as Yves Saint Laurent's Opium, a product of the seventies, and the resurgent florals of the eighties such as Eternity by Calvin Klein.

The catalyst for Lancôme's renewal was the arrival in 1986 of a youthful management team, which set up a small, three-person task force to work with outside consultants in defining the Lancôme woman.

They decided she should be fulfilled, sensitive, and self-assured—exactly the qualities possessed by Isabella Rossellini, who had been promoting the Lancôme cosmetics line since 1982.

Marketing department head Dina Ohayon organized briefings for the Lancôme perfumers charged with creating a "juice" to match the image of the "Lancôme Woman." Meanwhile, packaging had to be designed and a name selected. It was discovered that Trésor, a house fragrance created in the 1940s by Georges Delhomme for a children's hospital benefit ball, had never been patented.

Marketing an updated version of the fragrance under the previous name

forged a link with Lancôme's distinguished past. The color of the filled bottle and its shape—delicately unfurling upward from a pointed base—also recall the firm's traditional symbol, a rose. Trésor is thus an eloquent evocation of something both precious and secret.

### Classical Antiquity

Perfume production in classic antiquity was limited to the blending of odorous substances with plant oil, either by enfleurage or maceration. Distillation was probably only discovered in the first century B.C.

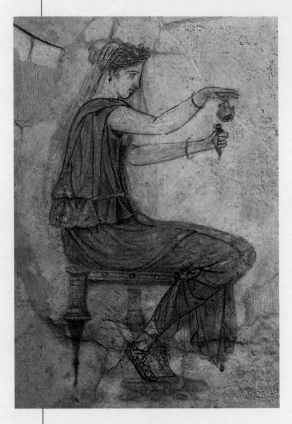

### The Middle Ages

In the Middles Ages, apart from incense burnt during religious services, ambergris and musk were highly prized, as well as the rose water which the crusaders brought back from the Orient.

Perfume exalted the body at a period when the population was in the habit of frequenting steam rooms and public baths, but its main purpose was to serve as a protection against illness.

### The Renaissance period

Large quantities of herbs and spices were brought back from the great sixteenth century exploratory expeditions. Perfumed animal skins were imported from the Orient for the making of certain garments, but more especially gloves. Glovers and haberdashers immediately rivaled each other for the sale of perfumes. In 1594 an edict forbade both guilds to call themselves perfumers, but nevertheless allowed them to perfume their merchandise. The printing press enabled perfume treatises to be circulated.

### The seventeenth century

In this century nothing escaped perfuming, neither clothes, gloves, wigs, handkerchiefs, cushions, nor wall coverings. Jasmine met with great success half way through the century. Fashionable citizens took to composing their own fragrances. In Paris, the glover-perfumer guild gradually became more organized. In 1614, the royal administration granted the exclusive right to the title of perfumer to glovers.

### The eighteenth century

At the court of Louis XV, it was considered good taste to wear a different perfume every day. Following the French occupation of the German town of Cologne, Madame du Barry launched the fashion for eau-de-Cologne.

**The perfume of the French Revolution**: At the end of the monarchic regime, France had

> *Eau-de-Cologne: In 1709, an Italian by the name of **Farina** founded a trading house in Cologne, which prospered under the management of his brother Jean-Marie, who developed a recipe of citrus-based camphorated Hungary Water. Farina named the mixture "L'Eau Admirable," but it was called eau-de-Cologne by his clientele throughout Europe. Success engendered counterfeiting and court cases and in Cologne, in 1865, thirty-nine houses were found to bear the name of Jean-Marie Farina, all impostors or distant members of the family. A descendant bearing the name of Farina, who had started trading in Paris in 1806, sold the business to Roger & Gallet in 1862.*

a monopoly of the perfume trade. The three techniques employed were distillation, enfleurage and maceration.

In 1755, **Jean-François Houbigant**, who supplied all the European courts until the revolution, founded the first perfume house. In 1882, the perfumer **Paul Parquet** pursued the establishment's successful activities by

creating *Fougère Royale,* which contained the newly discovered coumarin and paved the way to a whole series of olfactory accords of this type. **Robert Bienaimé** succeeded him and created *Quelques Fleurs* in 1912.

In 1798, **Pierre François Lubin** opened a boutique called Aux Armes de France, in which he proposed his first toilet water. He became the official supplier of the Princess Borghèse who gave her name to one of his perfumes and Lubin's reputation spread to the courts of England and Russia. He was the first to work for the American market. In 1843, **F.A. Prot** succeeded him and perpetuated the success of Lubin toilet waters.

As early as 1813, under the name *La Reine des Fleurs,* **Louis-Toussaint Piver** met with success in all the European courts because of the diversity of his products. In 1896, a synthetic product was used for the first time in the celebrated *Trèfle Incarnat,* created by **Armingeat** in 1896, and this marked the beginning of modern perfumery. In 1926 he composed another perfume archetype, Le Rêve d'Or, which contained an aldehyde base.

### The nineteenth century

After the revolution, perfumes and cosmetics were brought in line with contemporary tastes. Gradually the habit of perfumed baths and fragrant soaps began to gain ground.

Under Louis-Philippe, Grasse became the industrial center of the cultivation of raw materials and the production of essences. The finishing operations and distribution were carried out in Paris. Under Napoleon III, the perfume market underwent a considerable development, with the manufacture of vast quantities of perfumes bottles, the invention of the vaporizer, the rapid growth of houses composing personalized fragrances, and above all the elaboration of synthetic-based perfumes.

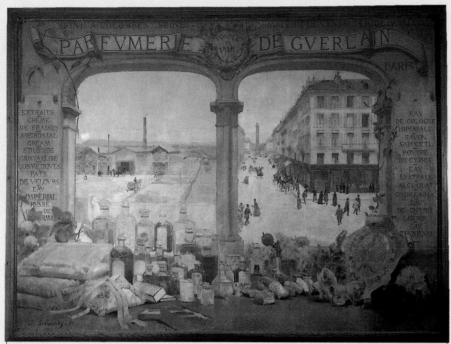

*Guerlain : En 1828, Pierre-François Guerlain ouvre une maison de parfumerie à une époque où seules les eaux de toilette étaient portées, le parfum étant réservé aux objets (gants, éventail, linge). Fournisseur de l'impératrice Eugénie, il réalise pour elle l'Eau de Cologne impériale. En 1889, son successeur, Aimé Guerlain, en créant Jicky, s'éloigne de la tradition des parfums soliflores et inaugure l'emploi de produits de synthèse (la coumarine), symbolisant un changement des mentalités. Avec L'Heure bleue, en 1912, et Mitsouko en 1919, il renouvelle son succès. Autres parfums de référence : Vol de Nuit en 1933, Chamade en 1969, Nahéma en 1979, Jardins de Bagatelle en 1983, Samsara en 1989.*

***Synthetic fragrances*** *: **François Coty** (1873–1934), an inspired initiator, was among the first to combine natural and synthetic products. His association with **René Lalique**, for the creation of his perfume bottles. marked a new step in the evolution of the perfume industry. He was the first perfumer to employ ionone which he used in* L'Origan *in 1905. His greatest success was* Chypre, *created in 1917.*

## The twentieth century. the industrialization of perfume manufacture

The dawn of the twentieth century was marked by the advent of mass-production. The glass industry became intensely mechanized and chemists developed artificial processes simulating rare essences, which had the effect of diminishing the cost price and increasing the range of products.

**Perfumes by fashion designers**: At the same period of time, **Paul Poiret**, in pioneer style, installed a perfume house next to his dressmaking workrooms. It was, however, with **Chanel** and her famous *N° 5*, the great prototype of modern perfumes composed in 1921, that the links between fashion design and perfume creation were sealed.

The mid-twenties witnessed great creative activity regarding both perfume bottles and

their contents. Faceted jewel-like bottles contained fragrances reminiscent of *The Thousand and One Nights*, bearing suggestive names such as *Shalimar*, by Guerlain.

**Perfumes for men**: In the fifties, the French perfume industry reached its apogee. Masculine perfumes were in great demand and resulted in the creation of *Vétyver* by **Carven** in 1957, a perfume of the same name by **Guerlain** in 1959, and *Eau Sauvage* by **Dior** in 1966.

**A world-wide market**: The Italian and American competition of the last few years has obliged French creators to reaffirm their image. Science and computers are increasingly employed for multi-layered perfumes, in which floral, amber, and fruity fragrances cohabit in the multiplicity of fashion which characterizes our era. A great deal of attention is focused on the conception of original or provocative perfume bottles.

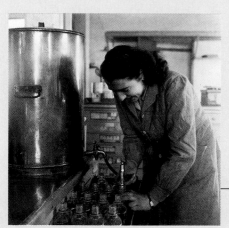

***From Caron to Lancôme*** *: In 1904, **Ernest Daltroff**, a perfumer, opened the Caron perfume house on rue de la Paix. In 1911 he launched the perfume,* Narcisse Noir, *which perpetuated the single floral tendency, followed by* Tabac Blond *in 1919, the first perfume in the leather family, which corresponded to a transformation in fashion and femininity. He entered into an association with **Félicie Bergaud** who defined the Caron style for the next forty years, introducing powders and designing the perfume bottle for* Bellodgia *in 1927 and for* Fleurs de Rocaille *in 1934.*

***Armand Petitjean*** *was **Coty's** representative in Brazil, and in 1928 he assumed the general management of the company. In 1935 he created his own trademark and founded the Lancôme perfume house, simultaneously launching five perfumes which he presented at the Brussels World Fair:*

Conquêtes, Kypre, Tendres Nuits, Bocages, *and* Tropiques.

# Fabrics and Textiles

There are homes that contain no fabrics, just as there are gardens that contain no flowers or faces without a trace of make-up. Questions of personal taste, such as these, cannot be disputed so long as they express a voluntary choice and not negligence or oversight. However, fabrics and textiles have been a popular passion since the dawn of time, whether in the tents of nomads, in the sanctuaries of the gods, or on the looms of mythical women such as the Three Fates, spinning and snipping, or the faithful Penelope endlessly weaving while awaiting Odysseus's return.

From the Middle Ages until Louis XIV, fabrics were so rare and costly they were considered genuine treasures. Generally small in size, they were reserved for religious settings and—in the home—for the bed, a center of domestic life. Bed curtains, canopies, and hangings were easy to put up and easy to fold

*Right-hand page:*
*Dobby loom in the Porthault factory.*

Below: *Chinese raw silk and weaving shuttles.*

away again into the trunks that followed the lord of the manor on his journeys. The same was true for tapestries, used as room-dividers, for rugs that covered simple, wooden tables, or for hangings that kept the wind from gusting through the door.

However, with the dawn of the Renaissance people began to lead a more sedentary life. Tapestries no longer hung loose, rather they were attached to the wall at top and bottom. Fabrics became less utilitarian and more decorative, and their uses became more diversified. As trade with the Orient expanded, damasks, brocatelles, velvets, and other more exotic fabrics made their appearance. England and Spain supplied wool, the Netherlands produced cotton and linen, and Flanders provided lace.

Jean Baptiste Colbert expanded the French textile industry by founding numerous mills which specialized in everything from pure silk to cotton. The seventeenth century brought a flowering of the decorative arts and French fabrics gained a significant place in everyday life, becoming for the home what clothing was for the human body: a language; a means of communication, distinction, and self-expression. During this period fabrics made for clothing and for home furnishing were virtually indistinguishable.

When the textile industry expanded during the nineteenth century, prices fell. Meanwhile, as the growing middle class took an

Below left: *Splicing broken yarn on a jacquard loom at D. Porthault. A tab stops the loom whenever there is a break in the yarn.*
Below right: *10-yard Schiffling embroidery loom at D. Porthault. A continuous dual-feeder embroidery loom.*

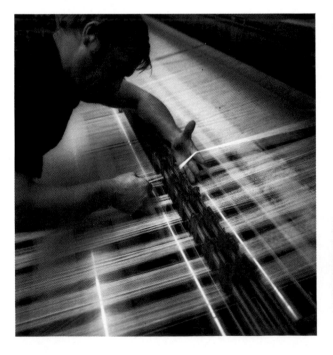

increasing interest in outward show and personal comfort, the French Second Empire witnessed the rising fortunes of the upholsterer. Walls and windows, chairs and beds were draped, shrouded and, so to speak, "dressed." At the same time, the emerging craft of *haute couture*, for which special fabrics were now produced, also seemed to draw inspiration for its vast confections from the art of the upholsterer–decorator.

Starting in the mid nineteenth century in response to the influence of William Morris and his Arts and Crafts movement, the art nouveau school brought rigorous draftsmanship and a much lighter spirit to fabric design. The heavy materials inspired by the Renaissance and its eighteenth-century imitations were replaced by art nouveau designs better adapted to the swift advance of modern technology. From this point onwards, a dizzying array of fabrics became available, fabrics that offered people a way to realize a cherished dream

Above left: Fabrics shop, *painting, 1864. City Museum, Copenhagen.*
Above right: *Jacques Grange's dining room in the Palais Royal, where the spirit of the writer Colette who lived there for many years is still omnipresent. Drawing by Isabelle Rey.*
"On entering a house one should feel at ease and its whole atmosphere should impart a feeling of well-being. One builds with space, volume and layout, then one develops style, decoration, textures, all contributing to the overall harmony."
(Jacques Grange)

Following double page:
*Elements from the* Jamaica *design by Manuel Canovas, inspired by primitive paintings executed in 1840 in Jamaica.*
Center left: *Manuel Canovas's creation of the model for the "Morgane" range.*
Center right: *Pattern for the design* Quel beau printemps *by Manuel Canovas.*

*91*

# Manuel Canovas: the world of the designer

"The first thing I'd like to point out is that textile designers practice an applied art. We're artists and creators, but what we do is intended for sale. This is fundamental, whether the design is destined for use in interior decoration, fashion, or upholstery. The similarity ends here, however, since the requirements of fashion and interior decoration, respectively, differ radically when it comes to fabric design. Fashion is inherently ephemeral, and changes every season. It continuously transposes reality, shaping it to fit an original design concept. The exact opposite is true of interior decoration, a world where durability rules. We need reassurance inside a house. Whether for wallcoverings, curtains, or upholstery, fabrics are chosen to last. We have to be able to live with fabrics over the course of many years. This means minimal novelty and a total elimination of the bizarre. Interior-decoration fabrics are designed to make people feel secure and relaxed, to contribute to a sense of well-being, which is why they're only incidentally 'fashionable,' since the very concept of shifting modes contradicts their purpose— to stand the test of time. Designing a new interior-decoration fabric implies striving from the outset to make it classic.

"Another aspect of fabric design for interiors is the great variety of styles available and their simultaneous use. Inside the same apartment building, the same house, you can find floors and even rooms that combine French eighteenth-century, art deco, high-tech and innumerable other exotic influences. Complete uniformity is rare inside private homes.

"The patterns for interior-decoration fabrics fall into two major categories: wovens and prints. Woven patterns are created by adjusting warp and weft threads on the loom. Print patterns, which originated in the West Indies, are created by using screens for the successive transfer of different colors on to the fabric until the pattern is completed. In the past, woven-patterned fabrics tended to be costly and sumptuous— brocades, figured satin, and the like—while cotton prints were inexpensive. This distinction has become almost meaningless, however, as fabric designers have increasingly used a wealth of new patterns, colors, and original designs to turn printed fabrics into luxury products.

"The myriad choices offered by all the great fabric houses fall under a few main categories, the first of which covers plain, or solid, weaves: moire, satin, velvet, linen, cotton, and so on. A sub-division of this family includes plain-effect or near-solid weaves, which add interest through subtle combinations of yarn-color and texture. Next come the actual woven patterns such as checks and stripes. These are created by using different colored yarns for warp and weft, respectively, and crossing them, at pre-determined intervals, at a ninety-degree angle. Last come the Jacquards—fabrics with non-rectilinear woven designs—ranging from small antique druggets to large decorative motifs.

"Stripes occupy a special niche between solids and prints, and have always struck me as the closest an upholstery fabric can come to a musical score. Stripes are like chords, with their modulations, their sometimes imperceptible variations. A scale of colors is selected and then, depending on its arrangement, on the proportions used, made to render a specific tone, a specific resonance. If these relationships are modified, the effect will be completely different. This is the colorist's work at its purest: in other words, it is the very core of our craft. In the course of a career spanning thirty years, I must have designed more than sixty striped patterns, not to

mention the variants on each model. Multiplying that by the eight to twelve basic color and fabric ranges available, that would put a total of over four hundred striped patterns to my credit. But the possibilities are endless, of course.

"Next comes the huge family of prints, which can be classified by pattern (small, medium, and large prints; abstracts, monochromes, etc.) and also by theme (florals, geometrics, and a host of others). We

generally bring out two major collections of fifteen to twenty patterns and their variants each year, and two small collections of about five designs—the maximum for firms such as ours. Our fabrics appear in the stores regularly each season and they disappear when customers begin to lose interest in them. There's a sort of popularity-rating reflected by sales. Some designs have a remarkable life span, while others that are not top-sellers are systematically re-introduced because their image is inseparable from the house that launched them. But this is very rare. I must repeat: we are at the mercy of our customers' tastes and of the factors that motivate their purchases. The first of these is color,

with its immediate appeal; the choice of pattern comes after.

"Designers must above all have an intuitive approach to their new collections. They must be attentive to their own desires, respond to a multitude of visual stimuli—books, exhibitions, films, museums, advertising—what else can I say?

"In this field, you can't lock yourself up in an ivory tower. A textile designer must be like a trout swimming in the stream of contemporary life. We need this type of sensibility to keep ahead of c o n s u m e r taste—which doesn't prevent us from listening to what our sales representatives have to say. We have to keep in touch with our base, and still do only what we really like when we think the time is right. Sales people always want to handle what's selling well elsewhere—an attitude that doesn't foster creativity. I have a design studio as part of my business. We start with a budget that tells us how much we can invest in each new collection. On the basis of this calculation, which channels our creativity instead of letting it go flying off in all directions, we construct a plan. Each component of the plan corresponds to one of the fabric families described above.

"The next step is to identify a guideline, a unifying concept and, at the same time, a dash of the unexpected. The balance of the color range is obviously the crucial factor. Design can

be taught—color cannot. Color is a question of sensibility, a gift, let us say. The approach to a palette of colors is purely poetic. We visualize the tones, nuances, and harmonies in our heads. We then give this harmony concrete form by deciding which tone, for each separate color, is exactly the one we are striving for. Try to imagine that if we want a navy blue, for example, we have ten possibilities to choose from. Even black must be studied with great care. But, once it has been selected, the color by itself is nothing. What counts is how it is combined. For me, combining colors is instinctive. Like a poet combining words— assembling permutations and combinations, echoes and ricochets—I ricochet mentally from one tonality to another. The chords will assume concrete form later. I never paint my harmonies. I have a code—A, B, C, D, E, etc.—with each letter corresponding to a color that has been previously determined using yarn or a gouache strip. I mark the chosen letter on each of the sections in the design to be colored. The result is an extremely abstract schema which never ceases to amaze the new fabric dyers to whom we subcontract the manufacture of our designs. Ours is a mental universe."

### Recruitment

*These highly specialized designers are mainly recruited from the local community. "We don't take art school graduates," explains Robert Gandit, "because all too often they've developed their own style and are incapable of adjusting to the constraints of a meticulous and exacting reproduction process. We also steer clear of industrial design specialists, who frequently have no real artistic sense at all." As a result, hiring (primarily of women) is done*

*from the local pool of secondary-school graduates.*

*"We've been working like this for twenty-two years now," concludes Gandit, "and it generally takes us about five years to bring trainees to the point where they become operational." It is perhaps surprising to know that behind the walls of an unobtrusive building in a forgotten town near Lyon, remote from the world of formal academic training, there exists a thriving school of art.*

or to escape from drab reality: it was easier to redecorate than to move house. The art of interior decoration, which in the not-so-distant past had been the preserve of a small elite, now became a mass phenomenon, catering for a public well-versed in the intricacies of the art by magazines with monthly circulation figures often far exceeding those of fashion magazines. It is certainly possible to imagine a home without fabrics, and some architects—the purists—do just that. But in this century of sound and fury, these soft envelopes are an infinitely precious addition to our often stressful lives.

### "Lyonnaise" printing

Bourgoin-Jallieu is a small factory town with little to distinguish it other than an accomplished rugby team. And yet it is here that many of the greatest French designers of luxury fabrics for fashion and interior decoration—Manuel Canovas, Pierre Frey, and Léonard—send their cloth and textiles to be dyed and finished. This little town's textile-finishing plants owe their success to the proximity of Lyon, the French silk capital, where fashion industries once attempted to rival Paris and then suffered for their ambition.

No one in Bourgoin-Jallieu dreams of competing with Paris. With a healthy dose of provincial realism, their more modest goal is to serve the capital and, in so doing, to support an industry that almost everywhere else in France is either waning or has completely disappeared. In the textile-finishing industry, the printing and dyeing sector is the only one to have registered growth over the past twenty years, and the most successful companies are those that practice traditional screen printing by hand, and flat-bed screen printing for mass production. In an international economic environment marked by fierce competition to improve productivity, by rising energy costs, and by massive imports into Europe of products manufactured abroad by cheap labor, the only successful areas in the French textile industry are those that rely on original design. They alone have been able to defend themselves against a tide of mass production which is increasingly dominated by competition from the world's less economically developed countries.

During the 1980s, the textile-finishing industry adopted a streamlined production strategy aimed at reducing lead-times and adjusting output to a shifting market demand. Suppliers tailored production to their customers' immediate needs, reduced product-line

size, and connected their information systems to their customers'
so they could respond in real time to the vagaries of fashion.
Industrial fabric-finishers have managed to hold their own by
investing heavily in modern technology, and by shifting to CAM,
or Computer-Assisted Manufacturing. Meanwhile, however, a few
small firms with a tradition of meticulous, high-value-added pro-
duction, have done very well indeed. Targeting a specialized sec-
tor that supplies the luxury market, they have continued to
occupy a valuable niche, providing customized service to a lim-
ited and highly demanding clientele. Craftsmanship and service
have always been integral to the work ethic of these companies,
and that is why, amid the increasing desertification of the French
textile industry, Bourgoin-Jallieu stands as an oasis.

### From the drawing-board
### to the final design

The progress of a silk scarf begins with the designers (Hermès,
for example, employs over twenty full-time designers) who cre-
ate the collections and patterns that are usually based on themes
drawn from archival documents and then reinterpreted in the
company style.

A paper sketch of the final design is sent to the color separator,
who will decide exactly what is needed so that the printer can
reproduce it on fabric. A single Hermès scarf might contain up to
forty tones, and the color separator's first task is to analyze the
design and identify each individual color. It is during this prepara-
tory phase, carried out in collaboration with the designer and the
printer, that the total number of separate color frames that will be
required during the printing process is determined. Since graphic
designers are not always aware of the technical problems
involved in printing, the goal at this stage is to strike a compro-
mise between the designer's artistic vision and the practical limita-
tions of the printing process. For example, in order to reproduce
the precise nuances and subtle shadings desired by the artist, the
color separator might decide that white (or a transparent or neu-
tral mixer) should be added to the basic color, rather than passing
successive screens of different shadings over the same spot on
the fabric, which could cause an unattractive "impasted" effect.

When a list of all the colors for the final print has been estab-
lished, the color separator then asks the designer to sketch a
master pattern on to transparent polyester tracing sheets, using
one sheet for each color in the design (an average of about thirty

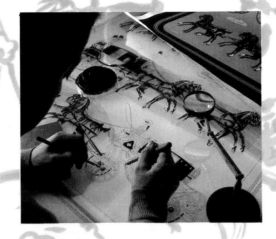

*Daniel Tribouillard retouches a design in
the studio at Léonard.*
Top: *The design studio at Hermès.
Here the subject-matter, layout and
drawing of motifs is carried out.
These motifs are largely borrowed from
documentary elements reinterpreted in
the house style.*
Bottom. *Gonesse fabric from Pierre
Frey's 1993 Collection. Interpretation
inspired by a canvas by Jouy of 1784.*

Left: *Working on photo-plates in the
engraving workshops at Gandit.*

for a Hermès scarf). The lines are traced in Indiaink, and the colors filled in with gouache. The designer executes these painted sketches entirely by hand. Rigid stencils cannot be used, since the design must be varied slightly depending upon the fabric to be used. For example (to take two extremes), terry cloth and silk will accept the pattern to different degrees, making it necessary either to expand or contract its outlines. These polyester sheets, which will serve as "transfers" for each separate portion of the design, usually take a total of three months to complete, and are always executed by a single designer in order, as color separator Robert Gandit explains, "to ensure there are no discrepancies in style between the various sheets."

### Flat-bed screen printing

While the transfer sheets are being painted, in another part of the plant metal stretchers are constructed for holding the final polyester fabric screens. Silk was initially used for this process, which explains the origin of the term "serigraphy" or "writing on silk." However, silk is not as effective as polyester, in which different thread types allow for greater precision in the final print. With the single-end or extruded-type thread, results are less precise than with the multi-ply or spun-type. This is because the spun-type thread forms a mesh through which the color can pass more easily, especially when the thread-count (or "loops") per square centimeter reaches ten thousand. This type of polyester is used for especially delicate tasks—such as printing necktie fabric—that involve extremely detailed patterns.

The patterns on the transfer sheets are now individually rendered on to this cloth, which is treated with a gelatinous, light-sensitive emulsion that prevents liquids from penetrating the portions of the cloth that are not intended to receive the dye. Only those portions that had been covered by the pattern will let the dye pass through on to the final fabric lying below.

Flat-bed screen printing, also known as "Lyonnaise printing," depends largely on the skill with which the color separator copies the designer's pattern on to the polyester in the metal stretchers before they are sent on to the printer. A crucial contribution is also made by the colorists, who work at the printer's from a palette selected by the original designer. They first attempt to achieve the exact shades specified in the original pattern, and then use a range of different colors to achieve four or five variations of the same model in different shades.

*Au fil de la soie, Hermès Spring/Summer, 1995.*
*"At the 'origin' of the legends and tales of silk, in distant China, the little prince Si Lingchi marveled at the fineness and softness of a thread drawn from a small grey ball he picked up at the foot of a mulberry tree where it had been dreaming. How many dreams took hold of the 'spirits' linked to this thread, that wove roads and rivers and enabled these legends to be recounted across countries and deserts, mountains and seas?"*
*(Annie Faivre)*

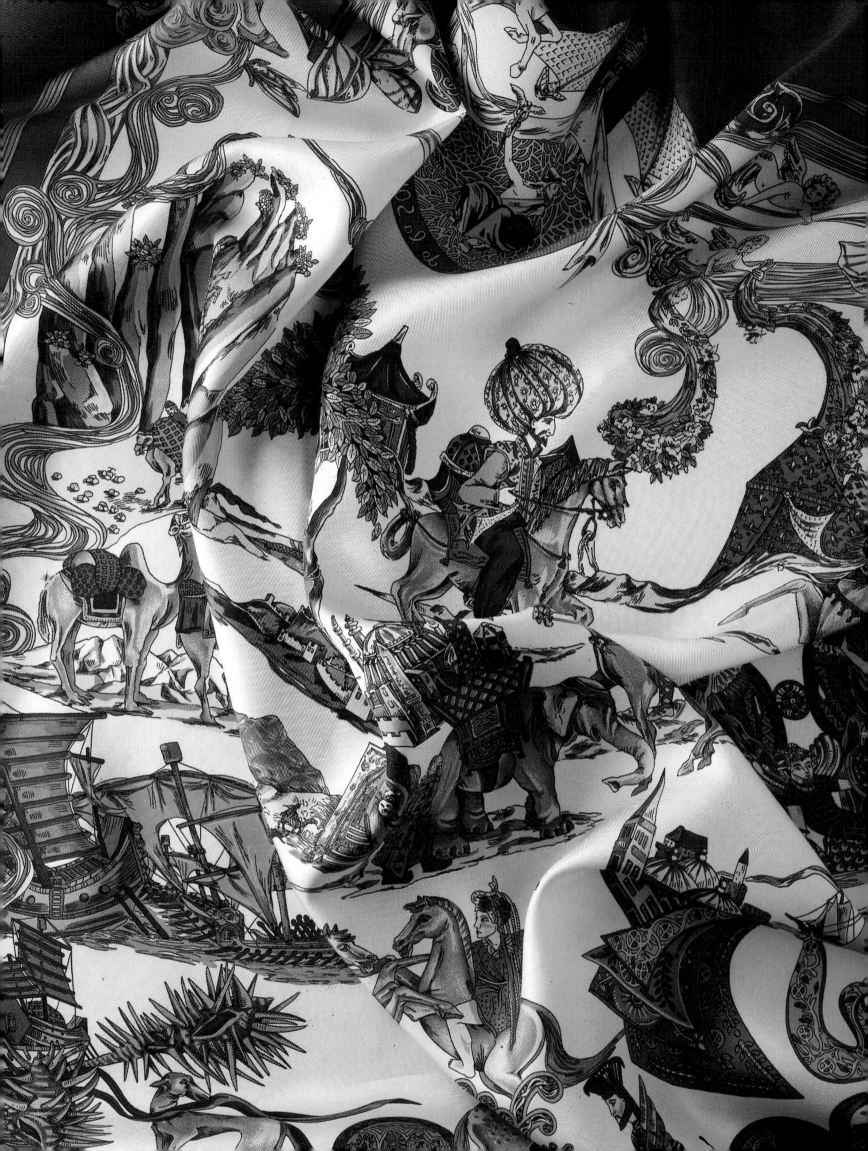

## Coloration

"The first job of the colorist is to analyze the type of yarn that will be receiving the color," explains Guy Raverat, manager at the Mermoz dye factory. For each separate dyeing process, colors must be found containing reactive agents specific to the fabric

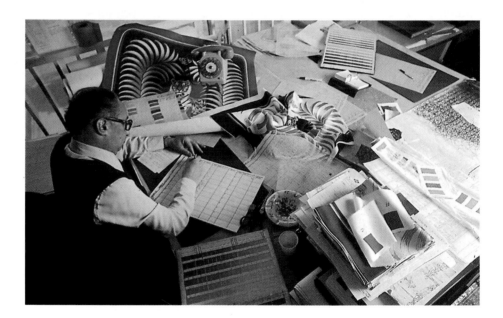

that is being dyed, and involving minimum use of glyceroph-taleins, a group of synthetic dye "cover-ups" that are very effective but literally kill the fabric's feel and freshness. Printers have a particularly difficult time when they are obliged to follow the imperatives of huge corporations such as Hoechst or Bayer, the major dye suppliers worldwide. Commercial considerations have led to a degree of standardization not always consistent with quality. "For example," notes Guy Raverat, "there's a very bright, very effective, dependable pink that has disappeared entirely

from circulation. Two or three other dyes have taken its place, but they all have flaws and weaknesses we have been forced to accept. Sometimes they perform beautifully, but sometimes, even when the same shade is used again, the result is flat and dull."

After a series of tests and trial runs, a result will finally be achieved that gains the client's approval and even enthusiasm. Designers such as Manuel Canovas, Patrick Frey, and Daniel Tribouillard for Léonard, spend a great deal of time at the printer's. They come in person to inspect the color ranges proposed by the colorists. "I supervise the coloring from start to finish," insists Patrick Frey. When Frey receives a first-run printing of the color ranges proposed by the printer and the dyer, he matches them himself so that the resulting harmonies will express his original concept perfectly. "The printer's job is to transcribe the client's specifications," notes Frey, "I refuse to work from standard color ranges. If a pink is too pink, it must be lightened." When explaining to printing technicians what he wants, Frey insists on using the language of painting, which emphasizes tonal values and concepts such as bright, pastel, muted, sanguine or *fauve.* "It's up to them to give me what I want," Frey concludes.

Top and bottom: *Pattern for the "Verger fleuri" range by Pierre Frey. Gouache on paper and rhodoid.*

Left: *The colorist in the Hermès workshop invents colors and translates them into formulae.*

### In the "kitchen"

Giving customers exactly what they want is precisely what these colorists—most of them native to the region and trained in the plant—strive to do. However, "the colorist often enjoys a degree of freedom when deciding how to vary the model," notes Gilles Guillermard of Mermoz. Guillermard supervises a "kitchen," or dye laboratory, with long lines of shelves holding tiny jars of dye samples. There are a vast number of possible color variations: for black alone there exist eight different shades: coal, charcoal, Congo, Senegal, Dakar,

tar, graphite, and Negus—all names imaginatively dreamed up by the technicians who mix the samples. From these they make color cards in various shade ranges that the designer can then compare with the original.

Prior to the actual printing, the dyes are mixed in the laboratory according to strictly codified recipes contained in a large book which lists all the formulae—and secrets, perhaps—of dye making. This compendium reflects the fact that until the middle of the twentieth century, each printer added a dash of personal

*Partial view of the printing room at Hermès. Printing is carried out in large rooms containing tables measuring from one hundred and fifty to three hundred feet in length, surrounded by fabrics which have already been printed and are hanging half-way up the walls to dry. This is called air printing and is characteristic of the large plants where space and light play a major role.*

Right-hand page:
*Marescot lace, detail of a Givenchy cocktail dress from the Fall/Winter 1994–5* haute couture *collection.*
Center: *Model from Chanel* haute couture.

*Double page following:*
*Silk satin pillowcase and bedspread by D. Porthault, made for Barbara Hutton, with small roses hand-sewn in satin stitch and seed-stitch. Lace appliqué in eyelet embroidery.*

innovation into his dyes—a bit of olive oil or talc, for example— that constituted the firm's hallmark and a secret never to be divulged to competitors.

The first phase of the dye operation is mixing the basic colors. This is entrusted to a "cook" who takes colors in powder or liquid-suspension form and mixes them with water, thickener, and chemical fixatives to achieve a dye that is liquid enough to be spread over the fabric, yet viscous enough to preserve the clarity of the design while being absorbed. This is referred to by specialists as the dye's "climb down" into the yarn. Next, the "cutter" blends the basic color to achieve the desired shade, and homogenizes the mixture in a turbine. Because the finished product must be as even as possible, all the ingredients are measured down to the last gram on precision scales.

which was not only unexpected but ultimately very lucrative? At the end of the 1970s, fashion designers such as Karl Lagerfeld, Emanuel Ungaro, and Chantal Thomass turned their talents to a neglected sector—frills and furbelows, ribbons and lace—in a word, the lingerie that had disappeared from the scene during the previous twenty years. Today lingerie is with us again, both as under- and overwear, and lace is back in style for haute couture *and* ready-to-wear alike.

### Calais, capital of French lace

*The town of Calais, located on the shores of the North Sea, is the capital of French lace. Its pre-eminence originates in the nineteenth century, when English lacemakers, in order to escape the French import duties levied against their wares, decided to move their Levers lace-looms to a town on the other side of the English Channel, opposite Dover. The Levers loom works like a barrel organ, using perforated strips of cardboard to execute complicated patterns automatically.*

*Today, following the break-up of Levers looms in Great Britain and the United States, France has a virtual worldwide monopoly of all Levers looms, boasting seventy percent of the machines currently in operation.*

### New fibers

*These technical marvels dating from the first industrial revolution can weave absolutely any fiber, from the sheerest silks to the heaviest guipures, including synthetics such as Elastane (most commonly known as Lycra or "stretch") for garments ranging from* haute couture *to lingerie and sportswear.*

*Furthermore, although lace has traditionally been limited to just a few*

ferent fibers in the same weave, thus paving the way for an infinite number of colors and shadings.

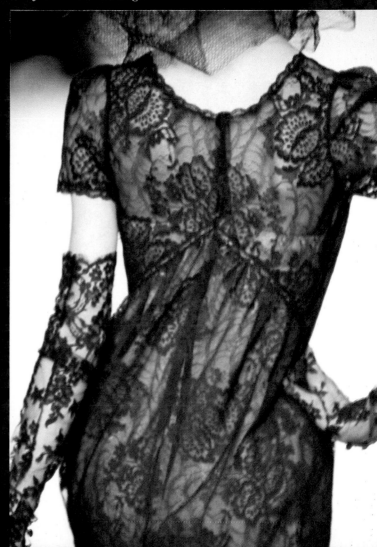

### From lacemaker to designer

*Calais, in the heart of Flanders, a major lacemaking region since the Middle Ages, and Chantilly and Valenciennes, the two most famous centers of fine French lace, all benefit from a long tradition of local craftsmanship.*

*Their designers draw inspiration from patterns that can be up to ten centuries old, as well as from the latest Parisian fashion trends.*

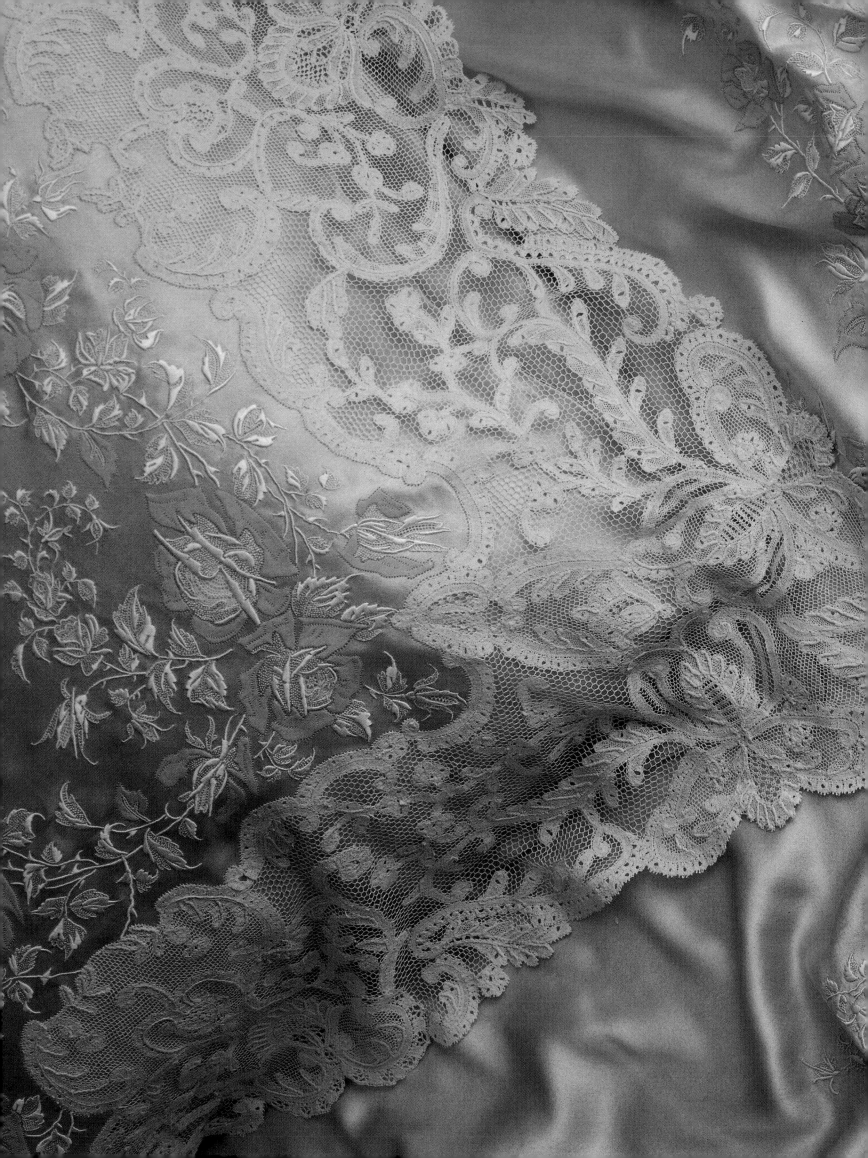

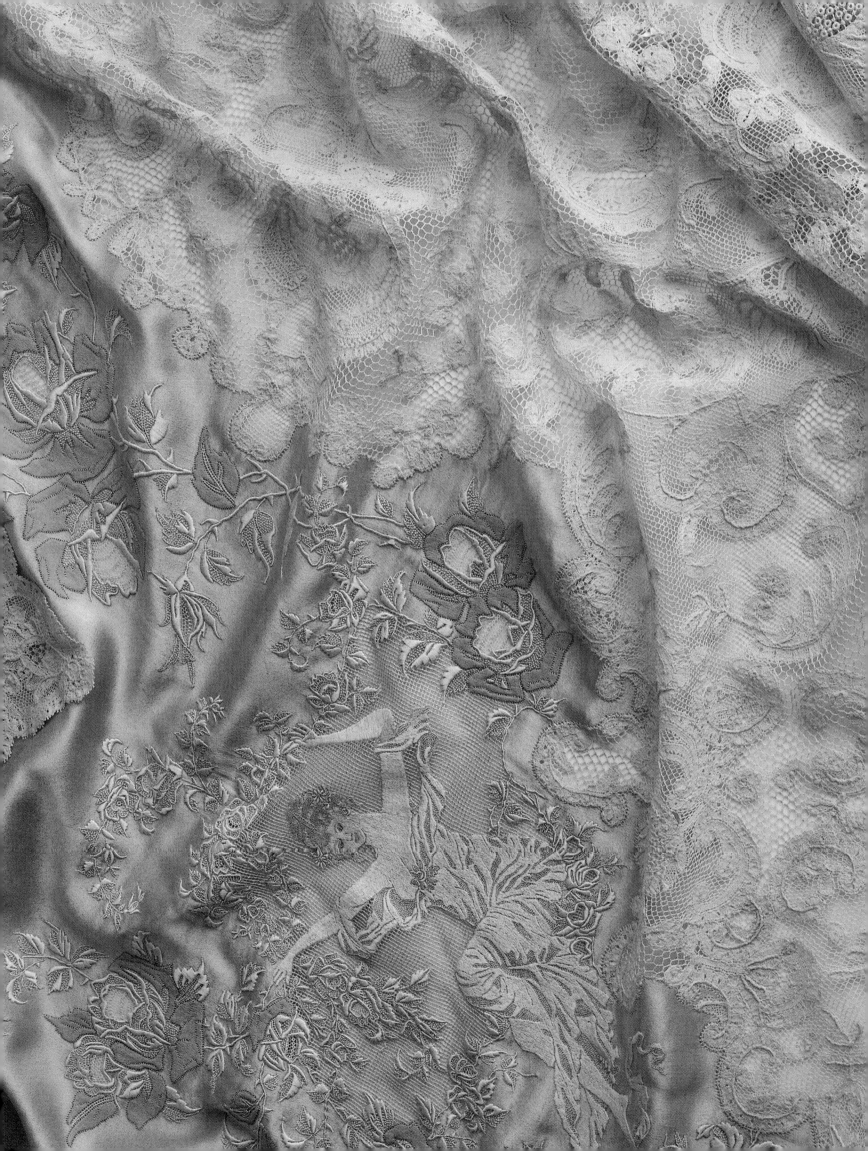

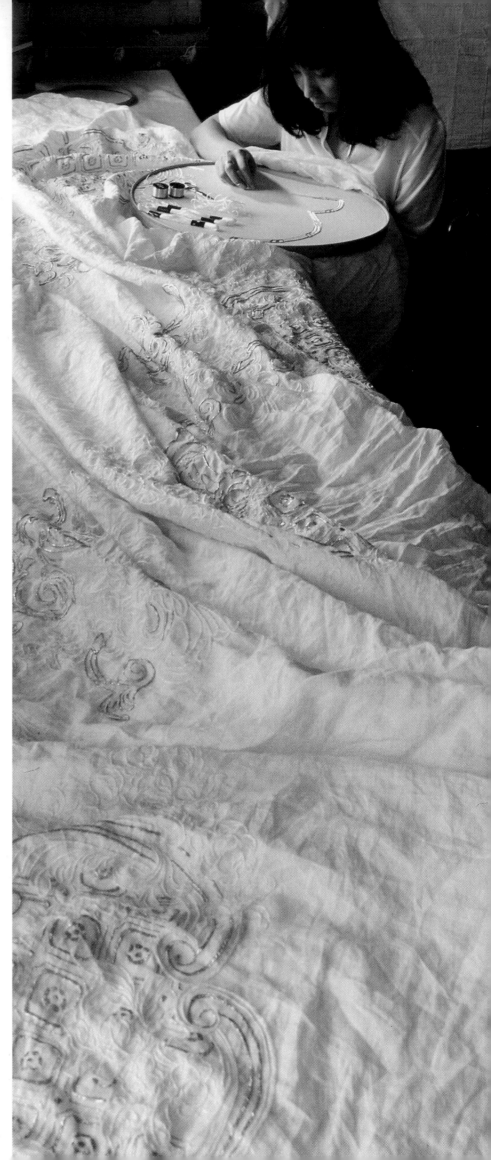

## Exquisite decoration

*Even the most beautiful household
linen is purchased primarily to
meet a practical need. The word
"linen" epitomizes our image of
"textiles"—lengths of cloth woven
from flax, cotton, silk, or linen that
are made to be used: as sheets,
handkerchiefs, tablecloths or nap-
kins; in plain or blended weaves,
batistes, lawns, or sateens; as back-
grounds for lace, damask patterns,
prints, or embroidery.*

*For the yacht belonging to the ship-
ping magnate Aristotle Onassis, the
D. Porthault company—famed pur-
veyor of household linens—designed
an entire trousseau based on a*

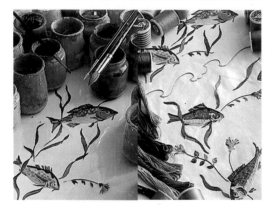

*deep-sea theme featuring flying fish,
mermaids, dolphins, coral, sea
shells, seaweed, and sea anemones,
inspired by the decorations in the
Ancient Cretan Palace of Knossos.
Each piece was hand-embroidered
in Beauvais stitch—probably the
most complicated of all to execute—
a delicate hooked chain stitch
worked on a frame or on canvas
backing. Some of these patterns con-
tain up to eighty different yarn col-
ors, worked in such a way that they
create highly subtle shadings when
combined.*

Opposite: *Creation of a gold embroidered
tablecloth at D. Porthault.*

Right-hand page, top to bottom:
*Open-work dust ruffle on a 10-yard
embroidery loom. D. Porthault;
Chain stitch on a Cornely embroidery
machine which is used only for special
orders. D. Porthault; Embroidery with
raised designs requires careful ironing.
D. Porthault.*

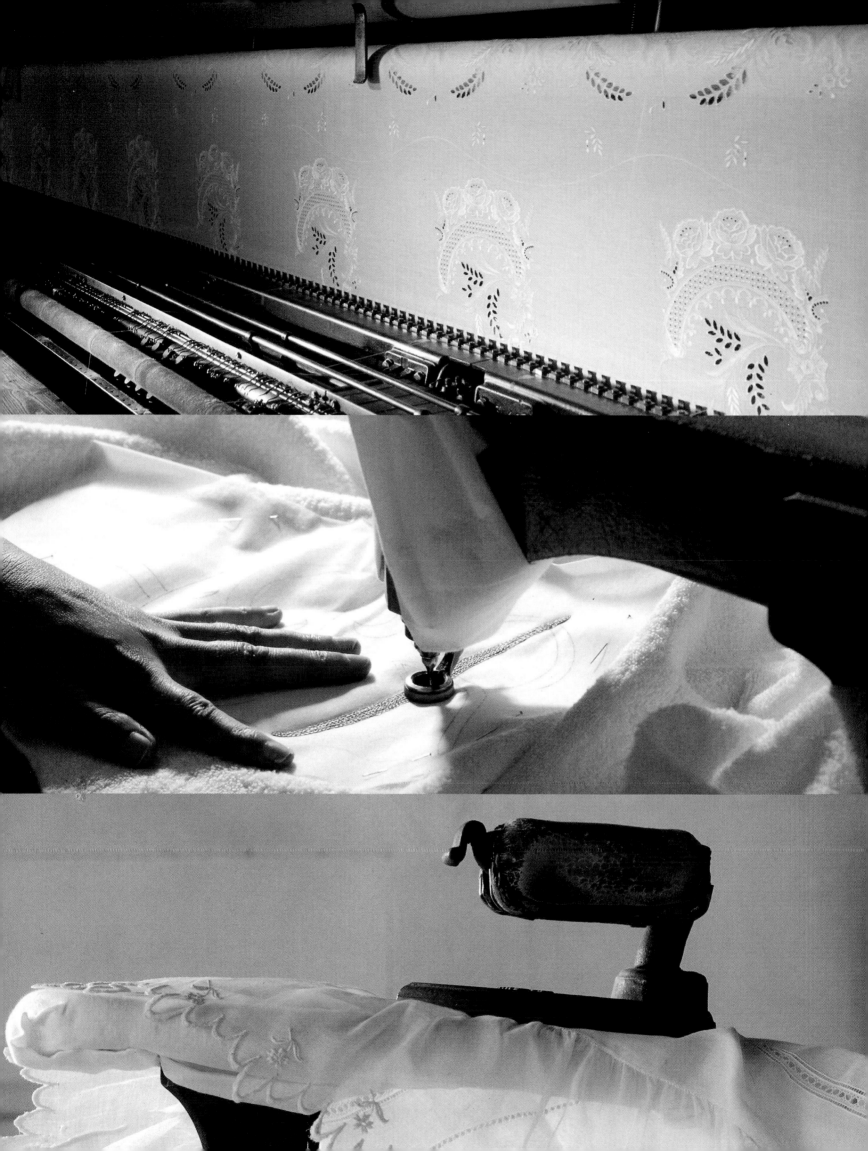

## The Indian tradition

*Wood-block printing is an ancient Chinese technique which involves carving a pattern on to a block of wood, dipping the block into dye, and pressing it on to the fabric.*

*This technique subsequently spread to India, where it was combined with the Indians' own skill in dye making, and was practiced with such artistry and success that it is now known as "Indian Printing." Red and pink dyes are made by combining aluminum salts with madder; lilac and black by combining iron salts with madder; indigo blue by steeping indigofera tinctoria leaves; and green by laying yellow directly over blue.*

*Dyed Indian textiles, with their patterns of exotic animals, flowers, and plants, were introduced into Europe in the sixteenth century by the Portuguese and the Dutch, and were widely used for hangings, upholstery, and clothing. Marseille, a port of call on the Levantine trade routes and a free port in 1669, was soon doing a thriving trade in Indian prints. These dyed cottons were so popular that local artisans set about imitating the technique themselves. This is how Indian-style printing gained a foothold in Provence, despite the protectionism of Louvois, a minister under Louis XIV, and attempts to stop local manufacture.*

*The textile company Souleïado, with its archives containing forty thousand wood-blocks, is the heir to this tradition, and has restored the ancient Indian art to its original eminence.*

## "Air printing"

Finally the printing can begin. It is carried out in large rooms holding tables that usually measure some one hundred and sixty feet in length (a piece of upholstery fabric measures three hundred feet on average) and which are surrounded by fabrics that have already been printed and are hanging halfway up the walls to dry. This is called "air printing" and is characteristic of the large plants where space and light play a major role: space, in which to hang the pieces of fabric; and daylight streaming in through large glass windows so that the printers can check "by eye" the quality of their work and the homogeneity of the shade. Measuring approximately three feet per side, the frame on to which the etched polyester cloth has been stretched is placed on a trolley. A guide rail lowers the frame and presses it against the fabric glued to the length of the table. The dye is then poured from the guide rail and spread over the polyester on the frame by two rubber blades attached to a "squeegee." The non-water-proof sections receiving the dye will let it pass through, thus imprinting it directly on to the fabric below.

It usually takes twenty minutes for the trolley to return to its point of departure, which gives the fabric time to dry before another color is applied to a new area through a different screen. When the entire length of fabric has been printed, it is unglued and raised above the table by a pulley. At this pace, which is virtually that of a cottage industry, it takes the equivalent of one person working one full day to print a single length of fabric. By comparison, mass-production roller printing can sometimes handle one hundred and eighty feet of cloth per minute.

## When the fabric recovers its "hand"

The final steps in the process involve washing the fabric with a detergent to eliminate the sizing, and to block the dye so that it does not "bleed" on to the white sections. The print is then "fixed" by placing the fabric in a bell-shaped dryer, where it hangs between two strips of linen voile that reduce the tension on delicate materials such as silk, chiffon, and silk jersey—the classic fabrics to be screen printed by hand. The cloth is then rinsed in cold water.

At this point, when the sizings and other additives have been rinsed out, the fabric is no longer heavy and stiff, and recovers its inherent "hand"—in the words of Patrick Frey—"the caressing rustle of a fabric on which the pattern seems to rest like a kiss."

Left: *Printing on the fabric with the aid of a mallet, the motif on the wooden block dipped in dye.*

Right: *Three Souleïado printing-blocks in wood and copper.*

### The Middles Ages

When the Crusaders brought back gold, satin and damask cloth from the Orient, the French responded enthusiastically opening factories to produce similar goods in Poitiers, Troyes, and Paris.

*The introduction of the mulberry tree in France: The first royal silk factory in France was founded in Lyon, in 1466, by Louis XI. Shortly after, another was opened in Tours in 1470. Civil wars and sumptuary edicts checked development until 1596, when Henri IV decided to stop foreign imports and had 20,000 mulberry trees planted along the paths in the Tuileries gardens and the grounds of the Fontainebleau and Madrid châteaux. Commissioners propagated the cultivation of silkworms throughout the realm and a factory was opened in the former Tournelles Palace. This initiative was not pursued by Louis XIII, but cultivation had been well developed in the Languedoc region where the climate was favorable, and it was renewed in the seventeenth century at the instigation of Colbert.*

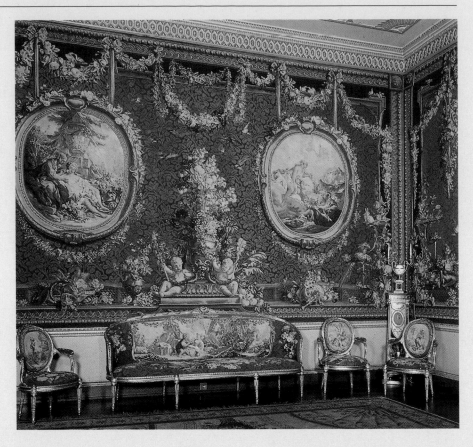

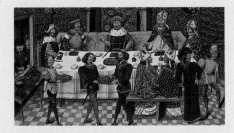

### Technical improvements in the seventeenth century

In 1605, **Claude Dangon**, a master weaver, introduced the drawloom to Lyon, enabling large figurative compositions to be woven in various colors. He produced satins with very fine floral motifs, shaded half-tones and gold and silver ornamentation.

Styles were imposed by princes and members of the court. Under Louis XIV, larger-than-nature flowers blossomed on damask and brocades, which were succeeded by Chinese or Turkish motifs. The floral theme remained predominant, but in a more naturalistic version.

The great artists of the period were **Courtois**, who used shading and raised motifs and **Jean Revel**, who excelled in the art of half-tones and shaping with his use of sunken stitches.

### The collaboration of painters in the eighteenth century

With Louis XVI, flowers diminished in size and were portrayed in clusters. The motifs were often separated by ribbons or branches.

The Lyon silk manufacturer, **Camille Pernon,** used the services of the greatest textile artist of the day, **Philippe de La Salle** (1723–1804), a pupil of **Boucher**, who designed large floral panels surrounding rustic scenes or vases inspired by antiquity. He worked with the Lyon silk manufacturers, bringing renewed inspiration with motifs portraying partridges, doves, baskets of flowers, peacocks, and pheasants, and his introduction of black backgrounds.

It was also at this period that printed fabrics were produced, imitating calico prints.

### The First French Empire

By opting for large decorative settings in his residences, Napoleon revived the activity of the Lyon factory, which had been severely disrupted by the revolution.

Empire silks are characterized by dazzling colors, symmetry, palmettos, and symbols alluding to Napoleon such as bees and gold stars.

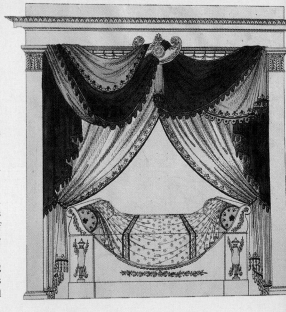

*Printed fabrics: In 1759, the printing of fabrics was finally authorized in France after a ban of more than sixty years. **Christophe-Philippe Oberkampf** (1738–1815) founded a factory in Jouy-en-Josas in 1760. Initially the* toiles de Jouy *were hand printed by means of wood blocks (one block per color); later copper plates were used to produce finer motifs. The* toiles de Jouy *were made of écru cotton or linen fabrics printed with monochromatic blue, sepia, or blackcurrant designs (green and gray appeared only in the nineteenth century) portraying rustic, mythological, or historical events. Oberkampf, with his nephew Widmer, subsequently invented the copper roller which enabled him to print 5000 yards of fabric per day! The artist, **J.-B. Huet** (1745–1811) worked almost exclusively for the Jouy-en-Josas factory, drawing cartoons and executing the copper engravings. It is to him that we owe the pastoral scenes, easily recognizable by the extremely fine strokes.*

## The nineteenth century

The Jouy factory closed down in 1843 and workshops in the regions of Rouen and Alsace filled in the gap. The town of Mulhouse had been manufacturing printed fabrics from the eighteenth century, but only became an integral part of France in 1798. In the nineteenth century, Mulhouse became the market leader and, apart from cotton and wool muslin, new fabrics were employed, such as the glazed percale invented by **Schlumberger**. The town was also renowned for its cashmere printing in a tone known as Turkish or Andrinople red.

> *William Morris (1834–1896). Through the influence of this designer, painter, writer, and founder of the Arts and Crafts Movement, printed textiles, chintz, woven designs, wallpaper, stained-glass windows, carpets and furnishings all took on new importance. Morris was opposed to the distinction between major and minor arts, advocating an art "made for the people and by the people" thus encouraging craftsmanship as opposed to mass-produced objects. He encouraged architects to take an overall view when designing private homes.*

At the end of the century, art nouveau brought about a revival of interest in Japanese themes for textiles that blossomed with irises, dragon-flies, water-lilies, and other naturalist motifs, especially in muted tones.

## The twentieth century

Between 1910 and 1925, motifs became gradually more geometric. Influenced by the Ballet Russe, silks took on dazzling colors. After a year of working with Paul Poiret, **Raoul Dufy** joined the Bianchini textile company from 1912 to 1928 producing the Tournon fabrics. Dufy employed a mixture of linen, cotton as well as an innovative use of silk for his boldly colored designs and floral motifs.

**A designer, a style**: In 1935, **Pierre Frey** (1903–1994) started to specialize in the creation and manufacture of upholstery and decorative fabrics. His style reflected the eighteenth century French tradition of high quality printing, with theme motifs, figurative Jacquards, quilted fabrics, and reversible cotton piqués.

In 1938, **Charles Demery** took over the family-run factory in Tarascon. Under the

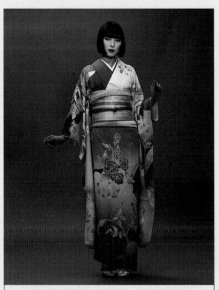

> *Léonard's flowered creations: Daniel Tribouillard, who was fascinated by the symbolism of Japanese flowers was granted the privilege of being initiated into the secrets of manufacturing traditional kimonos—a unique honor for a Westerner. Today more than two thousand kimonos leave his workrooms in Kyoto. The updating of an ancestral tradition by a European, in the silk kimono sector, is something of a revolution in the world of Japanese textiles.*

trademark **Souleïado**, he produced calico prints, using artisanal techniques.

**The turning point of the fifties**: The multiplication of synthetic fabrics and dyes resulted in total liberty for designers, who continued to draw inspiration from exoticism and eighteenth century French styles.

**Manuel Canovas**, with his particular approach to color, is an innovator in the domain of furnishing fabrics. Influenced by his trips to Mexico, India and Japan, he draws inspiration from his observation of nature and his profound knowledge of classical sources.

**Daniel** and **Madeleine Porthault** renewed the traditional white household linen by introducing colored prints and floral motifs. They added white and colored lace and embroidery to the printed household linen of the sixties, and continue to create exclusive, made-to-measure household linen.

> *Sportswear by René Lacoste: By being the first non American to win the Davis Cup in 1927, René Lacoste became a legend. He was nicknamed "the crocodile," due to the tenacity he displayed on the tennis court. His friend Georges Robert designed the first Lacoste crocodile, which was embroidered on a blazer.*
> *In 1933, René Lacoste joined with André Gillier, a knitwear manufacturer, to design a short-sleeved leisure shirt. He added his crocodile emblem and the Lacoste polo shirt was born.*

# Gems and

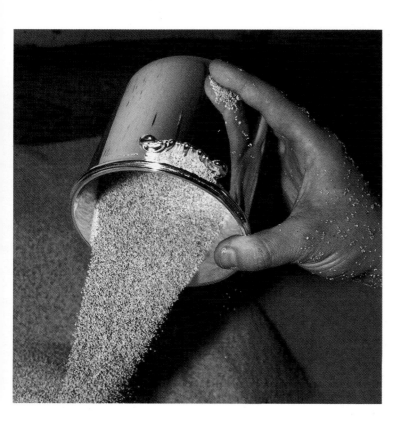

Jewelers, goldsmiths, silversmiths, and bronze casters all work with the same basic material—metal. The distinction between them resides primarily in the way we perceive their work. Gem settings appeal to the eye, at short distances. Bronzes, on the other hand, are usually admired from afar, as components in a larger decorative or architectural setting. And, although we also appreciate gold and silver objects with our eyes, they perhaps give the most pleasure to our sense of touch.

The craft of metalworking was born when human beings first learned how to smelt ore. Our oldest surviving historical records, including the Book of Genesis in the Bible, refer to wrought gold and silver, and to the aura of alchemy surrounding the artisans who manipulated these precious materials. However, the artistic durability of the artifacts they made has always been threatened by the monetary value of the materials they used. The wars, vandalism, and economic depressions endemic to human life have periodically led people to melt down and recast even the finest examples of the metalworker's art, countless examples of which we know only through hearsay, written descriptions, and contemporary ledgers. Silverware has traditionally served as a status symbol, but the precious metal contained in the sumptuous table-settings so proudly displayed by the wealthy during times of prosperity is all too frequently melted down and sold for its intrinsic value when prosperity wanes.

During the Middle Ages and the Renaissance, the goldsmiths' and silversmiths' guilds supplying Europe's noble and royal families gained power and wealth reflecting their artistry, but most of all the value of the materials they used. Emblematically, Saint Eloisius, their patron, was treasurer to Dagobert the Pious, who showered him with riches. However, honors and prerogatives did not exempt the French guilds—the first in Europe—from severe regulation, including the legal obligation to emboss every object with a hallmark attesting to its origin and authenticity.

# Precious Metals

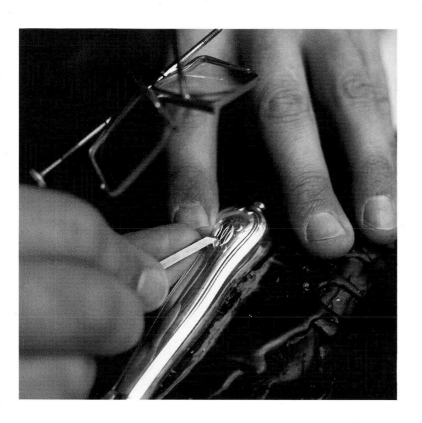

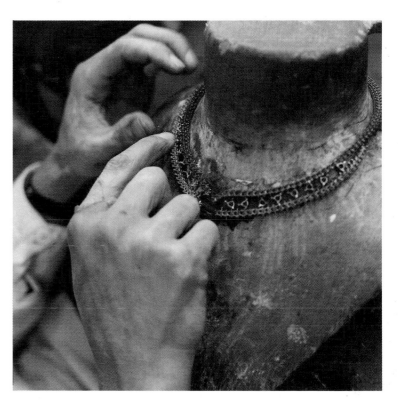

Left: *Engraving the figure on the handle of a piece of cutlery at Puiforcat.*
Right: *Setting the stones in a Boucheron necklace. The jeweler works on the places where the setter will insert the gems.*
Below: *Uncut Brazilian emeralds.*

Left-hand page:
*Polishing a Puiforcat piece in solid silver.*

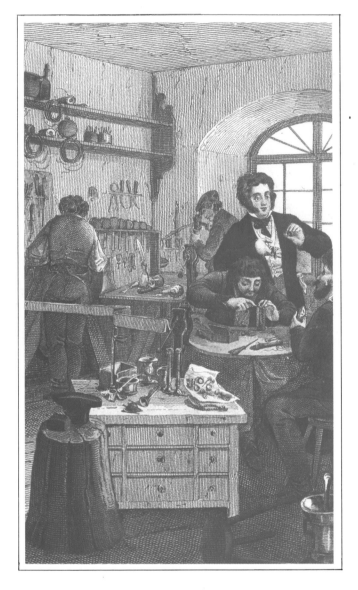

The foreground of *Louis XIV Visiting Les Gobelins* shows an array of the masterpieces produced there, including repoussé silver bowls and flagons, urns, épergnes and brackets. None of these perhaps over-elaborate works has survived, although we owe to their creators—Cousinet, Germain, Laurent de Montarsy, Leroy, Périgoux, Verbeck, and Duteil, among others—a number of models still current in modern silversmithing. The solid silver of the past has also been partially displaced in recent times by the use of plating, filling, and casing techniques so highly perfected that pieces made from metals other than gold and silver are often just as highly prized artistically.

As general living standards improved, silver became identified with a particular lifestyle, and played a leading role in the expansion of French decorative art. Prime examples of this trend were such citadels of luxury as the French Line's transatlantic ocean liners, the Orient Express trains, and the grand hotels of Paris and the Riviera. In ordinary families, outside this charmed circle, even modest pieces of gold, jewelry, and silverware came to fulfil a function similar to that of sacred amulets in African societies—that is, as tokens of their owners' fortune, good or bad, in the primary sense of the word fortune, designating "fate." Displayed on dresser, sideboard, or dining-room table, silverware symbolizes not only wealth, but also a legacy from the past and a hostage against future falls from grace. These artifacts are household icons affirming our social status, our esthetic sensibilities, and our dedication to the task of maintaining the high polish that can stud the darkest home with starlight.

Almost diametrically opposed to the art of the silversmith is that of the jeweler, since here the goal is to focus attention on the stone, and to render the setting as invisible as possible. In fine jewelry, an accomplished setting is a minimal one. Truly virtuoso gem setters modestly subordinate their own work to that of the gem cutter. Cutters, in turn, depend on those modern adventurers whose vocation is to seek gems in faraway places.

Only four types of gem are officially termed "precious": diamonds, rubies, sapphires, and emeralds. The invulnerable, translucent diamond—symbol of purity, eternity, and crystallographic perfection—today remains the most extraordinary of minerals, the legendary gem of which dreams are made. The flashing green of the emerald symbolizes power; from the Middle Ages onwards it has been identified with royalty. The ruby is a deep, pigeon's-blood red; the sapphire shines with every possible

gradation of blue. And yet, this sparkling bouquet of precious gems would have value only for commercial purposes if it did not possess the timeless capacity to stimulate extraordinary creative effort on the part of skilled artisans.

Oddly enough, the factor most crucial to the spread of the jeweler's craft was the invention of the printing press. Printing made it possible for the first time to circulate images of jewel design throughout Europe, providing jewelers in remote provinces with access to the sources of inspiration developed in the great capital cities. Meanwhile, progress in gem cutting and faceting technology enhanced the intrinsic properties of the stones themselves. In the seventeenth century, precious gems became firmly established as the essential component in fine jewelry, along with the non-spherical "baroque" pearls, which featured so prominently in Renaissance jewelry and art that the term was subsequently used to identify an entire period.

Queen Marie-Antoinette of France was extraordinarily infatuated with jewelry and precious gems, a passion she freely indulged until the affair of "The Queen's Necklace" made it a politically sensitive issue. Meanwhile, as masculine dress became more conservative, jewelry was increasingly worn almost exclusively by women, a situation that has remained unchanged from the late eighteenth century to the present day.

French jewelers reached their apogée in the twentieth century, exemplified by the renowned firms located on the Place Vendôme in Paris. Starting early in the century, a host of talented designers created novel vegetal, floral, animal, and completely abstract forms as technical progress paved the way for pioneering new methods. Colored gems were favored by the art deco movement, followed by a trend towards monochrome pieces using silver, platinum, and brilliants. The latter reflected a modernistic sensibility that rejected superstition but still recognized the symbolic nature of jewelry, replacing religious awe with romance. The idea of jewelry as a calculated financial investment to be hidden away in a safe-deposit box has also been relegated to the background today. In any case, the greatest jewelry has traditionally represented an act of love—on the part of the designer, the purchaser, and the recipient who proudly wears it. Although today jewelry is closely associated with dress and fashion, it is probable that it preceded clothing historically. Long before our naked forebears began to cover their bodies with clothes, they were already adorning them with jewelry.

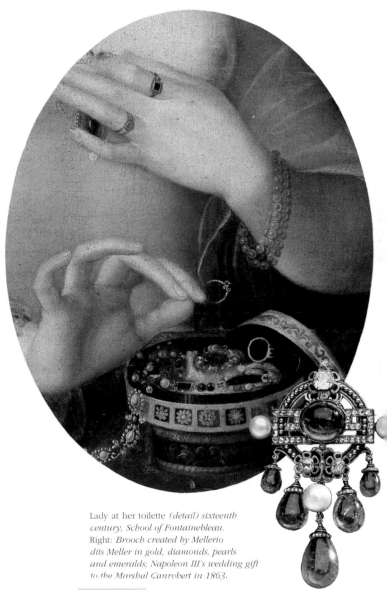

Lady at her toilette *(detail)* sixteenth century, School of Fontainebleau. Right: *Brooch created by Mellerio dits Meller in gold, diamonds, pearls and emeralds; Napoleon III's wedding gift to the Marshal Canrobert in 1863.*

Left-hand page:
*Nineteenth-century jewelry workshop. Engraving. Musée Carnavalet, Paris.*

# Files, chisels, and burins: the tools of the trade

Working with gold, silver, and precious gems is still fundamentally a craft industry. Although mechanization and even a degree of automation are now common in the field, many techniques survive that prove the primacy of hand over machine, of the skilled artisan over the robot.

As a result, regardless of the specific skill or speciality, today's silversmiths must still make most or all of the tools they use. This is true in raising, planing, engraving, and chasing workshops, where appren-

the metal "its shape, its color, its rhythm."

Artisans who do flat-chasing and embossing sometimes have to be carpenters, too, carving the wooden chucks they need for embossing new patterns that have never been tried before, and prototypes for carving the master molds that will be used in die-stamping. The chucks are carved into the desired shape from hard wood—boxwood, mahogany, walnut—and then are bored and threaded with comb and tap to fit the thread-screw of the machine.

tices carve by hand the shafts of their hammers from cornel wood, a hard, malleable material that can be tapered to fit the hand and which gives the ideal "swing" to each blow. It is also true for files and chasers, burins and rifflers, and also—more surprisingly perhaps—for some of the lathe components perfected in the nineteenth century that have replaced raising and planing in the mechanized world of the factory.

The "working end" of the pencil-sized chasing tool is a metal bit shaped to imprint a specific pattern in the metal. There are as many different types of chasers as there are designs—grained, striped, cross-hatched, blunt, pointed—for giving

Jewelers use files, hammers, and pliers, and often make the most frequently used ones themselves, "to fit their own hand." They may also use metal formers shaped specifically for imprinting a given pattern on to a gold bar held on a lead slab, as well as rifflers, scrapers, and drills and cutters, the smallest of which are only a fraction of an inch across.

## THE SILVERSMITH

### Taming the metal

"It takes instinct and intuition to raise a piece of metal by hand," explains Christofle's Patrick Peterffy. "You have to have a feel for the metal, an ear for the sound of the hammer as it falls, a caressing touch for easing out the curves until you sense the shape is rising and begin to see the metal turning frosty, almost transparent . . . " Silversmith Peterffy has been with Christofle a total of twenty-seven years, and yet he still experiences the same physical pleasure—an almost sensual thrill—when he bends the precious metal to his will and transforms it into a unique art object.

These finely-wrought silver pieces owe their appeal to two factors: the traditional skills of silversmithing, which go back to ancient times; and the way these objects forcefully project the proud and vital spirit of artisans who have succeeded in forcing flat metal discs to obey them, and to assume the desired shapes. This sometimes requires a degree of violence—as Patrick Peterffy puts it, when describing his first year of apprenticeship at the age of fifteen: "I had to learn how to get tough with the metal."

Precious metals such as gold and silver, and alloys such as nickel and brass, all tend to harden under the hammer. When the metal begins to lose its malleability, the craftsman applies a blowtorch to it until it turns cherry red (a process known as "annealing"), cools it, and then takes up his hammer and resumes work on the metal.

With any metal, the artisan always begins by testing its qualities, flaws, strengths, and weaknesses. However, no one can tell in advance who the winner of this battle will be, man or material. "Sometimes," admits Peterffy, "for some unknown reason, the piece just cannot be raised properly." The skills, knowledge, formal and informal training of the artisan combine in what is ultimately an almost alchemical encounter between human reactions and the vital properties of the metal itself.

### Craft and form

RAISING • The core of the silversmith's craft consists in giving form to the unformed. The metal always starts out as a sheet, a flat surface that successive blows of the hammer will shape,

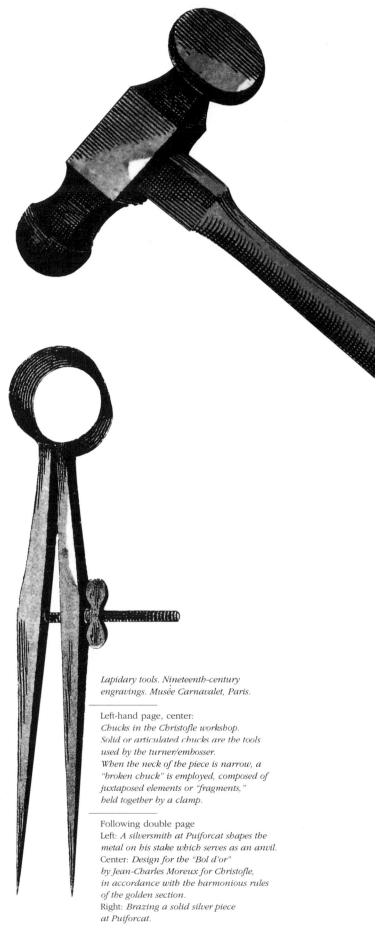

*Lapidary tools. Nineteenth-century engravings. Musée Carnavalet, Paris.*

Left-hand page, center:
*Chucks in the Christofle workshop. Solid or articulated chucks are the tools used by the turner/embosser. When the neck of the piece is narrow, a "broken chuck" is employed, composed of juxtaposed elements or "fragments," held together by a clamp.*

Following double page
Left: *A silversmith at Puiforcat shapes the metal on his stake which serves as an anvil.*
Center: *Design for the "Bol d'or" by Jean-Charles Moreux for Christofle, in accordance with the harmonious rules of the golden section.*
Right: *Brazing a solid silver piece at Puiforcat.*

round, and raise from two dimensions to three. If the final object is to be hollow—goblet, coffee urn, teapot, soup tureen—a paper, cardboard, or metal pattern of the base is placed on the flat sheet and outlined with the hammer. The metal sheet is then placed against a stake and hammered progressively upwards and inwards.

"Silversmiths start with the base," explains Jacques Villette, head of the raising workshop at Christofle. "They trace the pattern on to the sheet metal and then raise the piece with a wooden hammer."

ANNEALING • The sheet metal is turned on a stake and hammered from the base upwards until the entire surface has been worked. Turning continues for hours, since "if turning is done properly, it takes a long time to achieve the finished shape." When the metal becomes too hard to work, it is heated, or annealed, to restore its malleability. After annealing it is rinsed and cooled, and then the turning begins again. When the piece finally "fits the pattern," planing begins.

PLANING • Silversmiths use the word "caress" to describe the process of planing a raised piece. The hammers used at this stage are covered with a parchment-lined steel plate to soften their impact. The goal is to eliminate all traces of the initial hammering by pushing the impact marks towards the invisible surface of the piece—the underside of a platter or interior of a hollow receptacle—until the outer surface is completely smooth. Silversmiths refer to this as "easing," and the marks it leaves on the non-visible surface of the piece are proof that the fine hand of a genuine craftsman has been at work. "Here they are," approves Jacques Villette as he runs his finger over the tiny irregularities. "These are what make a hand-raised piece so valuable."

SHAPING • Whereas raising is used for forming hollow pieces, shaping is used for hand-crafted dishes, platters, trays, and plates—everything silversmiths commonly refer to as flatware. In this process, the sheet metal is hammered on an anvil to produce the rims and borders, textures, and depths which impart drama and harmony to the piece. The smith uses a mold clamped to the metal for imprinting the desired shape, and special hammers to pound it out. In one particular shop, the silversmith sits before his anvil, moving the sheet metal continuously back and forth as he brings his hammer down again and again. Dressed in his long white smock, this man might have walked

*Demi coupe avec listel* **M** *Demi coupe sans listel*

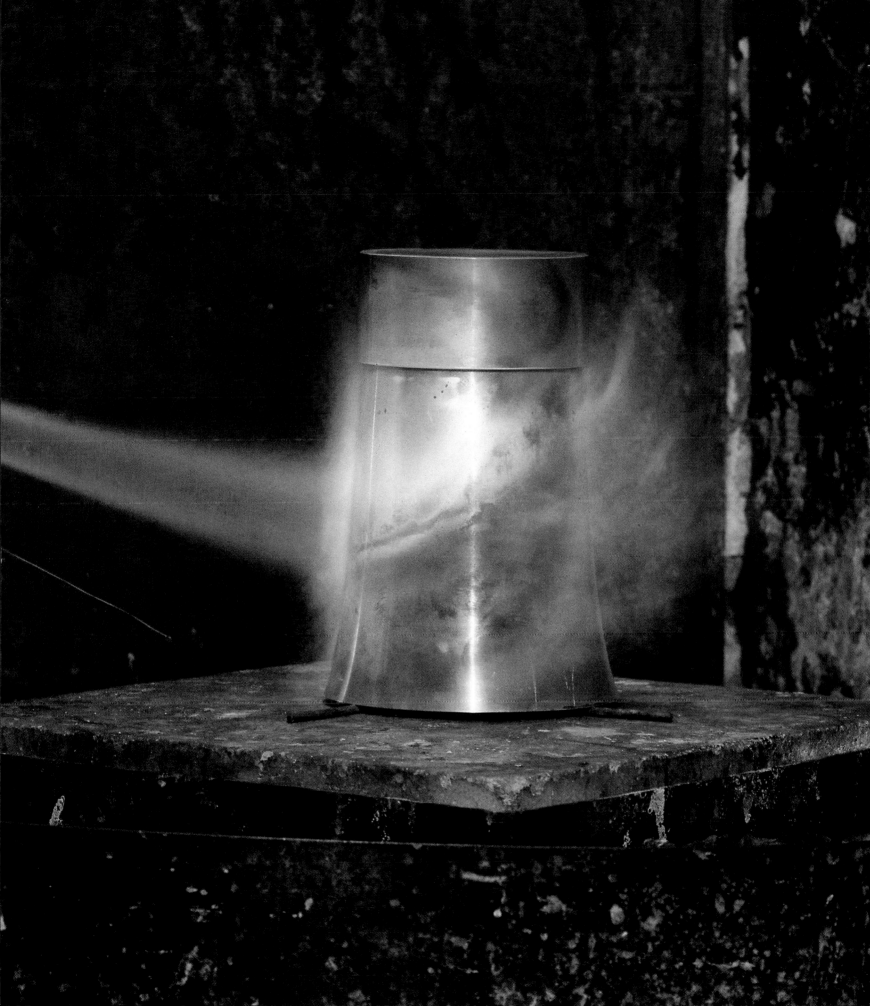

straight out of an engraving on the wall behind him showing the same shop over one hundred years ago.

There is no annealing in this process, since heat would soften the painstakingly achieved curves and details. "No heat this time," explains Jacques Villette. "We just have to do the best we can, even if the metal gets too hard." The shaping hammer does not caress the metal, but pounds, bends, and sometimes even breaks it.

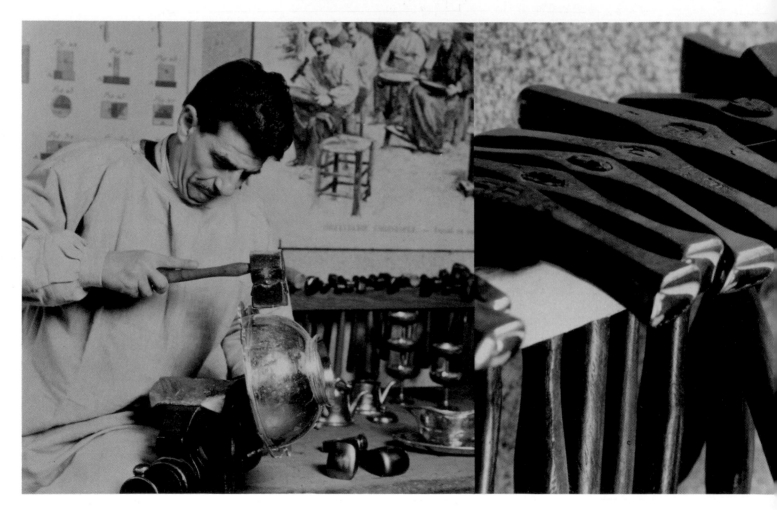

THE STAKES • During raising, hollow pieces are turned on stakes that imprint the desired form from the inside. The vast array of stakes they contain gives raising workshops a unique charm. Here, over two hundred of them are carefully hung from racks—a mysterious collection of tools whose functions are not immediately apparent to the visitor. Stakes vary dramatically in shape and size, from the minuscule, used for demitasse spoons, for example, to the huge, used to make monumental center-pieces.

PINKING • One of the final steps in the production of certain pieces is known as pinking or, in some houses, crimping. This ancient technique was revived to produce the new, angular shapes demanded by the art nouveau designers of the twenties and thirties. In pinking, the silversmith cuts a beveled slice from the metal, which he then folds over to make an angle. This method is akin to engraving, in that it involves removing a portion of the metal. It is also similar to raising, since it is the first

mark the craftsman makes on the virgin metal.

The techniques of raising, planing, and pinking are used only for noble metals such as the sterling silver in which Puiforcat and the Christofle and Ercuis workshops specialize. The mid nineteenth-century invention of electroplating made it possible to manufacture tableware and flatware from brass or nickel alloys covered with a thin layer of silver. This new technology democratized the market and opened the way for mechanization and mass production.

*Planing at Puiforcat. The object of planing is to eliminate all traces of the initial hammering until the surface is perfectly smooth. This is not achieved by obliteration, but by pushing the impact marks towards the invisible surface of the piece.*
Center: *Silversmiths' hammers in the Christofle workshops.*
Left: *Planing at Christofle.*

*Christofle's first silver workshop,*
*rue de Bondy, c. 1845.*
Top: *Case of silversmith's tools.*

Right-hand page:
*The repoussage process at Puiforcat.*
*The silversmith stands in front of*
*an electrically powered horizontal lathe,*
*and using a metal-ended lever, revolves the*
*flat silver disc against a wooden form*
*(the chuck) until the desired shape is*
*achieved.*

## From hand to machine

SPINNING • Spinning is the name given to mechanized raising. The worker stands in front of an electrically-powered horizontal lathe and, somewhat like a potter turning a potter's wheel, revolves the flat silver disc against a wooden form (the chuck) until the desired shape is achieved—a goblet, champagne bucket, coffee-urn, or teapot. Oval, oblong, and elliptical platter shapes can also be produced by moving the axis of the lathe slightly off center.

A metal-ended lever is used to move the metal over the chuck. It takes a little time before this operation starts running smoothly, and great skill is required to keep the pressure constant throughout. If the pressure is irregular, the finished piece will fall short of perfection. Silversmiths know this, and when a piece emerges from the spinning process, they invariably tap it all over to make sure there are no weaknesses or irregularities due to uneven pressure.

## Tableware: die-stamping

Today, tableware is usually mass-produced. However, even for this modern process, the first step—cutting the die for the mechanical stamping—is rooted in a bygone era. At the Ercuis factory, one entire workshop is reserved solely for die-stamp engraving. Michel Onclercq heads this workshop, in which heat and noise dominate. Wresting a pattern out of unyielding steel is a feat one might associate with the forges of Hades except that here, as so often in silversmithing, absolute precision is crucial.

THE DIE • "Each die is unique," comments the die-cutter, as he lays the design for a piece of tableware beside the steel die that has just been "sculpted" from it. No other word seems to fit a process that consists in outlining the pattern on the steel, and then hollowing it out exactly as specified by the designer.

"We carve directly into the steel," continues the cutter, indicating the slab of steel on which a fork has been outlined using a stylus and compass. A burin is then used to hollow out the design, which must be executed to within an error-tolerance of one millimeter or less.

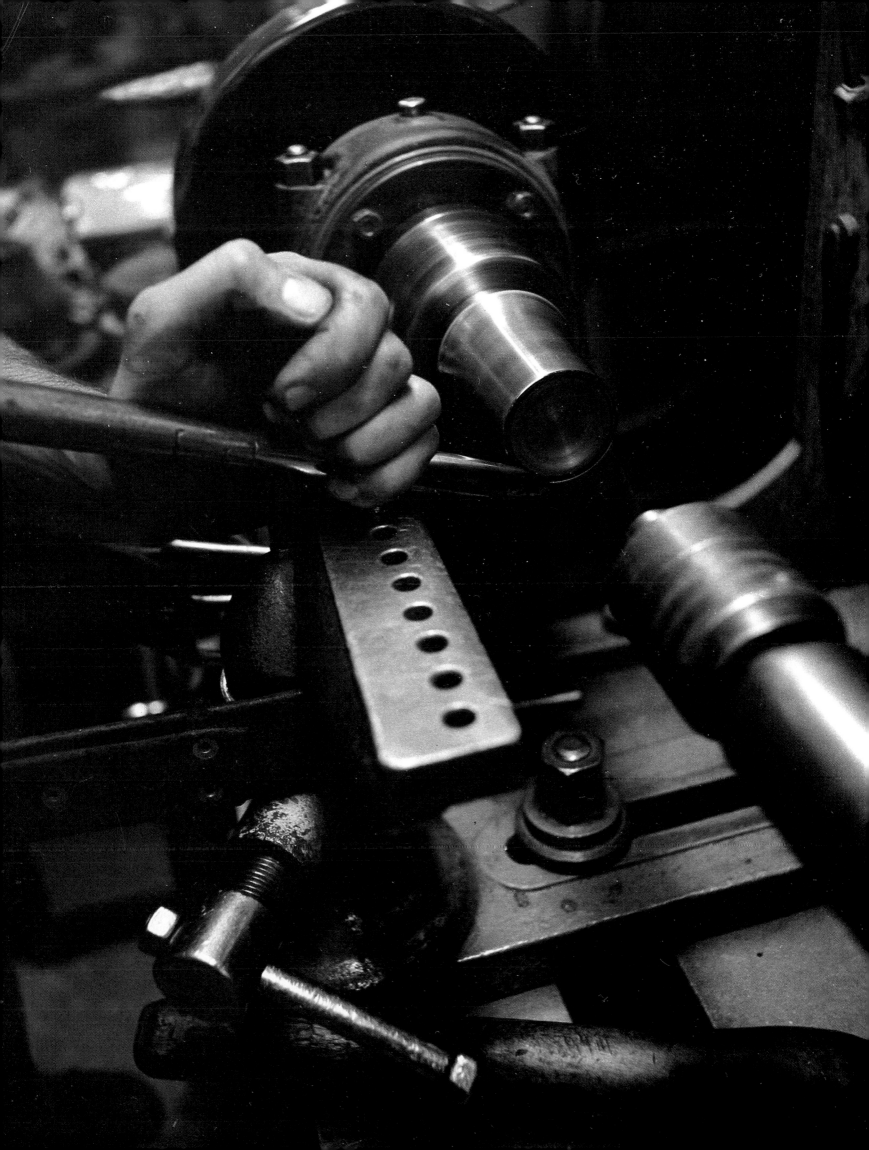

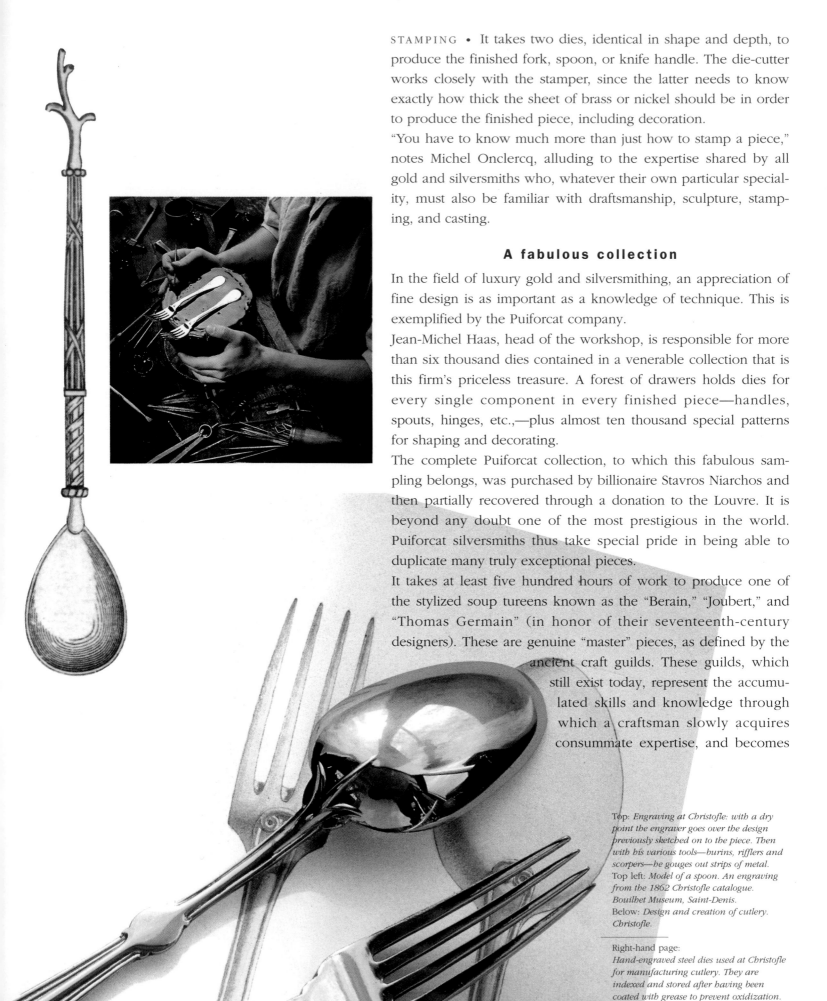

STAMPING • It takes two dies, identical in shape and depth, to produce the finished fork, spoon, or knife handle. The die-cutter works closely with the stamper, since the latter needs to know exactly how thick the sheet of brass or nickel should be in order to produce the finished piece, including decoration.

"You have to know much more than just how to stamp a piece," notes Michel Onclercq, alluding to the expertise shared by all gold and silversmiths who, whatever their own particular speciality, must also be familiar with draftsmanship, sculpture, stamping, and casting.

## A fabulous collection

In the field of luxury gold and silversmithing, an appreciation of fine design is as important as a knowledge of technique. This is exemplified by the Puiforcat company.

Jean-Michel Haas, head of the workshop, is responsible for more than six thousand dies contained in a venerable collection that is this firm's priceless treasure. A forest of drawers holds dies for every single component in every finished piece—handles, spouts, hinges, etc.,—plus almost ten thousand special patterns for shaping and decorating.

The complete Puiforcat collection, to which this fabulous sampling belongs, was purchased by billionaire Stavros Niarchos and then partially recovered through a donation to the Louvre. It is beyond any doubt one of the most prestigious in the world. Puiforcat silversmiths thus take special pride in being able to duplicate many truly exceptional pieces.

It takes at least five hundred hours of work to produce one of the stylized soup tureens known as the "Berain," "Joubert," and "Thomas Germain" (in honor of their seventeenth-century designers). These are genuine "master" pieces, as defined by the ancient craft guilds. These guilds, which still exist today, represent the accumulated skills and knowledge through which a craftsman slowly acquires consummate expertise, and becomes

*Top: Engraving at Christofle: with a dry point the engraver goes over the design previously sketched on to the piece. Then with his various tools—burins, rifflers and scorpers—he gouges out strips of metal.*
*Top left: Model of a spoon. An engraving from the 1862 Christofle catalogue. Bouilhet Museum, Saint-Denis.*
*Below: Design and creation of cutlery. Christofle.*

*Right-hand page:*
*Hand-engraved steel dies used at Christofle for manufacturing cutlery. They are indexed and stored after having been coated with grease to prevent oxidization.*

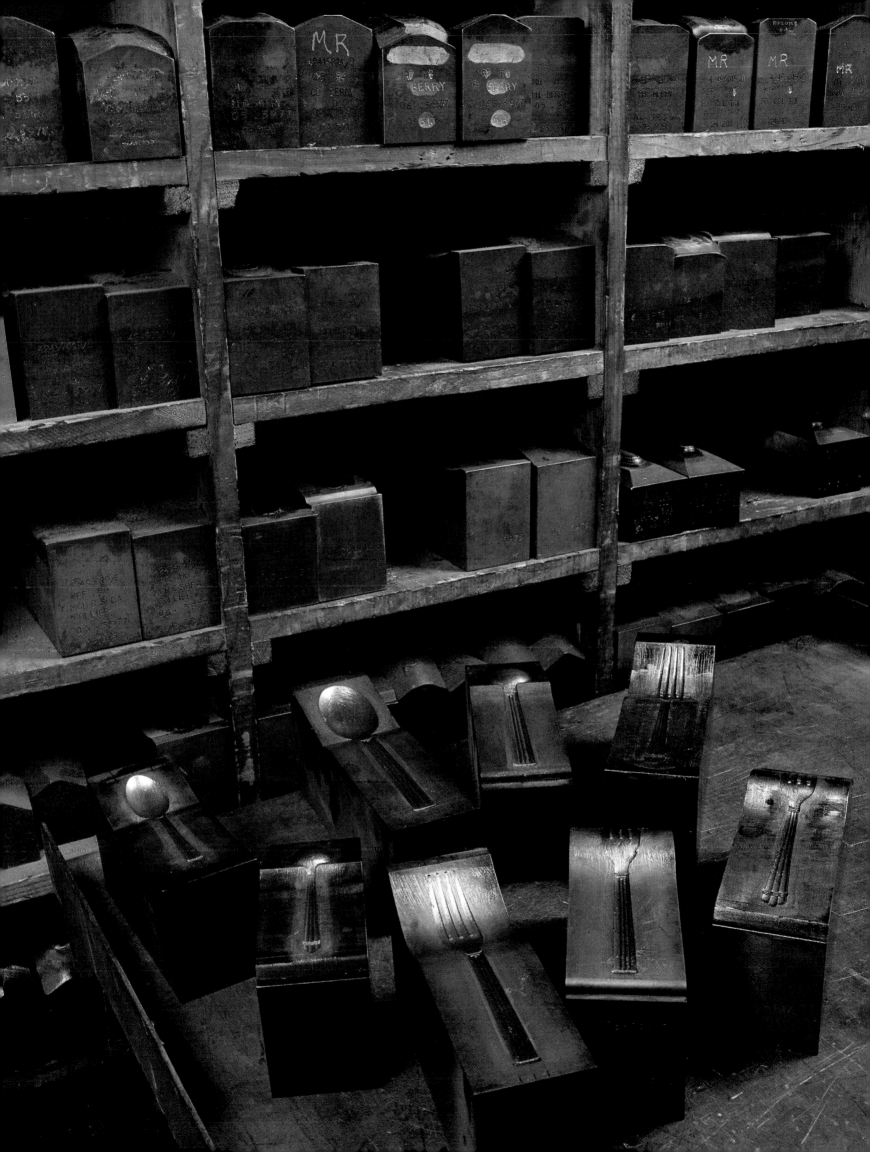

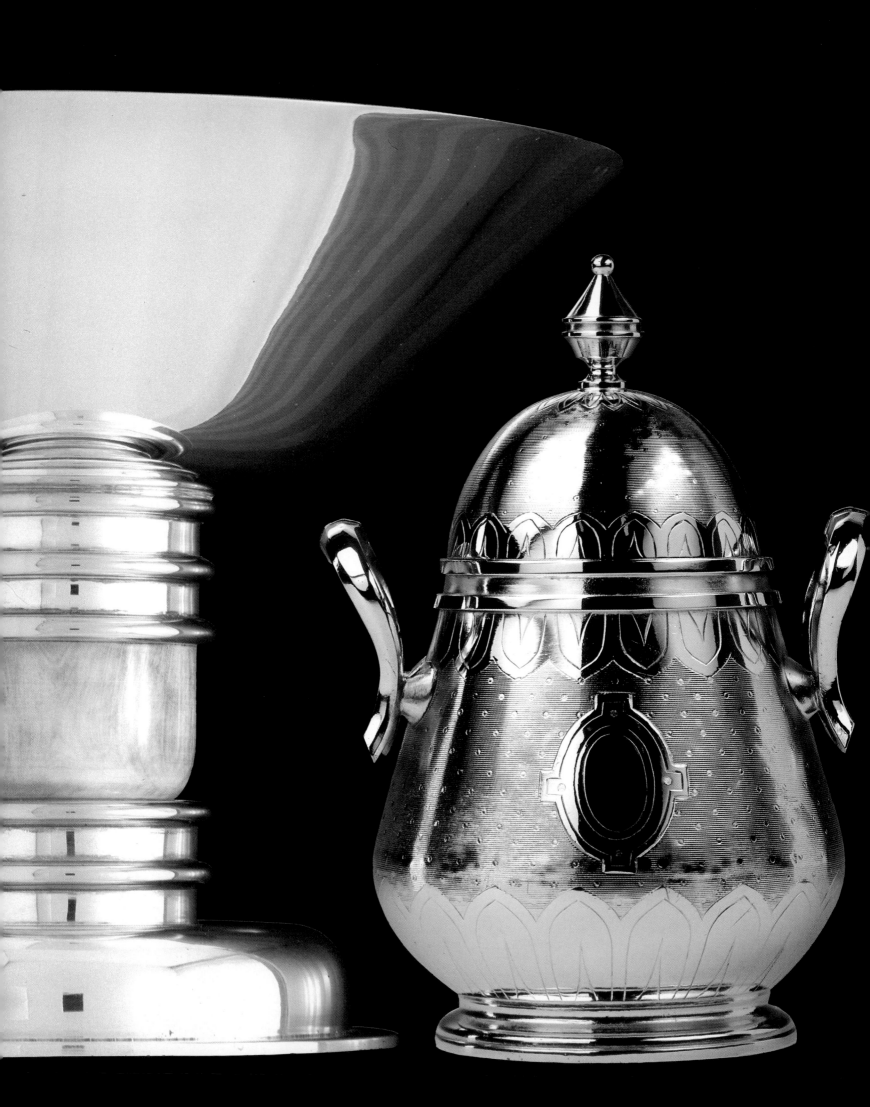

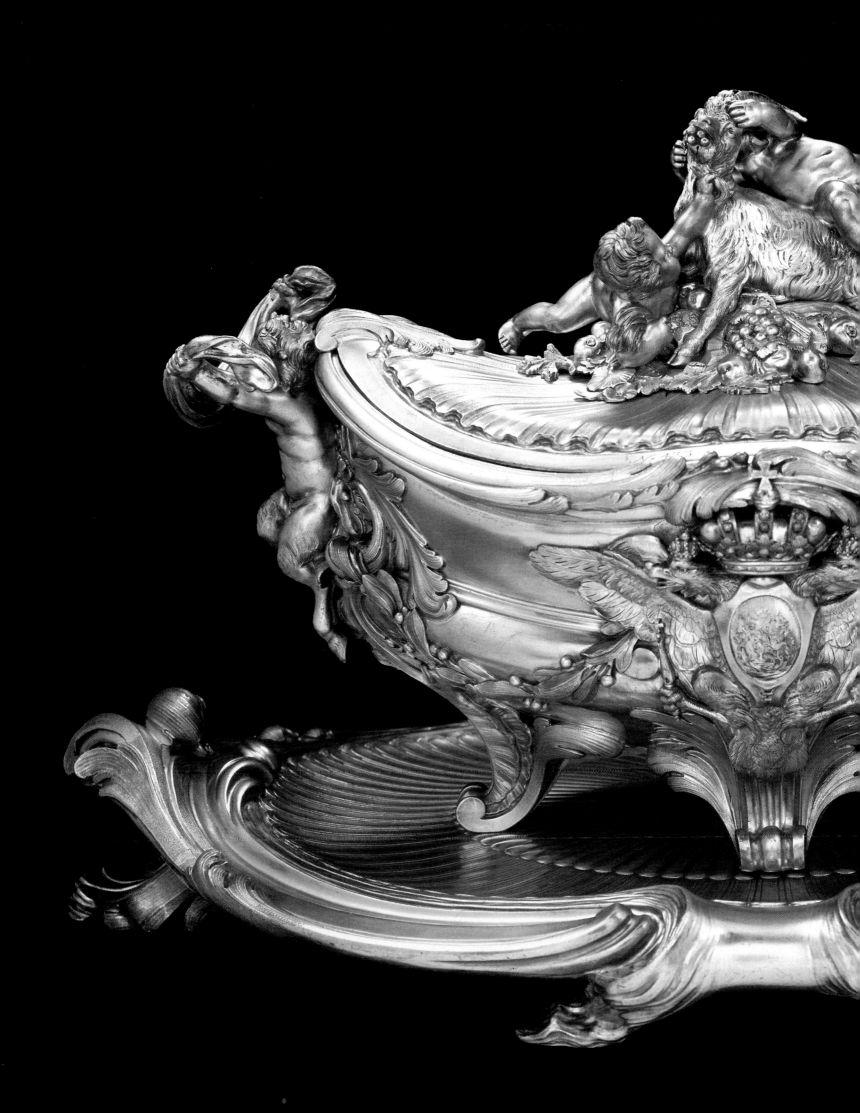

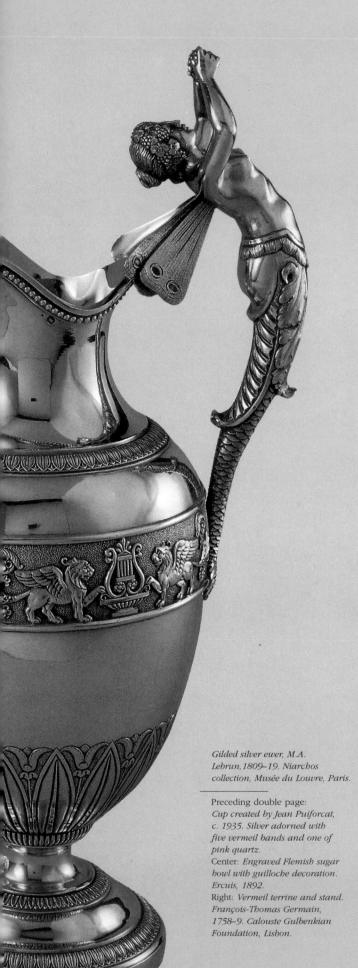

a master of his art. Orders for rare sterling silver pieces such as these are uncommon today, but each master silversmith must make at least one, "if only to keep it in stock," explains Jean-Michel Haas. The firm's latest "Joubert" stands nearby, and Haas proudly displays the imposing, as yet unpolished piece of silverware which weighs over twenty-two pounds.

This "Joubert" was raised by the new head of the planing workshop, Eric Popineau, who started his career as a boiler maker, but switched to silversmithing out of respect for family tradition. Although his silversmith's apprenticeship lasted ten years, Popineau appears never to have lost a certain rough-hewn quality common to his original trade and to this impressive but unpolished silver piece. As required by tradition, the piece has stood for half a day on Popineau's workbench before being consigned to the strong room. Popineau explains this tradition: "In a way, the pieces we make really belong more to us than to the customer. We keep them beside us for a while so we can have a little time to appreciate them." He points to the pedestal on which the tureen rests and, with the gesture of a true connoisseur, turns it to best advantage, adding, "Doesn't it remind you of a rose in full bloom?"

## Decoration

Although the workshop of a silversmith who produces hollow or flatware may be reminiscent of a sculptor's studio, the workshop of the engraver, chaser, or embosser who decorates these pieces has nothing in common with an artist's studio, even though his art is similar. The decorator transfers designs on to metal, just as artists transfer them on to paper and canvas.

Today, decorators are usually not regular employees of the great silversmiths. This is because the demand for the services of these peerless craftsmen is not limited to the decoration of tableware and flatware. They also work with master bronze casters, designing chandeliers, sculptures, and *objets d'art*; with cabinet makers, restoring bronze ornamentation on antique furniture; with the Paris Mint; and also, of course, with jewelers.

Jean Guénot's workshop occupies an old town house in the Marais district of historic Paris that today, as in the past, is filled with traditional artisans. Guénot's shop, run by his uncle and grandfather before him, has been in continuous operation since the end of the nineteenth century. From his table near a corner

*Gilded silver ewer, M.A. Lebrun, 1809–19. Niarchos collection, Musée du Louvre, Paris.*

Preceding double page: *Cup created by Jean Puiforcat, c. 1935. Silver adorned with five vermeil bands and one of pink quartz.*
Center: *Engraved Flemish sugar bowl with guilloche decoration. Ercuis, 1892.*
Right: *Vermeil terrine and stand. François-Thomas Germain, 1758–9. Calouste Gulbenkian Foundation, Lisbon.*

window overlooking the roofs of Paris, Guénot can see into the room beyond, which is swathed in black and contains a smoldering forge. The guiding maxim of Guénot's art is, he says: "The task determines the tool." By this he means that every embellishment, every special effect, and every style requires a specific tool; and that, if it is not already part of the impressive collection crafted by Guénot himself or inherited from his forebears, it must be created from scratch.

ENGRAVING AND CHASING • There are two methods for decorating metal: engraving and chasing. In engraving, the design is produced by using a burin to gouge strips of metal out of the surface to be decorated. In chasing, a hammer and punch, or chaser (a pencil-sized steel or iron tool) are used to raise the design. Chasing is further sub-divided into two types, flat-chasing and embossing or repoussé. Flat-chasing resembles engraving,

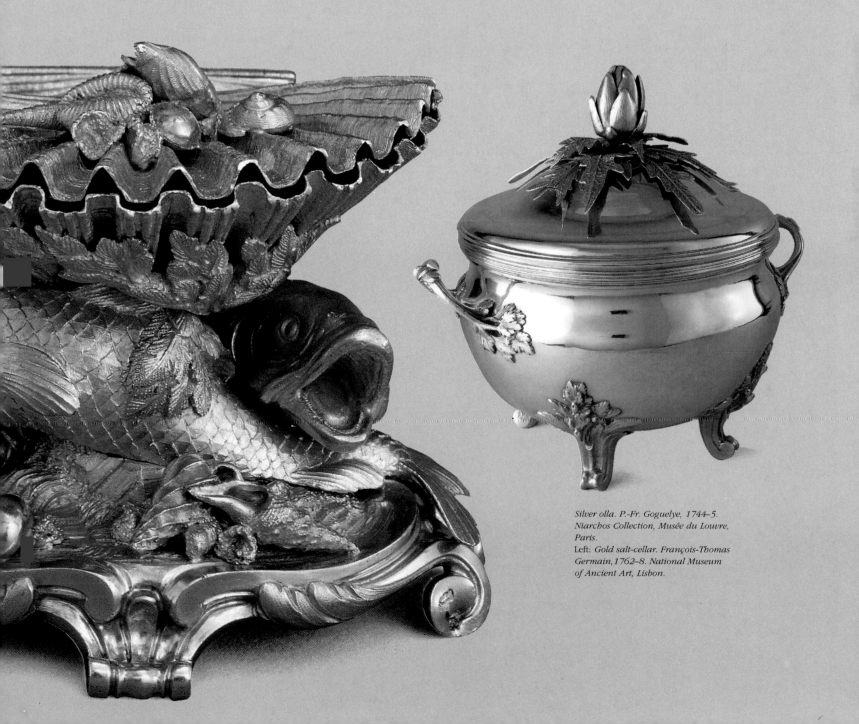

*Silver olla. P.-Fr. Goguelye, 1744–5. Niarchos Collection, Musée du Louvre, Paris.*
*Left: Gold salt-cellar. François-Thomas Germain, 1762–8. National Museum of Ancient Art, Lisbon.*

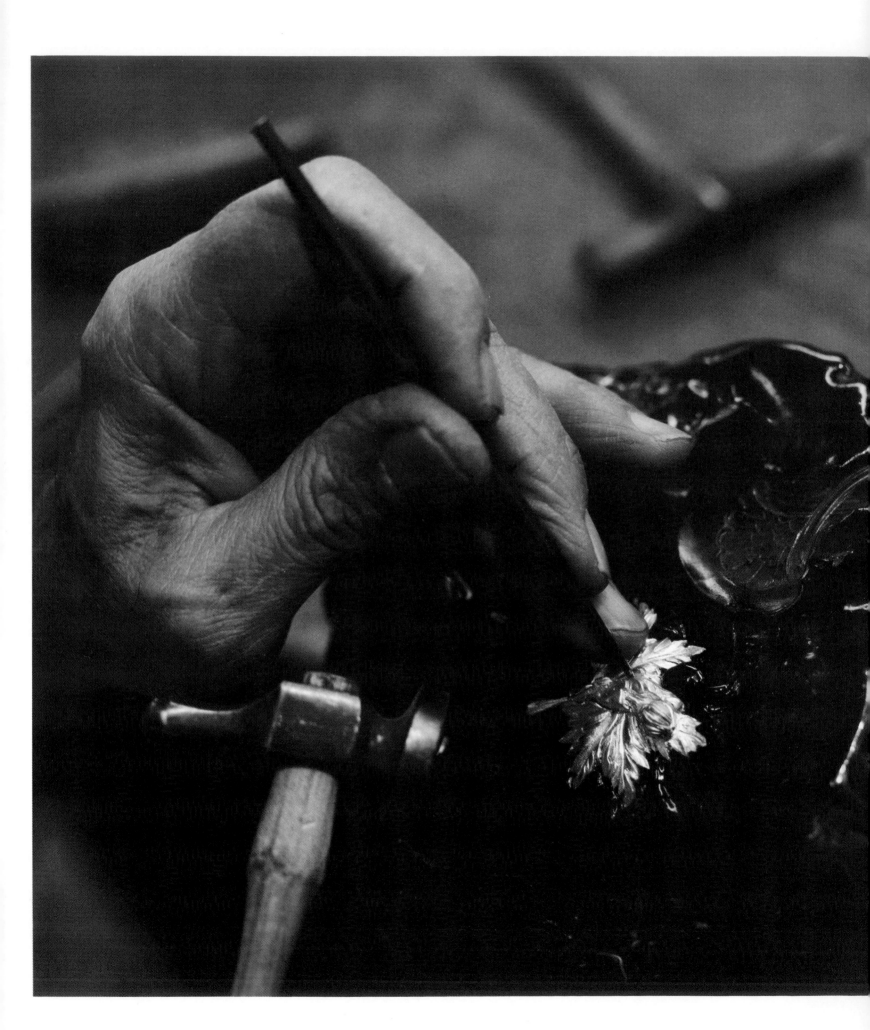

except that in chasing, the metal is compressed to produce the lines, rather than being gouged out.

The technique of repoussé is somewhat similar to the more delicate maneuvers of raising. The design is raised from the rear using hammer and chasers, and then their concavities are worked back from the front. For hollow pieces, the object to be decorated is fixed in a vise and a bent chaser introduced into its interior. For producing curves and rounded effects, hollow metal molds are used for hammering the piece into the desired shape, called the shell technique.

Chasing reveals the secrets of the decorator's work. Here, the design is given shading and the appearance of relief without any metal being removed; instead, the chasing tools compress the metal, leaving the surface as smooth and unbroken as it was before the decoration was applied.

This is the apogee of the silversmith's art. The artisan does not force the metal but works with it, gradually encouraging it to yield and assume a shape. Chasing raises the price of the most precious metals—gold and silver—to heights far surpassing their purely economic value. This increase in value reflects the artist's ability to endow cold metal with vibrant life.

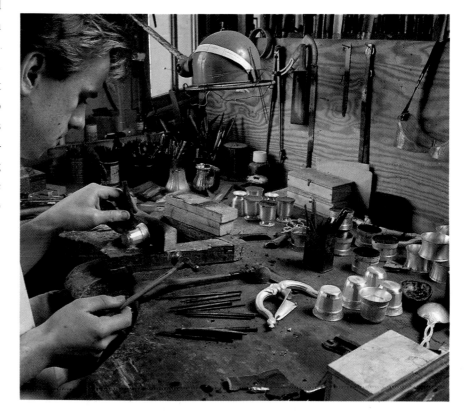

Above and left-hand page: *Chasing work at Puiforcat on various elements prior to mounting: handles, spouts and prongs are subsequently assembled by soldering or brazing.*

Following double page
Below: *Polishing a sunflower frame in the Charles workshop.*
Right-hand page: *Reproduction by Delisle of a Louis XVI style sconce from the Comte d'Artois collection.*

### Lighting sculptures

*Of all the metal crafts, founding and casting come closest to the art of the sculptor. Bronze chandeliers are unique objects, designed for visual effect more than practical function. They are decorative rather than utilitarian, and some especially fine*

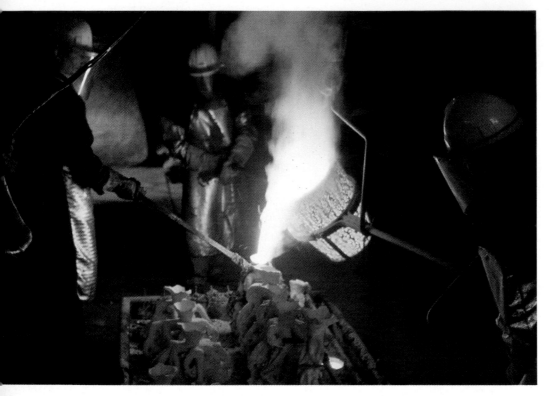

*ones approach the status of works of art. Chrystiane Charles calls them "lighting sculptures" and, in fact, their design and manufacture share many similarities with sculpture. Not only that, but the artisans who make them use the same suppliers and the same techniques as sculptors do, often in an attempt to produce the same effects.*

*As with sculpture, the creative process involved in producing a bronze chandelier begins with a model based on the original design, usually made of plaster, wood, or plastilin. Didier Landowski describes how a caster of art pieces—"the sculptor's third hand"—makes his mold from a model supplied by the artist. Landowski heads a foundry that has served the most famous artists of*

*recent times, including César, Étienne Martin, Ipousteguy, Jeanclos, and Igor Ustinov.*

*The most spectacular moment of the entire process comes when the caster pours the molten metal into the mold. With help from his two assistants, he tips a red hot cauldron and pours out the metal—a blindingly white liquid blend of copper, tin, and zinc (the white color comes from the zinc)—into the casks or boxes containing the molds. The process is then repeated as many times as there are molds to fill.*

### Sand casting

*Until the eighteenth century, sand casting was the only known technique for producing bronze pieces. It is still used for medallions and ornamental pieces requiring great precision.*

*In sand casting, a mold is made by pressing the prototype directly into compacted sand (which today also includes a resin and a catalyst) contained in a metal molding box. This produces an imprint or "negative" of the object to be reproduced.*

*In some cases, when a solid casting would be excessively heavy and massive, a pared-down duplicate of the model—also made of sand—is placed inside the first mold. This creates a space measuring some five millimeters between the imprint of the original and the smaller duplicate. This space will be filled with the molten metal, to produce a hollow piece. In modern practice, the original negative is lined with some combustible material such as cardboard or polystyrene—representing the 'metal skin'—during preparation of the smaller duplicate.*

*When the mold has been prepared, a number of conduits and vents are cut through the sand around the imprint. Feeder jets attached to an overhead funnel will pour the metal into the conduits leading to the mold, as air and other gasses escape through the vents, thus avoiding the danger of an explosion. Everything is now ready: the molding box is closed and the molten metal starts to flow.*

### Lost-wax casting

*Lost-wax casting is an ancient technique that returned to favor at the end of the eighteenth century because of its precision. For this process, a full-sized wax model of the piece to be cast is made. If the final piece is to be solid, the model is solid; if it will be hollow, the model will be filled with plaster or, more frequently, elastomer. It is then fitted with wax sprues, or pouring and ventilation holes, and completely covered (invested) with clay or other*

suitable material. It is then heated to a temperature of six hundred degrees or more. The wax melts and is "lost," leaving a hardened outer shell. This is the mold into which the molten metal will be poured.

### Finishing

After the metal casts have cooled and hardened, they are extracted from their molds and finished. The sprues, or channels and vents through which the metal flowed in and the air flowed out, are removed, and imperfections are smoothed with rifflers and files. The decorator, relying on his skill and knowledge of style, then compares the piece to the original design and adds the engraved, flat-chased, or repoussé detailing. The final touch for a chandelier is to affix the supports from which it will be hung.

### "A living metal"

"Bronze is a living metal," says Chrystiane Charles enthusiastically. "Its color changes depending on the elements it is exposed to. In a city like Paris, bronze statues placed outdoors turn black. In the country or by the seaside, they acquire a greenish patina."

Because bronze easily develops these different patinas, it can be given an "inherent" color from the start by bathing it in acid and then applying oxides of one kind or another with a blowtorch. Cupric oxide gives a fine green color, iron oxide a reddish-brown antique-coin effect, and sulfate of ammonium oxide a black surface. Foundries and bronze casters all have their own formulas, preparations, and secrets for coloring bronze.

Bronze can also be gilded or electroplated with chrome, nickel, or silver. All of these methods for giving a special finish to bronze result in the smooth, luxurious surface that makes bronze the recognized equal of gold and silver as a precious metal.

*Design for a Delisle chandelier*
*Fulfilling a commission from a luxury hotel for a wrought-iron chandelier, measuring over eleven feet high and six feet in diameter, and entirely covered in patinated gold leaf, presents a major challenge.*
*Based on an eighteenth-century model, the design for this lighting fixture had to be adapted for hanging in a vast lobby, and the resulting problems of weight were solved by reducing the number of crystal droplets. The finished chandelier weighs almost five hundred and seventy-five pounds.*

of the gems and settings sold, transformed, set and re-set over the years, some of which have since disappeared without a trace.

"PIGEON'S BLOOD" RUBIES AND "JONQUIL" DIAMONDS • Boucheron, Cartier, Chaumet, Mauboussin, Mellerio dits Meller, and Van Cleef & Arpels have indeed retained their titles as the indisputable monarchs of international jewelry. They have done so primarily by being able to draw on a pool of skilled craftsmen that for centuries has purveyed gems to the royal houses of

Europe, and which has managed, despite the vicissitudes of history, to confirm Paris in its role as the jewelry capital of the world—an international center for the finest gems: Kashmiri sapphires, Burmese rubies, Colombian emeralds, and the fabulous diamonds colored jonquil yellow, pink, and blue.

Jewelry from Paris epitomizes the brilliance of gems which are drawn from the greatest sources world-wide, and then enhanced by delicately artistic settings. At Mauboussin, as many as eight hundred diamonds can be found on a single necklace along with some one hundred colored gems, all carefully selected by the company's resident expert. Selection criteria include not only the purity and clarity of each gem, but also their combined effect on the necklace as a whole.

THE DESIGN: SKETCHES, GOUACHES, AND WATERCOLORS • The jeweler's goal is to underscore the effect of the gems by placing them in settings so discreet they seem to be floating on air, invisibly supported. Thus jewelers produce only prototypes, since each piece is by definition unique in terms of the number, value, and placement of the gems it contains.

This is why design is so important. Some pieces may require over five hundred meticulously executed sketches, gouaches, and watercolors. Based on existing gems owned by the firm or supplied by the customer, the "ideal" design is created, which will serve as the model for determining the composition, texture, and volume of the setting, and as a guide for creating the final piece. Some models are even presented set with real gems, so the ultimate effect can be judged with greater accuracy.

CRAFTING THE SETTING • The jeweler's real work begins after the design for the piece has received final approval. This is the stage when the almost invisible setting in which the gems will be placed is shaped and finished, articulated for flexibility, prepared to receive the gems, ornamented with beaten gold wire, and fitted with the "system" that will actually hold the gem. Since every gem is unique, each of these steps requires a specific technique.

The metals most commonly used for fine jewelry are the two with the most exceptional properties, platinum and gold. Gold is so malleable that one gram can be stretched to a length of two and a half miles; it can also be heated with a blowtorch and steeped in alcohol to be softened, turned, shaped, modeled, laminated, or twisted. The jeweler has a large array of tools at his disposal to help him in manipulating gold, both in the form of

*Mauboussin jewelry: The sketches are enhanced in gouache in order to be more realistic and facilitate the tasks in the workshop. The gems are chosen to suit the design, unless the gem is supplied by the client, in which case the procedure is reversed.*

Left-hand page, top to bottom
*Uncut diamonds; diamond cutting; gold ingots.*

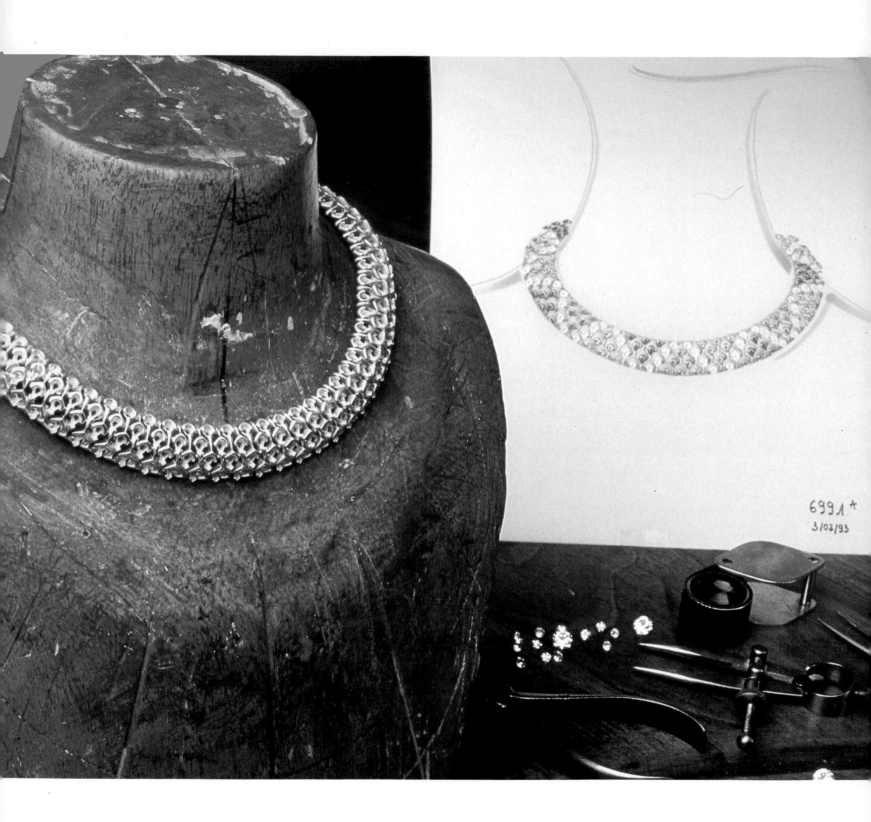

6991*
3/02/93

bars and round or flat wires. He uses them according to his own inclination, since there are no rules to guide him apart from personal taste and experience.

THE ARTICULATED SETTING • Once the design has been executed, the next step, for large pieces such as necklaces, chokers, and bracelets, for example, is articulating it. The body of the piece is severed at pre-selected points, and these are then hinged in order to make the piece flexible and supple. "The more separations there are, the easier it will be to wear," explains Van Cleef & Arpels master jeweler Pierre Waill, as he runs an undulating bracelet through his fingers.

Each setting requires its own special articulation, designed on the basis of the piece's volume and rigidity, and the types of gems it contains. The most common method for articulating a bracelet, for example, is to string the separate components on golden wires that hold them together. Another method is to use spring-snaps. In any case, Waill explains, "almost every new design will require a new type of articulation. The important thing is that the separation between each component remains invisible, and that the settings appear absolutely seamless to the eye."

SETTING THE STONE • The jeweler now proceeds to prepare the setting itself, using tiny drills and cutters to shape the places where the precious gems will be inserted. Here again, a major goal is to make the metal itself almost invisible.

The best jewelers add an extra touch of ultimate refinement when setting a stone. This is called "letting in the light" and involves allowing the full potential of the gem to appear. To see how this is done, the finished piece should be turned over, and then it will be seen that the underside of the setting is as subtly worked as the top. The jeweler's technique involves opening the inside rim of the hole in which the gem will rest, and carving a lattice-work, usually honeycomb in shape. This technique lights up the gem "from the inside."

The last step before inserting the stone is rimming, one of the most traditional of jewelry techniques. The piece is rimmed with gold wire to hold the stone. The rim can be open, with the wire attached at regular intervals with tiny studs, or it can be closed, with the rim attached all the way around the piece.

INSERTING THE STONE • The penultimate major step involved in creating a piece of jewelry is the positioning of the gemstones. This is the only time when the jeweler, or setter, handles the gems themselves. The setter's task is to fit and adjust the gem so

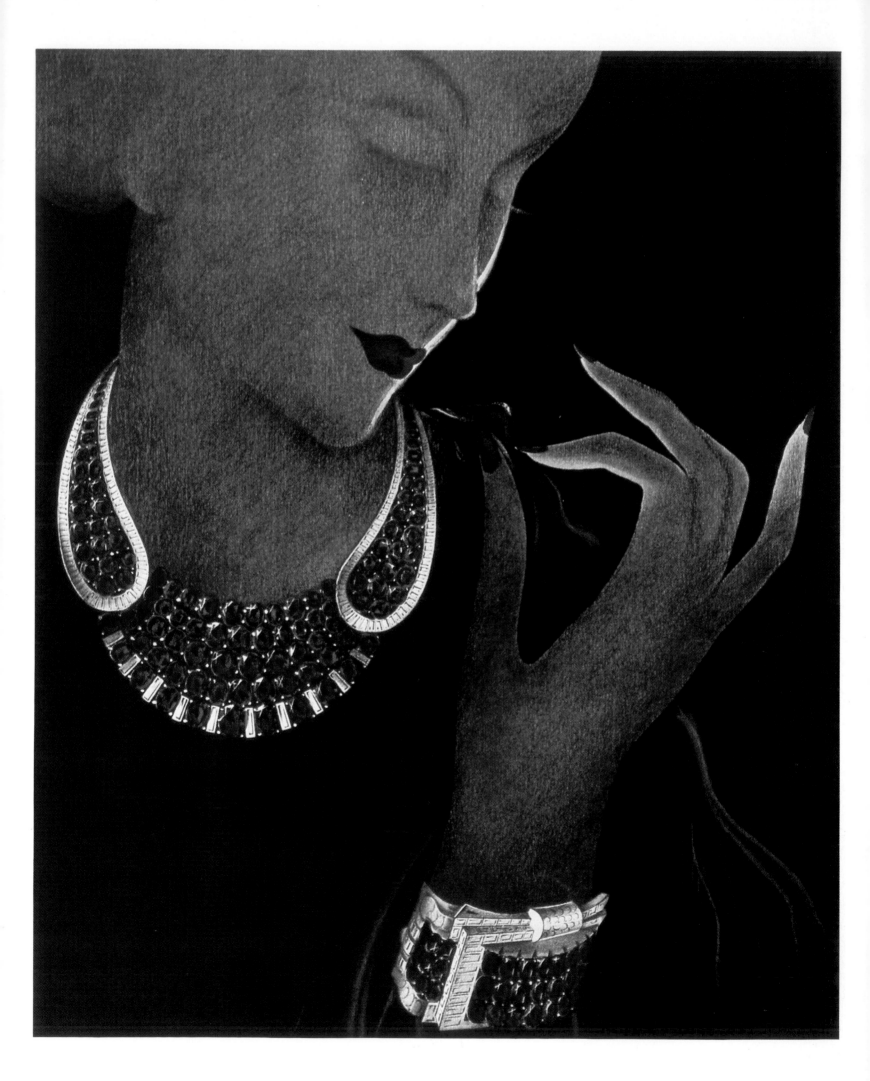

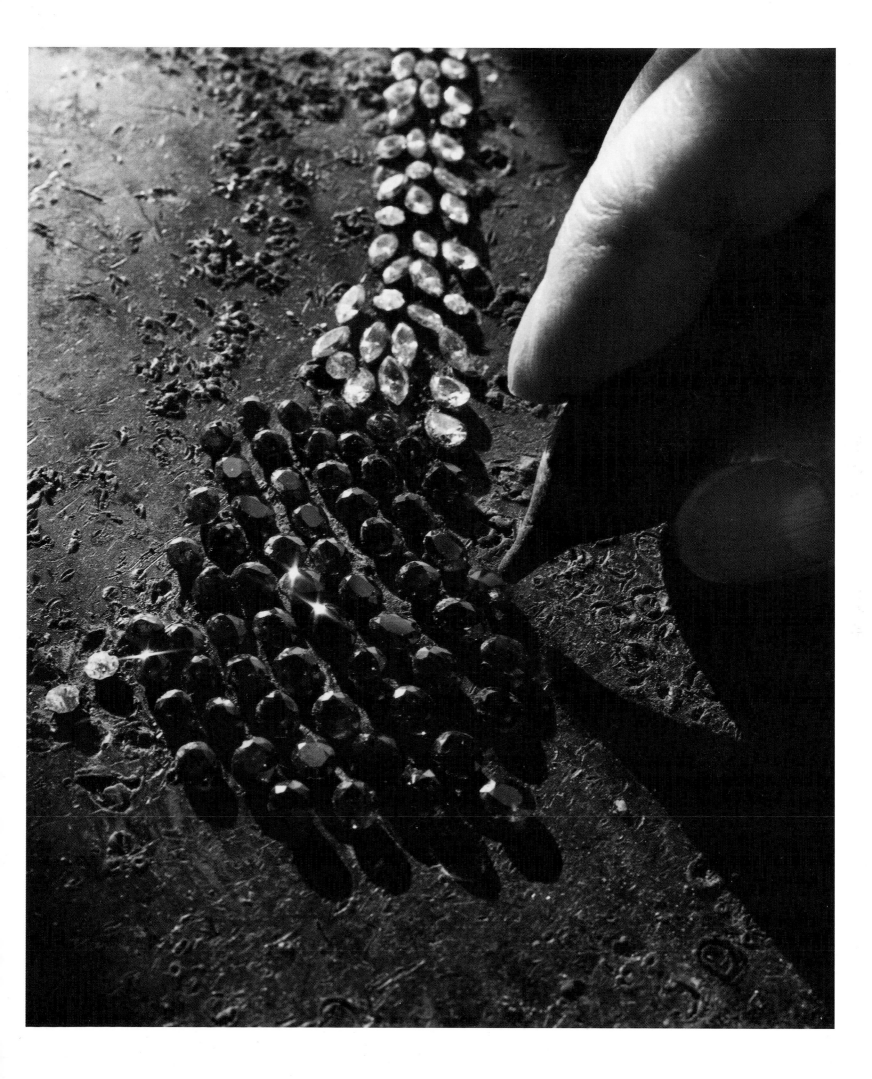

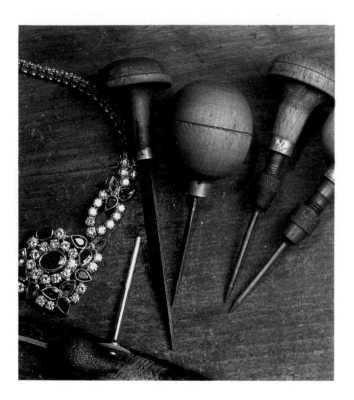

that the outer edge between the table, or top of the stone, and the culet, or base, will be flush with the metal setting and will form a single unbroken surface with it. Once the gem is fitted to his satisfaction, the setter uses miniature burins (called scorpers) to push the gold or platinum imperceptibly up against the stone, forming tiny claws that will hold it securely. These are then beaded. If the stone rests on a bezel, the setter will also use scorpers to fold the ends of the claws over before beading.

Perfection in jewelry implies the complete disappearance of the metal behind the gems it contains. Since the beginning of the twentieth century, fine jewelers have sought to achieve this goal with increasing degrees of skill. Mauboussin's Olympia ring reveals only the stone, an exceptional diamond, ruby, or emerald solitaire surrounded by cabochons and three baguette diamonds. In the 1930s Van Cleef & Arpels invented their "mystery setting" technique, which remains a closely guarded professional secret. Without giving this secret away, it can be said that the gems glide over tiny golden rails that hold them firmly inside the piece.

The final step in creating a piece of fine jewelry is polishing. The skilled polisher uses an array of special creams to bring out every inherent quality in the gem. Ultimately, the stone appears to float unsupported in space and light; the metal disappears, and only a prism of brilliant color remains.

*Miniature burins or scorpers used for setting.*

*Below: "Two Feathers" or "Holly Leaves" brooch by Van Cleef & Arpels made of brilliants, baguette diamonds and rubies in the "mystery setting", a present from King Edward VIII to Wallis Simpson in 1936.*
*Right-hand page: Setting at Boucheron is the penultimate step, and the only time when the jeweler, or setter, handles the gems themselves. His task is to fit and adjust them to the metal.*

*Following double page*
*Watchmaking*
*Top to bottom: Automatic hand-chiseled skeleton movement of a Breguet watch.*
*Top center: Repairing the gears for the phases of the moon on a watch using an old-fashioned balancing machine at Breguet.*
*Bottom left: Constant-force escapement: drawing by Abraham-Louis Bréguet, 1798.*
*Bottom center: In the foreground a Breguet "perpetual" (automatic) repeater watch with date indicator sold in 1791 to the Duc de la Force; in the middle ground, Breguet tact watch, off-center face with date indicator and phases of the moon, sold to Monsieur de Ross in 1829*
*Lacquer.*
*Chinese lacquer brushwork on a fountain pen cap. S. T. Dupont.*

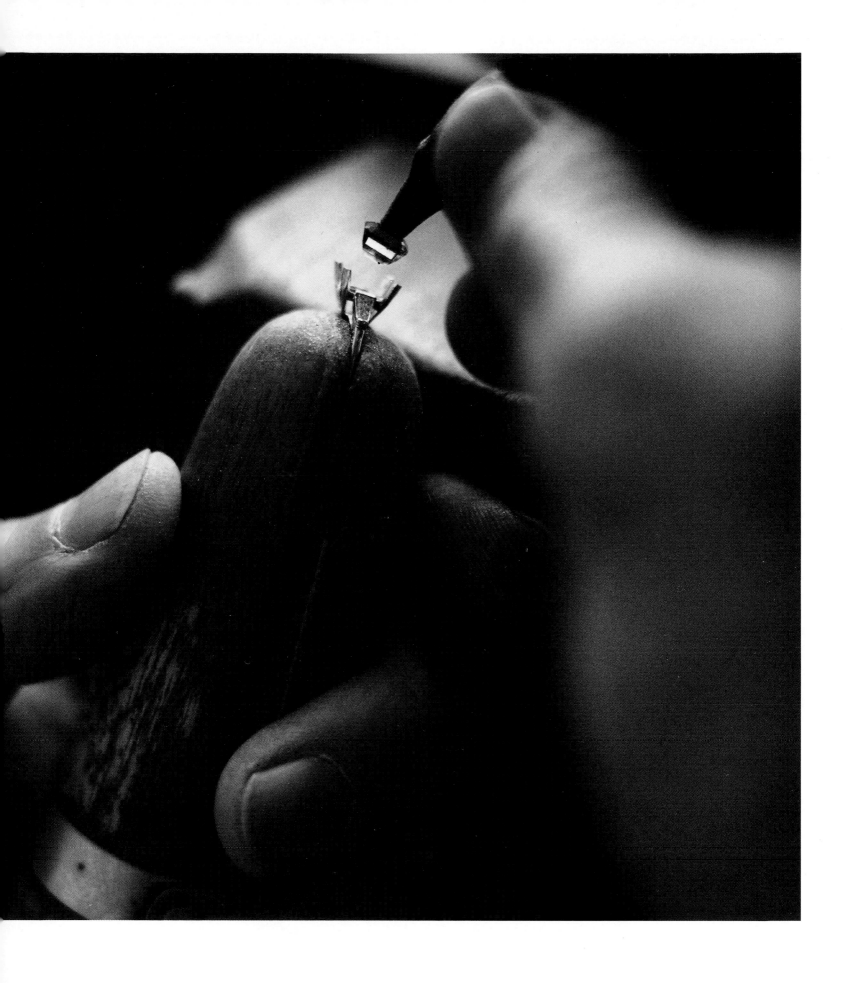

Are watchmakers akin to virtuoso musicians? Time is certainly of the essence for both, and their disciplines also require an acute degree of precision beyond the grasp of most people. The manual dexterity of a master watchmaker repairing a complicated movement is equal to that of a virtuoso violinist fingering chords on the frets of the instrument.

## "Complications" and simplicity of form

The Paganini of watchmaking in the early nineteenth century was indisputably Abraham-Louis Breguet, the man who invented the wrist-watch for the queen of Naples. The watch-movements Breguet

designed have never been equaled, either for the complexity of their functions or the simplicity of the forms used to execute them.

In watchmaking, "complications" and "extreme complications" are the terms given to all those functions of a watch or clock not involved in merely showing the time: these include date-indicators, calendars, phases of the moon, and alarms. Extremely complicated watches

combine several of the above, or house incredibly intricate precision systems such as local and solar time differentials, the perpetual calendar, and the automatic tourbillon, which contains all the escapement levers in a single revolving case.

Abraham-Louis Breguet was author not only of the automatic tourbillon,

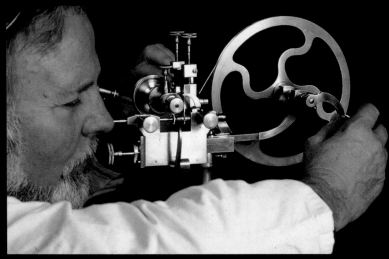

invented in 1795 and patented in 1810, but also of the perpetual self-winding pocket-watch that rewinds as its owner walks and on which all later automatic models are based. He invented the postage-stamp mainspring that turned alarm clocks from large unwieldy eyesores into slender modern devices, and was also responsible for the touch watch, the shock protector, and the constant-force escapement lever.

## Microscopic dust

Even the most technologically advanced watch occasionally needs to be cleaned, in order to remove the microscopic flecks of dust that dry out the oil used to lubricate the mechanism's moving parts. A fact rarely considered—every mechanical watch naturally needs a drop of oil: without it, the movement would clog and eventually grind to a halt. As is dries, oil leaves a gummy residue that gives watchmakers nightmares, since it can scratch a gear or block a bridge.

Specialists in the repair of antique watches examine the stalled mechanisms, replace damaged or lost components, and clean and re-start movements that often contain up to one thousand separate parts.

## Precision instruments

Luxury watchmaking came into

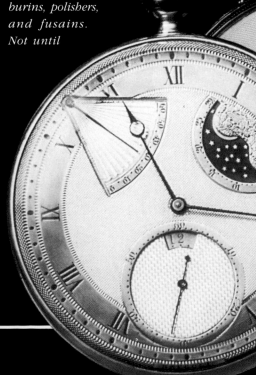

being with the invention of precision instruments capable of dealing with the infinitely small—microns, rather than millimeters. Like all who work in metal, watchmakers use burins, polishers, and fusains. Not until

the advent of precision instrumentation, however, could they produce the extremely complicated mechanisms we know today.

Meanwhile, with the proliferation of the quartz watch, many traditional watchmaking tools have become rare. Today, beginners in the trade are often forced to haunt the flea markets of Geneva to obtain the tools they need. Some also scour the antique shops of the Jura watchmaking region in France, or explore the famed Joux Valley—the cradle of watchmaking and the spot to which every watchmaker sooner or later makes a pilgrimage.

### Peerless performance

The traditional watchmaker bends over his small adjustable work platform, fitting a tiny gear to within a tenth of a millimeter's tolerance into a cone-shaped peg, and screwing the other extremity of the microscopic component into a tiny slot. As he grasps the handle on the side of the miniature platform and slowly revolves it, he resembles a musician playing a rare instrument that only he can hear. In a way, this is exactly what he is doing, since when he burnishes the tiny gear and hones it to fit inside the jewel, where it will function flawlessly in the transmission of movement to the spindle it *governs*, the watchmaker uses more than just his eyes. This is virtuoso precision—instinct combined with skill and long practice for a performance in perfect time.

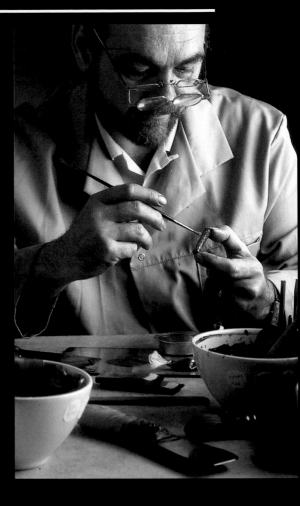

Lacquer is made from the sap of a tree native to China which belongs to the genus Rhus Vernicifera. The distinctive feature of this sap is that it hardens when exposed to air. When the trees are eight to twelve years old taps are inserted into the trunks and the sap that runs out is collected in buckets. During years when the monsoon rains are unusually heavy, the lacquer distilled from the sap is smooth and easy to spread; but during drought years it can turn brittle and be difficult to polish. Quality is standardized by blending saps from different years.

There is a special name for each stage of the lacquer-distillation process. The first boiling-off is called "Nayashi." The residue at this stage produces a lacquer used for protective undercoatings. The second boiling-off is called "Kurumei," and produces the finer-grade lacquer used for top-coats. Lacquer is colored by adding pigments such as pale tortoiseshell and Coromandel red, which are filtered through gauze mesh into earthenware bowls lined with moistened, oiled paper.

Lacquer is usually applied to wood. It is extremely difficult to make it adhere to metal, although the S.T. Dupont company has managed this feat. The metal must first be roughened by subjecting it to a process of electro-erosion. Then the lacquer is applied with a spatula or brush, depending on the object. Lacquerwork, whether metal or wood, can receive as many as six layers of this substance. Each layer is allowed to dry and then carefully polished before the next one is applied. The way each layer will harden depends on atmospheric conditions, but in any case it occurs through polymerization (a transformation of the sap's chemical structure). Quality is determined by the way in which the lacquer has hardened—a process brought about by the properties of a unique natural resource and human ingenuity.

### The Neolithic age

Precious metalwork began with the discovery of gold c. 5000 B.C. It was rarely found in a pure form, but usually alloyed with silver or other metals. Silver was discovered c. 4000 B.C. either in the form of native silver, silver chloride, or galena (silver mixed with lead).

### Antiquity

The silversmiths in Antiquity knew how to combine metals in order to change their color or make them more malleable or resistant. They were familiar with the majority of the metalworking techniques, which have scarcely changed since; these include smelting, casting (the lost-wax process) hammering, annealing, soldering (milling, filigree work), engraving, chasing and inlaying, etc.

### The Middle Ages

After the troubled times of the Nordic invasions, gold, which had become rare, was reserved for churches, monasteries, and royal courts. The favored techniques were cloisonné and champlevé enameling, filigree, niello and *opus inclusorum* (gold cloisonné stones or glass).

### The Renaissance

The discovery of the New World in the sixteenth century, brought an abundance of precious metals to Europe, of which kings and princes amassed vast quantities. They surrounded themselves with renowned artists. Benvenuto Cellini, for example, worked for François Ier, Hans Holbein for Henry VIII, and Leonardo da Vinci designed jewels for the duke of Milan.

The taste for ornamentation, already very evident in certain pieces of silver or gold plate (strong repoussé reliefs, allegorical subjects sculpted in the round, inlaid pearls, precious stones, cameos or enamels) became more accentuated in the following century.

### Jean Berain and the great baroque studio of the seventeenth century

In 1667 Louis XIV founded the Manufacture royale des Gobelins, where Charles Le Brun directed cabinetmakers and silversmiths, etc. and had exuberantly rich, solid silver furniture executed.

Seventeenth century metalwork was considerably influenced by baroque architecture (friezes, volutes, and caryatids, etc.). Towards 1675, however, a lighter style emerged (flat-chasing in geometric or oval frames), of which Jean Bérain was the initiator.

As of 1670 he was an ornamenter in the service of Louis XIV and executed sketches for opera and festivity sets, metalwork decoration, models for ceilings and woodwork, and cartoons for the Beauvais tapestries. He created a transitional style by renewing the theme of grotesques and inventing that of *singeries*. Engravings after his drawings propagated and perpetuated his work.

### Germain, Caffieri and Auguste, rocaille-style silversmiths of the eighteenth century

During the reign of Louis XV, in reaction to the monumental baroque style, taste evolved towards the rocaille, with curving, asymmetrical lines and natural forms.

Among the great silversmiths of the day, the master of this new harmony was **Thomas Germain** (1687–1748). Son and grandson of Parisian silversmiths, he qualified as master silversmith in 1720 and started to work for the king in 1723. He created jewelry for Marie Leckzinska, (thirty-five pieces) as well as for the wife of the Dauphin, and participated in the creation of a gold table service for Louis XV. He was the Regent's official silversmith.

**Jacques Caffieri** (1673–1755), who came from an Italian family of sculptors and bronze artists, created decorative bronze objects. He worked for the court of Louis XV, creating candelabras, clocks, lamps, and sconces in the purest rocaille style.

**Robert Joseph Auguste** (1723–1805) was a French bronze engraver and silversmith who qualified as master in 1757 and worked for all the great European courts, creating the instruments for the coronation of Louis XVI,

*Breguet's inventive watches*: Abraham-Louis Breguet (1747–1823) was born in Neuchâtel in Switzerland and effected his apprenticeship as a watchmaker in Paris. His name was brought to the attention of Louis XV because of his inventive spirit and perfect knowledge of mechanics. Some of his unique pieces created for the aristocracy and the European courts, included the perpetual self-winding pocket-watch, alarm watches, the automatic tourbillon, watches with "complications" such as calendars and phases of the moon, and marine chronometers.

the royal gold and silverware, table services for the king of Denmark in rocaille style, and classical services for Catherine II of Russia.

### Jewelry at the end of the eighteenth century

At the end of the century, jewelry experienced a boom and jewelry sets gradually replaced individual gems sewn on to garments. Sprays of diamonds in the form of roses and daffodils, osprey feathers, and

*Mellerio. The crown jewels*: The Mellerio dits Meller family of jewelers, originating from the Lombardy region in Italy, was granted the privilege of negotiating in France as compensation for having uncovered a plot against Marie de Medicis. François Mellerio was the first to open a boutique in Paris in 1801, working for the Empress Josephine, then for Queen Amélie. Under Napoleon III, all the members of the imperial court were clients of his two sons Antoine and Jean-François.

brooches shaped like bows to wear with powdered wigs were all very popular. To meet the needs of this fashion, mineral deposits in Brazil were intensely exploited as of 1728.

*The hallmark* is the only means of identifying precious metalwork. Until 1791, the master's hallmark, which had been obligatory as of the Middle Ages, bore the initials of the silversmith. The charge hallmarks corresponded to the taxes imposed by the general farmers and the discharge hallmarks, vouched for the payment. Since 1838 solid silver objects can be distinguished by the manufacturer's hallmark that is enclosed in a diamond-shaped frame and the guarantee hallmark which is represented by a Minerva head.

### The French Revolution

The revolution put a stop to the silversmith trade and in 1791, the constituent assembly abolished the guilds.

### Biennais, Odiot and Thomire, Napoleonic silversmiths

With the first French Empire the desire for luxury returned, and neoclassicism, which had made its appearance early in the eighteenth century, triumphed during Napoleon's reign. Fashionable women wore tiaras and strands of pearls as well as necklaces and earrings often decorated with cameos or cornelians and linked by double or triple gold chains.

**Martin-Guillaume Biennais** (1764–1843) who became master *tabletier* in 1788, made his name as a silversmith by creating travel cases for Napoleon for whom he became the official supplier. His production was inspired by Percier and marked by the style of the first French Empire, a distinction that would cause his decline during the Restoration.

**Jean-Baptiste Claude Odiot** came from a

dynasty of silversmiths whose origins can be traced back to the seventeenth century, but whose renown grew in Napoleonic times. With P.H. Thomire who executed the chasing, he created the Empress Marie-Louise's jewelry and the vermeil cradle—a gift from the town of Paris—for her son, the King of Rome .

## The Restoration period

The return of the monarchy engendered a pronounced taste for forms reminiscent of the Middle Ages (troubadour style) or the Renaissance period. Ancient silversmith techniques, such as niello, repoussé, and enameling were revived, whereas filigree work, purling, and milling were highly valued in jewelry.

> ***Christofle and Ercuis—the innovators***: *Charles Christofle was trained by his father-in-law, Calmette, who was a jeweler. Christofle took over the company in 1831 and rapidly changed its orientation by successfully launching into industrial production. Electroplating enabled him to mass-produce plated silver.*
>
> *The silverware company, Ercuis, founded in 1867, put into practice another of the recent discoveries in electrolysis, that of voltaic pantography, in order to produce silverware for religious and civic purposes. The firm changed hands in 1885 and started to*
>
>
>
> *specialize in the manufacture of cutlery and silverware for luxury hotels and the large maritime companies and in 1935 they equipped the "Normandie" ocean liner.*

**The twentieth century**: In 1840, **George Richard Elkington**, an Englishman, discovered electroplating, and thereafter silverplating and gilding could be accomplished by electrolysis instead of using fire and mercury. The process was acquired by Charles Christofle (1805–1863) and it democratized the market, marking the beginning of industrialization in the trade.

> ***Fabergé eggs***: *Peter Carl Fabergé (1846–1920) who came from a French family who had emigrated to Russia, exercised his trade as jeweler and goldsmith at the imperial Russian court as of 1881. He brought fanciful, precious objects in line with contemporary tastes, and in particular produced the imperial Easter eggs which the czar gave each year to the empress. His creations were a combination of eighteenth century French influences and the art nouveau movement.*

## The Second Empire

Naturalism with its vegetal and anthropomorphic motifs, became popular under Napoleon III and heralded art nouveau, in particular Fouquet, Lalique, Falize, and Christofle.

## The end of the nineteenth century. Art nouveau

In 1869, Jean-Baptiste Noury, an importer of pearls and precious stones, took over Rocher jewelers founded in 1827. His nephew, Georges Mauboussin, succeeded him and innovated by combining coral and jade with traditional stones, through colored composi-

> ***An international trade between the rue de la Paix and the Place Vendôme***: *Louis François Cartier set up his own business in 1853 and supplied a rich imperial clientele. The fall of the empire prompted him to move to England where some of his former clients had also settled; his son Alfred took over the French company in 1874. His clientele became increasingly more cosmopolitan and in 1899 he moved to the rue de la Paix, which remains the company's address today. The years from 1900 to 1939 marked a period of intense creativity and earned the firm its international renown.*
>
>
>
> *After a period of training with Jules Chaise,* ***Frédéric Boucheron*** *(1830– 1902) opened a jeweler's shop in the Palais Royal. He proposed novel creations which were a great success. He participated in the World Fairs of 1867 in Paris, 1875 in Philadelphia, 1878 also in Paris where he presented jewels in translucent enamel, and again 1889 where his models inspired by plants forms, such as mimosa and plane tree leaves, were particularly admired. He opened his jewelers at Place Vendôme in 1890.*

tions, and by using mother-of-pearl with gold and diamond.

**René Lalique** (1864–1945) manifested his originality very early on by conceiving and manufacturing jewels which renewed jewelry art, by his color associations and by the use of semi-precious stones, and new materials, such as ivory, horn, and enamel.

Several generations of diamond merchants— **Julien**, **Louis**, and **Charles Arpels** — entered into an association with **Alfred Van Cleef** in 1906, opening La Boutique des Heures on place Vendôme. They worked in the great tradition of the art nouveau artists and were acclaimed at the 1925 Decorative Arts Exhibition. The decorative powder compact made its appearance in 1930 and in 1935 they invented the invisible or "mysterious setting" as it was called, in which only the stones were visible.

## The twentieth century

The twenties were inspired by the primitive arts and cubism. **Puiforcat** (1897–1945), a silversmith, combined silver with wood, ivory, or gems. After gaining recognition at the 1925 Decorative Arts Exhibition, he participated in the foundation of the Union des Artistes Modernes in 1930, presided by René Herbs.

**The stakes of modernity**: Contemporary times are characterized by the frequent intervention of artists—such as Calder in the seventies—in the creation of jewelry, and the use of non-precious materials, such as rubber, wood, plastic, and steel for pieces in which the creative input takes precedence over the market value.

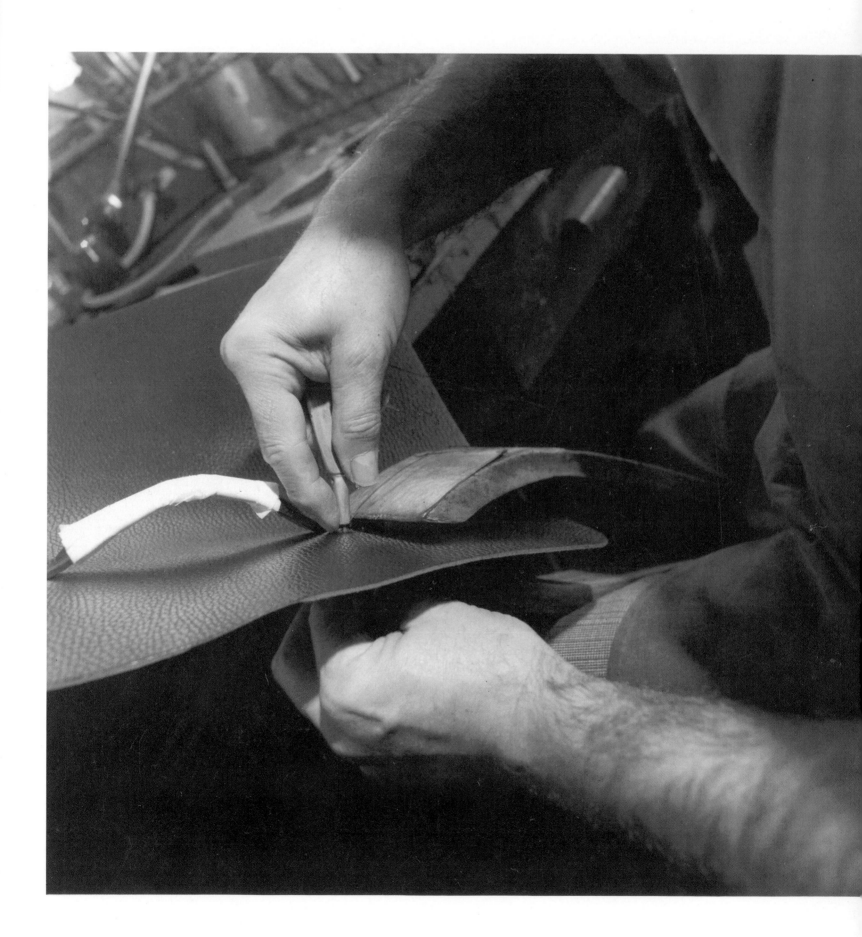

# Leather

Among leather's many remarkable properties, the most distinctive is the fact that it breathes. Animal skins and the leather made from them—whether tanned, stretched, cut, tooled, sewn, or dyed—all breathe. This is an apt metaphorical symbol for "living" leather, compared to the inert synthetic imitations scientists have worked so long and hard to develop. And yet, when it comes time to offer a special gift to a special person, the scientists themselves tend to call on luxury makers of "saddler-quality" handbags, wallets, luggage, or belts. Everyone knows a gift of leather will be prized by the recipient, who will cherish it for life. Its rich, characteristic patina is acquired over the years as it ages in harmony with its owner; this patina cannot be bought, it can only be earned with the passage of time. When properly cared for, leather will continue to give pleasure for generations, which explains why horsemen polish their leather boots as fastidiously as housewives polish their brass doorknobs. Leather craftsmen are true professionals with high standards of professional performance. It is to them that people turn for a truly outstanding product. In every civilization throughout history, only leather has proved resistant to the ravages of time, rough handling—and even competition from plastic. From humankind's earliest years animal skins have been cured to prevent them from deteriorating. Even the cavemen knew that smoke-cured animal hides could be used for clothing, for making "second skins" that would protect them from the elements.

Leather has a distinctive odor and, although the men and women of the Renaissance perfumed their gloves in order to mask it, today we tend immediately to associate it with fine living and an atmosphere of luxury and ease. Like the odor of beeswax, frangipani, or newly mown hay, the tangy animal odor of leather awakens dreams and memories, the host of happy images that only genuine leather can evoke. The first thing to strike our senses when we visit a great saddle, boot, or luggage maker is the odor of the raw mate-

## The art of tanning in France

*Although people in all historical periods have experimented with various methods for exploiting the inherent properties of leather and improving its appearance, it was the Saracens, during their eighth-century conquest of Spain, who brought the first dramatic technical advance to Europe with the introduction of alum salts (double sulfate) as a tanning agent. Early French tanners formed guilds, and these guilds persisted until the time of the French revolution. Colbert was an early supporter of the leather industry, decreeing that special sections of every major city in France be set aside for tanners. These areas were always near rivers, since large quantities of water are needed in the leather-tanning process. Vestiges of these special sections remain in many French cities today, reflected in street names such as rue des Tanneurs, and rue de la Mégisserie (another word for leather processing).*

## Saddle-stitching

*The saddler steadies the two pieces of leather to be stitchd together by placing them inside a long-stemmed clamp held between his knees and the floor. He then uses an awl to punch the even rows of holes in the two leather pieces through which the thread will be drawn. He then selects the thread, coats it thoroughly with beeswax, and attaches two needles by triple-knotting them to each end of the thread. The top needle is drawn up through the first two holes on both pieces of leather, and down through the second two. The bottom needle is then drawn up through the second two holes, thus crossing the thread and joining the two pieces of leather.*

A Purse-seller, *an allegorical engraving by M. Engelbrecht, Augsburg, c. 1735. Bibliothèque des Arts Décoratifs, Paris.*

Left-hand page:
*Saddle-stitching.*

# The art of bookbinding

Hungarian-born Sün Evrard has lived in Paris since 1971. Encouraged by her husband, who collects twentieth-century first editions, she enrolled at the Ecole de l'Union Centrale des Arts Décoratifs, and opened her own bookbindery in 1978. Evrard early chose contemporary design as her specialty, and credits Rose Adler, Monique Mathieu, and Jean de Gonet as important influences on her work.

Paris is the world's leading center for bookbinding, and bibliophiles from every corner of the globe bring their finest editions to the French capital to be bound. Bookbinding is a highly creative craft, more than just protective coverings with elegant

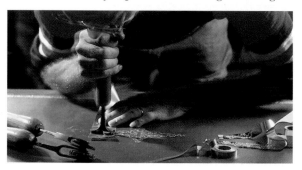

lettering and scrollwork, modern bindings can be works of art in their own right. Sün Evrard studies every book she works on with care, and then expresses her own personal reactions and emotions as a reader through the colors, materials, and shapes of her bindings. Here is the work of a true artist who invents, experiments, and innovates as she paints the leather, constructs collages, and selects the various components (paper, bits of metal or wood, etc.) that will contribute to the whole.

Leather in every shape and kind is her primary material. She uses the traditional kidskin and calf, plus pigskin, buffalo hide, kangaroo, and alligator. Her art is most evident in the way she exploits the inherent properties of the different leathers. Sün Evrard retouches, molds, reverses, strips, pleats, layers, and airbrushes. The diversity of the techniques she uses may seem exaggerated but it is actually central to the creation of her unique designs. When Evrard has finished her work, which takes maximum advantage of natural color and texture, it is then often complemented with detailing added by other specialists such as gilders, leather-toolers, woodworkers, and jewelers.

In 1984 Evrard invented a simplified binding with a soft spine, eliminating the need for stiffening, and making it easier to open the book. This innovation paved the way for totally new types of covers. For example, when designing the recently-completed cover for the manuscript of L'Ecume des jours, Sün Evrard created a completely new multi-section binding made up of three matched panels in airbrushed leather, protected by four fold-over flaps in gray pigskin.

Even when a binding is a work of art in its own right, it still must fulfil its primary function, which is to protect the book from the ravages of time, and to reassure the reader that its contents can be enjoyed without fear of damage. Skilled bookbinders specialize in enhancing the appearance and extending the life of rare editions. These two goals have led Sün Evrard to embark on a continuous exploration of the craft's technical possibilities, an endeavor that has required great inventiveness in combining new materials for the expression of her own personal inspiration, ultimately dedicated to the books themselves, their contents, and their authors.

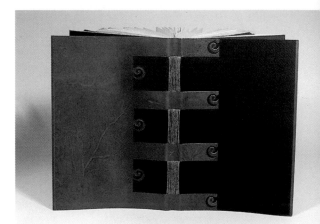

Left: *Gold vignette on inlaid leather desk-top.*
Right, from top to bottom: *Binding by Sün Évrard for Stéphane Mallarmé's work,* Un coup de dés jamais n'abolira le hasard. *Binding by Sün Évrard for Boris Vian's manuscript,* L'Écume des jours. *Bibliothèque Nationale de France, Paris.*

rial. The second, as we glide our fingers over the leather's surface, is its remarkable texture. When we polish leather we know we are really nourishing it, extending its life. People tend to handle leather almost lovingly, evoking the aphorist Chamfort's definition of love, which could perhaps be appropriated in this context: "The touch of two skins, the exchange of two fantasies."

Leather is made from animal hides, and before being turned into functional accessories, gifts for a beloved, or sacred artifacts, it lives out a thrilling adventure on the world's wide-open spaces. This is the adventure of the pioneer galloping over the pampas, the goatherd wandering over the mountaintops—an adventure implicit in the most ordinary leather-bound diary owned by a city dweller. However, a chasm separates the world of cattleman and goatherd from the workshop of the saddle or luggage maker, a chasm spanning the sum of virtuoso expertise employed in transcending the raw material, in transforming its appearance while respecting its essence. We have only to compare the gaucho's rudimentary saddle with the precision instrument mounted by modern equestrian champions: a gaucho's saddle has the wild beauty of a rough-hewn log; the equestrian's the elegance and sensitivity of a fine violin. One is a work tool, the other a fine instrument; one a necessity, the other a luxury. Only rarely does a single material thus combine, as leather does, the practical and the luxurious. There is not just a *difference* between ordinary suitcases and those made by a skilled saddle or luggage maker, there is a *distinction*. The pace and demands of modern travel have eliminated the cumbersome trunk of yesteryear, except for the dancers, entertainers, actors, and society luminaries who cannot afford to appear in public with a single wrinkle or crease in their clothing. For the rest of us, today's fine luggage-makers have designed models that are flexible, light, and eminently practical. However, although modern luxury luggage may be less imposing than its predecessors in terms of weight and bulk, its quality, design, and detailing immediately distinguish it from inferior models, even on a mundane airport baggage carousel.

Fine luggage may be beautiful, but beauty alone will not protect it from mishaps and mishandling. Today, perhaps only luxury-hotel porters not only know how to immediately recognize a Vuitton or Hermès bag, but also know how to treat it. Once your leather bag or attaché case has begun to show the marks of time and faithful service, it will take on a special luster in your eyes alone. Herein lies the true secret of fine leather's unique appeal:

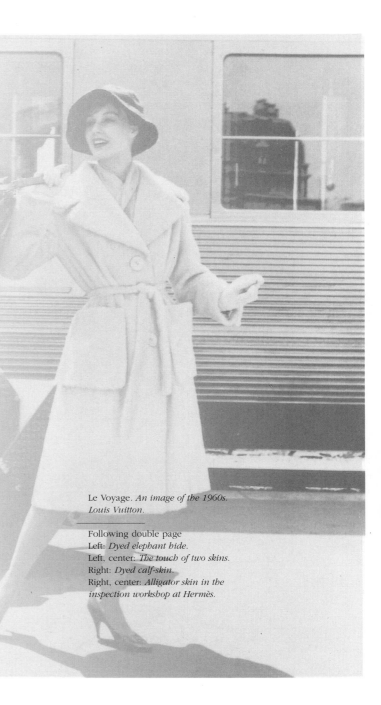

Le Voyage. *An image of the 1960s. Louis Vuitton.*

Following double page
Left: *Dyed elephant hide.*
Left, center: *The touch of two skins.*
Right: *Dyed calf-skin.*
Right, center: *Alligator skin in the inspection workshop at Hermès.*

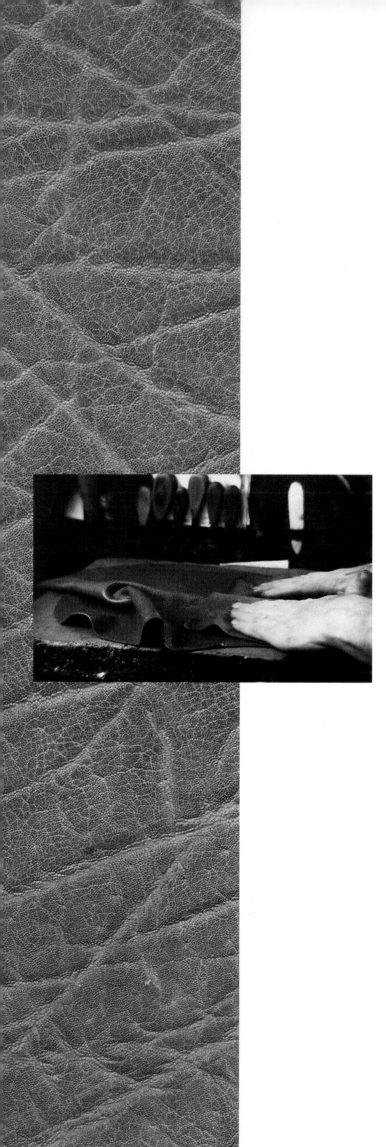

it is able to transmute scuffs, blows, and age into well-worn lines that gain in charm as the years go by.

Hermès leather inspector Michel Fort regularly visits tanneries to make his selections, carefully rating, accepting, and rejecting the hides offered to him. Here is a man who really knows, as he puts it, what it feels like to be "on my own, alone with the leather." He knows knows how difficult it is to find a truly fine hide or piece of leather, as well as the number of meticulous processes leather must undergo before acquiring its particular sensuousness.

Watching Michel Fort at work in the Hermès storerooms—running his hands over the hides under the bright northern light, turning them deftly and expertly in order to evaluate both grain and flesh sides, scrutinizing them, sniffing them—is a revelation of the passion he brings to his craft. "Hides are evaluated three different ways," Fort explains. "First, with the eye, of course, to locate superficial flaws, scratches, creases, spotting, poor dyeing or finishing. Second, with the hand, to estimate quality and handle; waxy, silky, velvety, glossy, or full-bodied are terms applied to leather that meets the luxury standard. Hides rated dry, flat, or limp are immediately rejected. Third, with the nose—for leather tanned by the traditional vegetable or chromium-salt methods. Only with the nose can we appreciate the marvelous odor associated with the natural tannins and nutrients that today are unfortunately being displaced by synthetic substitutes."

## Tanning

Leather is made from animal hides and skins. The term "hide" is used for large animals (cowhide, horsehide, buffalo hide), and "skin" for small ones (calfskin, kidskin, lambskin; ostrich, alligator). Because hides and skins are of animal origin, they are perishable and must be treated to prevent deterioration. Treatment converts otherwise perishable hides and skins into a material that is stable and non-decaying. The number of complicated operations involved in this process perhaps explains the dearth of skilled leather tanners today.

There are three major steps involved in transforming animal hides into leather: curing, tanning, and finishing.

First, the untreated animal pelts are washed and sprinkled with salt, or brine-cured in vats of salt crystals. They are then sorted, trimmed, and soaked in water and chemicals. This step corresponds to the old-fashioned "freshening" traditionally carried out in rivers. The conditioning eliminates soil, soluble proteins, and the curing agents.

Hair and excess flesh are removed in a lime solution, and then the hides are fleshed, or scraped with rotary blades. The skins are further purified and then washed and preserved in sulfuric acid until ready for the second stage of the process, tanning.

Fresh hides contain collagen, a fibrous protein held together by chemical bonds. The tanning process uses various agents to dissolve the nonfibrous proteins and strengthen the bonds between the polypeptide collagen chains, in order to arrest organic deterioration. There are three main types of tanning: vegetable, mineral (usually chrome), and oil. The most common and fastest of the three is chrome tanning.

The third and final stage in the process is fat liquoring. The tanned hides are soaked in vats of oils, chemicals, and fats to strengthen them and restore pliability. They are then stretched on frames and dried in the open air or in ovens. When tanning is completed, the hides are dyed.

Tanned leather is finished by spraying it with water to restore moisture lost during dyeing. It is then steam-rolled and buffed to remove blemishes. A finishing coating (to protect the leather and bring out its color) is applied in thin layers that are allowed to dry between applications. Skillful finishing is a final touch to enhance the tanned leather.

SELECTION • One reason hides vary in value is that they bear marks reflecting all of the knicks and scuffs of an animal's existence. This is what makes the task of hide inspectors like Michel Fort such a difficult one. When we see him in the storage rooms receiving hides he has already pre-selected, which require only final sorting, the job appears easy. However, during the pre-selection process, for which he travels to tanneries in England, Belgium, Germany, and Norway, Fort has only a few tests to guide him, along with his own eyes, nose, sense of touch, and lengthy experience.

The crucial factor, of course, is dedication. People who choose this career, on which the entire manufacturing process depends, have to live and breathe leather, know it inside and out, and maintain close relationships with tanners and leather goods manufacturers alike.

THE GREAT CLASSICS • The hands-on approach is the best way to appreciate a fine animal hide. Michel Fort spreads some hides out on a table, explaining how they differ in terms of origin, quality, and finishing. First he shows us some fine quality top-grain box-calf, noting that it is a great classic. The piece has received only one plating, or rolling, to bring out its characteristic grain, which

149

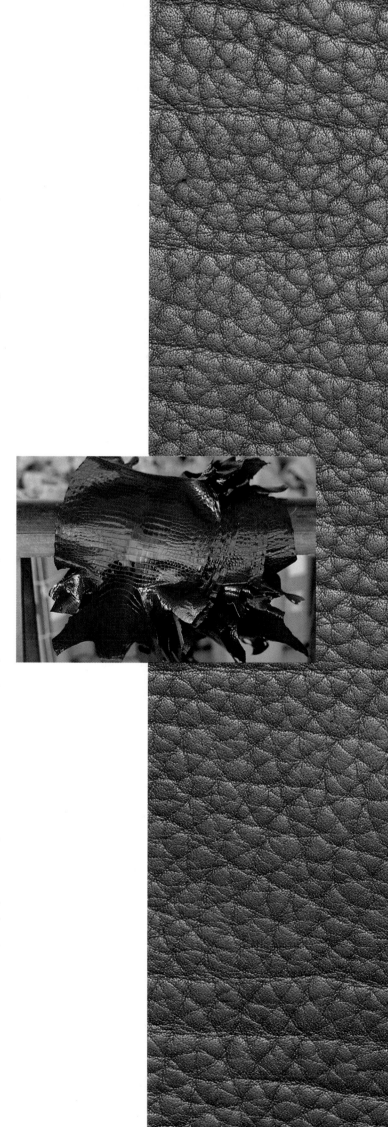

# Louis Vuitton, Parisian luggage maker

Bags, suitcases, and trunks are first and foremost designed to be transported under travel conditions of every kind. They must therefore be lightweight yet sturdy.

Progress in transport technology has radically altered the shape of luggage. In the nineteenth century, unfitted trunks were dome-shaped

in order to shed water when exposed to foul weather on the roofs of stage coaches and the bridges of ships.

Trains and ocean-going liners democratized travel by making it accessible to greater numbers of people. For these new means of transport Louis Vuitton designed flat trunks that could be easily stacked, fitting them with a variety of inside compartments. With the advent of air travel, modern luggage became more practical still, combining minimum weight with maximum volume.

To meet the demands of contemporary travel, the Louis Vuitton trunk is made from solid poplar, which gives the best weight-to-strength ratio. It is then reinforced with natural ecru cotton covered with the signature Louis Vuitton monogram canvas.

The linked initials L and V on the outside canvas covering has been frequently copied, but few people realize that the fabric is coated with special polychrome vinyl for resistance to the wet weather and rough handling to which most trunks are repeatedly exposed over their lifetimes.

The lid of the trunk is attached to the body by a canvas hinge inside the frame. This is a distinctive feature conceived by a luggage maker aware that traditional metal hinges can twist and break off, substantially diminishing a trunk's capacity to protect its contents.

Travelers rightly show great concern when it comes to the strength and resistance of their luggage. They know all too well what can happen to flimsy luggage in the course of being manhandled at air, rail, and sea terminals.

The trunk detailing is designed to strengthen the frame in every possible way through the addition of supports along the joints, both inside and out. These supports are made of lozine, a reddish vulcanized-rubber cord treated with sulfur compounds and heated to increase strength and elasticity. Lozine is as strong as iron or steel, but much lighter in weight. Louis Vuitton luggage is further strengthened with solid brass hardware used for corners, trim, locks, clasps, etc.

Interiors are lined with polychrome-vinyl-coated calico for the mass-produced models; and alcantara, a suède-look fiberboard for the limited-series models.

The trunks are also fitted with an inner frame holding removable compartments and drawers made of hard-wearing beechwood.

Two exterior details, the handles and the locks, are particularly noteworthy. The handles are made from cotton-trimmed reinforced hemp cable covered with classic hand-sewn saddle-stitched leather. Clearly, strength is the top priority for both trunk and handle.

Locks are crucial accessories, since travel can involve unpleasant surprises. Luggage is always vulnerable to theft, which is why special attention has been given to Louis Vuitton luggage locks. Each piece has its own integrated combination-lock designed to keep even professional thieves busy for at least two hours before yielding.

Patrick Vuitton's particular province is filling special orders for customers with unusual requests: portable wine racks, suitcases with hanging-file compartments for businessmen, trunks that open out into cots, tote bags for baby bottles, Japanese tea ceremony sets. Nothing

is too much for the inventive capacity of these artisans. Nothing, that is, as long as it is luggage. "I will not make furniture," states Vuitton categorically, "I am a luggage-maker and I make only portable luggage."

# Form and function

Handbags are containers that have become indispensable decorative and functional accessories. Although the history of the handbag is associated with the suit, it also parallels the history of modern fashion.

The differentiation between men's and women's clothing in the Middle Ages assigned the purse or satchel to men. Male pilgrims to Saint James of Compostello, for example, wore purses attached to their belts and bags slung over their shoulders, while women carried small loose objects in the pockets of their dresses. It was not until the invention of the reticule at the time of the French Revolution that women also began to carry bags. The term "handbag" was coined in the twentieth century, and today the object referred to by this term tells us more about shifts in fashion than about its own function. This is true of the Keepall bag, which made its début in the 1924 Louis Vuitton collection. The Keepall is a soft bag in solid brown canvas and natural leather, designed to be slipped into a suitcase. It thus began its career as a piece of matched luggage. The Keepall was subsequently produced in various sizes for use either as an extra piece of luggage or as a small travel bag, and was made available in monogrammed canvas, natural cowhide, or embossed leather. Today it exemplifies the contemporary trend towards combining form with function.

Another example of the handbag as history is the Kelly bag, which developed from a saddle bag designed in 1892 by Emile Hermès. The original model was a roomy trapezoidal leather bag with a clasp intended to hold a rider's saddle and boots; it appeared as such in Hermès catalogues until 1930, when a smaller (18 inch) version for ladies was offered under the heading, "small bag with simplified strap." In 1938 this became "ladies' travel bag with strap," in 1952 "travel handbag," and finally, in 1955, "flat, roomy handbag." A princess, Grace Kelly, and a photo on the cover of Life Magazine created a myth: the Kelly bag. The bag was first made of natural cowhide as a travel accessory, but when it moved into the world of high fashion, it became available in box-calf, grained calfskin, smooth calfskin, ostrich, lizard, alligator, and canvas-and-leather models that were either saddle stitched (for the rigid model), inseamed (for the soft model), or trimmed with fashionable crushed calf.

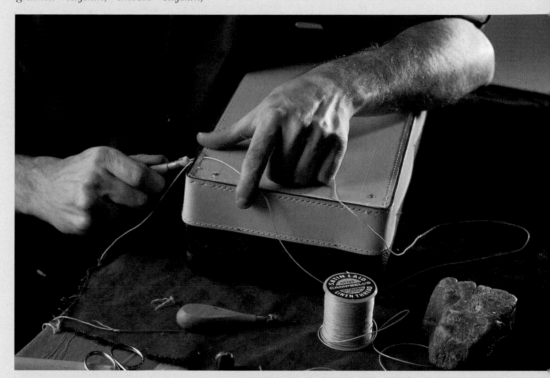

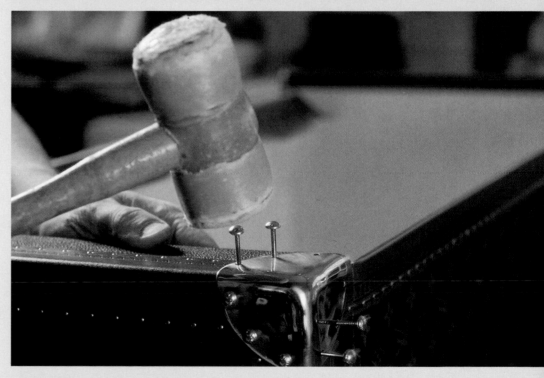

Left-hand page: *Design for a "Monogram" suitcase. Louis Vuitton.*
Bottom: *Manufacturing the poplar frames for suitcases. Louis Vuitton.*
Right-hand page: *Saddle-stitching on a Louis Vuitton bag.*
Bottom: *Riveting metal corners on to the trunk trim. Louis Vuitton.*

### Gloves

*Gloves have a symbolic significance, reflected in the terms "to throw down the gauntlet" (challenge to a duel) and "to pick up the gauntlet" (accept the challenge). They were once de rigueur but have now become optional accessories, continuously evolving to keep pace with custom and fashion.*

*The glover's craft comes into play only after the leather—whether lambskin, kid, peccary, or antelope—has been tanned and dyed. Despite the mechanization of certain operations, glove-making tools have scarcely changed over the centuries, and methods are surprisingly simple and uncomplicated. The leather is placed on a high table along with trimming knife, cardboard sizing and glove patterns for estimating the amount of leather needed, shears similar to those used by tailors (except that the blades are shorter and wider), and a folding ruler known as a "pied du roi" or "pied de Charlemagne."*

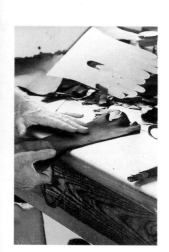

*Because they work with only a few tools, glovers express their art primarily through hand and eye, and through meticulous gestures executed in an immutable order. Glovers evaluate the quality of the skin and then decide on the appropriate cut and model.*

*As a preliminary step, the leather is wrapped briefly in the "sheet," a moistened cloth, to make it soft and springy. It is then carefully inspected before being cut into the rectangles from which the final glove pattern will be cut by a template-punch.*

*Precise measurements are taken in two steps, one for length, one for width. The leather is stretched along its length, across its width, and then marked for size, leaving a one-inch allowance for the volume of the hand and seam of the glove. A pattern of the hand including fingers and thumb is*

varies from one section of the hide to another: delicate and fine on the butt-end; wider-spaced on the flank. Box-calf is considered the aristocrat of leather because only light plating with glass rollers is needed to conceal minor flaws and emboss the grain.

After box-calf, the next highest grade is grained calf. This type of leather is embossed using a heated plate on which the pattern of the grain has been etched. The contrast between the raised and unraised portions of the pattern gives a highly-prized and subtle two-tone effect. Box-calf and grained calf are both "top-grain," varieties, and thus more difficult to evaluate definitively on arrival, since they will have been subjected to less pre-processing than other grades. Several traditional tests are used to evaluate hides. For example, hides can be rubbed first with a dry and then with a damp cloth in order to ensure that even those sections handled the most will not "sweat." Rolled calfskin is notable for its softness and delicate grain. This texture is obtained by rolling the leather over on itself between revolving cylinders. Only those hides with the closest grain will be retained during the selection process.

Another variety, crushed calf, gets its characteristic mottled effect from being buffed on the flesh side of the hide; it is the opposite of nubuck, which is buffed on the grain side.

For luggage, another great classic is natural cowhide. "For this type of leather goods," explains René Marchand, technical supervisor at Louis Vuitton, "we look for hides the tanner hasn't cheated on, hides that conform to our high standards." The primary difficulty is selecting the raw hides, only ten to fifteen percent of which will ultimately turn out to be flawless. This means five or six hides must be purchased for every one used. Testing carried out at one major Brazilian tannery revealed only one hide out of a thousand that met the selection criteria. This is because Brazilian cattle are exposed to harsh weather conditions and multiple insect bites that leave indelible marks on most of the hides. After slow tanning in an organic tannic acid solution, most effective when carried out over several weeks in a deep trench, the final selection is made. Ideally, natural top-grain cowhide should be left untreated, and its color allowed to develop naturally with the patina of time. For this grade of leather, Hermès specifies minimal dyeing and finishing, using natural products, so that the surface of the leather will not acquire a glazed plastic look, but will retain all of its intrinsic sheen. However, cowhide can also be used for colored leathers such as the Louis Vuitton "Grain Epi" and "Taïga" types, because of its large area and superior strength.

*From top to bottom: Glove by Givenchy. Before the cutting process the skin is stretched to a maximum. Saint-Junien. Glove by Léonard.*

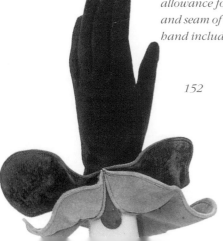

Buffalo hide is a recent addition to the field of saddle and leather-accessory making. Used primarily in upholstering, buffalo is prized for the evenness and delicacy of its natural grain.

Hermès imports a type of leather from Pakistan called "Qurbani," which is made from the hides of sacred buffaloes sacrificed during religious ceremonies.

"Our standards are as high for leather linings as they are for exteriors," notes Michel Fort. "We use dip-dyed rather than dye-finished lambskins, since dip-dyeing preserves the natural grain and gives the product an exceptional handle. "Madras kid, which like lambskin is dip-dyed, is used for the linings of alligator and lizard handbags. What we call shagreen has a special grain produced by rolling the grain sides of two pieces together, in opposite directions, while pounding them with a cork-tipped wooden mallet that embosses the characteristic blistered grain.

"Calfskin, which is softer than cowhide and not as thick or as strong, is also used for handbag linings."

EXOTIC LEATHERS • "And then," continues Michel Fort, "we also use more exotic types of skin from ranch-bred animals." Here we enter the specialty department, where small quantities of exotic skins are stored separately. First ostrich, with the unique texture of its feather follicles. Michel Fort is a connoisseur of natural unpressed ostrich skin, a purist who exclaims, "there's no accounting for tastes!" since at Hermès the ostrich-feather follicles are flattened slightly with a metal plate.

Next comes that royal tidbit, the great alligator skin. Especially fine is the skin of the *Porosus*, an aquatic species found in Papua New Guinea and north of Queensland in Australia: "The best alligator, and the most sought-after," sighs Fort appreciatively. Because its scales are unusually fine and even, and because the gradations in color between the scales on the abdomen and those on the flanks are more subtle, the *Porosus* is the most prized of all alligators, although the larger *Mississipiensis* of Florida and Louisiana also has its fans. Alligator skin is somewhat dull and lusterless after tanning, so tanners use agate cylinders to give it brilliance and heighten the contrast between the dyed scales and the lighter natural tone of the spaces between them.

CUTTING HARMONIOUSLY • A good cutter's goal, as young artisan Philippe Fleury explains, is to achieve unbroken harmony in the finished piece; the hardest problem he must solve is how to deal with flaws in the hide or skin. For a handbag, cutting must either incorporate the flaw into a component of the bag

*then placed on the leather, and shears are used to cut a rectangular shape around it. This step is then repeated. Scraps from around the cut rectangles are also stretched vertically and horizontally, for later use as the fingers and thumbs of the glove, the strips between the fingers (fourchettes), and the edging and/or wristband. Each cut piece is immediately numbered in order to avoid mis-matching.*

*The rectangular pieces of leather are then arranged in lengthwise stacks corresponding to the cardboard-pattern sizes.*

*Fancy work is executed by stitchers and embroiderers who add distinctive tucking, braiding, appliqués, and special stitching. The stitcher sews up the sides of the glove, adding thumb and finger pieces and decoration. A variety of stitches may be used: with a machine, for whip-stitching, saddle stitching, and eyelet stitching; or by hand, for saddle-stitch seaming. After the glove is completed, a wooden spindle is inserted into each finger to test its resistance to pressure. The glove is then pressed on a heated iron form to eliminate all traces of handling. A last touch of the hot iron gives the glove its final, appealing sheen.*

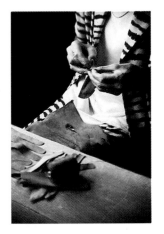

*France retains two luxury-glove making centers today: Millau, in the Aveyron; and Saint-Julien, near Limoges. The modern decline of gloves as an essential fashion accessory together with competition from low-cost labor in the Far East have caused the disappearance of one entire branch of a glove-making industry that was once famous worldwide. The few surviving glove makers owe their success to close cooperation with major haute couture designers.*

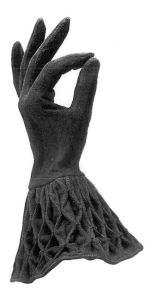

From top to bottom:
*Glove by Michel Klein for Guy Laroche.*
*Assembling the glove: the small strip is stitched to the thumb which in turn is stitched to the inside hand piece. Saint-Junien.*
*Lambskin and red velvet glove. Pétronille Norval.*

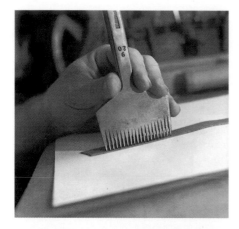

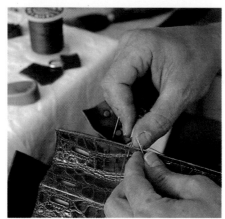

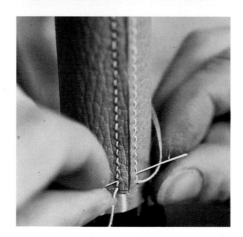

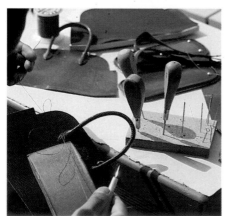

that will not be visible, or eliminate it completely. This explains why it has always been said in the leather trade that profits depend on good cutting. Not only should a good cutter engineer a piece so that what might have been a total loss becomes usable, he must also "cut harmoniously."

THE EXAMPLE OF THEIR ELDERS • In days gone by, a leather worker achieved the status of cutter only after many years. It took long experience to be deemed worthy of cutting. Today, however, the demand for handbags at Hermès and Louis Vuitton is so great, younger men have had to be especially trained for the job. Not that this has necessarily meant any lowering in standards. The example of their elders reigns over the workshop in which the younger men work. The dexterity of these true craftsmen, both young and old, is evident in the precision with which they execute their work.

FITTING THE PIECES TOGETHER • Cutters are responsible for ensuring that all the separate pieces for a handbag—front, back, flap, etc.—will fit together perfectly, following the grain of the leather and avoiding undue differences in color shading. For an ostrich handbag, the cutter must see that all the follicles lie in the same direction; for an alligator bag, that the ventral rib is centered and the scales on either side perfectly symmetrical.

Charged with preparing the pieces that will subsequently be sewn together by the assemblers, the cutter must continue the rigorous selection process begun by the inspectors in the storage rooms. Of the three factors crucial to evaluation—eye, hand, and nose—the cutter relies most heavily on the hand. The relationship of cutters to leather is primarily tactile, and cutters have no compunction when it comes to rough handling. "You see," explains Philippe Fleury, "we have to get a real feel for the hide, crush and pummel it a little in order to evaluate how it will age. When you crease some parts of a hide, the 'V' of the groin for example, you can see immediately that the grain of the leather will retain scuffs and scratches. But when you crease the butt, it just wrinkles momentarily and snaps right back into shape again."

## Towards the finished product

Three major steps are involved in the construction of a handbag: cutting and preparation, assembly, and stitching.

CUTTING AND PREPARATION • To make a box-calf Kelly bag, the cutter uses the butt section of the hide—the finest-textured part of the skin—for the body of the bag (front, back, and flap), the handle, the handle loops, and the expandable sides. The inner side of

From top to bottom:
*Marking the glove prior to hand stitching. Hermès.*
*The sewing of a Kelly bag, which when made of alligator skin, is always saddle-stitched. Hermès.*
*Saddle-stitched seaming operation. Hermès.*
*Attaching the saddle-stitched handles. Hermès.*

the flap, the bottom of the bag, the stiffening, and the reinforcements are cut from less noble parts of the hide. The interior lining and compartments are cut from two pieces of kidskin or morocco leather. After they are cut, these components are evened out by "skiving" or shaving off excess thickness. The seams ultimately joining them together will be smoothed by the trim. The gold-plated hardware—chain, hinges, clasp, plaques for strap loops and flap, brads for the base—are added to the pieces of cut leather and then sent to the assembly table.

ASSEMBLY AND STITCHING • At the assembly table, the components for the body of the bag are glued together with the stiffening, the strap loops, the sides, the shoulder strap, and the base. The workroom foreman trims all the assembled components to the exact dimensions desired and then attaches the clasp or chain fastener with rivets, immediately protecting it with a piece of lambskin, since "nothing scratches more easily than gold." He then assembles the entire body of the bag—front, base, back, and flap—and sends it to be stitched. Meanwhile, he assembles the inner morocco-leather compartments and the sides, shoulder strap, tab and strap loops.

Constructing the handle is a particularly delicate task. The curved upper and lower sections must be attached to the core and then rolled over the hinges while adjusting each component with precision. Next the seam is compressed with a bone plane to smooth the thread and give it a "finished" look. Lastly, the ends of the strap are sewn on to the body of the bag.

The final steps follow: the assembler takes the lining of the bag, with the pockets sewn on to it, and adds a felt interlining to one side "for softness." The inside and outside of the bag are now sewn together while both parts are adjusted in order to eliminate bulging. The assembler trims the sewn pieces, stitches around the space for the clasp opening and then punches out both clasp and flap openings. He polishes the flap and upper front part of the bag, attaches the metal plate for the flap with rivets, and sews the strap loops to the back of the bag. He glues the sides to the body of the bag and then places the entire bag on a felt-covered wooden block that steadies it during the final stitching, which is executed with a saddler's riveter on a lithographic stone. Finally, the bag is rubbed with coarse and then fine abrasive paper, dyed, buffed, dipped in hot wax, stripped, cleaned, and polished. After a final polishing to eliminate all traces of handling, the stitcher embosses his own mark on each bag with a hot branding iron and sends it to the shop foreman for final inspection.

**The art of saddle making**

*Out of the ten saddle makers in the Hermès team, most are enthusiastic horseback riders, since a knowledge of horsemanship is almost a prerequisite in this field. The first step in making a saddle is to stretch webbing over the length of the saddletree from cantle to pommel, and then over its width, starting from the hollow center. The webbing is nailed to the wood with upholstery tacks, compressing the saddletree until its dimensions have been reduced by about half an inch. The webbing is then covered with felt padding bonded to a thick layer of latex. The seat of the saddle is made of pigskin, more resistant than calfskin to constant pressure. The saddler moistens the pigskin and stretches it over the saddletree, folding it under the cantle. This is the stage at which three pairs of essential saddle components, the skirts, sweat-flaps, and*

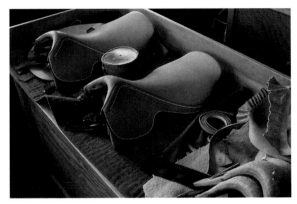

*under-flaps, are added. Skirts are pieces of cowhide about a quarter of an inch thick that are inserted under the seat of the saddle to protect the rider's legs from the stirrup-strap buckles and rings. The seat of the saddle is lifted off the saddletree and the skirts sewn on to it, one on either side. The saddler then re-moistens the seat and installs it in its final position on the saddletree. When the seat is in place, the saddler permanently affixes the skirts with a saddle pin. The sweat-flaps, which protect the rider's legs from the girth, are screwed directly into the saddletree. The saddler then sews three strips of extra-strong chrome-tanned leather on to the horizontal webbing holding the saddletree in shape. Last to go on to the saddle are the under-flaps, which protect the horse's flank from the girth. The saddler then adds a leather tongue to conceal the opening inside the saddletree, and leather-covered pads under the saddle to minimize friction between the saddletree and the horse's back.*

For the complete gentleman, shoes are the ultimate indicators of genuine elegance, the final touch distinguishing the true connoisseur from the dilettante. The well-dressed man's tweed jacket can be slightly worn and his gray flannels slightly creased—the "too-new" look has always been considered somewhat vulgar. But his shoes must be impeccable. Custom-made, of course, and by the very best boot maker.

At John Lobb in Paris, customers for bespoke footwear are received by the firm's skilled craftsmen, the fitters and last makers whose first task is to measure the foot meticulously from front to back and side to side,

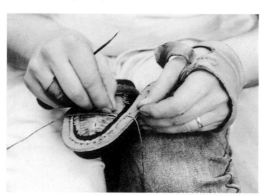

including each individual toe, the height of the arch, the curve of the instep, and the circumference of the ankle. These measurements are used as a guide for cutting and shaping the wooden block, or last, that will exactly reproduce the dimensions of the customer's foot. The new last is then used as a model for producing a pair of test shoes made from scrap leather. The customer is invited to try out the test shoes in person, so that the fitter can evaluate his last: does the curve of the shoe adhere perfectly to the foot? Do the laps of the front opening meet evenly when laced? And so on. On the basis of results from the preliminary test-shoe fitting, the fitter adjusts the last, whittling slivers off to reduce it, or glueing strips of leather on to expand it. The finished last must be an exact replica of the customer's foot because, as head fitter Michel

Renneteau explains, "the fit and style of the shoe depend entirely on the accuracy of the last."

Thus, the first material used in producing a pair of custom-made shoes is not leather but wood. Wood . . . and paper. As Philippe Atienza, head stitcher and cutter explains, "the last is an exact replica of the customer's foot, and the paper pattern for cutting the leather has to be an exact replica of the customer's foot as well." Obvious? No, elegant. The unique elegance and fit of a custom-made shoe reflect the fact that the paper patterns used for cutting the leather components are made to the exact dimensions of the last, which is made to the exact dimensions of the individual's foot. A custom-made shoe contains some fifty separate pieces of leather, from the more or less invisible components that ensure comfort and fit (shank, lining, and interlining) to upper, wings, heel, and sole.

All the components are cut from various types of calfskin, which is preferred for footwear except in the case of special models made from more exotic materials such as alligator, ostrich, and sharkskin. The calfskin used for shoe leather is naturally tanned on the underside, and lightly chrome or aniline-tanned on top—just enough to preserve the material without masking the natural grain. When cutters make their incisions into the leather, they are careful to work around any flaws and to respect the direction of the grain in order to get the most out of the piece.

In boot making, the word "upper" refers to the visible and often decorative part of the shoe that covers the upper surface of the foot. The deli-

cate task of joining together and decorating the components of the upper is performed by stitchers. Before the stitchers can begin their work, however, the components of the upper must be molded to fit the curve of the foot. The leather is moistened, and a blocking grip used to stretch it over the last. The blocking grip is also used as a hammer to nail down the edges of the leather while it dries. When the leather components dry, they retain the shape blocked by the last, and are ready to be joined by the stitchers. A variety of stitching styles can be used, depending on the final effect sought.

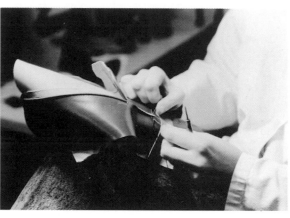

Double seaming forms a depression; raised seaming forms a ridge; Norwegian through-seaming gives a sturdy, rough-hewn effect. Classic models each have their own special styling: cross-seaming for the Oxford; tucked-seaming for the Derby; low buckled-boot for the Jodhpur; elastic sides for high-top boots; and so on.

The work performed by the stitchers who assemble the upper is highly visible and much appreciated, but that of the sole assemblers, though less obvious, is no less important. Inserting arch and heel supports between lining and upper with no overhang or overlap, and then joining sole and heel to the whole requires high levels of craftsmanship.

When the upper is stitched and the heel and sole have been assembled, the upper is again blocked on the last and hammered around the bottom

*edge to form a ridge indicating the line where the sole of the shoe will be welted to it. The sole assembler places a piece of leather under the last, and glues a strip of leather around the outside edge to indicate the rim of the sole beyond the welting. The upper is then welted to the sole by joining the raised ridge around the blocked upper to the inside of the leather rim running around the sole. Invisible stitching is used for this operation because, as all connoisseurs know, true elegance is always discreet.*

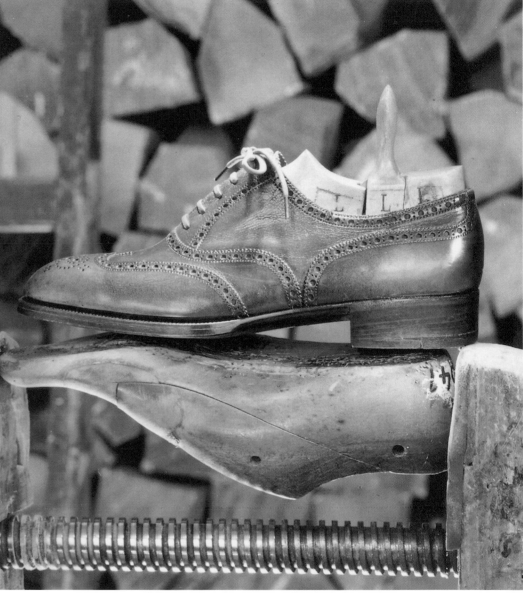

*Fancy upper for a Derby shoe.*
*Stages of shoe production at John Lobb*

From left to right:
*Sewing the shank: the different pieces of leather are assembled by mechanical or hand stitching.*
*Shank assembly on to the last.*
*Triple stitching.*

### The Paleolithic Age

Animal skin was one of the first materials to be employed by humankind, and although an element of somewhat precarious comfort, it rapidly proved to be practical and resistant. It protected the body against the rigors of the climate, enabled people to build huts, to assemble tools and weapons, and to tie them round their waists. However, in prehistoric times the

process of tanning skins to keep them from deteriorating had not yet been discovered.

### The Neolithic Age and Antiquity

As early as six thousand years B.C., the Egyptians are thought to have tanned skins by means of acacia or alum pods. Leather thus became more resistant and could be used for making various objects such as upholstery, sandals, helmets, shields, and straps for wrapping mummies. Throughout antiquity, skins ensured the best protection during combats. Roman warriors, from the gladiator to the legionnaire, were equipped with a leather breastplates, called a *cuirasse*.

### Arabian expertise

As early as the eighth century, the Arabs perfected a vegetable tanning process, using sumac leaves, acacia and oak bark. After drying in the sun, the skins were in an ideal condition for shoe manufacture, bookbinding, repoussé, etc.

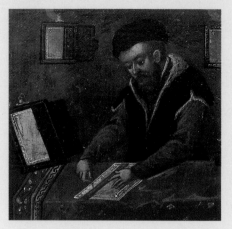

***Cordovan and morocco leather****:* Until the seventeenth century, there were three main centers for producing and exporting tanned leather: Venice, Fez, and Cordoba.

Until the seventeenth century only leather from Cordoba, called cordovan came into France; during the seventeenth century, cordovan was used exclusively for decorative purposes and upholstery.

The term "morocco" leather was used for goatskins tanned in Fez in Morocco; in French the person who works this leather is a maroquinier. Some attributed its introduction in France to a certain **Granger,** who imported sumac, the plant used for the tanning and dyeing of morocco leather, from Turkey, Cyprus, and Sicily. Others attributed it to **Sigismond d'Adelin,** who came from a family of tanners in Montélimar and who had brought back two soldiers from the entourage of the Sultan Moulay Ismail in Morocco, who knew how to tan and dye morocco leather. In the seventeenth century the three known dyes were black, kermes red, and morocco green.

### Leather trades in the Middle Ages

Monarchs, princes and lords led extravagant lives at court. With the increased demand, the leather trade expanded to include the manufacture of shoes, gloves, trunks, coffers and money bags. Tanners and curriers set up guilds and in 1345 Philippe VI de Valois drew up statutes and rules for "master curriers, belt-makers, and cobblers."

***Glover–perfumers****: After perfumed skins had been brought back from the Orient by the Crusaders, Philippe Auguste granted glovers the exclusive right to manufacture perfume. Constant rivalry broke out between the two professions and Henri IV was obliged to abolish the glovers' title of perfumer, but nevertheless permitted them to use the fragrances. By 1614 they had regained their monopoly which they were unable to maintain in the eighteenth century due to the cost of essences.*

As of the fifteenth century, leather was embossed and gilded for upholstery purposes and above all used as floor and wall covering for noble residences. The vogue for this luxurious element of interior decoration did not decline until the arrival of wallpaper in the eighteenth century.

### The Renaissance period

In the sixteenth century the range of leathers expanded to include lamb, calfskin, and kid. Shortly after, morocco leather and exotic skins such as lizard and snake also appeared; they had been brought back, along with new dyes, by the great navigators.

### The seventeenth century

**Colbert** facilitated the import of skins through the Compagnie française des Indes.

***Hungary leather*** *is tanned by a technique first used in France during Henri IV's reign in the eighteenth century by a Magyar tanner named* **Kandar***. Henri IV had been looking for a rapid tanning process to equip his army, as the traditional methods using oak could take up to two years. By shaving the skins with a knife, submitting them to the action of salt and alum and subsequently tallowing them, it was possible to obtain a tanned skin in three months.*

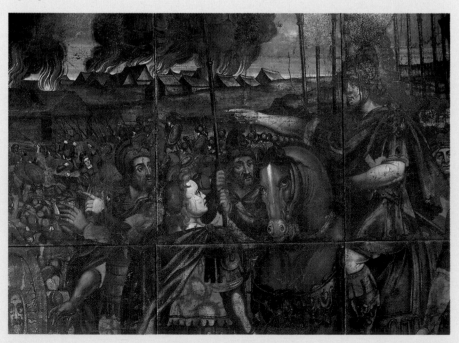

## The eighteenth century and French leather production

In 1749 the Manufacture royale du Cuir was created. The eighteenth century witnessed a considerable development in luxury objects made by master casemakers, from lavishly worked coffers to trunks, not to mention the hand mirror, the wallet, and above all the indispensable writing, sewing, or toilet cases in embossed, gilded morocco leather or sharkskin.

*Galuchat: This material is in fact the skin of the dogfish (a species of small shark) or skate and usually tinted green. The master casemaker, Jean-Claude Galluchat, who traded during Louis IV's reign, gave his name to this process when he discovered the art of softening and dyeing fine and heavily grained skins. Sharkskin is used for small objects such as boxes and cases and became popular in the second half of the eighteenth century.*

## The leather industry in the nineteenth century

The treatment of leather in the nineteenth century did not escape industrialization. In the United States, Samuel **Parker** invented a leather-cutting machine. In 1816, an English-man named **Kurz,** produced chrome-based dyes. In France, **Thimonier** manufactured the first wooden sewing machine in 1820

and in 1850 the American, **Howe**, was pro-ducing about a hundred a day. Chrome tan-ning became industrial practice in 1884.

The discovery of aniline in products resulting from the distillation of pit coal, by the Swedish chemist, **Underborben**, radically transformed dyeing techniques, enabling all sorts of colors to be obtained and repro-duced with exactitude. In 1840, the German chemist, **Fritsche** gave this product the name of aniline, which is derived from the Por-tuguese word, anil, meaning indigo.

Throughout the century shoe manufacture became increasingly diversified to include pumps, ankle-boots, buckled court shoes, and boots, which had for a long time been reserved for the army.

*A well-shod adventurer, John Lobb: After training at Thomas's, the best bootmaker in London, John Lobb tried his luck in Australia, inventing hollow heeled boots for gold prospecters. On his return to London in 1850, he opened a shop specializing in made-to-measure shoes, which supplied the royal family and the British aristocracy.*

*With the advent of the handbag in 1835, the fine-leather trade became an important industry and rapidly produced a multitude of small objects.*

*The founders of the fine-leather industry in France: Thierry Hermès (1801–1878) belonged to a protestant family who had settled in Paris. In 1837, after a training period in Pont Audemer, the main center of leatherwork, he opened a workshop producing harness equipment. The Sec-ond Empire engendered ostentation, equipages, and a taste for equestrian pleasures. The second son of Thierry Hermès, Charles-Emile Hermès (1831–1918) started assisting his father in 1850 and was awarded a prize at the 1878 Paris World's Fair. In 1880, at No. 24 rue du Faubourg Saint-Honoré, in the district of high finance favored by the aristocracy, he opened a sad-dlery, which supplied the Elysée Palace and the great courts of Europe.*

*Louis Vuitton (1821–1892) opened his own workshop in Paris in 1854, and presented his first trunks, not in the customary pigskin, but in gray, glazed waterproof can-vas. They were fitted with com-partments and, being flat, could be stacked. In 1872 to avoid copies, he created a red and beige striped canvas, followed by a check design in 1889, the year in which he also created the first trunks fitted with hanging facilities and drawers, as well as trunk–beds for French military officers.*

The notion of right and left shoes had emerged during the French Revolution.

## The twentieth century

At the beginning of the twentieth century, artisans working in art nouveau chose leather as the medium for all kinds of creations, such as wallets, ladies' handbags, powder com-pacts, bookbindings, and desk blotters. These were made of the finest leather, decorated with engraved, repoussé, or floral and animal fretwork motifs.

In the twenties, leather was abundantly used for upholstery and morocco leather, parch-ment, and sharkskin enhanced ladies' furni-ture designed by artists such as Iribe, Mère, Rousseau, and Groult.

The two world wars, the discovery of artificial leather in 1942 by **Dupont de Nemours,** and intensive mechanization all contributed to the gradual decline in craftsmanship.

**Georges Vuitton** (1857–1936), who was confronted with the problem of counterfeit

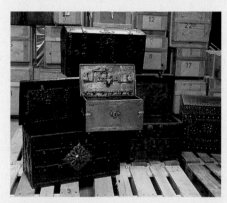

*International competition and the importance of trademarks: In 1900 Emile-Maurice Hermès (1871–1951), the youngest son of Charles-Emile Hermès, decided to open up the Rus-sian market and returned with the title of Supplier of the Stables of the czar of Russia. During the First World War he served in Canada and North America, and with the development of transport he became aware of the evolution of luggage and the importance of trunks and suitcases. He brought back a new system, the zipper, which he used in his fine leatherware, such as carry-alls, handbags, and sports bags.*

copies, designed a new mono-gram canvas with decorative motifs and the initials, "LV," those of his father, and which he patented and used for his new hat and shoe boxes and cabin trunks. It is to his son Gaston Vuitton (1883–1970) that we owe the creation of sup-ple, waterproof canvas baggage in 1959.

# Hotels and

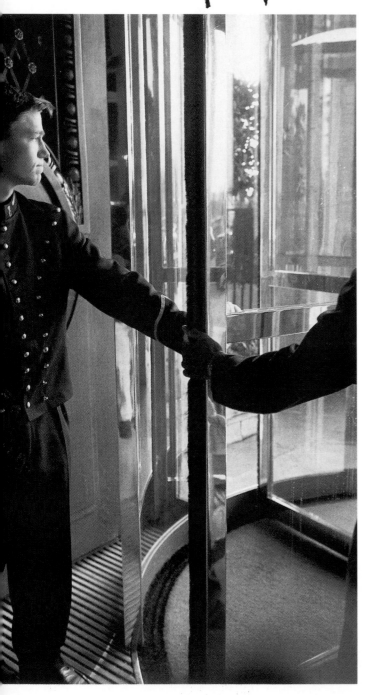

Grand hotels, select country inns, and fine restaurants stand as reassuring proof that machinery, however modern and sophisticated, will never replace the personal attention of expert managers and skilled staff. These are people who are responsive but not intrusive, attentive but not obsequious, discreet but not colorless. In short, personnel that is never impersonal.

This elite of the hotel and restaurant industry have chosen a path that demands infinitely more than the ordinary care, courtesy, and attention all hotel and restaurant patrons everywhere rightly expect from the people who serve them. Although impeccable service at the highest level has often been compared to a stately ballet or a well-ordered military maneuver, an even apter comparison might be to the mechanism of an elegant timepiece that never stops and can always be relied upon to give the exact hour. The fine-tuned human components that make up the complex mechanism of a grand hotel are also unfailingly reliable: visible yet unobtrusive, vital yet unassuming. These efficient, self-effacing professionals perform with deceptive ease the hundreds of large and small tasks underpinning the delicate equilibrium of a great establishment. Their work must never seem to be work, but rather a ceremonial function, an esthetic exercise, or even a religious vocation. It requires sacrifice, and it cannot be done hypocritically. Staff members must show sincere devotion for their guests, but—with consummate tact—only when required. At other times, they blend into the woodwork, disappear into the background, assume the blank expression of guards at Buckingham Palace. Every country on the globe has its international luxury hotels and its idea of what such a hotel should be. All have their starred restaurants and virtuoso chefs. But a few leading lights stand out in even the most distinguished company. The very best banish all traces of the cold, impersonal, and even artificial atmosphere found in so many expensive hostelries. At the greatest hotels, even the most reticent guests are made to feel completely at home—immediately, unpretentiously, and without undue familiarity. These establishments are designed

# Gastronomy

to provide the ultimate in comfort for the ultimate clientele, and their staff members are attentive to every detail, large and small. Their job is to smooth every difficulty, including any arising from over-strained perfection itself. "Possessing great qualities is not enough," La Rochefoucauld states in a maxim, "you must know how to use them." Discretion is definitely the better part of valor when it comes to making hotel and restaurant guests feel at home, but not to the point of invisibility. Members of a luxury hotel staff must actually adjust their performance so that it falls somewhere between clockwork regularity and ghostly elusiveness. The best among them are domestic genies, benign spirits who effortlessly grant every wish. Nothing works better than imperturbable tact, courtesy, and willingness to please when it comes to making bad-tempered or even uncouth guests seem as graceful and charming as royalty.

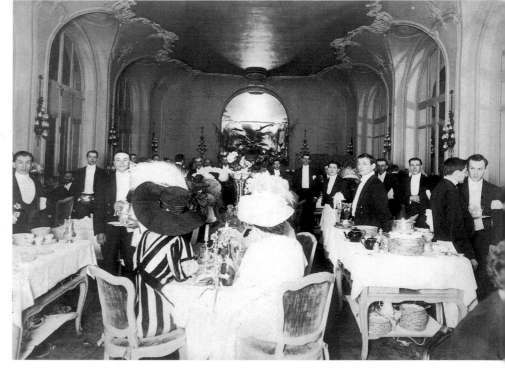

The basic tasks carried out in all grand hotels worthy of the name include accommodating the most diverse tastes in the most diverse ways; responding to any demand—and often to conflicting ones simultaneously—while also leaving each guest with the impression that they alone are the most important people in the world; and enveloping new arrivals in an atmosphere of genuine warmth while steering them without mishap into the empyrean of well-being. People do not simply "stay" at grand hotels, they enter a realm of carefree bliss—or carefree ease, at least—over which they reign supreme until the day they depart. When guests are once again cast forth from this paradise, they cherish the memory of having been, for all too brief a time, in the very best of worlds, leading a charmed existence beyond the invisible frontiers that separate these palaces of our time from the rest of the planet.

*Engraving by Eugène Lami.*
*French Second Empire. Bibliothèque*
*des Arts Décoratifs, Paris.*
Top: *The dining-room at the Ritz at the*
*turn of the century.*

Left-hand page: *The bellhop. Guests walk*
*into a dream, and when they leave,*
*that dream should still be with them.*

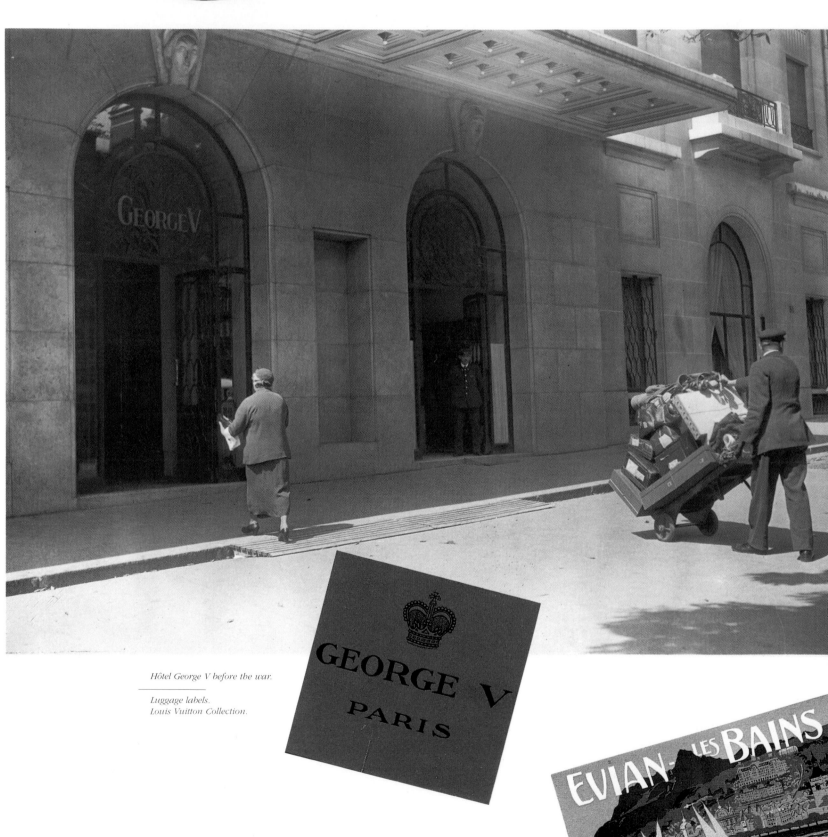

*Hôtel George V before the war.*

*Luggage labels.*
*Louis Vuitton Collection.*

There is something warm and almost homely about staying in a luxury hotel, or returning to one after an absence. Although not all concierges resemble P. G. Wodehouse's inimitable Jeeves, their welcome contains much more than just professional courtesy. It expresses their love of life, of the job they do, and their pride in serving such a good "house." They make any stay at a grand hotel a real pleasure.

True luxury is reflected above all in the quality of a hotel's staff. Senior staff members frequently boast over twenty years' service at the same establishment. Their customers are the crowned and uncrowned elite of international high society, and this experience gives them a refinement and polish that makes them truly "men for all seasons."

Hervé Houdré, director of the Hôtel de Crillon, explains the importance to a hotel such as his of relationships built up between staff members and guests from the moment the reservation is first made until final departure. "Guests walk into a dream, and when they leave, that dream should still be with them. I have a little speech I always make to each new staff member: 'Running this hotel is like producing a play. We have a stage set, and we're the actors. If the actors bungle their lines, it doesn't matter how magnificent the set is, the play will be a flop.' Furthermore," Houdré continues, "there's no room for error in the hotel business, as in some other professions. Every second of the day and night, every day of the year, we have to be ready and able to solve any problem that arises, to calm any disturbance that might disturb our guests' dreams."

### The art of hospitality

This attitude explains why great hotels are sometimes compared to ships at sea, and also why staff are indeed often recruited from the navy. In a hotel, as on a ship, every crew member must be ready to serve at all times.

A "seaworthy" luxury hotel will have a crew numbering no less than two employees for each guest. This is the absolute minimum required for achieving the levels of service that give luxury hotels their distinction. This service starts even before guests register at the front desk in the lobby: it begins when the reservation is made. For example, several highly important guests might all request the same suite for exactly the same dates. It takes the tact of a diplomat and the insight of a psychologist to smooth things over and

satisfy each valued guest. The head desk clerk must know regular guests personally so that he can soften their disappointment at not being able to have a specific suite or room by providing extra services tailored to their individual tastes. "Our guests must feel they're coming home," as Houdré puts it. Birthdays are noted, children and grandchildren are asked after by name, honeymooners find flowers and champagne in their room. In a word, everything possible is done to personalize the service. Everyone on the staff makes a point of learning as much as they can about regular guests, their tastes, and their preferences—and of remembering what they have learned for next time.

*Running a hotel is like directing a play, with its scenery and cast of actors.*

The team at the front desk also makes every effort to expedite departure formalities by preparing bills in advance according to guests' instructions. Some people want the charges for rooms and extras billed separately, others want everything billed to their business accounts. Part of the head desk clerk's job is to make tactful inquiries regarding guests' wishes, either during the stay or, even better, at the time the reservation is made. This eliminates awkward misunderstandings and delays at check-out time.

The final task of the head desk clerk or, when he is not available, of the head cashier, is to enquire whether the guest's stay was satisfactory. The staff have instructions to ask departing guests without fail for their reactions, since "a guest who has nothing to say will never return."

## A man you can count on

The person guests will have the most contact with during their stay, and the one they can count on to fulfil the most difficult requests, is the concierge. A concierge is like a guardian angel presiding at his desk near the hotel entrance. He is the person to whom everyone turns instinctively, even if his exact functions are not fully understood. He is a living symbol of the luxury hotel and all it stands for, and the roots of his unique status lie in France. The concierge's profession has been fine-tuned on French soil over many centuries, and through all the vicissitudes of history. Indeed, the *Association des Clés d'Or*, a federation of some three thousand

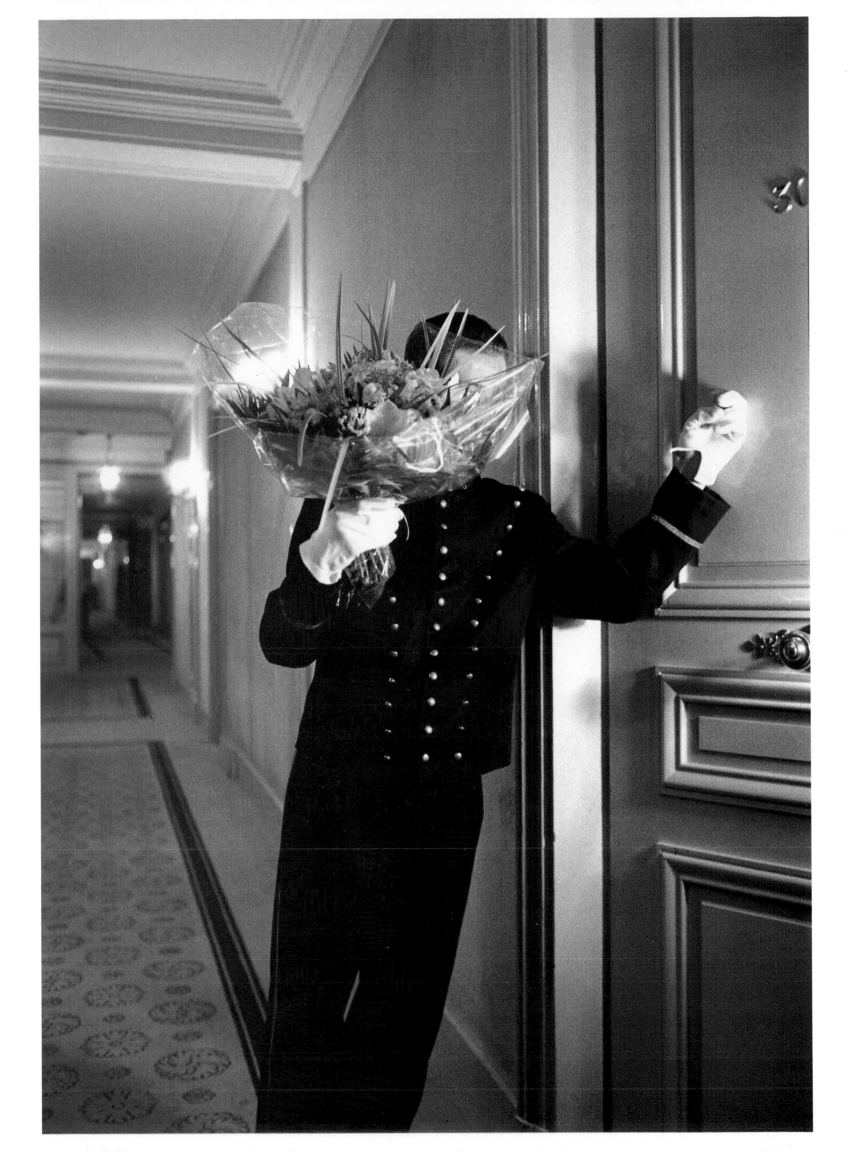

**The legendary
Royal Evian**

*The Aga Khan kept a suite at the Royal Evian Hotel for forty years so he could take "stationary cruises" on Lake Geneva. This hotel is indeed royal,*

*since its first illustrious guest, at the time when international socialites wintered on the Riviera and summered at spas, was King Edward VII. The hotel's dining room, rotunda, and salons, decorated in 1909 by Gustave Jaulmes, still express the infinite charm of a secluded resort boasting a spa, a casino, and some of the earliest sports facilities.*

concierges employed in luxury hotels throughout the world, was founded in France. By contrast, in the United States the position of hotel concierge languished for thirty years before attempting a recent revival.

A seat at the concierge's desk is won only through long years spent climbing the ladder of hotel service. Christian Freron, currently concierge at the Crillon in Paris, began his career aged sixteen as a luggage clerk, and served for twenty-four years before attaining the coveted position he holds today. Gérard Avez, who joined the staff of the Paris Hôtel Ritz at the age of fourteen, waited twenty-six years before winning the supreme position. The long wait is partly due to the fact that this post is a managerial one: concierges head a team of employees whose attractive uniforms may sometimes obscure the fact that they are crucial to the smooth functioning of the hotel, and are are not just there for decoration.

Concierges work with one or two assistants who themselves have almost reached the top of the ladder. At their post near the concierge's desk stand the bellhops, schooled to leap to attention when even the smallest service—such as carrying packages or delivering mail—is required. Nearby are the commissionaires: young men, who do guests' shopping for them and carry confidential messages. The doormen direct traffic in front of the main door, and the luggage clerks handle suitcases and trunks in the lobby and the storerooms.

The concierge, who reigns over all, is there to execute special requests: "Anything, so long as it is legal. The possibilities are endless, which is what makes this job so fascinating." The concierge will reserve a table at the greatest, most famous, most over-booked restaurants. He can find seats for standing-room-only shows, and make last-minute plane or train reservations. And this—along with running errands for guests, and delivering and receiving packages, parcels, and letters—is just the beginning.

EXPECTING THE UNEXPECTED • The most important qualification for the concierge in a luxury hotel is an ability to deal with the unexpected and carry out unusual requests. A Saudi-Arabian prince once wanted to rent a stadium so that he could play football that evening. An American executive whose baggage had been mislaid telephoned from his plane to order an entire new wardrobe. Christian Freron sent a commissionaire out to find a top Parisian tailor and rush him to the airport. "We fitted out our guest from head to foot on the side of the road into town," recalls Christian Freron, describing how he saved the day for the man without a suitcase.

Thanks to the *Association des Clés d'Or*, a concierge can also provide long-distance service. Reserving a box at the Madrid bullring or the Vienna Opera is an everyday part of the job. With a phone call to a colleague in another city the international network of concierges immediately goes into action to obtain whatever is desired.

In order to develop his plethora of personal contacts, a concierge needs to keep abreast of everything that is going on, attend play openings, and participate fully in the city's cultural life. A concierge "knows everyone," which is useful for someone who needs to have access to everything. Affable, courteous, and cultivated, the concierge is a sparkling conversationalist who also knows how to listen and how to be discreet.

It should come as no surprise that lasting relationships are often formed between concierges and regular guests of the hotel, if not of friendship, at least of keen mutual regard. "We're here to help our guests, to support them," notes Gérard Avez. "For us, hotel guests aren't just numbers, they're individuals. At the concierge's desk you would never catch us referring to a guest as number 126, for example, but always by name." Not many guests today take up permanent residence in hotels, as Coco Chanel once did at the Ritz, in the suite that now bears her name. Nevertheless, many people still think of their hotel as a home-away-from-home, a place to spend the spring or fall, the space of a "Paris season." These guests leave their "Paris wardrobe" in the hands of the concierge and his team. The clothing is placed in storage at the hotel, taken out again on the eve of the guests' arrival, and carefully hung in the wardrobes of their suite or the closets of their room. This is just one more of the many small but important services cheerfully provided. Better yet, guests can call on the concierge for assistance even after their stay at the hotel has ended. A phone call from a regular guest, even from another city or country, will always bring an immediate response from the concierge.

**Immutable gestures**

*The experience of dining at a restaurant in a luxury hotel is a rediscovery of a whole series of gestures that in themselves form part of the gourmet experience. "Cutting,*

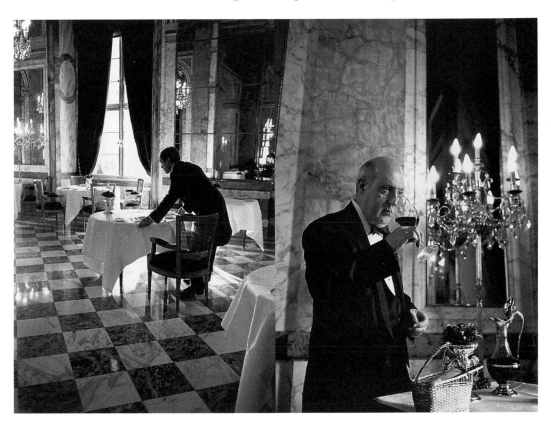

*carving, flaming, and even tossing a salad on a side table become a kind of theater of the dining-room," explains Laurent Vanhoegaerden. The restaurant of a great hotel can surround the subtleties of its cuisine with a theatricality that in former times was an integral part of the art of gastronomy.*

## The master strategist

The last bastion of a great hotel, the Head Housekeeper, works behind the scenes to provide guests with perfect comfort as well as perfect service. The woman who discreetly supervises the hotel's

physical condition and its guests' comfort as if she were a hostess in her own home is the final link in the chain that makes luxury hotels unique. Her most difficult task is deploying the battalions of cleaning, serving, and maintenance personnel who care for all of the hotel's equipment: electricity, plumbing, radio and TV, furniture, carpets, curtains, and fittings. "In fine old hotels such as ours," explains Sylviane Parlier, head housekeeper at the Crillon, "no room is exactly the same as any other. There are lots of little passageways and nooks and corners that make inspection much harder than it would be in a modern, standardized building." This means that Madame Parlier spends much of her time roaming the hotel's six or more miles of corridors, checking on such fine points as the freshness of the flower arrangements (which is crucially important) and the cleanliness of cellars that no one but the staff will ever see. "Staff areas must be as well kept as the parts of the hotel visible to our guests," she notes, like a military staff officer who knows that the troops' morale depends on the way they and their quarters are treated.

## Fine dining

ON THE ROLODEX • Hotel restaurants are also important to the satisfaction of guests. Fortunately, the bland "international style" is a thing of the past, and the great Parisian luxury hotels are now havens of gastronomy. The Ambassadeurs restaurant attached to the Crillon and the Espadon at the Ritz have each earned two stars. Franco Cozzo, who manages both the Plaza Athénée and the George V, spearheaded the change by hiring talented young chefs

for both establishments, and then giving them free reign in the exercise of their art.

This freedom is limited only by the laws of hospitality. A great hotel is a second home for its guests, and must therefore be a refuge where the slightest whims can be satisfied. This is why Gérard Sallé, executive chef of the Plaza Athénée restaurants, keeps a very special Rolodex beside him at all times. It contains a file of all the dietary requirements and special tastes of the hotel's regular guests. These can be odd as well as illuminating: Monsieur X likes to snack on Swiss-style Grisons dried beef and mozzarella; Madame Y is allergic to scallops but loves Saint-Honoré pastry; Madame Z prefers her chicken poached in strong broth with vermicelli; Countess P likes waffles, which are not a staple of the menu, so a waffle iron must be available at all times in case she suddenly feels the urge to order one; Duchess S insists that her consommé be served in tiny china cups and delights in unsauced venison with plenty of preserves, chestnut purée, and three fried apples. There are hundreds more files of this kind, a gallery of culinary tastes, habits, and quirks that could have been drawn directly from Proust.

*Waiter and chambermaid.*
*It is the service which makes the grand hotels very special.*

THE MEALTIME MINUET • Restaurants in luxury hotels tend to be huge and overwhelming, and can give new arrivals the impression that they are on public view. "That's why," notes Laurent Vanhoegaerden, manager of the Ambassadeurs, "an important part of our dining-room staff's job is to make guests feel at home."

This involves a stately minuet featuring the *maître d'hôtel*, who guides guests to their table and takes their order; the head wine waiter, who advises them on what wine to choose; and the waiter, who both serves the meal and responds promptly and attentively to any request. The purpose of this carefully choreographed show is to provide impeccable service and to create a congenial atmosphere. When exquisite cuisine and perfect service are combined like this, the result surely attains something close to the luxury standards of days gone by.

## Dining out: a chef's market

At eight o'clock in the morning at Taillevent, suppliers are busily unwrapping the day's offerings in the Parisian restaurant's Second Empire courtyard. The restaurant's chef, Philippe Legendre, carefully inspects a sea bass as the dealer weighs it. This man is a regular supplier who comes in daily from the central wholesale market at Rungis on the outskirts of Paris. Legendre takes the magnificent fish from the scale and holds it aloft. A few seconds pass and then he pronounces his verdict: "Not firm enough." The fish is splendid—gills white, scales shiny, eyes still bright. This bass would be the pride of any ordinary display at any ordinary fish market, but Philippe Legendre's keen eye has detected some almost imperceptible lack of freshness. Perhaps the fish has been out of the water for three or four days. In any case, it does not meet Taillevent's exacting standards. The dealer does not argue: he is used to this degree of rigorousness and knows how lucky he is to have been selected to supply the famous three-star restaurant.

For Philippe Legendre, the veal sweetbreads from Corrèze are never plump enough, the rack of lamb from a milk-fed animal never white enough, the pigeon breast never tender enough. Legendre's menu emphasizes hearty regional dishes over delicacies like truffles and *foie gras*. For example, his latest addition to the menu is country-style loin of pork, and he is also the man who brought back tiny Lake Geneva perch and trout ("straight from the lake," he hastens to point out to sceptical diners, "never from the fishery tank"). He delights his clients' palates with no less than three à la carte dishes made from veal, the meat that slumped in popularity when it began to be treated with hormones, and is only now, thanks to a more enlightened labeling policy, recovering its dignity and reputation as a "noble" meat.

## Team spirit

Procuring the best raw materials available is the keystone of the restaurateur's craft, and this is fully understood by youthful, 35-year-old veteran Philippe Legendre. After an apprenticeship in Normandy and positions at the Sheraton and the Ritz, Legendre's entire career since 1981 has been spent at Taillevent, where he started as section head and then rose to the post of executive chef.

Legendre comes from French peasant stock, a background that has left him with a certain native reserve accompanied by undeviating loyalty and genuine modesty. His modesty comes to the fore when he describes the sanctum of French culinary tradition

over which he has presided for the past thirteen years, and the team he directs there. He disapproves strongly if implicitly of today's media-centered celebrity chef system. "Chefs have no business seeking fame," declares Legendre, "since what we really need is to retain our humility. A great kitchen doesn't have a leading man surrounded by supporting players, it has a team of twenty-five equals, all working together." Teamwork is Legendre's top priority, the kind of teamwork needed to win at rugby, a sport dear to his heart because it represents the values he believes in. In his own words it is "a sport that's still played for the love of the game. A noble sport. A pure sport."

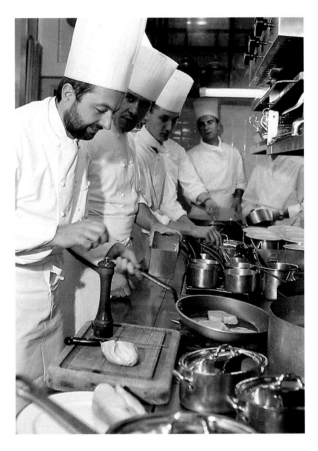

### Turning basic ingredients into gourmet meals

In Taillevent's cramped kitchens at nine-thirty in the morning Legendre's team, divided into five sections, is getting underway. On the central table (the "piano," as professionals call it), the sauce bases are bubbling in their pots. Cauldrons of fish and meat stock, for adding later, simmer gently to reduce their volume and increase their strength.

These are the basic steps in classic French cuisine, the exercises all chefs practice as diligently as a concert pianist doing his scales. "However," says Legendre, "we have modified some of our sauces to suit modern tastes, and I have nothing against 'light' cuisine."

Legendre's preferred station is the supply area, where he can keep an eye on the cutting, slicing, and chopping operations. "Skillful handling of raw materials is essential," insists Philippe Legendre, one of the rare great chefs in today's media-conscious world who still prefers the "hands-on" approach.

### Rush hour

Lunchtime, when Taillevent fills with businessmen on tight schedules, is the busiest part of the restaurant's day. The pace begins to quicken about eleven, as the ingredients for cold appetizers and salads leave the pantries for preparation.

*171*

Above and following pages: *Rush-hour at Taillevent.*
Center: *The chef, Philippe Legendre.*

### Rush hour at the Plaza

*In the kitchens of the Plaza Athénée, which serve two restaurants—the gourmet Le Régence and a grill, Le Relais—plus handling room service orders, the young chef Gérard Sallé heads a team of some twenty cooks. Today there are only nine present, but in the vast, well-organized kitchen, they seem to work with the effect of many times their number. It takes a while to realize that the apparent confusion is really highly efficient. Orders come in by computer to the "relay" and are immediately given out over the intercom. First sous-chef Gérard Guérineau stands at the microphone, affable but authoritarian, keeping one eye on the waiters linking the kitchen to the restaurants, and the other on the*

*orders, duplicates of which are posted in front of him. He listens attentively to the noises rising from the various stations in the kitchen, and to the answers punctuating his order. The executive chef seems to be everywhere at once, opening fresh scallops, sprinkling grated Parmesan on a plate of risotto, rolling a spoonful of warm* foie gras *on to an aspic, wiping the edges of a plate, raising a silver lid to check a dish about to be carried off by a waiter. During rush hour, he can be a slicer, sauce-stirrer, cold-dessert man, grilled-meat expert, and assistant to all the section chefs in an infernal fandango lasting until mid-afternoon, when the last order is taken, the last order filled. Only then does the kitchen recover the precarious calm that precedes and follows great battles.*

At noon, the execu- command post at the When the first order the day comes in, he phone and relays his line to the roast and tive chef moves to his central serving table. from the first diner of turns to his micro- instructions down the grill chef, the fish chef, the sauce chef, and so on. Just five to seven minutes after the order is given, the finished dish arrives at the serving table. The chef checks it, gives the plate a final polish, and signals his approval. His post is an island of calm in the midst of chaos. After an hour or more of frantic activity the pace slackens and clean-up work begins. Constant, spotless cleanliness is the rule for this temple of fine dining.

Finally, the chef and his team can take a break, another rush hour behind them. Just business as usual . . .

### A passion for fine food

The noise, confusion, heat, and competing odors of a great kitchen make it a less than ideal place in which to appreciate the dishes that are prepared there. Only as the completed dish journeys towards the dining-room does its distinctive personality begin to assert itself. Philippe Legendre realizes this, admitting, "I believe the only way to appreciate what my kitchen can do is to sit down in the dining-room and be waited on as if I were a customer. There's too much going on in the kitchen—it's impossible to savor the food fully there." Thus, every Friday, chef Philippe Legendre and Taillevent's owner Jean-Claude Vrinat sit down together in the dining-room of their own restaurant, to be waited on by their own staff, for what they refer to as the "Friday Ritual." Vrinat's goal is to preserve the unique style of the establishment opened by his father André in 1946. The restaurant is named after the first French chef to have served the public, the fourteenth-century founder of that much-needed facility, the public cookshop. The name "Taillevent" symbolizes a restaurant that stands above passing fashion and is totally dedicated to the great French culinary tradition. "Not the style developed in the nineteenth century," Legendre points out, "which was a 'nouveau riche' variation on the real thing." Taillevent subscribes to an older tradition

handed down by chef at the Savoy and hotels headed by motto was "Simplify!" follows an undeviat-

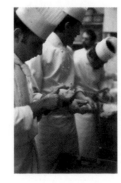

Escoffier, legendary Carlton in London César Ritz, whose The "Friday Ritual" ing sequence. Legen-

dre and Vrinat sit plete meal, and sampler that often test of a restau- down to a com- not the kind of passes for a valid rant's quality. The two men enjoy their meal at leisure. "Three mouthfuls don't allow all the subtleties of the flavor to develop," explains Legendre, "but when you eat the entire dish, your hunger is completely satisfied. Only then can you sense whether the dish is too heavy, over-spiced, and so on. Chefs are artists who should of course be allowed to express themselves fully—but not to the detriment of the dining experience. Sauces, for example, should enhance a dish and not completely overwhelm it."

Taillevent owner and host Jean-Claude Vrinat concludes, "What really counts is our passion for what we do, the time we spend on it, and the distinction we bring to it."

ARTISTIC CREATION • At Taillevent, diners are clearly

in the realm of artistic creation, where every dish might be compared to a masterpiece of painting or a symphony by a talented composer. Great chefs are like the leaders of great artistic movements. They break new ground that is then cultivated by their followers. On another level, and in cooperation with major names in the food industry, Michel Guérard conducts international culinary seminars that have helped him hone his own ideas. Seminar topics include the unusual "Humor and Cuisine," analyzing an important factor in institutional catering; and the abstract "Cuisine and Geometry," dealing with pasta.

This master of the culinary arts chose to settle at Eugénie-les-Bains in a remote corner of the Landes region—a risk, according to some of those commenting on his decision to leave Paris. Once there, Guérard began creating dishes not merely on the basis of their main ingredients, although these of course remain primordial in his conception of cuisine, but on the basis of what he calls his "aromatic notes," a term borrowed from oenology which, as practiced by this master chef, is analogous to the defining notes of a wine's bouquet. Guérard's travels—particularly to China—with his colleagues and peers Troisgros, Chapel, and Senderens have led him to explore the cuisines of the world, enriching his palette with new flavors he then combines much as a vintner combines grapes from different rootstocks.

**A symphony of flavors**

*An example of Michel Guérard's distinctive work is his* Homard de l'Abbé Pistre en Bouillon d'Aromates, *a subtle blend of oriental and French provincial flavors. The lobsters are poached in a cabbage consommé made of beef stock, combined with a bouillon native to Thailand, "with curry and ginger adding a spicy note." Genuine gourmets will also detect other flavors, even when they cannot identify them exactly. "To the cabbage*

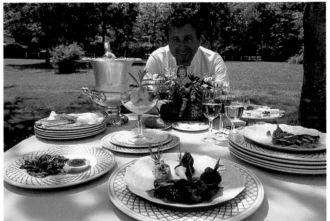

*consommé I added an infusion of boletus mushrooms," explains Michel Guérard, "because it seemed a little bland to me. Also, since I needed something to bind the beef-based cabbage stock with the Thai bouillon, I decided to add a little honey. This was just what I needed to orchestrate the whole, while allowing the tart note of the Thai bouillon to predominate."*

## The Plaisir laboratory

*The Plaisir testing and production laboratory located in a western suburb of Paris constitutes, according to product development supervisor Christian Ignace, "a village in miniature."*

*The quality of the food is improved by assembly-line production, since there are fewer interruptions in processing and much higher standards of hygiene are maintained than is usual in individual kitchens. Furthermore, since Gaston Lenôtre is one of the largest bulk buyers of quality raw materials—whether meat, fish, dairy products, or produce—this greatly increases his ability to supervise and control both grade and quality.*

*The laboratory houses master craftsmen from every field of food preparation. With its bakeries for bread and pastry, its "sweet roll" tower, its ice-cream and sherbet factory, its confectionery, its kitchen for prepared dishes, its charcuterie center, and even its food-decoration workshop, the Laboratoire Lenôtre de Plaisir could set itself up as a gourmet republic if it were not already too busy feeding—or rather delighting—thousands of appreciative diners.*

HAUTE CUISINE IN A RUSTIC SETTING • If a gourmet meal can be compared to a symphony, then the dining room of a great restaurant is like a concert hall, the setting in which its soul is unveiled to the public. Jean-Claude Vrinat, for example, knows that even the satisfaction of his chef is not enough, explaining, "the customer's verdict is the one that counts." Some of the dining rooms in which this final verdict is pronounced can be found in exceptional surroundings, such as Raymond Thuilier's Oustau de Baumanière, opened in 1945; and of course Michel Guérard's at Eugénie-les-Bains.

At Baumanière, the demands of modern-day diners are met by Thuilier's grandson and successor Jean-André Charial, who trained with Alain Chapel, the Troisgros brothers, and Paul Bocuse. Charial has gently modified the emphasis of a cuisine that is nonetheless still based on the inspiration and products of Lyon and its surrounding region.

DINING FOR MODERN TIMES • Shifts in dining patterns that began in the early 1980s inspired famed *pâtissier* and confectioner Gaston Lenôtre to branch out into custom catering. Today, the Laboratoire Lenôtre catalogue lists a total of fifteen hundred separate dishes, and the talented chefs serving in this imaginative enterprise are also ready and able to fill any type of special order, for any occasion.

This "restaurant with a difference" literally cooks without kitchens, and maintains consistent quality under conditions that can often be challenging, to say the least. Christian Lacour, head of the catering department, gives an example: "For the Paris–Le Bourget Air Show, I had to hire seventy chefs for a two-week period. I scoured the best kitchens in France to set up my team, starting with the Elysée Palace." Prepared and semi-prepared dishes leave the shipping-bays at the Plaisir research and production laboratory near Versailles, are delivered to the customer, reheated on steam tables, and individually served to thousands of diners who can thus enjoy all the pleasure of a "home" cooked meal. There are occasions, however, when Christian Lecour procures his supplies at Plaisir, and then prepares everything from scratch on location.

The Lenôtre achievement is based on the maintenance of constant quality standards at all times and under any circumstances. This is the responsibility of Lenôtre's skilled chefs, all of whom can boast at least fifteen to twenty years' experience working in the firm's various departments. Lenôtre's standards are high, and no compromises are ever made when it comes to the freshness of ingredients. Despite the high volume at Lenôtre, quality is kept at levels that rival those of the most famous chefs in France.

Left: *Coating chocolates at the Ecole Lenôtre.*

Right-hand page: *The first spice counter at Ferdinand Hédiard in 1860, at 15 rue Notre-Dame-de-Lorette, Paris.*

## A Parisian spice emporium

Crossing the threshold of the new Hédiard on the Place de la Madeleine in Paris is like entering an Arabian coffee merchant's in Aden, exploring a shop in Tokyo's Asakusa section, and touring the pantries of lady Elizabeth Anson, a cousin of the Queen of England. It's a round-the-world cruise right in the heart of Paris, an exploration of products selected by youthful lines dedicated to the gastronomy of certain "key" countries: the Italian line, the English line, the Japanese line, and the soon-to-be-added Chinese line. Brochures for each of these contain a few simple recipes and a list of the available products and how to use them. A host or hostess who is pressed for time can consult the brochures for information on how to nomic. From his meetings with suppliers and their customers he gathers information that is then studied by a "Selection Committee" in Paris that analyzes and evaluates the research. This cultural approach no doubt explains why diners on the upper floor of Hédiard's Place de la Madeleine headquarters find themselves in a room lined with books,

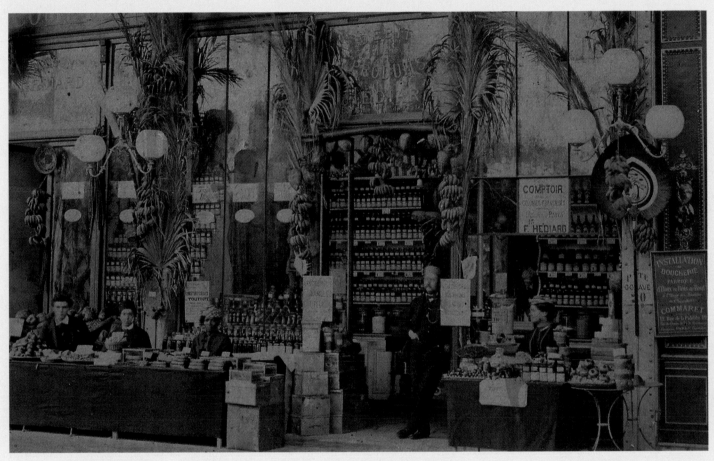

gourmet and globe-trotter Jean Philippe Zahm, former assistant chef under Alain Chapel. Zahm traveled to Japan to teach gastronomy at the Tutsi group—the largest hotel school in the archipelago—and Hédiard's management traveled to Tokyo to bring him back again, installing him as food manager of their flagship store.

Jean Philippe Zahm possesses the gourmet connoisseurship of someone who travels extensively and never tires of exploring and tasting culinary specialties and exotic products in every corner of the globe. Zahm's curiosity is reflected at Hédiard in newly added improvise a Japanese buffet, an English dinner, or a potluck Italian supper. All products are selected by experts with first-hand knowledge of the best products available in each category. The panel of experts includes associates of Great Britain's royal family, Sino-American businessmen living in Hong Kong, the venerable spice traders in the port of Tokyo and, nearer Hédiard's home base, Les Dombes restaurateur and charcutier Bobosse, who chooses Hédiard's andouilles and andouillettes sausages. Jean Philippe Zahm's approach is cultural rather than purely gastro-

and why the firm has quietly embarked on a plan to reprint rare works dealing with gastronomy. Hédiard's list of publications includes a monograph on tea, first published in 1843; Parmentier's treatise on how to serve potato cakes; and a 1777 treatise on champagne. Promised soon is a Dictionnaire de l'Epicier (Grocer's Dictionary), first published early in this century. With books now just a step away from the grocery counter, this spice emporium on the Place de la Madeleine is fast becoming a treasure trove of tempting intellectual treats as well.

### The Middle Ages

Medieval feasts were held on special occasions and only attended by gentry. Roast meat and game abounded, but the culinary preparation was not particularly refined and often very spicy. The first cooking manuals date from the fourteenth century, one

*Taillevent: By taking the name of the celebrated master chef of the fourteenth century when he opened his restaurant in 1946, André Vrinat showed an intention to perpetuate traditional French gastronomy.*

*Oustau de Baumaniere: Raymond Thuilier imagined a hostelry in the style of an old country inn when he discovered Les Baux de Provence in 1945. He opened a temple of gastronomy in his traditionally simple and refined style. Today, his grandson, Jean-André Charial perpetuates this culinary art.*

example being *Le Viandier* (1379) by **Taillevent**, the master chef at the court of Philippe de Valois, Charles, and Charles VI.

### The Renaissance

Renaissance cooking became more elaborate and less spicy. Under the Italian influence, the percentage of meat-based recipes diminished and an increasing interest was taken in vegetables, fruit, and pastry.

### The seventeenth century

The publication of *Cuisiner Français* by La Varenne in 1651, marked the beginning of a specifically French culinary style, using fat

and flour mixtures called *roux* and broth or bouillon, which are the basis of classic French cooking.

In Paris, inns and hostelries were opened in the streets and on the ramparts. The public

*Table Service —French and Russian styles: French-style service established in the seventeenth century was based on the following principle. The dishes instead of circulating from one guest to the next through the good offices of a servant, were placed on the table in successive series, called services, which varied in number from two to eight. In the simplest case, appetizers and entrées were brought for the first course, roasts and entremets for the second and the meal ended with desserts. The dishes, which were placed symmetrically on the table at the beginning of the meal, were decorated in a luxurious, spectacular style at the expense of gastronomy.*

*Russian-style service, adopted by the Paris ambassador of the Czar Alexander I, in 1810, consisted in having one dish, previously prepared in the kitchen, served successively to all the guests. The meat was carved in advance, either in the kitchen or on a table placed for that purpose in the dining room. It led to a progressive simplification of table organization. This style became widely adopted and was at the origin of fixed and à la carte menus.*

frequented them to quench their thirst and partake of morsels supplied by roast meat and sauce chefs, or by general caterers.

#### The Regency of Philippe d'Orléans

At the beginning of the eighteenth century culinary habits underwent a distinct evolution. The delicate dishes served at the Regent's suppers, who, it was said, sometimes officiated at the stove in person, paved the way for *nouvelle cuisine*. The principal characteristics resided in the diversity of the dishes (hors d'oeuvres or entremets were as important as the roasts, if not more so) and the triumph of sauces.

#### The end of the monarchy

*Les Dons de Comus,* by François Marin, was published in 1739 and proposed, in particular, information on the art of serving a meal with the utmost elegance. At this time houses specializing in the sale of fortifying broth ("restaurants") obtained the right to sell all types of dishes. Anglomania in France was one of the factors leading to development of these establishments, which resembled English taverns. Certain chefs employed in the large estates, opened their own restaurants (the movement grew during the French Revolution). One example is Beauvilliers (1754–1817), who, in 1782, opened one of the first great restaurants, La Grande Taverne de Londres, in the Palais Royal.

### The nineteenth century

In the nineteenth century the French dominated the international culinary scene. Certain chefs, like Antonin Carême (1783–1833) won incredible renown. He was the author of several works, including *L'Art de la cuisine française au XIXᵉ siècle*. He codified procedures, which resulted in their simplification, even if his somewhat architectural preparations were extravagant and complicated.

#### The "monster" hotels of the end of the nineteenth century

Large international hotels were built at the end of the century and their dining rooms became fashionable meeting places, where women were allowed to appear at dinner parties. In 1862, Le Grand Hôtel, one of the largest in Paris, opened next door to the Opéra Garnier; it boasted some 800 rooms, numerous dining

rooms, and a café frequented by writers such as Zola, Maupassant, and Oscar Wilde.

**The Grand Hôtel du Louvre,** opened on 16 October 1855, was built at the instigation of Napoleon III, financed by a company belonging to the Pereire brothers. It comprised more than 700 rooms equipped with the most modern

facilities and built around a courtyard protected by a glass roof. It was called the *l'hôtel monstre* due to its great size, the width of its staircase, and the sumptuous décor of the reception rooms. A drapers shop on the ground floor of the building, became so popular that it finally dethroned the hotel which moved to the place du Palais Royal in 1878.

**The Hôtel du Palais** in Biarritz was originally Empress Eugénie's summer villa. It became the property of the French government in 1870 and in 1881 it was transformed into a hotel and casino, inaugurated by the Duc d'Albe. The building was destroyed by fire and restored in identical style in 1905. When Edward VII and the Russian aristocracy took to patronizing this former villa it once again shone with imperial splendors.

**The Hôtel Royal Evian**, which was opened in 1909 on the shores of the Lake Léman, has lost nothing of its original vocation, but although a prolonged stay is just as pleasant for today's clients, their activities have evolved with the century—golf and tennis have replaced walks, while diet programs and hydrotherapy have taken precedence over drinking the famous water from the Cachat spring.

**The Hôtel de Crillon**, overlooking the Place Royale (now the Place de la Concorde) was begun by Jacques Gabriel in 1758. Shortly after it was enlarged by the architect Trouard and acquired in 1788 by the count of Crillon. In 1907 it was bought by La Société des Grands Magasins et des Hôtels du Louvre and transformed into a Parisian palace in a style in keeping with the existing architecture. The disposition of the series of salons is inspired by the Château de Versailles. The hotel offers the latest refinements in modern comfort and its location is exceptional.

**The Hôtel George V**, which was inaugurated in 1928, was built on a section of the quarry site from which the Arc de Triomphe foundation stones were extracted. Because of the origins of its first proprietor, **Joël Hillman**, who also owned hotels in the United States, it was patronized by an American clientele. The collection of antique furniture and tapestries soon won the hotel a reputation of luxury and elegance.

**The Hôtel Plaza Athénée** took its name from a first hotel built by the Bischoffsheim family, the Grand Hôtel de l'Athénée on the rue Scribe. The previous hotel possessed a

REVEILLON 1905

theater in the basement, but unfortunately for the guests, when the hotel was transferred to avenue Montaigne, the stage did not follow. The new building was erected in 1913 and extended in 1919 by the architect Jules Lefebvre. In 1936, as a concession to the new fashion for cocktails, an American bar called the Relais Plaza was installed.

## The twentieth century

The latest culinary revolution dates from the sixties. *La nouvelle cuisine* as Gault and Millau dubbed it, was developed by chefs such as **Bocuse**, **Oliver**, and **Guérard**. Its novelty resided in the simplification of dishes, the lightening of sauces, the reduction in cooking time, an increased use of fresh, seasonal ingredients, dietary concern, and liberal creativity.

# Haute

# Couture

Fashion—a perpetual movement that by its very definition escapes definition—is always going out of fashion. Fashion is a state of mind decreed by the few and momentarily shared by the many. A fashion emerges, matures, is accepted and adopted, declines, and then vanishes. It is immediately supplanted by another fashion that emerges, matures, and so on. We might well ask what connection Jean Baptiste Colbert, with his sense of permanence and continuity, could possibly have with the vagaries of *haute couture*—that lovely captive paraded down the runway each season and then locked away again in the stronghold of fashion. Everything proper to "fashion" might seem to conspire against the alliance of its fickle fancy with the staid French statesman. Versatile and volatile, constantly making and breaking promises, *haute couture* is not even French, it is Parisian—which explains quite a bit! And yet, through one of those paradoxes that cause so many headaches in so many non-Parisian heads, it is precisely fashion's capacity for perpetual change that makes it constant to its own ideal. More than just a craft, *haute couture* is above all a form of distinction. We apply the term to a dress the way we apply the word "thoroughbred" to a horse. Fashion is skittish, self-absorbed, whimsical, fickle, extravagant, and even mendacious by nature. But qualities that would be flaws in human beings are virtues in fashion, which is ruled by an arcane alchemy effected in the retorts of *haute couture*, under a few rooftops in a few select Parisian neighborhoods.

There is no craft more closely linked to lifestyle than *haute couture*. Clothing is the most immediate extension of the human body, guiding, constricting, matching every movement. We wear clothing as a shield, but also to project a message early on. Up until the middle of the fourteenth century, European clothing styles reflected individual resources and local custom; men and women alike wore superimposed tunics that were similar in style. Then breeches appeared and in the western world were worn only by men until recent times. It was with the dawn of the Renaissance that the

*Formal evening dress by Jean-Louis Scherrer: Bodice in plum-colored velvet embroidered in old gold and precious gems, skirt in checked gold and plum-colored net with plum-colored velvet and gold faille embroidery. Lesage embroidery. Fall/Winter 1994–5* haute couture *collection.*
Right: *Abraham Bosse,* Le Retour du baptème et la visite à l'accouchée *(detail), c. 1630. Engraving. Bibliothèque Nationale de France, Paris.*

Left-hand page: *Taffeta evening dress. Jean-Louis Scherrer, Spring/Summer 1994* haute couture *collection.*

179

concept of pleasure was added to the etiquette governing dress. The fortunate of the world, as was their due, were the first to sip from the chalice of fashion, and we have suffered ever since from the after-effects of the potion they imbibed. Then came the arbiters of taste, supplied and influenced by drapers, haberdashers, tailors, and purveyors of fine accoutrements. By the late eighteenth century, fine-feathered men and women had become accustomed to being distinguished as much by their plumage as by their rank, but their finery would soon be democratized. Impelled by industrialization and the free circulation of information, this process reached larger and larger segments of the population during the nineteenth century, continuing into our own time until distinctive regional, professional, and religious clothing have virtually disappeared. These have been replaced by the ready-to-wear garment, which could easily have become a drab uniform were it not for the persistent influence of shifting fashion and tastes. It is women who are most often subjected to this influence, being forced to review and restock their wardrobes with daunting regularity. A creative designer is called upon to conceptualize and vitalize (thus rendering them all too mortal) these signature envelopes. Couturier, artistic director, and fashion consultant, a designer is first and foremost a person of elegance and impeccable taste. In the world of high fashion, to create means to select, to reject, and then to decide on the single formula that for a single season will govern the fate of an entire industry. Whether a designer invents, projects a desire, or evokes the memory of a silhouette, his creations often glide on a higher plane before swooping down into "the street." Couture designers maintain complex relationships with the street—not unlike the Venetian doges who had intricate acoustic conduits installed in their palaces so they could eavesdrop on the city's gossip from on high.

Fashion may be fickle, but it has a long memory. With unpredictable selectivity and the regularity of a pendulum, fashion resurrects the banished fashions of the past and uses them as recruits in the war to banish the fashions of today in their turn. Treading a fine line between a clean break with the past and a lingering nostalgia for it, fashion spins and weaves, cuts its cloth, and confects apparel and ornament boasting an ephemeral charm. It is in the service of this charm that *haute couture* seamstresses with magic fingers work tirelessly throughout the year, and high-tech ready-to-wear factories churn out their wares virtually unaided by human hands.

In years gone by, customers purchased lengths of cloth from the draper and took it to their dressmaker or tailor to be made up. During the Second Empire in France, Charles Frédéric Worth was the first couturier to present models of his designs already made up in a range of different fabrics. The Empress Eugénie heard about the clever young designer and his lovely wife, and granted them an audience at the Tuileries Palace. Worth's wife, who served as his first mannequin, attended the audience wearing an ample gown of flowered brocade, and made a sensational entrance into the royal reception rooms. The Emperor Napoleon III happened to be calling on his wife at the time, and was delighted by the couturier's charm and creativity. Foreseeing the commercial possibilities that crinolines and the ample dresses worn over them could open up for the Lyon textile industry, the emperor decided to support Worth. Thus, the first "fashion plate" is a painting by Winterhalter of the empress surrounded by her ladies-in-waiting. This painting marked the beginning of the intense media spotlight that has ever since shone relentlessly on fashion, sometimes reflecting current styles, and sometimes inspiring them. Less than a century and a half after Worth's Tuileries triumph, François Mitterrand received an elite group of French couturiers and fashion designers at the Elysée Palace during his first term in office. Some of those thus honored were later awarded a greater honor still: the rosette of the French Legion of Honor.

Meanwhile, high fashion gradually spread out from its Parisian center, attaining a degree of influence far surpassing that exercised by other fields of design. Before the outbreak of World War I, couturier Paul Poiret revolutionized the female figure in ways comparable to the revolution then being waged by the avant-garde movement in contemporary art. He was followed by Coco Chanel, whose variations on a few basic themes prefigured style as we know it today. After World War II, Christian Dior raised *haute couture* to a previously unheard-of degree of excellence. Dior also instinctively understood the potential impact of licensing his brand image and thereby projecting it worldwide. Yves Saint Laurent represents a synthesis of these three personalities, placing the individual fashion designer firmly in the ranks of the contemporary elite and also serving as a symbol of the extraordinary explosion experienced by the ready-to-wear industry between the 1960s and 1980s.

However, to describe this adventure is to freeze it on the page, and thus to falsify its very essence. Fashion continues to outpace its own history, eluding every attempt to pin it down. "Costume" is static, but "fashion" will always be in continuous motion.

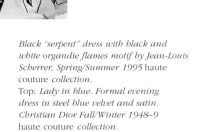

*Black "serpent" dress with black and white organdie flames motif by Jean-Louis Scherrer, Spring/Summer 1995* haute couture *collection.*
Top: *Lady in blue. Formal evening dress in steel blue velvet and satin. Christian Dior Fall/Winter 1948–9* haute couture *collection.*

Left-hand page
Top: *Dinner-dress, model by Paquin, 1904.*
Bottom: *Drawing by Gruau of a* haute couture *model. Pierre Balmain, Fall/Winter 1952–3 collection.*

## The challenge
## of a great house

*The challenge of taking over from Christian Dior, Yves Saint Laurent, and Marc Bohan at the helm of a fashion-establishment icon as revered as the House of Dior was a risky undertaking, especially for an Italian newcomer to the Paris scene—even one boasting a well-earned reputation in his own right. In 1989, when Gianfranco Ferré assumed the role of* haute couture *designer at Dior, there were many who wondered how he would fare. Would he opt for servile imitation, or would he spearhead a revolution against the traditions of the venerable house?*

*Ten collections later, Gianfranco Ferré is firmly in place, having*

*walked a fine line between the daring and experimentation of his own past, and the traditions and policies pioneered by the House's founder and followed by all the designers who succeeded him. But to Ferré, Dior stands for a certain spirit rather than a specific style. "To me," Ferré explains, "Dior is synonymous with high style in the broadest sense, peerless quality, glamor, and greatness."*

*Gianfranco Ferré's own inclination is to take a resolutely modern position. He achieves modernity today by accentuating and streamlining his styles, combining classic form with fearless daring in the use of materials. Ferré will experiment with anything: nylon woven with silk, embroidery on tulle, upholstery fabric, triple-ply silk. Anything goes, provided that, in his own words, "the result is a unique response to a unique demand."*

182

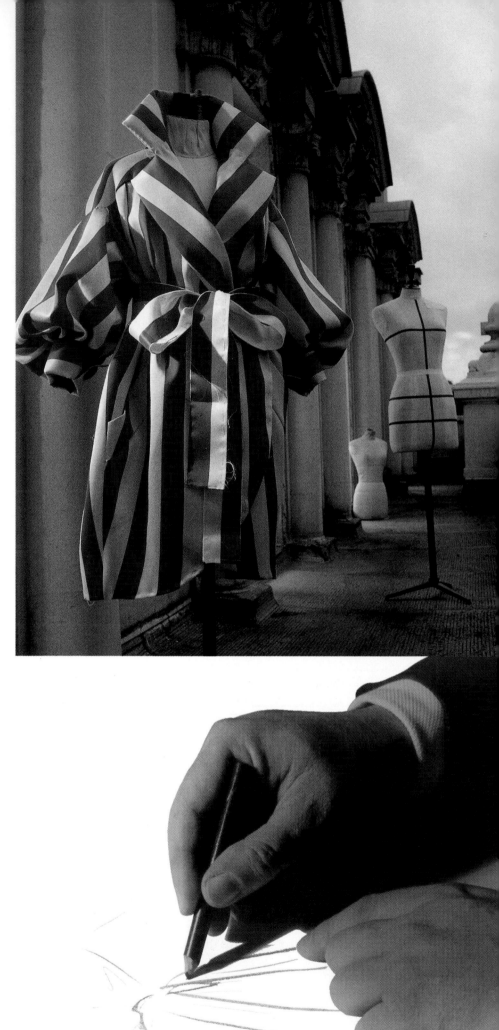

## The clients: a small international elite

HIGH-HANDED HAUTE COUTURE • Annick de Cizancourt, Director of *Haute Couture* at Dior, describes the situation: "We have no more than two or three hundred clients in the entire world"—a number probably reduced still further by the economic slump of the early nineties. A tour of the famed fashion house on rue François I$^{er}$ in Paris brings this small international elite very close, however, since each of the dressmaker's dummies in the workroom is made to the exact measurements of an individual client. These superficially anonymous figures reveal all the hidden secrets a designer garment is intended to conceal, secrets that these exceptional women would only entrust to the one very special person who can make them look like royalty. This is the head modeler, who enjoys the privilege of taking clients' measurements, and of fitting them with the "skin-tight" muslin from which the dressmaker's dummies will be made.

At Christian Dior, the head modeler is also head of the tailoring workroom, Claude Laurent, who entered the fashion house just before the advent of Yves Saint Laurent. In the eyes of his clients, Claude Laurent is guardian of the flame handed down directly by Christian Dior himself. Apprenticed at fourteen to the great Schiaparelli, admired by Givenchy, and finally hired by the venerable House of Dior—where at the age of twenty-three he was the youngest person ever to be named head modeler—Laurent nevertheless still treats his wealthy clients with considerable deference. And yet many consider him their best friend and closest confidant. Today Claude Laurent is preparing the way for his successor, and the Christian Dior management has asked him, as a recognized intimate of the rich and famous, to leave them his address book.

Laurent's contacts are especially important since the success of any *haute couture* house depends primarily on the delicate relationships built up between the women who are imperturbed by the idea of a dress or suit costing twenty thousand dollars, and the designers and stylists of these unique models. In this sense, a house's clients are as firmly committed to it as its employees, a fact demonstrated by the enduring links forged between Isabelle Adjani and Gianfranco Ferré, Catherine Deneuve and Yves Saint Laurent, Audrey Hepburn and Hubert de Givenchy. This relationship can be marred and even destroyed by ugly feuds and hostile divorces, which is where the patient, tactful diplomacy of a Claude Laurent comes to the fore. He watches for storm warnings, trims the sails, and, when worse comes to worse, gets ready to ride out the tempest and repair the damage.

**The tailor-made suit**

*Custom tailoring remains the province of a few great fashion houses. When one realizes that Lanvin offers over fifteen thousand different patterns to choose from, it becomes clear that merely selecting the fabric for a suit constitutes a major step in which the habits, tastes, lifestyle, and profession of the client all play a role. There are over one hundred and fifty separate operations and some one hundred hours of work involved from the moment the tailor's shears first touch the bolt of cloth, and to final press of the iron on the finished suit. The first steps are taking the measurements, constructing the canvas interlining, fitting the interlining on the client,*

*and making the paper pattern from it. When all the sections of the suit have been cut from the selected cloth, using the pattern, they are then basted together and reinforced at strategic points with five to six thicknesses of horsehair (for resilience), camel hair (for drape), and all-wool felt (for volume). Fitters, piece-workers, and finishers then assemble the suit and sew it on to the interlining. At this stage, the client comes in for the second fitting.*

*When the body of the suit is completed, the lapels, collar, sleeves, pockets, lining, zipper placket, and buttons are added—all sewn by hand in the finest tradition of custom tailoring.*

Laurent's diplomacy is exercised through intimate lunches and dinners with clients who have slipped from the house's grasp and must be won back, or at least talked into benevolent neutrality. "If a woman wants to change her image," he explains, "you mustn't try to argue her out of it; but you can try to salvage a good relationship. Then, if the new image turns out to be a disappointment to her, she can return without opening up old wounds." This is an elegant way of giving clients their freedom, as it were, since in the client–couturier relationship, the client is perhaps not as free as one might suppose.

Every client of a *haute couture* house has her own personal sales consultant, someone familiar with her tastes, likes and dislikes, and idiosyncrasies. Within the rigid *haute couture* hierarchy, this person holds the rank of *première vendeuse*, or head sales consultant. However, the *première vendeuse* habitually previews the collection independently, ordering models on the basis of her own assumptions about the client, who is often not asked to express an opinion and who may only have seen the collection on video-cassette. Although this custom might seem high-handed, it should come as no surprise. In *haute couture*, the client does not dictate to the designer, the designer dictates to the client. Women choose their couturier and then allow themselves to be "dressed," resigning their own decision-making authority to the experts. The highest praise for a client in the world of *haute couture* is that she never argues with the designer's choice. This procedure is also followed in the workrooms, where a single highly qualified *première main*, or head seamstress, supervises the client—or at any rate the client's dressmaking dummy—without the client herself having any say in the matter. In this context the term "made to order" seems inappropriate. Nevertheless, the hallmark of *haute couture* is still the uniqueness of every ensemble, dress or suit, all of them wholly owned by the client, and the function of *haute couture* is to adapt a unique design to a unique individual. However,

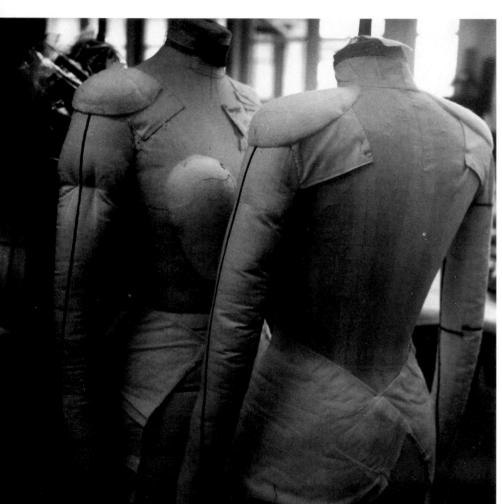

*Tailor's dummies in the Chanel workshops.*

Preceding double page
*Finishing touches on the Daphné model.
Long high-waisted pleated dress in celadon
green and straw-colored silk, with floral
design and lace-up effects on an
asymmetrical embroidered bodice.
Christian Dior Spring/Summer 1993* haute
couture *collection.*
Top: *"Galante" model: trench-style evening
coat in raw silk with wide pink and
raspberry-colored stripes. Christian Dior
Spring/Summer 1993* haute couture
*collection.*
Bottom: *The hands of Christian Dior.*

while the creative designer's vision is ideal, projected on to professional models who exemplify perfect beauty, the head of the tailoring workroom, on the other hand, faces individual clients and must take this ideal style and turn it into something an ordinary human being can wear. This is why, for clients of *haute couture*, the workroom head's role is often equal to that of the designer. As in music, interpretation is the operative word here: interpretation of sketches produced by the designer during the formation of the collection; interpretation and adaptation of an ideal model to the specific physique of a client.

### From paper sketch to muslin

A designer's sketch can be an intriguing sight, a random jotting rather than an exact scale model. "Of course," explains Lysiane Jacques, head of the tailoring workroom at Chanel, "they do give us some indications—a knee perhaps, an elbow or a neckline—so that we can figure out what shape and volume the piece is supposed to have." On the basis of this cursory sketch, experiments are made with modeling muslin, a swatch of lightweight cotton fabric that is draped on a dressmaking dummy and manipulated until just the right shape is achieved. For a suit, the muslin is marked for seams and darts and then notched and cut with scissors to show waist, hip, and bustlines. The position of the pockets and sleeves is also marked. When the muslin is being manipulated, the weave of the final fabric is always kept in mind. "The suit has to hang properly," points out Lysiane Jacques, adding—with the note of irreverence characteristic of tailoring workrooms—"you can't just let it flop around." "The weave of the fabric," confirms Elisabeth Gallet, head of dressmaking at Christian Dior, "is the seamstress's equivalent of the plumbline." In Gallet's workroom, where dresses and blouses are made, absolute respect for the vertical and horizontal weave of the fabric is an iron-clad rule, something all professionals instinctively check when they see a dress or suit coming down the runway. The modeling muslin for a dress does not have to be structured with the same geometric precision as that for a suit, however. What counts for dresses and blouses, with their relative lack of rigidity, is finesse. Here, the workroom head's job is to smooth, tuck, pinch, and pull into shape dozens of muslin pieces—as many as twenty for a wedding dress, the high point of every designer show. In this way the designer brings to life the inanimate dummy. This is an especially delicate task for dresses, since designers tend to include even fewer firm indications for dresses than for suits on their brilliant but undetailed sketches.

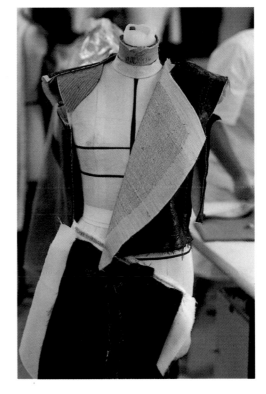

*Fine hand-stitching of the collar facing and overstitching of the shoulder strap. Christian Dior.*
Right: *Sketch by Gianfranco Ferré for Christian Dior of a* haute couture coat, *Fall/Winter 1994–5.*

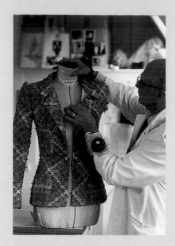

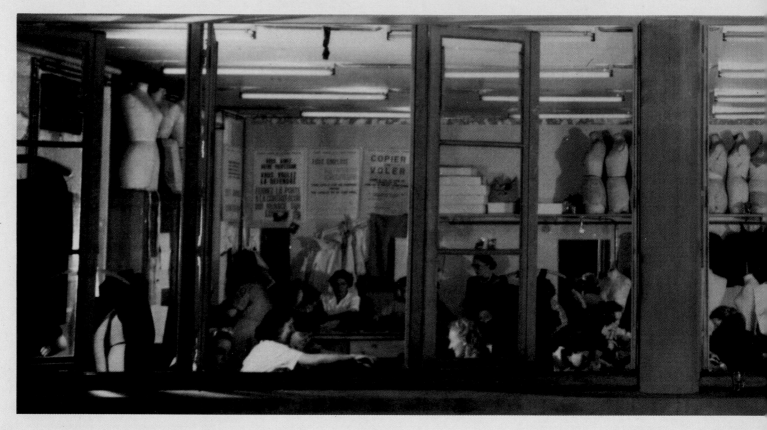

From left to right, top to bottom:
*In the rue Cambon workrooms,*
*Monsieur Paquito checks the cut and hang*
*of a* haute couture *jacket by Chanel.*
*Embroidered suit jacket in cream-colored*
*shantung. Christian Dior.*
*Ironing silk mousseline. Chanel.*
*The Christian Dior workrooms*
*in the 1950s.*
*Gathering the accordeon pleats*
*of the "Psyché" model. Christian Dior.*
*Gérard Pipart accessorizes a wedding*
*dress at Nina Ricci.*
*Muslin pattern for a wedding dress:*
*detail of armhole and neckline decorated*
*with roses worked into the material.*
*Givenchy.*
*Fitted bodices in tulle and black silk*
*mousseline. Chanel.*

Following double page
Left: *"Eurus" model : Loose, double-pleated*
*organdie blouse with low neckline.*
*Christian Dior, Spring/Summer 1993*
haute couture *collection.*
Right: *Black hat and baroque jewels:*
*the Chanel Woman.*

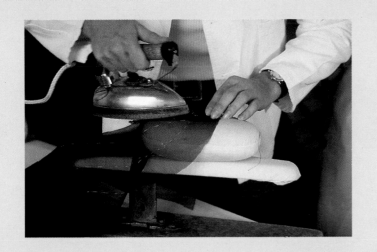

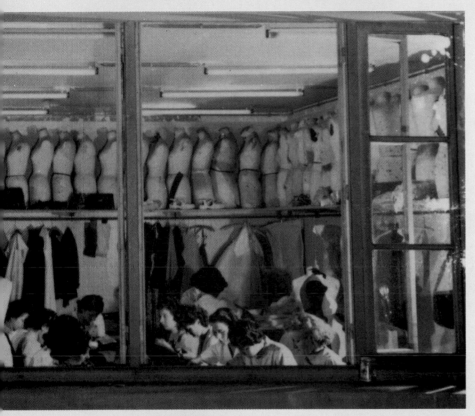

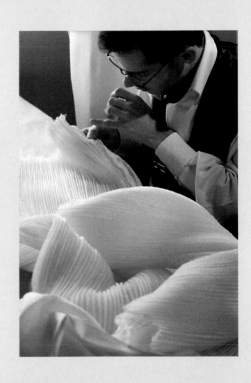

# The hat story

The success of a hat depends even more than that of a dress on the person wearing it. Anni Gaucher, head milliner at Nina Ricci, came to this realization through her contacts with the house's clients, women for whom "a pretty hat is the essential finishing touch for an outfit, and sometimes its saving grace—like dotting an 'i'." But even these women have to know how to wear a hat and how to appreciate it, since "the loveliest hat in the world, worn by a woman who doesn't like it, turns into a dull, ordinary lid."

A woman has to like hats, be able to wear them, and know how to look her best in them. Not all haute couture clients share this unique passion. Perhaps they are not aware that hats are very special, the only designer fashion

where the client herself participates fully in the design process. For hats, unlike haute couture, the design really is "made to order" in a very personal sense which reflects the client's own character and temperament.

### From head to hat

At fitting sessions in the Nina Ricci salons, according to Anni Gaucher, "we try different things, different styles, and the client always participates actively in the process, she has her own ideas. If she really likes the

hat, she'll know how to wear it." The scene is easy to imagine: glances at the mirror, questions, giggles, complicity between client and designer, creative tension alternating with moments of relaxation, resulting in a decision. The unique design of a hat is the fruit of a creative dialogue between the milliner and her client.

### No straight lines

The millinery department in a haute couture house is governed by rules of its own. Here there are no straight lines, no fabric weaves that must be respected, no perfect hang or drape. Couturier clothing designers must make models for garments that will fall correctly, in disciplined lines. But milliners work with volume rather than line, cutting their esparto hat-forms on the bias to create shapes that are rounded and hollow.

A ring of brass wire is placed inside the esparto form to make it rigid, and the form is then molded into shape, stiffened with moistened gauze, and coated with "tip-fix," a kind of white paint milliners use for smoothing and hardening.

The final hat is constructed on this basic form. The milliner builds up the hat by adding more molded esparto—

sometimes stiffened with brass wire—and rims it with another strip of moistened gauze stiffener. She may then apply brushed cotton to the form for added shape, especially for hats to be made of delicate fabrics such as silk, satin, or crêpe. In the final step, the basic forms for brim and crown are covered with the selected fabric and assembled. The hat is now finished except for the trim specified by the designer—flowers, ribbons, draped fabric, etc.

### Stretching felt

Felt is made pliable by steaming and stretching it over a wooden block. It is then slowly heat-dried to preserve its shape, a process which can sometimes be done in an ordinary clothes dryer. Stretching heavy felt requires great physical strength, a fact officially recognized in France during World War II when felt-stretchers were eligible for supplementary food ration coupons given only to workers in trades requiring heavy manual labor.

Felt workshops remain extremely loyal to the haute couture houses they work for, despite the current tendency on the part of some houses to sub-

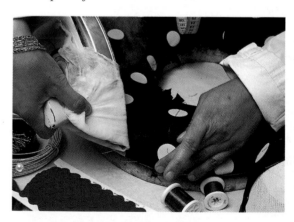

contract the design and manufacture of their hat collections. This kind of esprit de corps and pride in craftsmanship reflects the degree to which haute couture is made up of different specialized skills, all producing high quality items.

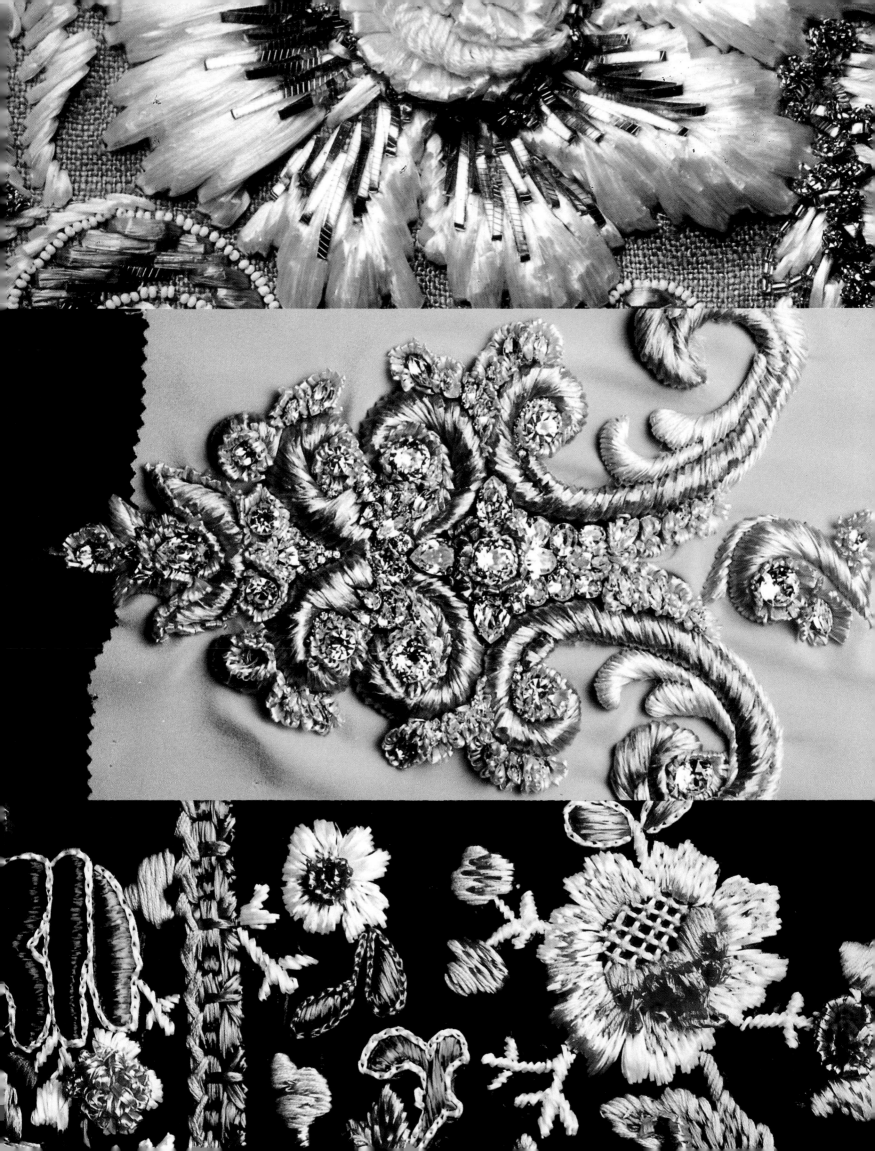

## A master hand

*The craft of embroidery is both ancient and contemporary. Alongside modern tastes embroiderers work in the languages of past centuries. Embroidery as practiced today draws both on its roots as a handicraft and its capacity to offer an escape from harsh reality, which is prized now more than ever before. Embroidery—a priceless heritage, a memory transmitted over the centuries, a creative and joint endeavor—is to the garment what accessories are to the total outfit: the final touch. This particular final touch is an especially eloquent one, however. Embroidery embodies and projects the wealth and opulence of the women for whom it is made, and, if the craft of luxury embroidery is still alive in France today, this is due primarily to one man, François Lesage, and to his company, his staff, and their pupils. The art of Lesage the embroiderer is not only a conservatoire of endangered skills, but also—and above all—a creative, thriving, living craft that season after season*

*delights a public astonished by pyrotechnic displays in which all that glitters is worth its weight in gold. If today there existed only a single "master hand," in the literal sense of the word, that hand would be the one belonging to this embroiderer. Here is*

*the story of a fanatic who, appropriately, is called Lesage.*

**François Baudot: Based on your forty years' experience, how would you evaluate the position of embroidery today and, as the millennium draws to a close, the future of couture craftsmanship in general?**

*François Lesage: Remember that* haute couture *as we understand it is barely one century old. However, we do*

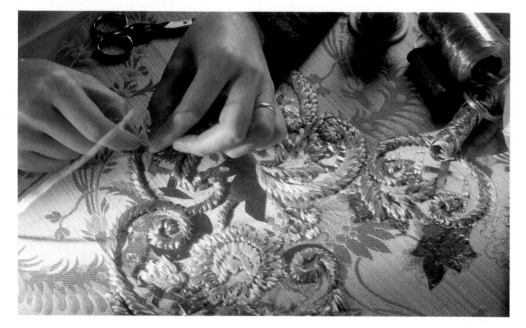

*appear to be coming to the end of a cycle. I'm an embroiderer, a man who works behind the scenes, in the secret corridors of fashion. Our craft is a marvelous one, but we shed many, many tears. We shed tears in our efforts to be taken on by a great designer. Then we shed tears to prevent the great designer from buying us out so we can't sell to his competitors. We shed tears rushing to make delivery deadlines. And, finally, when the great designer's show is a resounding success and the great designer thanks us from the bottom of his heart, we shed more tears.*

**F.B. Do you look back on a golden age?**

*F.L. You must remember that before the war, during my parents' time,* haute couture *didn't have the same status it does today. Many of the houses that existed then, most of*

*which have since disappeared, designed clothes for a large middle-class clientele—the same group, more or less, that in our own time constitutes the market for luxury ready-to-wear. The* haute couture *houses in those days did an extraordinary amount of work by hand, and houses like Jeanne Lanvin and Madeleine Vionnet employed two or three thousand people.*

**F.B. Can you tell us something about Lesage's most outstanding clients?**

*F.L. I should explain, first of all, that embroidery was originally a separate component that was sewn on to the completed garment and which could be renewed. It was Madame Vionnet whose virtuoso cutting techniques and lightweight fabrics forced us to refine our own techniques so that embroidery could be worked directly into the garment. Elsa Schiaparelli, queen of the spectacular* couture *of the thirties, was another designer who changed the image of embroidery, by using it for jackets, suits, coats, dresses, boleros, and even capes. Schiaparelli was the first great designer to treat embroiderers, who are great* couture *artisans in their own right, as fully-fledged partners rather than as subordinate suppliers. I also have fond*

*memories of Cristobal Balenciaga, who had a profound influence on me when I was a young embroiderer in the fifties, as did Jacques Fath and the brilliant Jean-François Crahay. But for me, the "golden age" means working with Yves Saint Laurent, Karl Lagerfeld for Chanel, Jean-Louis Scherrer, Marc Bohan at Dior, Claude Montana at Lanvin, and Givenchy— whom I knew when he was an assistant at Schiaparelli. American designers too, such as Calvin Klein and Oscar de la Renta, whose assistants hop on the Concorde to bring me the models as soon as they're finished. More recently, younger designers such as Christian Lacroix and Olivier Lapidus have enthusiastically rediscovered this craft's full potential, and have forced a new generation of suppliers to keep pace with them.*

*their average age is twenty-five to thirty. We employed one hundred people in the eighties. With the economic recession, we're now down to sixty or so. But I also believe most of the good suppliers owe their training to me.*

**F.B. What are some of the greatest changes since your parents' generation?**

*F.L. I follow new technology very closely—heat transfer, stiffeners, holograms, etc.,—just as I have done for materials such as plastic. Also, the new haute couture look of the eighties influenced ready-to-wear lines as well. And, as long as fifty years ago, the Callot sisters were already asking my father for embroidery adapted to sportswear. We also design our own accessories: embroidered handbags, jewelry, belts. We continue to serve as an experimental laboratory. It's important to*

*or for various special events. People want to know about us, and that's fine with me. To the Paris craftsmen who find this disturbing, I reply that planting vineyards in California— and throughout the world—has not done any harm to Bordeaux wine. In fact, it has made wine familiar to people who before knew nothing about it, and given them a taste for it. Our training and educational work is the best international ambassador there could be for Paris embroidery. Providing, of course, that the fount of creativity stays right here, and that we retain control over it.*

**F.B. How many firms are left that can still embroider for haute couture?**

*F.L. In France there used to be twenty-five to thirty embroidery houses. Forty thousand hand-embroiderers before 1914, four thousand after World War II. There are only one hundred and fifty to two hundred left today, about forty of whom work with us. Many have been designated* Meilleur Ouvrier de France. *The encouraging thing, however, is that*

*make our work known and appreciated throughout the world.*

**F.B. Is that why you have founded a school of embroidery?**

*F.L. Our school is located immediately below our workrooms. The notion of secrecy and confidentiality has become meaningless today with the extraordinary growth in media coverage. Our doors are open to TV journalists, and last year we welcomed ten thousand visitors either to the school,*

Left: *Sample of gold-covered braid framing cabochons of iridescent mother-of-pearl sequins under painted chiffon. Lesage.*
Top: *White beaded Lesage embroidery applied to the reverse side of the loom by the Lunéville technique, for the Chanel Summer 1995* haute couture *collection.*

Left-hand page
Left: *"Lunéville" embroidery at Lesage. The embroiderer stitches the sequins on one by one, working from the back of the stiff fabric.*
Right: *Lesage embroidery. Christian Dior Summer 1992* haute couture *collection.*

Preceding double page
Left-hand page
Top: *Givenchy hat. Headband with stitched-straw trim. Spring/Summer 1994* haute couture *collection.*
Left: *Hat workroom at Christian Dior.*
Right: *Silk blocking of a silk taffeta hat. Nina Ricci.*
Right-hand page:
*Lesage embroidery for (top to bottom) Jean-Louis Scherrer, Givenchy, and Christian Lacroix—Summer 1990* haute couture *collections.*

## Fur

*"We use the same modeling techniques and patterns as haute couture, and we follow the same fashion trends," explains Jean-Paul Avizou, designer at Revillon for nearly ten years. Increasingly stringent regulations governing the use of fur have limited available pelts to those from just a few "authorized" animals, including fox, mink, chinchilla, marten, and sable. Paradoxically, however, the new restrictions have not acted as a brake on creativity,*

*but, by forcing designers to give up their dependence on the variety of raw materials available, have impelled them to concentrate on originality of conception and innovation in treatment. Different types of finishing can vary the look of fur in ways limited only by the designer's imagination. Fur can be sheared like velvet, textured, patterned, and lacquered on the skin side of the pelt for a frosted effect.*
*The expansion of ranches specializing in white-furred animals has also opened the way for dyeing, and this has given* haute couture *designers an opportunity to use colors not previously available in natural fur.*

When the muslin prototypes based on the designer's sketches have been completed by the heads of the tailoring and dressmaking workrooms, they are shown at "studio" sessions where they are paraded by special in-house mannequins, subjected to merciless criticism, and then either accepted or rejected. When a muslin prototype has been approved, the search then begins for fabrics, trim, and accessories, and the final suit or dress gradually begins to take shape. Paper patterns tend not to be used, since during the frenzied preparations for an official *couture* showing, there is rarely time to make

them. Time is the great enemy of *haute couture* and, in order to work more quickly, the final garment is assembled directly on to the live mannequin, with the last fitting often taking place only hours before she is scheduled to walk down the runway.
After the official showing is over, the season's new creations are adapted to fit the individual clients who have purchased them. This entails plenty of work, but life can return to normal.

### From fashion runway to real life

The task of adapting a model for the client is a complex one, however, since clients rarely share the same measurements as the designer's favorite mannequin or muse. For suits, a pattern is traced by the workroom head on to tarlatan, a lightweight, heavily sized (starched) cotton muslin. The skilled first seamstress then uses this pattern to cut directly from the cloth, carefully reproducing the sections

that when assembled will form the finished suit. She bastes the sections together on the flat surface of her sewing table, working with the weave of the fabric so that the garment will fall correctly. She then uses pieces of organza or satin crêpe to prepare an interlining that remains inside the completed garment after the seams have been sewn. The collar and lapels are then added, reinforced with the thin line of picot stitching visible under the lapels of every completed *couture* suit. Shoulder pads are evened out with heavy cotton to soften their sharp corners, and finally the front of the jacket

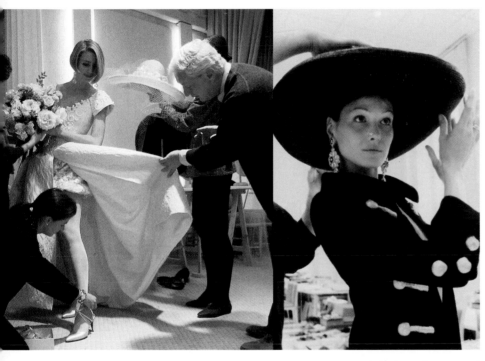

is stiffened to ease the bustline, eliminate unsightly bunching, and improve the hang.

All of these minute details—the interlining "for a finished look," hours of ironing on the "hog," as the workroom staff calls the padded forms where every separate section of the suit is pressed into the exact shape required for an elegant hip or bustline—all these "finicky minor operations" in the words of Annick de Cizancourt—are done by hand. It takes a minimum of seventy hours to produce a suit jacket at Jean-Louis Scherrer, and more than seventy hours to produce a dress. But time is no object when perfection is the goal. The final step, and perhaps the most important in the creative process, occurs when the finished garment is actually worn by the client—similar in kind to the moment when a great work of literature reveals its innermost meaning for the first time. As Christian Dior once put it, "I believe every dress has a soul."

*Trouser suit. Céline, Spring/Summer 1994 ready-to-wear collection.*

From left to right: *Printed raw silk pelisse with lustrous beige Saga fox-fur edging. Revillon.*
*Dressing-room at Saint-Laurent.*
*Final adjustments to a Nina Ricci dress by Gérard Pipart.*
*Trying on hats at Christian Lacroix.*

Following double page:
*Backstage at Guy Laroche.*

*195*

This is the Avenue Montaigne in Paris, the first-floor studio at Guy Laroche Haute Couture. The official showing is two weeks away, and relative calm still reigns at Guy Laroche. The key models have been completed, and Michel Klein is now working on accessories—and on seeking reassurance from those around him. Pascale emerges from the dressing room dressed in a very simple, very understated orange silk "Mao" suit. She twirls around in front of Klein, who watches from one of the armchairs. Klein and Pascale discuss the problem of what stockings should be worn with the suit for the show. "A while ago I was sick and tired of that suit," mutters Klein to himself, "but now I love it." This is Klein's pre-show mantra, which he will be repeating almost verbatim throughout the entire afternoon. A low murmur of approval rises from the audience in the studio. Pascale returns to the dressing room behind the mirrors, and head dressmaker Anne-Marie comes in, clutching a blue taffeta dress. Mariane examines it and announces: "This is urgent. It has to be sent off on Monday to be embroidered in India." Everyone scrutinizes a pair of black kid gloves that will go with the outfit, and then turns to stare at Pascale, who re-emerges wearing a pink suit. Michel Klein inspects the suit, circles Pascale, smooths the area above her left breast with the back of his hand, and remarks, "I love it when the shoulders curve like that."

The floor is now covered with fabric swatches the assistants are sorting through to find just the right shade for the suit linings. Nathalie, in charge of shoes, asks for the exact shoe sizes of the mannequins who will be in the show—Lucy, Nadia, Karen, Leila, and the rest. Mariane Oudin moves back and forth between the assistants and Michel Klein, carrying fabric swatches from the floor. When Klein points to the line of sketches on the bulletin board and decrees, "I need some pink between the gray dresses

and the black ones," Oudin obediently changes the order of the sketches. Back to in-house mannequin Pascale, now wearing a flowered dress. Mariane Oudin asks about the belt, and notices a ridge caused by the mannequin's tights. But Klein's eyes are riveted on Pascale's face. "Do we have a little veil?" he wonders aloud. Someone hands him a wisp of veil, he wraps it around Pascale's face, stands back to admire the effect, and declares it "pretty as a cloud." Guido snaps a Polaroid. Pascale disappears once more and then comes out in a shorts-suit—but by this time Klein is concentrating on hair styles, hats, veils. He decides to make a veil out of rod-hoid and pencils his fresh inspiration on to one of the bulletin-board sketches while Olivier stands behind him, jotting down the master's words. "Maybe a black shantung parasol lined with pink taffeta," muses Klein, "with a black bamboo handle and braided pink loop." Famed embroiderer François Lesage huddles in a corner with Mariane Oudin. Michel Klein leaves the room to take a call from New York. The assistants sweep the fabric swatches off the floor. Pascale puts her jeans and baggy sweater back on again and runs lightly down the stairs. The studio is suddenly empty of people as quickly and mysteriously as it had been filled.

The countdown: one day to go
"Today's Wednesday, right? No, Wednesday's tomorrow . . . I must be going nuts!" Nerves are beginning to fray, but on paper at least, preparations for the show are right on schedule. Each sketch now has the proper fabric swatches attached to it, plus designs for handbags, shoes, and masks. Olivier is working on the sixty-one panels holding Polaroid photos of every model in the show. But today's big excitement is the arrival of Stephen Jones, hatter by appointment to Her Majesty the Queen of England, and the hats he has been commissioned to design. Jones, a small,

rotund, bald, elfin man wearing a cobbler's leather apron, pads silently into the studio and begins working in one corner.

Tense, raised voices can be heard from the offices. The great invitation chase is on, and it's not always easy to turn people away. Head couturier Monsieur Mouton slowly circles Pascale, now dressed in trailing black chiffon.

Pascale's current problem is how to walk while holding the filmy chiffon at arm's length so she won't trip over it. Various drapes are tried, all of which make the mannequin look like a lifeless statue. Wouldn't it be better just to lop off some of the material? Stephen Jones wields his clippers in his corner of the room, turning out incredible little hats. Michel Klein looks around for him, spots him, and asks: "What hat with this model?"

Stephen puts a huge bow on Pascale's head. It makes her look like a dragon-fly. Jones pins it on, unpins it, takes it off, and comes back again with something that looks like a huge banana. This one is approved. "Try it with a pair of dark glasses!" A final glance: "Yes . . . It looks nicely ridiculous . . ." The Polaroid camera clicks, and moves on to the next model. One outfit after another is marched down the

runway, all worn by Pascale or Lucy, an in-house mannequin who specializes in dresses. Hats, jewelry, beaded belts are added. The designer outfits are beginning to take shape. There's another drama going on behind the scenes. "Any news?" "Is she here yet?" But no one really has any time to spare worrying about the absent supermodel who commutes between Paris, Milan, and New York. Pascale goes out again, this time in a

blue dress with white trim strongly reminiscent of the Air France flight-attendants' uniforms of the nineteen-fifties. "Fasten your seat belts," murmurs Michel Klein, momentarily pursuing his fantasy. The discussion now turns to the Ritz Hotel, where the show will be held.

"OK, let's go!"
The scene shifts to the Ritz. The big day has arrived and we're backstage with the mannequins, hairdressers, make-up team and photographers. The team is all here: Olivier and Guido are gluing white feathers on to the bride's hat. Stephen Jones, armed with his clippers, is back in another corner turning out more incredible little hats. The two workroom heads stand guard over garment racks holding the sixty-one models, which are hung in the order they will be shown. Michel Klein has draped a long red muffler over his perennial black suit for the occasion, and is feverishly checking the audience on a video-screen that gives a panoramic view of the house.
The mannequins are being made up and having their hair done. A few bottles of champagne have been provided to lift everyone's spirits. The sketches pinned on the wall are now inscribed with the names of the mannequins who will be wearing each model. Photographers wander in and out, among them Sarah Moon, who is respectfully acknowledged by her peers.
Michel Klein takes time out to answer questions from Anna Piaggi, a fashion fanatic who goes to all the showings, each time dressed in an outfit more outrageous than the last, and about whom lingers a hint of mystery. No one can ever remember exactly what newspaper she works for. The house is beginning to fill up. An announcement that Madame Balladur has just arrived out front does not faze the mannequins, who are still in the dressing room being made up. The show is already running forty-five minutes late. "Hurry up! Get

a move on! Three-quarters of an hour . . . this is beginning to look bad . . . "
A sudden surge in the music signals that the girls are ready to go. "Downstairs, everyone!" The mannequins tumble out of the dressing room and form a line in half-mocking response to orders from Mariane Oudin. Oudin slips a microphone headset on and begins to call the roll: "Nadia!" Nadia goes over for a final inspection from Michel Klein, who takes her by the elbow and pushes her on to the runway, whispering "OK, let's go!" Oudin's roll call continues: "Christelle! Nadejda!" Each girl's name is echoed by the photographers who vie for their attention in the hope that they will strike a brief pose in front of the crowd before starting their journey down the runway. Meanwhile, back in the dressing room plaintive cries ring out for "Carla, Carla!"—the make-up artist, and "Paul, Paul!"—the hairdresser.
The show is on. The pace is frantic. When the mannequins reach the end of the runway, they rush backstage again to change, have their make-up repaired and their hair rearranged, and get another hat from Stephen. The flash bulbs flash, the cameras click, and off they go again. Suddenly a burst of applause comes from the audience. Michel Klein stops for a moment to exclaim "Hear that? They're applauding!" But there is no time to enjoy it now. The models still have to be checked, the mannequins sent off down the runway, and the TV monitor watched to see how the show is going.
The bride appears. The other mannequins cluster round her as she mounts the podium, glides down the runway to a storm of applause, and returns backstage for Michel Klein, who is glued to the TV monitor surrounded by a forest of chiffon, silk, and taffeta. Backstage everyone is applauding, too. The master takes a bow and returns to his models for one last photo—until next season

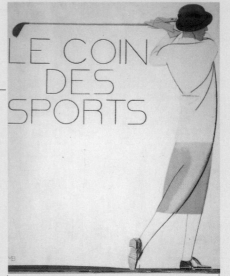

## The end of the Middle Ages

It is difficult to speak of European fashion as such before the fourteenth century. Until then only colors and fabrics distinguished rank or social function, whereas widely cut tunics were worn indifferently by men and women. From 1340, costume changed periodically and differed depending on sex. Women's dresses were very long, with tightly fitting bustlines and low necklines. Men wore breeches or were clad in doublet and hose. At that time fashion depended on political importance and people imitated the style of the most prestigious European court of the day.

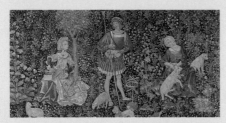

## The seventeenth century

Under Louis XIV, France began to create its own style. Encouraged by Colbert, an association of craftsmen specializing in the manufacture of articles of clothing was formed. Masculine costume reached the summits of extravagance with ornamentation such as lace, ribbons, and embroidery. The rivalry existing between the elegant courtiers largely contributed to changes in fashion. Paris imposed its style in Europe and even sent dolls to the foreign capitals clad in the tailors' latest innovations.

## The eighteenth century

In 1776 a new trade association was constituted, that of fashion merchants specializing in decorations for dresses, hairstyles, and millinery.

At the end of the eighteenth century, under the influence of the hygienists and the return to nature movement, costume was simplified. Whalebones were abandoned, sailor suits were invented for small boys and unpadded white dresses for little girls. Women wore light muslin dresses, drawn in under the bust with a scarf, reminiscent of the silhouette of the costume worn in antiquity.

## The nineteenth century

At the beginning of the nineteenth century, under the pressure of public opinion, borne out by the Napoleonic code, women's costume rapidly renewed with constricting forms

*The first fashion show: In 1845 Charles Frederick Worth (1825–1895) entered into an associated with Gagelin, who supplied the imperial court. He became one of the symbols of fashion as we know it, by evolving from the role of supplier to that of designer. He was the first to present his garments on living models, revived the Lyon silk production, developed machine-made lace, launched his fashion house via the press and exported his patterns and fabrics.*

such as boned corsets, wide skirts, and bonnets which blocked lateral vision.

By mid-century men had given up their colorful garments and adopted a sort of lounge suit, often black, composed of a jacket or frock coat and trousers. The only imagination remained in the choice of shirt collar and cravat.

**Fur**: In 1839, when **Louis-Victor Revillon** took over the century-old Parisian furrier Givelet, fur choice was limited to beaver, ermine, and squirrel and it was only worn by members of the court. Revillon revolutionized the treatment of fur by approaching it with the rules of dressmaking for cut, fit, and shape, enlarging the range of furs used, introducing color, and a promoting a new method of shearing. Revillon soon after invented the first cold storage rooms for furs and opened trading posts and shops in Canada, Russia, Caucasia, and Siberia.

In about 1830, department stores started selling ready-made clothes, which were simplified versions of the prestigious fashion designers' creations.

**The turn of the century**: Until 1900, constricting crinolines, bustles, and leg-of-mutton sleeves were essentially worn by ladies of leisure. An English designer, Charles Poynter, promoted the "walking suit" consisting of a man's jacket with buttons down the front and an ankle-length skirt flared in the back to allow for easy walking. It rapidly became a basic element of women's wardrobes at a time when they were gaining access to higher education and sports.

## The twentieth century and the new feminine condition

At the beginning of the twentieth century, doctors advocated the elimination of the corset. In 1907, Paul Poiret (1879–1944) proposed straight dresses worn without petticoats, and liberating women from corsets. He promoted a supple, elongated silhouette, enhanced by magnificent printed fabrics inspired by Oriental art. He profoundly marked decorative art by collaborating with

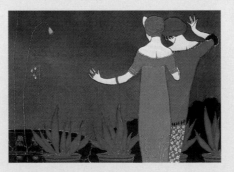

contemporary artists, such as Louis Sue, Raoul Dufy, and Paul Iribe.

**Three young women in Fashion** :Jeanne **Lanvin** (1867–1946) was a milliner at sixteen, a dressmaker at eighteen and opened her first workshop, in 1885, in the rue Boissy d'Anglas. Her "robe de style," or "picture" dress, full-skirted and gathered in at the waist, contrasted with the tubular silhouettes of the twenties. A virtuoso, she innovated with rich embroidery and daring insertions.

**Nina Ricci** (1883–1970), an extremely talented technician, entered the world of fash-

*The influence of men's garments in women's fashions: Jean Patou (1887–1936) profoundly influenced Paris fashions between the two wars, by his revolutionary conception of simple, sporty clothes. After the ornamental exuberance of Paul Poiret, he created a new silhouette characterized by sportswear, an urchin style, and the use of jersey.*

*Gabrielle "Coco" Chanel (1883–1971) sensed the evolution in the condition of women. She drew inspiration from the trends in English men's fashion and was the first to impose women's trousers. In the 1920s she designed a braid-trimmed suit, which was re-introduced in 1954 and has become a timeless classic.*

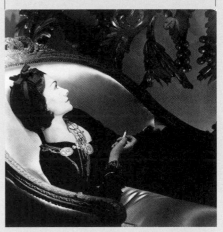

ion at the age of eighteen. In 1932, with her son Robert Ricci, she opened salons which were frequented by a clientele in search of taste and traditional elegance. She founded a family-run fashion house of international renown and succeeded in associating her personal desires with the sensibilities of the day.

**Madeleine Vionnet** (1876–1975) demonstrated her originality very early, by creating dresses whose style was closer to lingerie than the models created by Worth. She opened a fashion house in 1912, presenting a style based on paneling, draping, and bias cut, which she designed on miniature dummies in light fabrics such as crêpe. She was much influenced by the art deco style and incorporated Lesage embroidery in her models.

The notion of sportswear, a style linked with sport and relaxation, made its appearance in the twenties and contrasted with city clothes and matching ensembles. When René Lacoste invented his now-famous polo shirt for his

*An avant-garde fashion:* Elsa Schia-parelli (1890–1973) was of Italian origin and her innovative style attracted attention as early as 1935. She was influenced by avant-garde artistic movements such as cubism and surrealism and created collections based on themes involving the circus, music, and butterflies, etc. Her "press-cutting" fabrics, oilcloth models, and Bérard-inspired "shocking pink" caused as much astonishment as her hats designed by Dali.

personal use, he greatly contributed to the popularity of leisure wear.

**Fashion accessories**: In the postwar years, jewelry designed to match garments became the vogue. Jewelers worked directly with *haute couture* designers, while the costume jewelry industry developed along with that of ready-to-wear fashions. Since the eighties, handbags, belts, necklaces, earrings, and other accessories, in both luxury and middle-range price brackets, have experienced an unprecedented boom.

At its creation in 1946 only shoes bore the **Céline** trademark; in 1947 leather accessories were added to the collection. The creation of a ready-to-wear line in 1967 reinforced the Céline style, which is that of an elegant and discreetly sporty woman.

**A designer, a style: Christian Dior** (1905–1957) received his training from Lucien Lelong, alongside Pierre Balmain. On 12 February 1947, at 30 avenue Montaigne, the New Look saw the light of day. Narrow shoulders, high bustlines, fitted waists and flared skirts one foot from the ground for day wear and very long and wide for evening wear, were the new criteria for the Dior woman. In 1954, with the "string bean" line, he caused another revolution.

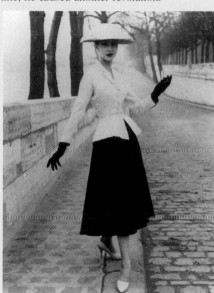

In 1937 **Cristobal Balenciaga** (1895–1972) presented his first collection, dominated by a taste for black. In 1955 he pursued a very personal style, turning away from the New Look by creating the sack dress. Wide toreador capes followed in the sixties. His color range was inspired by the deep tones of his native country of Spain.

In 1945 **Pierre Balmain** (1914–1982) presented his first collection in which his sober lines and contrasting fabric shades were a tri-umph. His architectural training was reflected in structured garments, padded shoulders, and fitted waistlines which accentuated the bust and lengthened the silhouette.

**Yves Saint Laurent** had been Christian Dior's assistant for two years when the maestro died in 1957, at which time he took over creative responsibility at the Dior fashion house. He was universally acclaimed with his first collection presenting the trapeze line, and he launched his own fashion house in 1962. His unconventional outlook was illustrated by safari jackets, pants suits, and see-through blouses.

His dresses are inspired by pictorial trends and are a tribute to Mondrian, Picasso, and Van Gogh.

**From the street to the stage**: In 1941, Germaine Krebs (1903–1993) opened a fashion house under the name of Grès and imposed new fabrics such as silk jersey, mohair, and nylon. Her mastery in the art of draping and pleating, usually in solid colors, her expert cutting, and her extensive knowledge of

*The "futurists" of the sixties and seventies:* The eleven years which André Courrèges spent with Balenciaga, familiarized him with the rigor and structure of a garment. When he opened his fashion house in 1961, he imposed a style which heralded the liberating trends of the seventies, such as mini dresses, tights, vinyl, and futuristic designs.

*Pierre Cardin* started his career under the guidance of the great masters Paquin, Schiaparelli, and Dior where, through specializing in suits he learned to sketch, cut, and sew. He was soon also producing theatrical costumes. Cardin's first collection in 1953 confirmed his talent as a futurist designer with bubble dresses; other trend-setters followed including Mao suits, Op Art coats, and a "space age" collection. *Paco Rabanne,* an artist, architect, sculptor, and designer of accessories for haute couture designers, made his début in fashion in 1966 with "12 unwearable dresses in contemporary materials," such as aluminum and rhodoïd. He pursued his research into alternative materials and experimented with non-conformist work which went far beyond the frontiers of fashion design.

ancient costumes, led to her participation in numerous theatrical creations.

**Classic, exuberant, and sensual artists in the service of women:** After training with Jacques Fath, Lucien Lelong, and Elsa Schiaparelli, Hubert de Givenchy presented his first collection in 1952, in which his matching separates attracted everyone's attention. For forty years, Audrey Hepburn symbolized the natural elegance of the Givenchy woman. A long friendship with Balenciaga gave him a taste for structured shapes, brightly colored prints, and attention to detail.

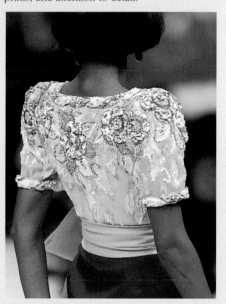

In 1956 **Jean-Louis Scherrer** began his career with Christian Dior and continued working with Yves Saint Laurent after Dior's death. He opened his own house in 1962 and moved to avenue Montaigne in 1971. His is a very refined, elegant, and sophisticated style, in which classic lines are enhanced by the rich fabrics, contrasting colors, luxurious embroidery, and transparent effects.

**Guy Laroche** (1921–1989) created his fashion house in 1957 and opened a salon on avenue Montaigne in 1961. For this designer, elegance is more a question of enhancing the feminine personality, than one of creativity. He is famous for his pleated coats, his dresses with low, blouson or cowl style backs, his sophisticated shorts, as well as embroidered and pearl covered dresses.

**Christian Lacroix** opened his fashion house in 1987. Drawing inspiration from his Provençal origins, he assembles and reinvents structure and forms influenced by his cultural heritage. His personal interpretation of traditional codes gives his style an exuberant, baroque character in dazzling colors.

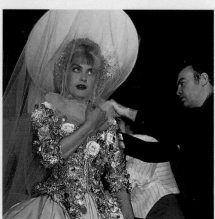

# Vineyards

As any French schoolchild knows, the history of wine cannot be divorced from the history, geography, and geology of the land on which vineyards are grown. Venerated, celebrated, and joyfully consumed, wine comes in many different guises, is drunk from divers vessels, and means a variety of things to all sorts of people. It has figured importantly at every stage in the history of France, of Europe, and of numerous other civilizations.

Wine plays a major role in poetry, literature, and art; in manners and morals. In practice, connoisseurs of wine are people who use their palates like precision instruments to gauge the infinite subtleties that distinguish one wine from another. Wine tastings are occasions for the display of this expertise in a spirit of friendly rivalry or fierce competition. And yet, despite all the advanced technology and traditional skill involved in making wine—all the intuition, experience, secret formulae, and just plain common sense—something elusive and mysterious remains. Even today, the transformation that occurs between vineyard and glass is not totally explicable. We recognize this secular transubstantiation without being able to describe it, an inability that has given mythical status to the simple contents of a glass.

Bordeaux, Cognac, Champagne: three geographic regions; three types of wine among many others; three distinct but complementary processes. All share a common history, however, a history of pure enjoyment and finely honed skills. So finely honed, that of the twenty-five million acres of vineyards in the world, these few thousand have become almost sacred ground, their modest local place-names universally renowned.

The best land for vineyards is often arid, stony, and unpromising. The Médoc region, for example, located in a remote area between

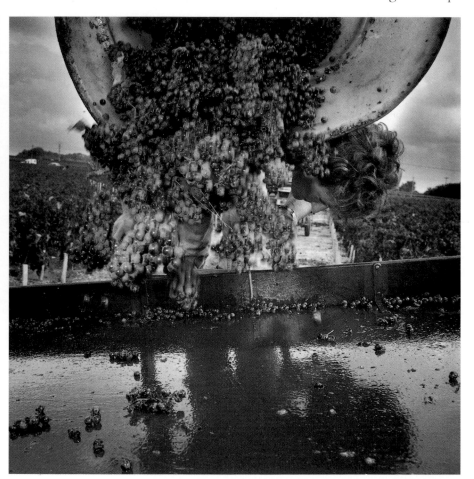

*Harvest at Château Lafite-Rothschild. Experience has taught vintners that, so long as the grapes remain on the vine, the entire crop can still be lost and a whole year's work and effort destroyed in a moment.*

the Gironde River and the Atlantic Ocean, was a swamp in the seventeenth century. However, in much the same way as friction stimulates oysters to produce pearls from a grain of sand, the inhospitable land into which the finest vines must push their roots stimulates the production of superlative grapes. Even before the French Revolution, the prosperity of Bordeaux depended on wines from the Médoc, and from other nearby regions such as Saint-Émilion, Saint-Estèphe, Sauternes, etc. By the middle of the nineteenth century owning a vineyard in the Médoc had become fashionable, and grape harvests the occasions for élite social gatherings. This period gave birth to the mystique of the "château," a term used here to denote any of the miscellaneous structures ranging from simple farm houses, to troubadours' mansions, to magnificent examples of French neoclassical and Palladian architecture. Today these structures are symbolized by the various armorial symbols that mean so much to connoisseurs of Bordeaux wine. Not every château boasts an officially listed growth, but all are distinct economic enti-

*Veronese,* The Wedding at Cana *(detail), 1563. Oil on canvas. Musée du Louvre, Paris.*

ties with their own rules, codes of behavior, and charms.

Connoisseurs of fine wine always sniff the contents of their glass before tasting it. This is a particularly rewarding gesture in the case of cognac, which has a complex, heady aroma. The unique aroma of cognac accounts for the invention of the brandy snifter, a glass designed to concentrate the bouquet and funnel it directly to the nose. The wine-growing areas in the imme-

# Appellations d'Origine Contrôlée

## The East

*Marc de lorraine*

## Champagne

*Champagne*
*Coteaux champenois*
*Rosé des Riceys*

## Alsace

*Alsace ou vin d'Alsace*
*Alsace grand cru*
*Alsace grand cru Altenberg*
 *de Bergbieten*
*Alsace grand cru Altenberg*
 *de Bergheim*
*Alsace grand cru Altenberg*
 *de Wolxheim*
*Alsace grand cru Brand*
*Alsace grand cru Bruderthal*
*Alsace grand cru Eichberg*
*Alsace grand cru Engelberg*
*Alsace grand cru Florimont*
*Alsace grand cru Frankstein*
*Alsace grand cru Froehn*
*Alsace grand cru Furstentum*
*Alsace grand cru Geisberg*
*Alsace grand cru Gloeckelberg*
*Alsace grand cru Goldert*
*Alsace grand cru Hatschbourg*
*Alsace grand cru Hengst*
*Alsace grand cru Kanzlerberg*
*Alsace grand cru Kastelberg*
*Alsace grand cru Kessler*
*Alsace grand cru Kirchberg*
 *de Barr*
*Alsace grand cru Kirchberg*
 *de Ribeauvillé*
*Alsace grand cru Kitterlé*
*Alsace grand cru Mambourg*
*Alsace grand cru Mandelberg*
*Alsace grand cru Marckrain*
*Alsace grand cru Moenchberg*
*Alsace grand cru Muenchberg*
*Alsace grand cru Ollwiller*
*Alsace grand cru Osterberg*
*Alsace grand cru Pfersigberg*
*Alsace grand cru Pfingstberg*
*Alsace grand cru Praelatenberg*
*Alsace grand cru Rangen*
*Alsace grand cru Rosacker*
*Alsace grand cru Saering*
*Alsace grand cru Schlossberg*
*Alsace grand cru*
 *Schoenenbourg*
*Alsace grand cru Sommerberg*
*Alsace grand cru Sonnenglanz*
*Alsace grand cru Spiegel*
*Alsace grand cru Sporen*
*Alsace grand cru Steingrubler*
*Alsace grand cru Steinert*
*Alsace grand cru Steinklotz*
*Alsace grand cru Vorbourg*
*Alsace grand cru Wiebelsberg*
*Alsace grand cru Wineck-*
 *schlossberg*
*Alsace grand cru Winzenberg*
*Alsace grand cru Zinnkoepflé*
*Alsace grand cru Zotzenberg*
*Alsace ou vin d'Alsace*
 *Gewürztraminer*
*Alsace ou vin d'Alsace Riesling*
*Alsace ou vin d'Alsace Pinot*
 *gris ou Tokay-pinot gris*
*Alsace ou vin d'Alsace Muscat*
*Alsace ou vin d'Alsace Pinot*
 *ou Klevner*
*Alsace ou vin d'Alsace Sylvaner*
*Alsace ou vin d'Alsace*
 *Chasselas ou Gutedel*
*Alsace ou vin d'Alsace Pinot*
 *noir crémant d'Alsace*
*Marc d'Alsace Gewürztraminer*
*Vin d'Alsace Edelzwicker*

## Burgundy

*Aloxe-Corton*
*Auxey-Duresses*
*Bâtard-Montrachet*
*Beaune*
*Bienvenues-Bâtard-Montrachet*
*Blagny*
*Bonnes-Mares*
*Bourgogne*
*Bourgogne Aligoté*
*Bourgogne Aligoté Bouzeron*
*Bourgogne Clairet*
*Bourgogne Clairet Côte*
 *Chalonnaise*
*Bourgogne Clairet Hautes Côtes*
 *de Beaune*
*Bourgogne Clairet Hautes Côtes*
 *de Nuits*
*Bourgogne Côte Chalonnaise*
*Bourgogne grand ordinaire*
*Bourgogne grand ordinaire'*
 *Clairet*
*Bourgogne grand ordinaire rosé*
*Bourgogne Hautes-Côtes*
 *de Beaune*
*Bourgogne Hautes-Côtes*
 *de Nuits*
*Bourgogne irancy*
*Bourgogne mousseux*
*Bourgogne ordinaire*
*Bourgogne ordinaire clairet*
*Bourgogne ordinaire rosé*
*Bourgogne passetoutgrain*
*Bourgogne rosé*
*Bourgogne rosé Côte*
 *Chalonnaise*
*Bourgogne rosé Hautes-Côtes*
 *de Beaune*
*Bourgogne rosé Hautes-Côtes*
 *de Nuits*
*Chablis*
*Chablis premier cru*
*Chablis grand cru*
*Chambertin*
*Chambertin-Clos de Bèze*
*Chambolle-Musigny*
*Chapelle-Chambertin*
*Charlemagne*
*Charmes-Chambertin*
*Chassagne-Montrachet*
*Chassagne-Montrachet*
 *premier cru*
*Chevalier-Montrachet*
*Chorey-lès-Beaune*
*Clos des Lambrays*
*Clos de la Roche*
*Clos de Tart*
*Clos de Vougeot*
*Clos Saint-Denis*
*Corton*
*Corton-Charlemagne*
*Côte de Beaune*
*Côte de Beaune-Villages*
*Côte de Nuits-Villages*
*Crémant de Bourgogne*
*Criots-Bâtard-Montrachet*
*Eaux-de-vie de marc*
 *de Bourgogne*
*Eaux-de-vie de vin*
 *de Bourgogne*
*Échezeaux*
*Fixin*
*Gevrey-Chambertin*
*Givry*
*Grands-Échezeaux*
*Griottes-Chambertin*
*Ladoix*
*La Grande Rue*
*La Romanée*
*La Tâche*
*Latricières-Chambertin*
*Mâcon ou Pinot-Chardonnay*
 *Mâcon*
*Mâcon supérieur*
*Mâcon-Villages*
*Maranges*
*Marc de Bourgogne*
*Marsannay*
*Mazis-Chambertin*
*Mazoyères-Chambertin*
*Mercurey*
*Meursault*
*Montagny*
*Monthelie*
*Montrachet*
*Morey-Saint-Denis*
*Musigny*
*Nuits ou Nuits-Saints-Georges*
*Pernand-Vergelesses*
*Petit Chablis*
*Pommard*
*Pouilly-Fuissé*
*Pouilly Loché*

diate vicinity of Cognac are Grande and Petite Champagne, Les Borderies, Les Fins Bois, Les Bons Bois, and Les Bois Communs. Each of the six has its own distinct geological and climatic properties. Cognac producers use grapes from several or all of them, grading the final blend according to the number of years it has been aged in the cask.

Cognac does not age after bottling, but retains all of its original characteristics. Produced according to time-honored methods, cognac is one of the most sophisticated and consistent of all the products made from grapes grown in French soil. Today cognac is appreciated world-wide, but only the largest producers have the resources required for marketing on this scale. On the other hand, none own vineyards extensive enough to meet their own demand for distilled spirits. This is why most major producers are supplied by small local vintners and distillers, a fact that differentiates them from the makers of Bordeaux wine, for example, whose product is identified by the specific "château" it comes from. Cognac is produced by major firms, often working in concert. These are businesses managing the long-term bulk marketing of a product blended from spirits distilled locally, in small amounts, that must then be aged for lengthy periods. The problems involved become clear when we realize that some of the freshly-distilled spirits now beginning the aging process will not be sold until well into the next century.

Champagne's image as a bubbly festive drink is so strongly fixed in our minds we tend to forget that some sparkling wines come from regions other than Champagne, and are thus not true champagne. Even genuine champagne can vary in subtle ways; it is made from very fine white wine that is subjected to the "champagnization" process to make it effervescent. Only the best grapes, grown in the most favorable soil, and fermented according to the most meticulous methods, are used to make champagne. The fermented wine is bottled, tended, turned, tipped, and racked until effervescence is complete and the last of the sediment can be removed.

Bordeaux, cognac, champagne. These great wines and spirits have deep cultural roots. They are appreciated by connoisseurs because the people who produce them are skilled professionals with an abiding respect for ancient traditions. Bordeaux wine, admired for its color and bouquet, is judged by vintage year and origin—those châteaux surrounded by row upon row of legendary vineyards forming the invisible boundaries of metaphorical countries. Fine cognac is appreciated for the pungent aroma resulting from careful distillation and long aging—for the many years spent slumber-

Pouilly Vinzelles
Puligny-Montrachet
Richebourg
Romanée-Conti
Romanée-Saint-Vivant
Ruchottes-Chambertin
Rully
Saint-Aubin
Saint-Aubin premier cru
Saint-Romain
Saint-Véran
Santenay
Savigny ou Savigny-lès-Beaune
Vins fins de la Côte de Nuits
Volnay
Volnay Santenots
Vosne-Romanée
Vougeot

## Beaujolais

Beaujolais
Beaujolais-Villages
Brouilly
Chénas
Chiroubles
Côte de Brouilly
Freurie
Juliénas
Morgon
Moulin-à-Vent
Régnié
Saint-Amour

## Jura

Arbois
Arbois mousseux
Arbois-Pupillin
Château-Chalon
Côtes du Jura
Côtes du Jura mousseux
L'Étoile
L'Étoile mousseux
Macvin du Jura

## Savoy

Crépy
Mousseux de Savoie
Pétillant de Savoie
Roussette de Savoie
Seyssel
Seyssel mousseux
Vin de Savoie
Vin de Savoie mousseux
Vin de Savoie pétillant
Vin de Savoie Ayze mousseux
Vin de Savoie Ayze pétillant

## The Rhone Valley

Château-Grillet
Châteauneuf-du-Pape
Châtillon-en-Diois
Clairette de Die
Clairette de Die mousseux
Condrieu
Cornas
Côte rôtie
Coteaux du Tricastin
Côtes du Lubéron
Côtes du Rhône
Côtes du Rhône-Villages
Côtes du Ventoux
Coteaux de Die
Crémant de Die
Crozes-Hermitage ou
    Crozes-Ermitage
Gigondas
Hermitage ou Ermitage
Lirac
Muscat de Beaumes-de-Venise
Rasteau
Rasteau rancio
Saint-Joseph
Saint-Péray
Saint-Péray mousseux
Tavel
Vacqueyras

## Provence

Bandol
Bellet

Cassis
Coteaux d'aix-en-Provence
Coteaux de Pierrevert
Coteaux varois
Côtes de Provence
Palette

## Corsica

Ajaccio
Muscat du Cap Corse
Patrimonio
Vins de Corse
Vins de Corse calvi
Vins de Corse coteaux
    du Cap Corse
Vins de Corse Figari
Vins de Corse Sartène
Vins de Corse Porto-Vecchio

## Languedoc and Roussillon

Banyuls
Banyuls rancio
Banyuls grand cru
Banyuls grand cru rancio
Blanquette de Limoux
Clairette de Bellegarde
Clairette du Languedoc
Collioure
Corbières
Costières de Nîmes
Coteaux du Languedoc
Côtes du Roussillon
Côtes du Roussillon-Villages
Crémant de Limoux
Faugères
Fitou
Frontignan
Grand Roussillon
Grand Roussillon rancio
Limoux
Maury
Maury rancio
Minervois
Muscat de Frontignan
Muscat de Lunel
Muscat de Mireval
Muscat de Rivesaltes
Muscat Saint-Jean-de-Minervois
Rivesaltes
Rivesaltes rancio
Saint-Chinian
Vin de Frontignan

## The Southwest

Armagnac
Bas-Armagnac
Béarn
Bergerac
Buzet
Cahors
Côtes de Bergerac
Côtes de Bergerac moelleux
Côtes de Duras
Côtes du Frontonnais
Côtes du Marmandais
Côtes de Montravel
Floc de Gascogne
Gaillac
Gaillac Première Côtes
Gaillac doux
Gaillac mousseux
Haut-Armagnac
Haut-Montravel
Irouléguy
Jurançon sec
Madiran
Marcillac
Monbazillac
Montravel
Pacherenc du Vic-Bibl
Pécharmant
Rosette
Saussignac
Ténarèze

## Cognac

Bon bois
Borderies
Cognac
Eau-de-vie de Charente
Eau-de-vie de Cognac

Esprit de Cognac
Fine Champagne
Fins Bois
Grande Champagne
Grande fine Champagne
Petite Champagne
Petite fine Champagne
Pineau des Charentes

## Bordeaux

Barsac
Blaye ou Blayais
Bordeaux
Bordeaux Clairet
Bordeaux Côtes de Francs
Bordeaux Haut-Benauge
Bordeaux rosé
Bordeaux sec
Bordeaux supérieur
Bordeaux supérieur clairet
Bordeaux supérieur rosé
Bourg ou bourgeais
Cadillac
Canon-Fronsac
Cérons
Côtes de Blaye
Côtes de Bordeaux Saint-Macaire
Côtes de Bourg
Côtes de Castillon
Crémant de Bordeaux
Entre-Deux-Mers
Entre-Deux-Mers Haut-Benauge
Fine Bordeaux
Fronsac
Graves
Graves supérieurs
Graves de Vayres
Haut-Médoc
Lalande de Pomerol
Listrac-Médoc
Loupiac
Lussac Saint-Émilion

Margaux
Médoc
Montagne Saint-Émilion
Moulis-en-Médoc
Néac
Pauillac
Pessac-Léognan
Pomerol
Premières Côtes de Blaye
Premières Côtes de Bordeaux
Puisseguin Saint-Émilion
Sainte-Croix-du-Mont
Saint-Émilion
Saint-Émilion grand cru
Saint-Estèphe
Saint-Foy Bordeaux
Saint-Georges Saint-Émilion
Saint-Julien
Sauternes

## The Loire Valley

Anjou
Anjou-Coteaux de la Loire
Anjou-Gamay
Anjou pétillant
Anjou mousseux
Anjou-Villages
Bourgueil
Bonnezeaux
Cabernet d'Anjou
Cabernet de Saumur
Cheverny
Cour-Cheverny
Chinon
Coteaux de l'Aubance
Coteaux du Layon
Coteaux du Layon-Chaume
Coteaux du Loir
Coteaux de Saumur
Crémant de Loire
Jasnière

Montlouis
Montlouis pétillant
Montlouis mousseux
Muscadet des Coteaux
    de la Loire
Muscadet des Côtes
    de Grand-Lieu
Muscadet de Sèvre-et-Maine
Quarts de Chaume
Rosé d'Anjou
Rosé d'Anjou pétillant
Rosé de Loire
Saint-Nicolas-de-Bourgueil
Saumur
Saumur-Champigny
Saumur pétillant
Saumur mousseux
Savennières
Savennières Coulée-de-Serrant
Savennières Roche-aux-
    Moines
Touraine
Touraine-Amboise
Touraine-Azay-le-Rideau
Touraine-Mesland
Tourraine pétillant
Tourraine mousseux
Vouvray
Vouvray pétillant
Vouvray mousseux

## Central France

Blanc fumé de Pouilly
Côte Roannaise
Menetou-Salon
Pouilly-sur-Loire
Pouilly-fumé
Quincy
Reuilly
Sancerre

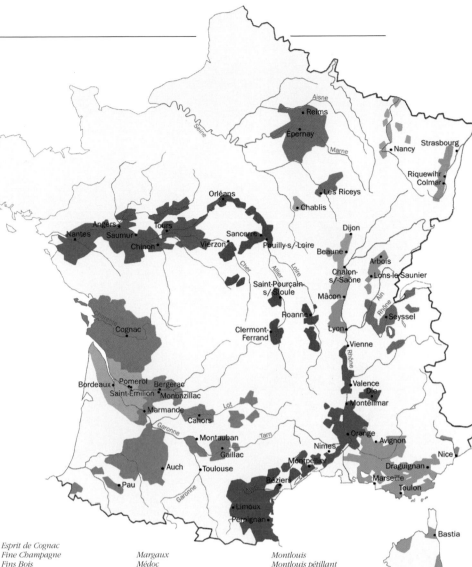

ing in oak casks, in dark cellars, while time is allowed to do the work that it alone can do. Champagne is for celebrations. When the cork pops and the bubbles fizz, the party can begin.

From humble grape to divine nectar, vines bring joy to humankind. What better way to warm the heart than with the thought that some things improve with change, maturity, and age.

### "Fine wines are nurtured, not made"

This is the philosophy of Alain Terrier, cellar master at Laurent Perrier Champagnes. Terrier, with his luxuriant moustache and broad Gascon accent, is a native of Bordeaux, who works on

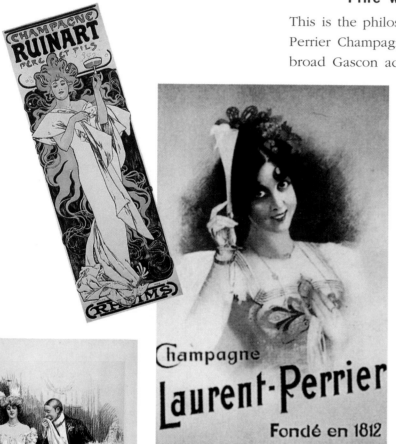

the slopes of the Montagne de Reims and the Tours-sur-Marne estate. These are, moreover, words that every oenologist, vintner, and cellar master in the regions of Bordeaux, Cognac, and Champagne would endorse. Wine is indeed "nurtured," in the sense that both the grapes and their juice must be tended, encouraged, and supported in a continuous effort to create the optimum conditions under which they will be able to fulfill their potential and achieve their peak of perfection. This effort involves a sum of acquired knowledge based on observation, discovery, and learning that makes oenology an applied science: a science rooted in the geography and history of the landscape—a science of the land itself.

Kees van Leeuwen, the young vineyard manager at Château Cheval Blanc, knows this only too well. When he finished his secondary-school education at the age of eighteen, van Leeuwen decided to study oenology in Bordeaux, and that was where he, too, learned that "wine-making has deep cultural roots." He had to learn this culture from the ground up, but as a European already sensitive to concepts of harmony, balance, elegance, and finesse, it came naturally to him.

"Today," he points out, "there are places in the world where vintners new to wine making are trying to produce great vintages at the first attempt. What they don't realize is that in traditional wine-producing countries like France, it took centuries to identify the best areas for growing the grapes that yield the best wines."

*Advertisement for Louis Rœderer champagne, 1920.*
Top: *Poster by Mucha for Ruinart champagne, c. 1900.*
Right: *Poster for Laurent-Perrier champagne.*

Cultural roots need time and accumulated tradition if they are to flower, and the cultural roots of fine French wine have flowered only in specific regions, and sometimes on tiny plots of land that have proved their potential for greatness only gradually.

What are these regions and these lands? What makes them so hospitable to vineyards? And how is the so-called "typicity" of a wine determined? Geology is part of the explanation, and yet there is no single geological formation necessarily favorable to vineyards. Clay, limestone, and gravel have all contributed their unique properties to the nurture of great vineyards—and great wines.

## Soil and climate

It was once believed that the minerals found exclusively in poor, stony soil were essential to the production of great wine. Since then, however, many great vintages have been produced successfully in a vast range of different soils, from rich clay to dry gravel. In the absence of firm evidence to the contrary, this would seem to prove that the specific minerals vines receive from the soil do not play a crucial role in the mysterious development of an exceptional wine.

Moisture, on the other hand, is a different story, with an unusual slant. An ample supply of water in the soil is not favorable to the production of fine wine: too much water stimulates quantity at the expense of quality. It is also interesting to note that to a vintner, "water supply" does not necessarily refer either to rainfall or ground water, but rather to the presence of microscopic water droplets in the soil that force the vines to root more deeply in their search for them. The discipline imposed on the vines by this microscopic, hard-to-reach moisture is indeed a standard feature of all great wine regions.

This is because grapevines need adversity in order to develop strength, as Courvoisier's head vintner Pierre Szersnovicz implies when he says, "Cultivating vines is like raising children; if they don't have some discipline, they'll be spoiled." In countries with a long tradition of viticulture, where the quality of the final product is valued more than its quantity, conditions which tend to provide the vines with some discipline are highly prized. Grapes cultivated according to traditional methods in relatively cold climates mature slowly, and slow maturation of the grapes improves the bouquet of the wine.

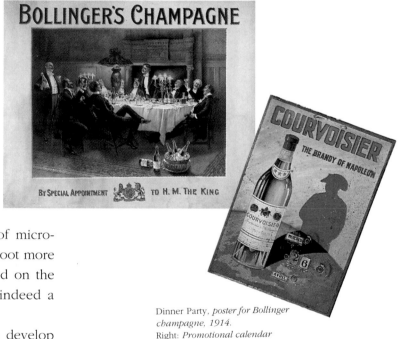

Dinner Party, *poster for Bollinger champagne, 1914.*
Right: *Promotional calendar for Courvoisier cognac, c. 1925.*

Thus, while the minerals supplied by the soil probably have only a minimal effect on grape quality, the discipline of adversity is definitely needed to spur its development. In the stony Graves region, this adversity is provided by the poverty of the soil; in regions of richer clay soil, such as those where the great Pomerols are grown, adversity is provided by the compactness of the earth. This compactness forces the vines to make a real effort in putting down roots. It also tends to suffocate the roots during the winter, stimulating the vine to put new ones down through

*A Château d'Yquem grapevine.*

the limestone soil in the spring. On this type of soil, nitrogen is released more slowly from the rotting humus used as fertilizer, which also inhibits over-abundant growth. The greatest wines always come from grapes grown in soils that are parsimonious with water and that also present some adverse, or even hostile, chemical or physical property.

It is necessary to say a word about grape varieties, one of the three components (soil, climate, grape) crucial to wine quality. The great Bordeaux wines, for example, are blends of wine made from different grape varieties grown on different plots of land. Together they endow the finished product with its complexity and distinctive bouquet. The Saint-Émilion *grand cru* classification covers some ninety acres. Half of this area is all gravel, and half clay with a sandy surface. The clay area has the same effect on vines as the high-clay soil of the nearby Pomerol area.

Uniquely for the Bordeaux region, sixty percent of the Château Cheval Blanc vineyard is planted with cabernet grapes, which have great finesse. Another thirty-seven percent is planted with merlot, a variety popular in the Saint-Émilion region, and one that gives body to wine. The rest of the estate is planted with two minor varieties, malbec and cabernet sauvignon.

In traditional wine-producing regions, the identification of favorable soil has always been combined with close observation of the local microclimate, a procedure that enables the vintners of the Champagne region, for example, to determine the exact altitude at which vines should be planted on each slope in order to avoid winter frosts above, and sudden spring frosts on the plains below. Following close observation of the microclimate in the

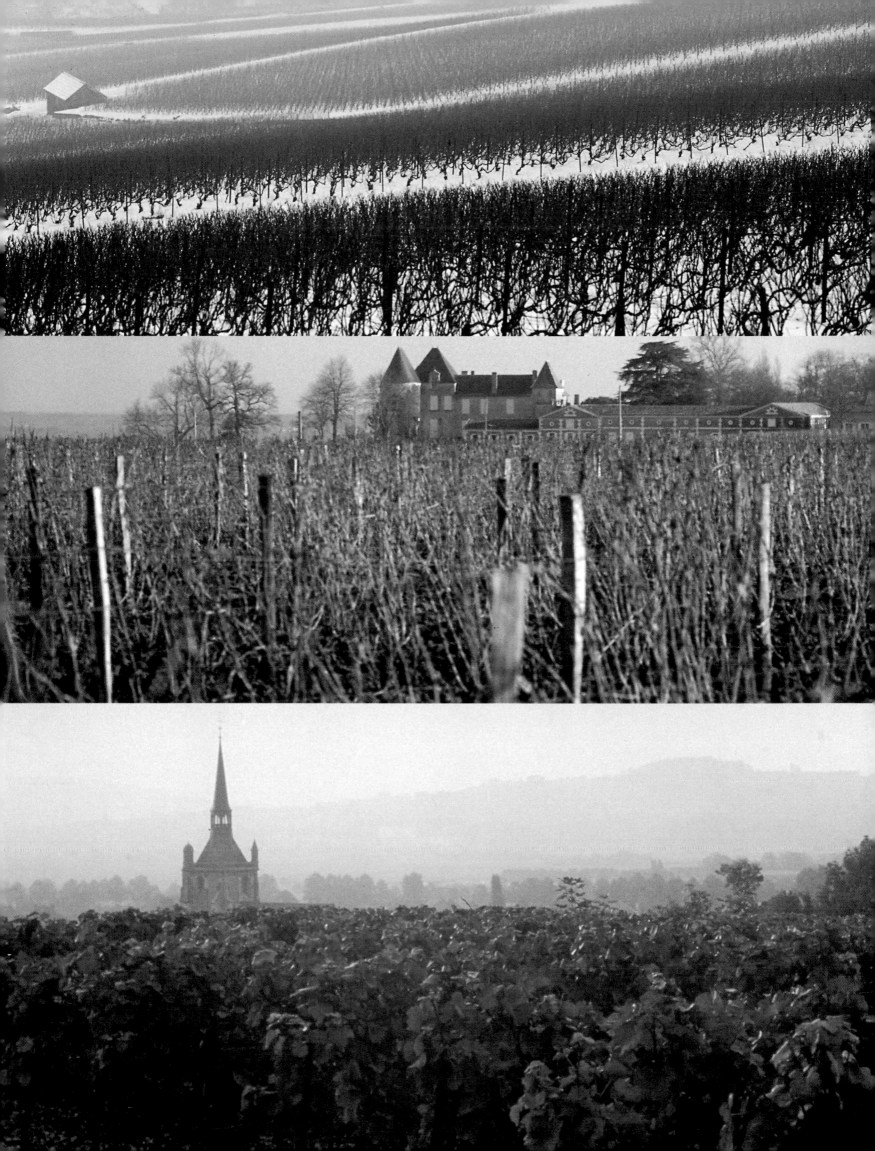

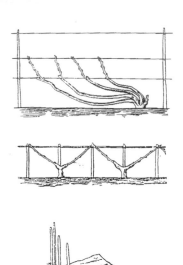

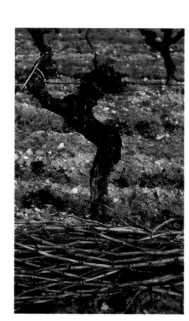

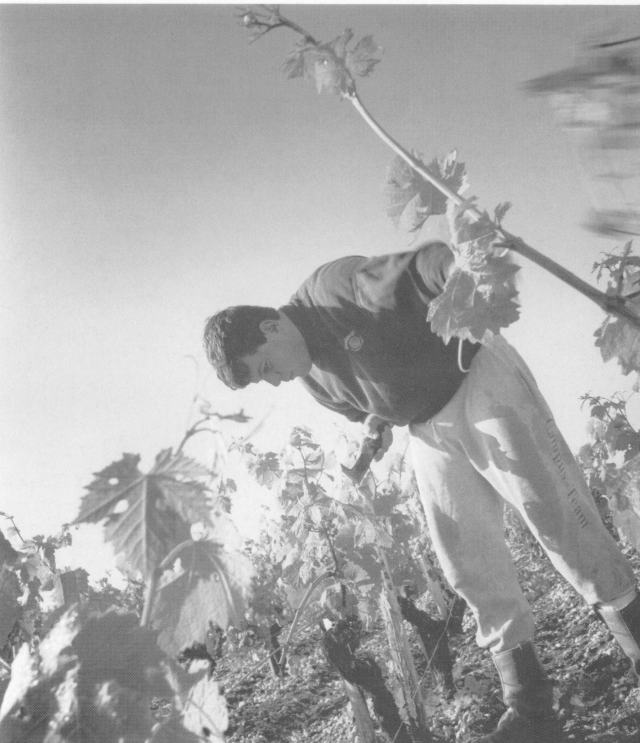

"Lifting" time at Château Lafite-Rothschild: the branches are in fact pulled back by hand so that more sun will reach the bunches of grapes. The foliage is lifted to create a shield against inclement weather on the side of the plant exposed to the prevailing west winds.
Left: *A pruned vine at Château d'Yquem. The vines are cut back until only two, or at most four, branches are left.*
Bottom: *First buds in the Rémy Martin vineyards. The Charente region is almost entirely planted with ugni blanc, a hardy Italian variety of grape.*

Right-hand page: *Treating the vine, which nowadays is a mechanized process. Château Lafite-Rothschild.*

Côte des Blancs area, also in the Champagne region, one vine-
yard was actually planted right in the middle of a village. The
grapes from this vineyard are used to produce Clos du Mesnil, a
single-variety vintage. This is very rare for champagne, which is
usually blended. For similar reasons of soil and climate, the plots
of land in each of the Bordeaux *grand cru* areas are also planted
with several different varieties of grape. Depending on soil com-
position and exposure, two and sometimes even three varieties
are planted in the same plot.

In Pauillac, where the moisture-filled gravel soil requires deep
drainage, the Château Lafite-Rothschild vineyard is split into lots
corresponding to the exact properties of each grape variety.
Cabernet sauvignon goes into the light, deep gravel; merlot into
the compact clay. This vineyard benefits from a north–south
exposure which provides plenty of sunshine and air to protect it
from disease and parasites.

## Tending the vineyard: an enduring tradition

Once the best soil for the vines has been chosen, the climate
carefully observed, and the appropriate grape varieties planted,
the vineyard must then be tended. The procedure for tending the
great vineyards is based on a long tradition which has under-
gone change gradually, almost reluctantly.

PRUNING • The vintner's four seasons begin in winter, with
pruning. In a procedure known as single or double "Guyot"
pruning, the vines are cut back until only two, or at most four,
branches are left. These will bear five or six buds in the spring.
The goal in the great vineyards is to limit yield in order to con-
centrate the bouquet in a reduced number of grapes. Since care-
ful pruning cannot be mechanized, the operation, including
removal of dead branches or canes and collection of the cut
wood left at the foot of each vine, is carried out entirely by
hand. At the great Bordeaux vineyards, the upkeep of each indi-
vidual plot is usually the responsibility of a single person. At
Château Cheval Blanc, seven women are paid on a piece-work
basis to tend plots measuring approximately twelve acres each.
These women are responsible for all the minor tasks that must
be performed throughout the year in addition to major mainte-
nance work.

Proper pruning is crucial to the longevity of a vine, and the fact
that the best wine comes from grapes grown on older vines
makes it especially important. Vines cannot be allowed to age

### Tending the vines: treating and lifting

*In summertime the vineyards are
treated to protect them from disease
and mildew, which can spread
swiftly if the fruit
has been damaged
by rain, wind, or
hail. Close supervi-
sion of the vines is
essential, especially
for the grape vari-
eties used to pro-
duce great wines,
which are more
than usually vul-
nerable.*

*Summer is also the
time when the sag-
ging branches and
leaves of each plant
are "lifted." The
branches are
pulled back so that
more sun will reach the bunches of
grapes, and the foliage is lifted to
create a shield against inclement
weather on the side of the plant
exposed to the prevailing west
winds. Lifting requires the participa-
tion of every worker on the estate,
two or three times per season.*

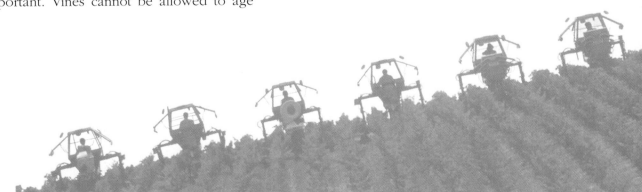

indefinitely, however, since they eventually weaken and become sterile. At Château Lafite-Rothschild, vines over fifty years old are pulled up and the soil stripped, plowed, fertilized, and left fallow for five years before being replanted with young vines.

Plowing is done in the spring. Oxen once drew the plows, but today this work is done by oddly-shaped, mechanized, raised tractors that straddle the rows of vines and plow between them. Following behind the plows come women workers who rake out the "balks," or unplowed ridges of earth thrown up against the plants. Weed-killers are never, ever, used in the great vineyards, and fertilizer of any kind is used only sparingly. At Château d'Yquem, for example, the preferred method is to mulch the vines with stable-straw from which the manure has been

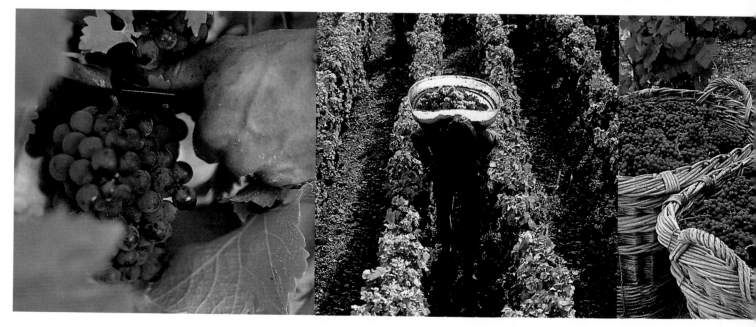

*Grape harvesting scenes.*
*Grape harvesting is always carried out*
*manually in the large vineyards.*
Center: *Large wicker baskets known as*
*mannequins. Veuve Clicquot Ponsardin.*

removed, and then to spread the manure itself very thinly over every eight or nine acres. Quality, not yield, is the top priority.

### The harvest

With very few exceptions, grapes are harvested in September or, at the latest, October. The first hint of fall is a signal to vintners that they must decide on the exact date for the harvest. Their decision will be based on the degree of the grapes maturity—the "bursting point," as oenologists call it—and on an evaluation of the general outlook in the region as a whole. A human factor is also involved: Spanish grape-pickers form the backbone of the labor force, especially in the Bordeaux region, and at harvest time they travel north following the weather and the contours of the land. In Charente,

on the other hand, ninety percent of the grapes are machine-harvested. There is always a risk that the harvest date set in one vineyard will clash with that of another, since weather is not the only factor that determines when the grapes will mature, and some varieties mature earlier than others. Conflicting dates can be a real threat to the harvest, since it takes only a few minutes for an entire crop to be ruined by wind, rain, or hail.

UNIQUE SKILLS • Grapes from all truly great vineyards are harvested by hand, as is frequently the case in over half of all French vineyards. One advantage of hand-picking is that the grapes can be sorted as they are harvested, and leaves, stems, and unripe or rotten grapes removed. Only the perfect fruit, with its skin, juice and pips, goes to the winery.

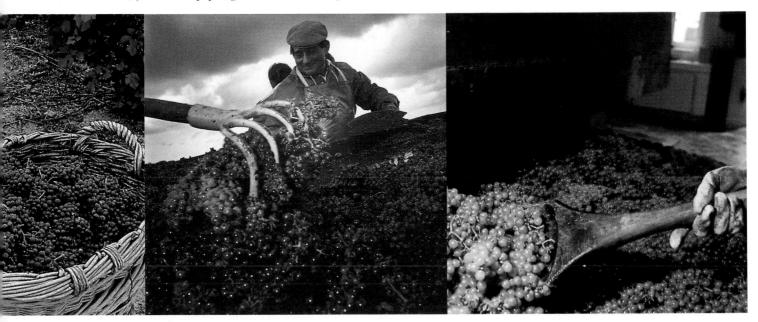

Oenologists, vintners, and cellar masters are unanimous in believing that this attention to detail in tending and harvesting grapes is essential if the fruit is to produce a great wine. Visitors touring vineyards are usually most impressed by the mysterious process that goes on in the vats and cellars, but tending the soil and vines represents three-quarters of the vital work done on a vintner's estate.

THE VAGARIES OF THE WEATHER • After soil, climate, and grapes there is one more factor involved in the ritual surrounding the creation of a great wine—a crucial one that might almost be called the "whim of God." This is the local weather. Proverbially, no one—not even a vintner—can do anything about the weather. When it freezes or rains the day before the date set for

the harvest, as happened in 1973 at Château Cheval Blanc, all hopes for the fabulous vintage promised by the ripening grapes are immediately dashed. Farmers everywhere suffer from the vagaries of weather, but for vintners—a special breed of farmer—the stakes are particularly high. "Vintners are never happy," explains Pierre Szersnovicz, "rain or shine, heat or frost, they always have something to complain about." This is inevitable as experience has taught vintners that, so long as the grapes remain on the vine, the entire crop can still be lost and a whole year's work and effort destroyed in a moment.

Even after the grapes have been successfully harvested, however, the vintner moves into a new area of expertise which has more in common with chemistry than farming. Under the cellar master's care, the fruit that was so carefully tended on the vine now embarks on a new process, its conversion into wine—perhaps a great wine.

### Nurturing the wine

Thierry Garnaud, Château Cheval Blanc cellar master since 1987, dislikes the phrase "turning grapes into wine": he prefers to substitute the word "nurturing," a term which more accurately reflects the way alcoholic fermentation breathes life into the inert raw material. Fermentation is the first process to which the crushed harvested grapes are subjected, endowing them with a capacity for autonomous action and reaction that must be skillfully and patiently supervised, guided, and sometimes anticipated. Every task carried out by the cellar master during the long year that begins with the harvest is focused exclusively on nurturing the nascent wine's exuberant life, disciplining it, and, finally, after it has been stabilized, guiding it to the exact degree of maturity that will make it a great wine truly representative of its region.

FERMENTATION • Crushed grapes from each plot of land are processed in their own individual vats so that, initially, the specific properties of the soil in which they were grown will be preserved. At Château Lafite-Rothschild, traditional methods are combined with modern technology. In the traditional fermenting room stand twenty-nine large oaken casks with an average capacity of about five thousand gallons. Nearby is another fermenting room, this one an ultra-modern facility containing stainless-steel vats equipped with integrated, thermostatically controlled cooling and heating coils—new technology backed by ancient skills and experience.

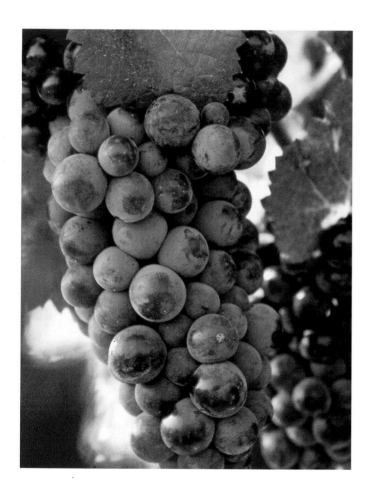

*Côte du Ventoux grapes.*

Center: *Maturing grape juice
at Courvoisier.*
Right: *The first sorting operation:
a bunch of sémillon grapes containing
a mixture of golden, rotten, full and
sun-scorched grapes. Château d'Yquem.*

Following double page
Left: *View of Château d'Yquem.*
Center: *Château d'Yquem, 1892
vintage: "Heady bouquet, incredibly
solid, classic, exquisite"* (Michael
Broadbent in Decanter, *1984).*
Right: *The aging cellar prior to 1987.
Château d'Yquem.*

Botrytis Cinerea. *This is the name of a tiny fungus that, when it attacks grapes, will sometimes generate the curious but valued condition known as "noble rot," and sometimes a fatal disease that can destroy an entire crop. For, paradoxically, the grape parasite* Botrytis *is responsible for one of viticulture's most magnificent inventions—the sweet white dessert wine. It is an "invention," only in the sense used by pioneers who like to say they "invented" something which in fact they discovered. The great* Botrytis *discovery, resulting from a combination of luck and shrewd guesswork, was probably made during the first half of the nineteenth century, when vintners in the Sauternes region noticed that grapes they had dismissed as "spoiled" produced a wine that was not. In fact, it was so delicious it aroused unexpected enthusiasm among international royalty, including Grand Duke Constantine, a member of the imperial family of Russia. The Grand Duke became so enamored of this wine that he bought up the entire crop year after year—somewhat in the style of the eighteenth-century Prince de Conti, who purchased the Romanée estate so that he could keep all the wine it produced for himself.*

### Noble rot or gray rot

*The vintners of the Sauternes region began to look more closely at the phenomenon that had inspired such keen infatuation with their wine, which until then had been thought of as an honest blend of sémillon and sauvignon.*
*The dark spots of* Botrytis *first appear in September, when the grapes are already ripe. The fungus erodes the grape skins, making them permeable. If the sun continues to shine without interruption after the fungus appears, the grapes become dehydrated, their sugar becomes concentrated, and they gradually shrivel until they look almost like white raisins. This concentrated sugar is what gives*

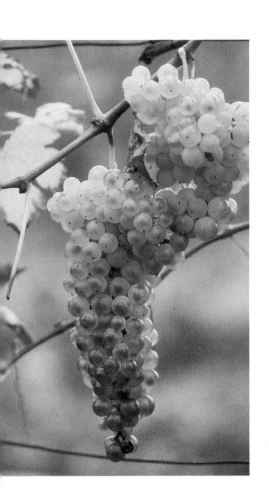

Sauternes *wines their sweet liqueur quality, if all goes well. However, if the onset of the fungus is followed by cloudy weather or rain, the permeable grapes will fill with water, have all their sugar leached out, and will rot. Since the grape harvest in this region does not begin until October and can last well into December, it is easy to appreciate the full extent of the risk run by those Sauternes vintners who allow the fungus to develop.* Botrytis

*is a capricious fungus which even under ideal conditions may develop unfavorably, becoming a dangerous disease known as "gray rot" that can damage grapes irrevocably and can cause the partial or total loss of an entire crop.*

### "We're just gardeners"

*"You see," explains Alexandre de Lur Saluces, owner of the Château d'Yquem estate and heir to a line of vintners going back four centuries, "we're just gardeners." This may be*

true, but these gardeners are also gamblers dealing with a bizarre, mysterious, and uncontrollable phenomenon. Botrytis sometimes appears and sometimes does not; sometimes develops favorably and sometimes unfavorably. The Château d'Yquem "gardeners" labor all year until September to produce the best fruit possible, and then find themselves at the mercy of a minuscule fungus whose mysterious ways they can only hope and pray will be kind. This explains why the Château's history is marked with great years followed by disastrous ones. By way of comparison, good years in Bordeaux tend to alternate with mediocre ones, but none is a total loss. Château d'Yquem, however, has had six disastrous years

one hundred and forty plots planted on slopes covering more than two hundred and fifty acres of remarkable soil ranging from gravel above, to clay below.

### "A fine bouquet, but hard to handle"

The Château d'Yquem vineyards are planted with eighty percent sémillon, a variety with a high tolerance for the "noble rot"; and twenty percent sauvignon, which is more vulnerable to the onslaughts of botrytis but produces a finer bouquet. The estate is thus a mosaic of different grapes. Harvesting is carried out in stages, with certain days set aside for certain plots and grapes. This system of staggered harvesting is the keystone on which the

Guy Latrille explains: "We're the only estate that doesn't harvest the grapes until they've reached a potential alcohol level of twenty degrees, although it already takes three extra days on the vine for the potential to rise from thirteen to seventeen degrees, which is where most other Sauternes makers stop. Those three final degrees, from seventeen to twenty, are much more difficult to achieve." For the grapes to attain the three additional degrees, the sun has to shine steadily for five or six more days. The yield from grapes left on the vine this long will be reduced by fifty percent of their volume, but the final result is worth it. Fermentation converts thirteen to fourteen of the potential degrees into alcohol,

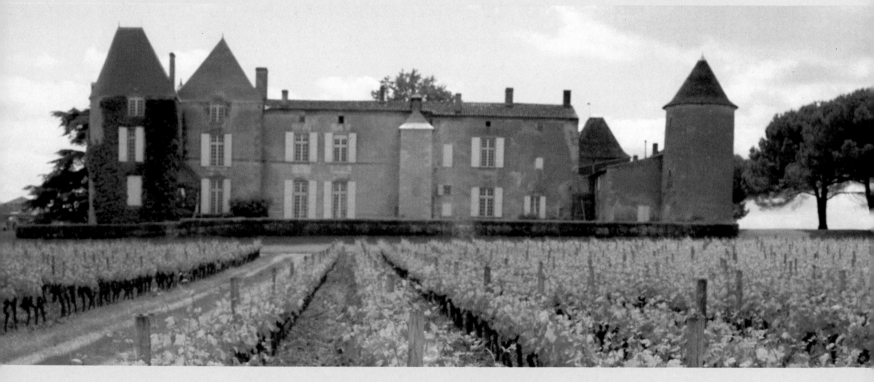

since 1950: 1951, 1952, 1964, 1972, 1974, 1992—years when the entire crop was downgraded, or produced barely two hundred gallons, or was lost entirely.

When all goes well, however, Château d'Yquem produces a peerless wine reflecting its location in the heart of the finest Sauternes country, the ideal climate within a microclimate that prevails there, and the diversity of its

wine's careful blending and ultimate richness depends.

The grape harvest is a time of stress in all wine-producing regions, but here the tensions and risks are multiplied. Furthermore, Château d'Yquem has to contend not only with the botrytis fungus, but with an additional, voluntary, risk factor distinguishing it from its peers. Château d'Yquem's cellar master

leaving the remaining six to seven in the form of sugar (over one hundred grams per quart). It is this extra sugar that gives Château d'Yquem its unique texture and exceptional bouquet.

### Risk management

In the drawing-room of his family estate, Château d'Yquem owner Alexandre de Lur Saluces raises his

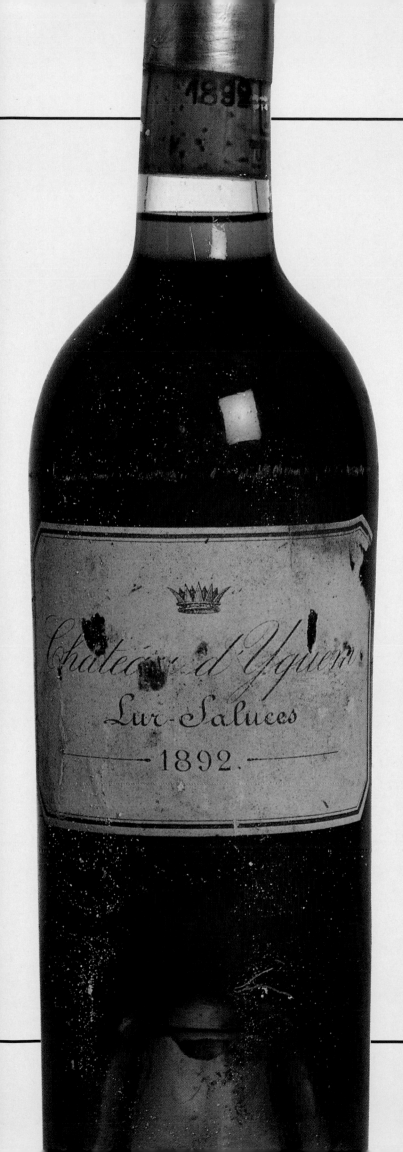

glass and comments on the properties of the wine it contains: "A great Château d'Yquem is a complex wine. Its qualities melt together progressively as its smooth texture glides over the palate."

Grapes that do not contribute to enhancing this wine's virtues are ruthlessly eliminated from the vintage, a decision that assumes heroic proportions when the entire harvest is involved. "But," insists Alexandre de Lur Saluces, "we would never put a dubious year on the market." Successive owners of the estate have attempted to manage this risk by building up reserves, which today represent over one year of sales. This resource is not only a form of insurance, but also primarily a means of

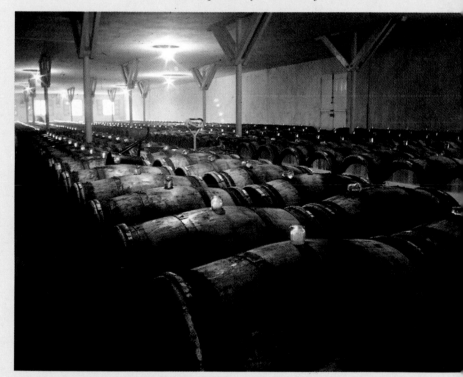

maintaining the highest standards at a reasonable cost.

When dealing with vines that yield only a single glass of wine per plant, and with the problems involved in caring for grapes that depend for their ultimate quality on the whims of a tiny fungus, extreme prudence must be combined with a willingness to take major risks.

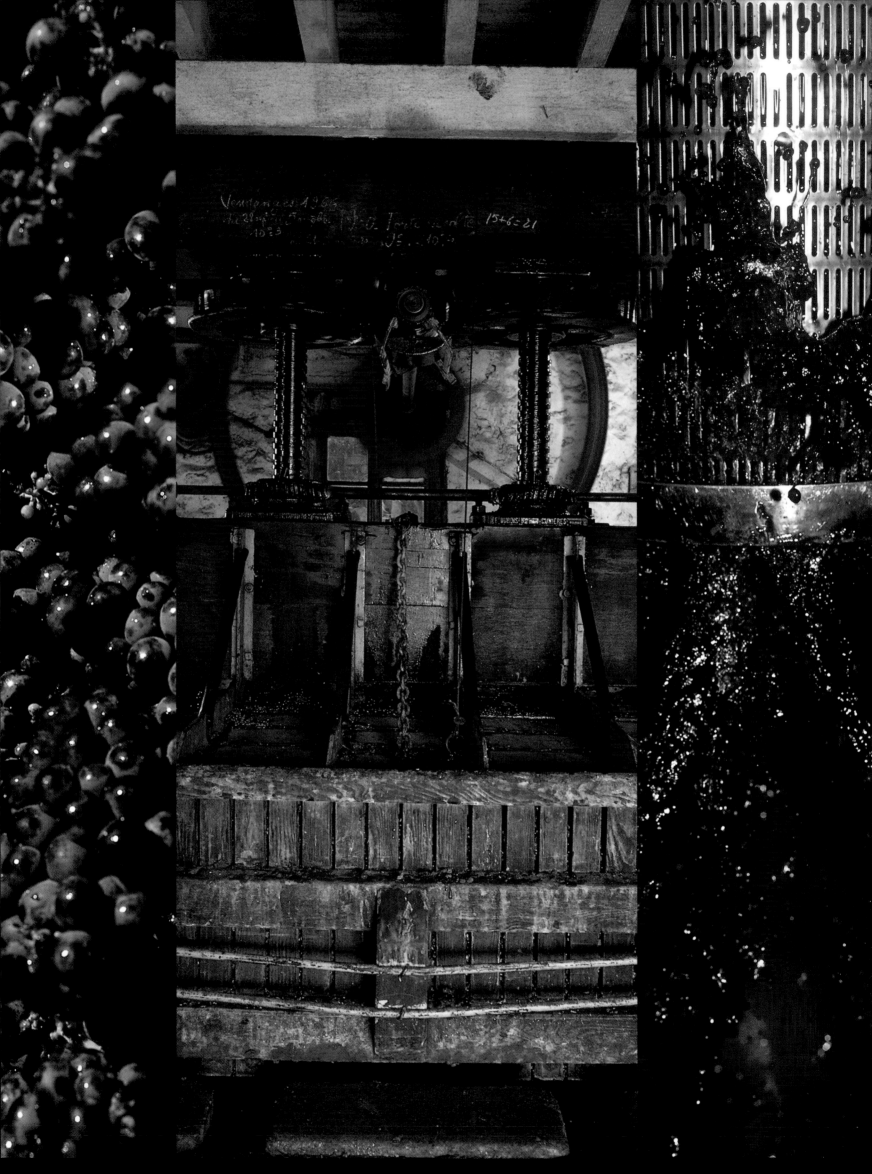

Fermentation is started thermostatically. The vats are heated to a temperature of between twenty and twenty-five degrees Celsius, so that the yeasts will reach their optimum potential for converting sugar into alcohol, transforming the grape juice into wine. It usually takes six or seven days to achieve an alcohol level of twelve and a half to thirteen degrees. However, even at this early stage in the process, the cellar master must exercise extreme vigilance. If fermentation starts at too low a temperature, mold will form on the surface of the liquid and the wine will have an unpleasant hay-like taste; and, if fermentation starts at too high a temperature, the yeasts will expire before their job is completed. When this happens, an entire vat of grape juice can turn to vinegar in the space of forty-eight hours. This delicate balance is complicated by the fact that in order to obtain the optimum alcohol content, the vat temperature should ideally be raised to between thirty-five and thirty-seven degrees, that is, the precise temperature at which yeasts expire.

DECANTING • During this crucial period, the cellar master also ensures maximum extraction of the coloring agents and tannins contained in the grapes by decanting the fermenting juice. In this process, essential to the production of red wines, juice is drained from the bottom of the vat into a large wooden receptacle, and is then poured back in again at the top, over the grape skins and seeds. Decanting, which lasts about half an hour, is repeated twice daily for every two-and-a-half-gallon vat.

When alcoholic fermentation is complete, maceration begins. The vat is pressure-sealed with carbonated gas and its contents left to age for two weeks. At the end of this two-week period the grape juice will have become wine. But the adventure of nurturing a great vintage to maturity has barely begun.

### First tasting:
### "pressed wine" and "filtered wine"

Grapes from the forty-two Château Cheval Blanc plots yield enough juice, skins, and seeds to fill twenty-five fermentation vats each containing two and a half thousand gallons. After an initial tasting by the estate's experts, the skins and seeds are filtered out of the wine, reducing it to about two-thirds of its original volume, or enough to fill eighteen vats. The skins and seeds are then pressed to extract every bit of goodness they still contain, and the resulting "pressed wine" is placed in special individual casks corresponding to the plot of origin.

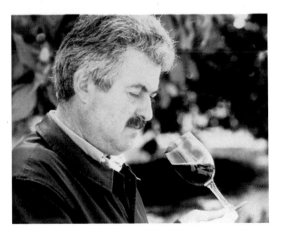

*Robert Revelle, cellar master at Château Lafite-Rothschild, engaged in wine tasting. Top: Fermetation vats. Fermentation takes about five to six days and no feverish patient receives more vigilant attention from his doctor than the vats do from the cellar master, who checks the thermometer every morning and keeps temperature and density graphs.*

# Cognac

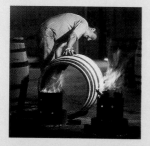

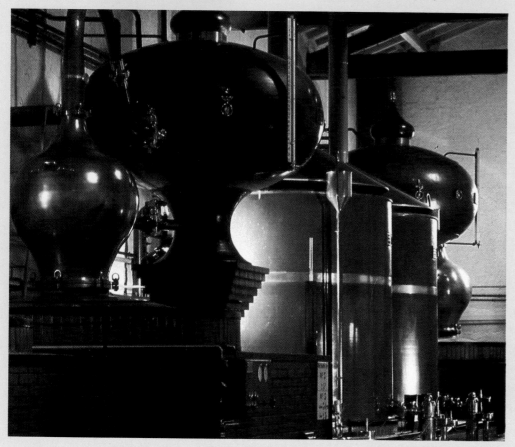

*The distillery at Rémy Martin.*
*Top: The work of the cooper at Rémy Martin.*

*Right-hand page: The birth of cognac, or new eau-de-vie, at Courvoisier.*

In the small privately owned distilleries of the Cognac region, you will often see a bed or cot set up next to the still. This seems strange in a room used for the conversion of wine into spirits, and creates the impression that someone must live there, at least for part of the time. This impression is absolutely correct: the law governing distilleries in the Charente region specifies that distil-

lation of the new wine must be completed, at the latest, by March 31 of the year following harvest. A race against the clock thus begins in November, and distillers work literally day and night to process their newly harvested wine. They sleep next to their vats and live throughout the entire winter surrounded by the sounds of bubbling alcohol. Most of these distillers are also vintners, usually working under contract to the major firms that rule the cognac trade: Courvoisier, Hennessy, Martell, Rémy Martin. Some are independent, however, and make

considerable efforts to obtain official listings for both their wine and the spirits distilled from it. When they succeed, their own product goes into the cognac blends marketed throughout the world.

## Double-distillation

Distillation as practiced in Charente involves a distinctive double-heating process. The boiler is a huge copper vat with a maximum capacity of six hundred and twenty-five gallons, because, as Pierre Szersnovicz explains during a tour of the Jubert distillery now owned by Courvoisier, "In a smaller boiler the cognac's 'typicity' will be lost, and in a larger one, the distilled spirits will have too rough an edge."

The boiler is filled with white wine and, usually, the lees as well, that is, with the unrefrigerated, unfiltered, unprocessed wine still containing the expired yeasts responsible for alcoholic fermentation. The first distillation process lasts for twelve hours, during which time the wine is converted into an intermediary liquid with an alcohol content of approximately twenty-eight degrees. At this point it is neither wine nor spirits, but a semi-distilled wine, referred to in Charente as brouillis.

A swan-neck curves from the head of the boiler down into a vat containing over one hundred feet of coiled piping submerged in cold water. When the wine in the boiler is heated, its alcoholic content is concentrated and it turns into steam. The steam rises through the neck on the head of the vat, is compressed by its small diameter and pushed on to the water-cooled coils below, where it condenses into a liquid with a higher degree of alcohol than the original. This semi-distillate or brouillis, which will have boiled down to approximately one third of its original volume, is then heated for a second time. It is the second distillation that converts it

into cognac, and it is at this stage that the skill and vigilance of the distiller become crucial. This is because the second distillate must be split, or cut, into three parts at just the right moment. During the first cut, the "heads" containing the most volatile and aromatic spirits, but also the headiest and harshest, are removed from the vat. These discarded "heads" represent approximately two percent of the total volume. Sometime during the next five to six hours, the distiller will be warned by the odor of the distillate and the gauge on the vat that alcoholic content is beginning to fall below sixty percent, at which point he extracts the "core distillate," which is mellower, subtler, and better balanced. This is the only portion retained for the final cognac. The distiller then pours the remaining "tails" into a different vat. The entire process is known as "cutting."

### Cots and cutting

It is the need to cut the distillate into three separate parts that keeps the distiller constantly on the alert, next to his vats. He must act quickly, and at just the right moment. That is why beds and cots are to be found in distilleries, and why it is proverbial in Charente that "a distiller lives with his still."

### From cask to demijohn

Cognac must be monitored as it matures. As Courvoisier cellar master Jean-Marc Olivier points out, "whisky can be left in the same cask throughout aging, but we have to sample our

cognac once every year and then, depending on how it tastes, transfer it into different casks and cellars." These transfers are hard work, considering that the reserves of distilled spirits can amount to as much as twenty million gallons at Courvoisier and twenty-five million at Rémy Martin. Freshly distilled spirits are put into freshly made casks, where they leach tannin out of the wood. Aged spirits are transferred

to "red" casks that have lost all their tannin and have become porous enough to admit air from the outside, a process which accelerates oxidation and mellows the spirits. Jean-Marc Olivier describes how, and why, the casks are then moved from cellar to cellar: "Casks containing spirits that still have a raw edge are stored in damp cellars—near the Charente riverbank, for example— to mellow. Casks containing spirits that have not yet developed sufficient character are stored in dry cellars, under the limestone hills, where they will be sharpened by contact with the air." The aging period varies in length, depend-

ing on the distiller, and ends when the spirits are judged to have achieved the desired character. Since over-aging causes over-oxidation and a decline in quality, the mature spirits are removed from the casks and bottled in demijohns containing between six and eight gallons. They then remain in the cellar for periods of sometimes over a century. Cognac is derived from the exposure of wine to two influences: first, the distillation process; and second, the oak wood of the casks in which the distillate is stored. It takes ten to fifteen years of aging in the cask for these two influences to generate the characteristic rancio, or blend of wood tannin and distilled alcohol that endows cognac with its unique bouquet. The taste of rancio is described by connoisseurs as a combination of mushroom, cinnamon, aged wood (the cask), and even cigars—in other words, an elusive complexity unique to fine cognac, and the result of a mysterious alchemy that never ceases to intrigue and amaze.

## Blending

*Cognac is also a product of blending. As Jean-Marc Olivier explains: "Unblended distilled spirits will never achieve perfection. Only when spirits are blended do they lose their raw edge and attain the desired harmony. The cellar master's task is to create exactly the same final product every time. Each year's crop of grapes is different, and only by blending can we produce cognac of consistent quality, with no discernible variation from one year to the next."*

*Blends contain wines from grapes grown in different localities and in different years. Weather conditions in any one year thus have no percepti-*

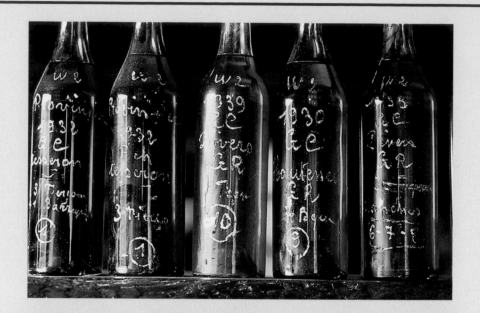

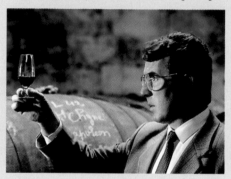

*ble impact on the final product, which is why cognac is never labeled by year, but only by quality: VS, VSOP, Napoleon, XO, etc.*

*The soil also plays an important role. The Cognac region covers six distinct areas, all planted with the same variety of grape, ugni blanc. This is a hardy Italian variety that yields a wine low in alcohol content (nine degrees), but high in natural acidity. The latter protects the vines in winter and eliminates the need for chemical treatment of any kind. Of the six official cognac growing areas, only four are significantly involved in the blends sold under the best labels. These are: Grande Champagne, Petite Champagne, Les Borderies and Les Fins Bois.*

*Grande and Petite Champagne, at the heart of the region, stand on hard chalky soil which provides the precise type of adversity that spurs vines to greater effort when estab-*

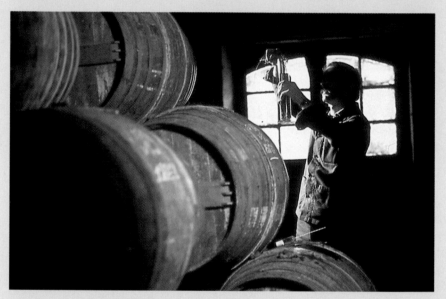

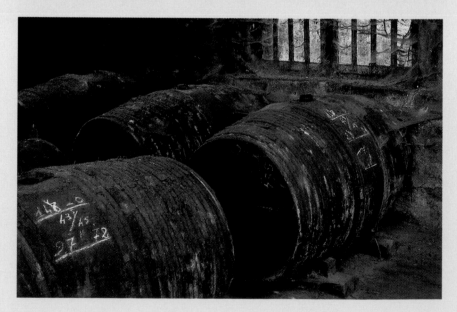

*lishing their roots. The limestone in this soil endows the distilled spirits with a unique "typicity" perceptible only after several years' aging. In the initial stages of development the spirits have a floral quality soon overwhelmed by the flavor of the oak cask, but with the development of the rancio, they achieve the inimitable, mature bouquet found in all great cognacs. Rémy Martin has based its reputation on it, and uses grapes from this area only.*

*The soil of Les Borderies is also chalky, but with an eroded surface that admits more water. The "typicity" of Les Borderies resembles that of Grande and Petite Champagne, but is less perceptible at the time of casking. During aging it produces a bouquet combining spice, flowers, cinnamon, and honey that contributes a mellow, smooth, full-bodied note when blended. To capture this note, Jean-Marc Olivier blends wines from Les Borderies and Grande and Petite Champagne for his superior grades of cognac.*

*Next comes Les Fins Bois, an area of chalky soil formed during the early Quaternary geological era, covered to a depth of two to three feet with loamy topsoil which contains an alluvium of marshland loess. Spirits made from grapes grown on this combination of soils have a fruity, winy, almost exuberant bouquet when young, but as they age the bouquet "collapses," (in the language of the local cellar masters), and so they are used primarily in younger blends.*

*"Blending cognac begins as an intellectual exercise," explains Jean Marc Olivier, "the final product can only be imagined." Cellar masters must be able to analyze the exact qualities of each batch, and know where the grapes were grown and how the distillate was aged. They also must have sufficient experience, extending over a long enough period of time, to identify the perfect "cut" with infallible certainty.*

*With its rows of test-tubes and vast sampling table, Olivier's office resembles a laboratory. It is here that he measures out small amounts of different core distillates, or final "cuts," blends them, and samples them. Promising blends are then mixed in larger batches and placed in experimental casks. Olivier has samples brought up from the experimental casks every two weeks, at which time he evaluates their progress and decides whether or not something more should be added to achieve a more balanced bouquet. "During my experiments, I can sometimes imagine a certain type of distillate in the abstract better than I could describe it in words, or explain exactly why I need it to balance my blend." The quality of a great cognac must remain constant, but the proportions used in the blends that provide it year after year are highly variable.*

## Lees-distillation

*"The lees," comments Rémy Martin's cellar master Georges Clot, "give cognac the body and length it needs for the floral aromas to expand fully on the palate." At Rémy Martin traditional lees-distillation is the rule, although elsewhere it is practiced only during certain years, or has been abandoned entirely. When grape juice ferments, the lees, or spent yeasts, sink to the bottom of the vat. At this point the wine is often racked, or drawn off the lees, before being distilled. In the lees-distillation method, however, the lees are left in the vat, "whisked" until they become suspended in the wine, and then distilled along with it. "The lees add complexity and richness to the spirits, and also play a role in the formation of the famed Charente rancio," concludes Georges Clot, who believes the micro-organisms responsible for fermentation make as important a contribution to the production of cognac as the wine itself and the oak casks, albeit in a more indeterminate way.*

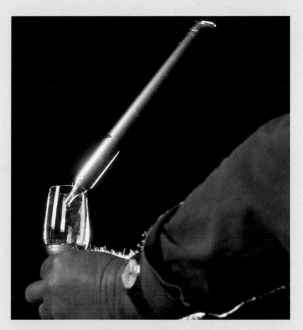

*Collection of labels from old cognacs.*
*Top: Sampling at Rémy Martin.*

Left-hand page
Left: *Jean-Marc Olivier, cellar master at Courvoisier.*
Center, from top to bottom:
*Preparations for the annual inventory of aging stock.*
*Sampling from the cask at Rémy Martin.*
*Aging cellar at Rémy Martin.*

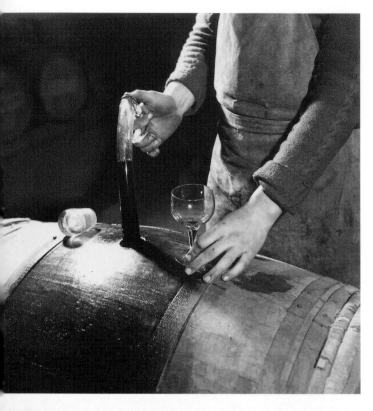

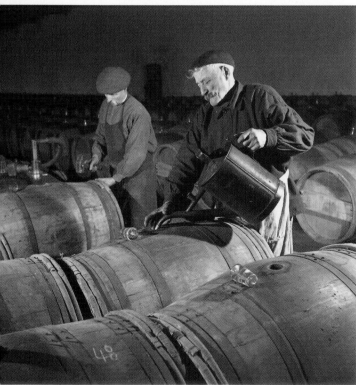

The steps described above do not necessarily take place with military precision, however. The cellar master must adjust his pace to that of deliveries from the vineyards. He begins vinification as soon as the first batch of grapes arrives, and then works in tandem with the pickers and sorters, keeping one eye on his fermentation rooms and the other on the sorting tables where fresh batches of grapes are delivered continuously. Maceration of the first batch will be completed by the time the last crates of fruit arrive at the cellar.

Before the filtered wine in the vats is casked, it goes through one more process, called malolactic fermentation. The wine is heated to twenty-one degrees, and a special bacterium is added that transforms the malic acid in the wine into lactic acid. This stabilizes the wine, which otherwise might foam and turn to vinegar in the bottle—a phenomenon known in the nineteenth century as "bottle disease."

Another essential precaution repeated by the cellar master throughout the "nurturing" process is treatment of the wine with sulfite, an odorless, colorless preservative that kills off residual yeasts and bacteria by depriving them of oxygen. Since the total amount of sulfite allowed per quart is thirty milligrams, the sulfite solution can be added at every step in the wine-making process, from decanting to racking and bottling, without harming the wine's inherent quality. Indeed sulfite is essential for eliminating microscopic foreign bodies that might affect the wine's purity.

CASKING • The "filtered wine" contained in the eighteen vats is then tasted and transferred to the oak casks. At Château Cheval Blanc these are divided into nine lots corresponding to the château's grape varieties and growing areas. The nine casked lots thus exactly match each area in terms of both soil and grape variety.

At this stage a new factor enters the wine-nurturing equation. "Grapes and soil have their own 'typicity,' and so do the casks," explains Thierry Garnaud, using a neologism favored by oenologists and wine-lovers. "When coopers construct a cask, they instinctively combine woods from different sources." The cask itself thus adds its own flavor to the wine it contains.

At the end of the first year of aging in the cask, the wine is racked (drawn off the lees, or decanted), placed in new casks, and moved into another cellar to make room for the next crop. The cellar master's goal in transferring the wine into new casks is

to improve and balance its "woodiness." "If you use casks from four different coopers," claims Garnaud, stating a basic mathematical law in wine making, "the sum will always be greater than any one of the parts, no matter how good." Château Lafite-Rothschild uses casks made from new wood for each new crop, since fresh tannin improves the wine's bouquet and balance. All the casks are made in the château's own cooperage shop, which employs five people. The new casks are placed in the cellar where the current year's wine will be racked.

BLENDING • The pivotal step in nurturing a great Bordeaux to maturity is blending. This involves evaluating a range of flavors, from that of the wine itself to the oak casks in which it was aged. The greater the diversity of flavors in a blend, the greater will be the complexity and richness connoisseurs associate with all truly great wines.

Blending begins with a general tasting of the wine in each lot. A group including the estate steward, a consultant oenologist, the cellar master, and the vineyard manager sample the wine from every casked lot in order to evaluate the crop's overall quality, and to pin-point those lots exhibiting the body and depth associated with great vintages. Lots considered too harsh or raw on the palate to meet the very highest standards are set aside or eliminated entirely.

The cellar master then creates some test blends for tasting. One blend might contain wine from every lot, others wine from four or five or even less. The final blend will usually have been selected by late January, at which point the cellar master mixes the entire crop in the approved proportions, blends the mixture thoroughly, and immediately casks it.

The blended and casked wine is now left to age and mature in the cellar for a period of eighteen to twenty months.

RACKING • During this period, the cellar master undertakes a series of racking operations designed to separate the wine from sediment and lees. More sulfite is also added at this stage. Two initial rackings are carried out in March and June: this is done according to the traditional "bellows" method. Air is blown into the cask from an opening in the top, forcing the wine out through one of two taps at its base. When wine stops flowing

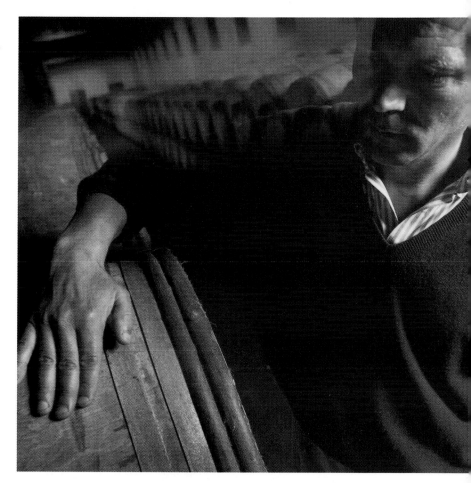

*The blended and casked wine is now left to age and mature in the cellar for a period of eighteen to twenty months. Château Lafite-Rothschild.*

Left-hand page, top to bottom: *Racking and ullaging at Château Lafite-Rothschild.*

Following double page
Center: *The aging cellar at Château d'Yquem.*
Right: *Bottle of Château Lafite-Rothschild.*

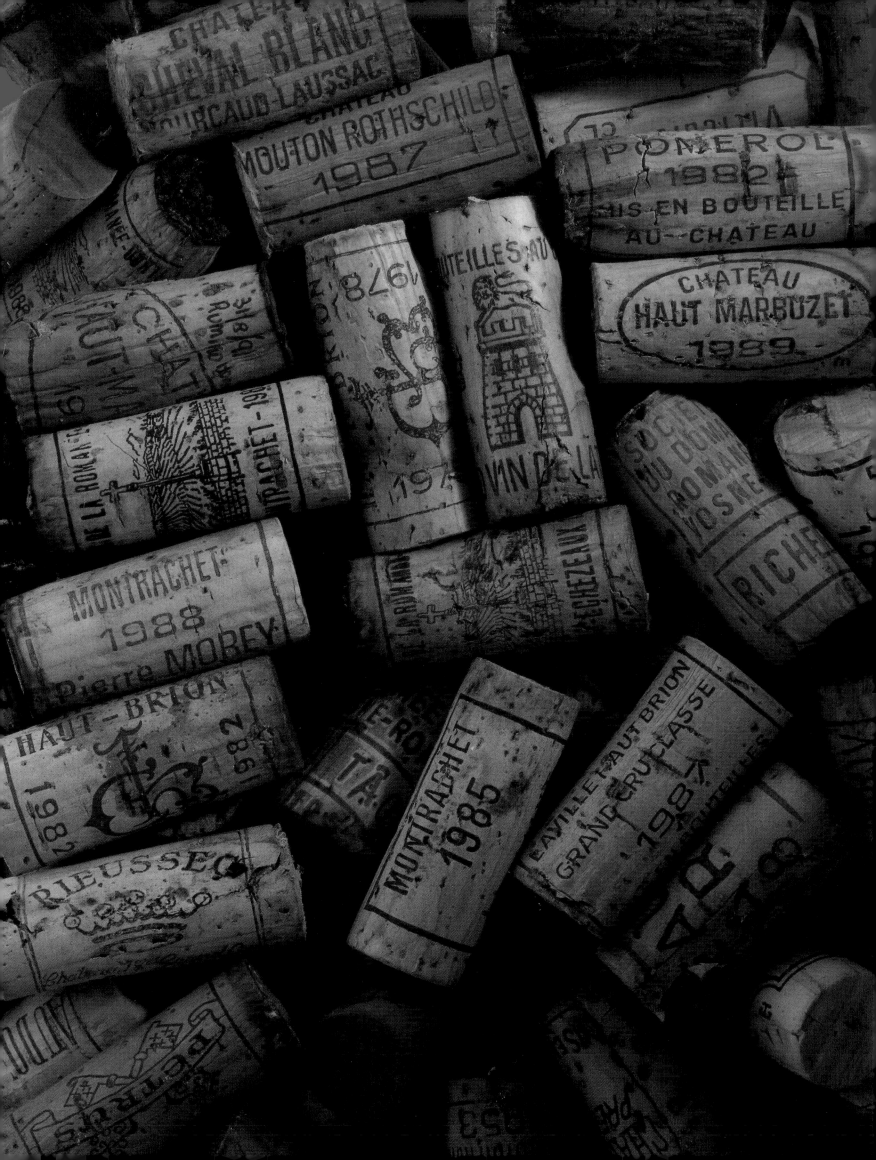

out of the first tap, the cask is laid on its side and the second tap—located on a line with the first but at the cask's outer rim instead of its center—is opened. The last four to five gallons of wine that were not forced out by the air are then drawn out through this tap.

In September the wine is again transferred to new casks, which are placed in different cellars to make room for the new crop. Three more rackings, exactly as described above, are carried out after the transfer.

CLARIFYING • Following the December racking, the wine is clarified. This involves adding four to six slightly beaten egg whites to the contents of each cask, where they immediately attract all the stray solid particles suspended in the wine. The particles adhere to the egg whites, forming a single glutinous mass that sinks to the bottom of the cask. The wine is racked

again five to seven weeks later to remove this "gum." The clarified wine, now pure and translucent, is tipped through the tap near the rim of the cask and drawn off, while the six quarts or so of viscous lees remain in the bottom of the cask.

A final "bellows" racking takes place in May. The wine is pushed out of the tap at the base of the cask by blowing air into the top, until only four or five gallons remain inside. The cask is then placed horizontally on trestles and levered so that the tap tilts forward. The last of the purified wine drains from the cask, and only two or three quarts of slightly cloudy wine remain inside. The wine is now ready for bottling, which takes place during a single session in June.

Thus tended, nurtured, fermented, stabilized, blended, racked, and clarified, the wine will now continue to age and mature in the bottle until it finally encounters the connoisseur's glass, and palate. If the vintage fulfills its potential, if it proves worthy of all the care lavished on it by vintner and cellar master, a sublime apotheosis will then occur—an apotheosis that is at the same time a swan-song.

*225*

MIS EN BOUTEILLE AU CHÂTEAU

In the Champagne region of France, quality criteria reflect a particular identity, style, and character rooted in unique traditions and techniques. Proverbially, "there are many champagnes," even when the grapes—the most common being chardonnay, pinot noir and sometimes pinot meunier—are the same. A vintage champagne's pedigree depends on both the variety of grape used, and the soil in which it was grown. However, traditional classifications are based primarily on the

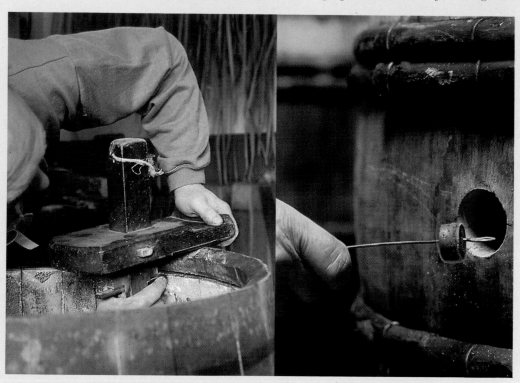

variety of grape, which can range from the one hundred percent chardonnay used for the so-called "blancs de blanc," to the very rare one hundred percent pinot noir for Bollinger's "Vieilles Vignes" blend and Laurent-Perrier's pink champagne—and all possible combinations in between. A secondary classification is by soil: Montagne de Reims, Côte des Blancs, and the Marne valley around Épernay where the names Mesnil sur Oger, Oger, Cramant, and Avize are associated with chardonnay; Aÿ, Mareuil sur Aÿ, Bouzy, Ambonnay, and Verzy are associated with pinot

noir; and Verzenay and Tours-sur-Marne are associated with both chardonnay and pinot noir.

In champagne making, the bunches of unstemmed, unseeded grapes are placed in presses and the juice extracted under a pressure of at most four pounds per square inch. This ensures that the ripest grapes will burst first. The juice from the first pressing, a batch amounting to only about five hundred gallons, or half the volume of the original grapes, is reserved for the great

champagne makers and, after being cleansed of skins, seeds, and other impurities, is sent off to Reims.

### Preparing the casks

At Krug and Bollinger, initial fermentation takes place in wooden casks varying in age from brand new to thirty-five years old. Henri Krug insists that exposing the juice to wood is "the only way to mature wine." But first the empty casks must be prepared to receive the juice from the freshly harvested grapes. The casks are rinsed and dried in the sun for five days and then subjected to lengthy individual inspection. The cellarmen, using

portable lamps, carefully scan the interior of every single cask for signs of mildew, although statistically barely one percent will be affected. They also check for "wine stone," a tartaric precipitate that forms a kind of jagged, porous gray coral, spectacular samples of which adorn the walls of the Krug and Bollinger coopers' shop. Lastly, the cask is fumigated with sulfur, which kills unwanted micro-organisms by depriving them of oxygen.

After all these chores have been completed, the casks are filled two-by-two with the fresh juice, to a level not exceeding four-fifths of their total height. The headroom is necessary because when fermentation is initiated, the new wine "erupts" and continues to seethe and bubble for days inside the casks. The task of monitoring fermentation conducted according to this method is a difficult job because of the large number of casks and the irregular progress of the fermentation going on inside them. When fermentation is complete, the contents of the casks are topped up with new wine and left for over a month on the lees. As the lees settle, the wine absorbs their aroma and clarifies.

A different method is used at Laurent-Perrier, where fermentation takes place in steel vats at relatively lower temperatures (between sixteen and eighteen degrees) that enhance the primary esters and aromas. Cellar master and veteran oenologist Alain Terrier defends his choice of method by explaining that it produces a champagne for "enjoyment" rather than "analysis"—a crisp, fruity, light wine which he believes "has contributed decisively to the fantastic growth in demand for champagne throughout the world," and he adds, "there used to be too much emphasis on analyzing subtleties of richness and texture, and not enough on pure enjoyment." With the advent of "pure enjoyment" came the first attempts at blending.

### Blending

The very essence of champagne rests on the concept of blending, namely, the combination of wines from different grapes grown in different areas and—in the case of non-vintage champagnes—of "reserve" wines from different years. Rémi Krug likes to compare blended champagne to a piece of music played by a symphony orchestra: "If even the triangle is off-key, the entire piece will be subtly marred." The comparison is especially apt for the Grande Cuvée de Krug blend, which contains no less than fifty different wines from three grape varieties and eight to nine different years. Even the smallest amount added to the whole is carefully evaluated in terms of its effect on the overall balance of a product that must meet the same exacting standard year after year. Although it is relatively easy to evaluate a single wine according to its intrinsic merits, it is extremely difficult to predict just how it will work in combination with others. As Krug says: "It is like composing a symphony by listening to each instrument play alone."

It takes someone with a vast store of knowledge based on an osmosis-like grasp of champagne, the grapes, and the soil to decide, year after year, which of the acid chardonnays, mellow meuniers, and robust but unyielding pinot noirs will age well and develop the staying power needed for future blends; which already exhibit "Grande Cuvée" qualities and can be used at once; and which will unfortunately have to be eliminated altogether because they are not appropriate to the delicate balance desired. Louis Rœderer, for example, sets aside some one hundred and eighty thousand gallons of selected "reserve wines" to be aged in large oak casks for five years. The ultimate goal, however achieved, is a certain simplicity of style. For its Cuvée Grand Siècle, blended in 1957 by Bernard de Nonancourt, Laurent-Perrier did not attempt to exploit the complexity of wood casks or incorporate a multitude of growths and vintages. This blend combines just a few great growths from two or three traditional areas in the Champagne region—including Montagne de Reims and Côte des Blancs—and from only three different years, according to the theory that "one dominant year and two subsidiary ones will always create a subtly harmonious balance." Some prestige blends have an interesting historical background. For example, in 1876 Louis Rœderer created its special Cristal blend in response to a request from Tsar Alexander II of Russia, who sent his own cellar master every year to assist in the blending process.

*Rémi Krug tasting the Krug vintage blend. Center: Champagne presses at Veuve Cliquot-Ponsardin.*

Left-hand page, from left to right: *Crozing and plugging casks at Krug.*

The Tsar also commissioned the design of a distinctive crystal-clear bottle for the blend, to make it easy to identify. The original Cristal blend reserved exclusively for the Russian court was probably an undated, heavily sweetened wine containing about nine and a half ounces of sugar per gallon—much sweeter than today's champagne. After the Russian market collapsed, the Cristal blend was re-launched between the two world wars in a much drier version using a vintage wine containing only two and a half to three ounces of sugar per gallon.

With the advent of the consumer society in the early twentieth cen-

tury came the development of "special" champagnes—much to the dismay of some champagne-makers, such as Veuve Clicquot Ponsardin, whose motto is "only one quality—the very best." It was not until 1972 that the firm gave in and began to market its special blend, La Grande Dame.

Are these relative newcomers "special blends" or "specialties"? The new R.D. de Bollinger blend inaugurated with the 1961 vintage is a "specialty" more than a "special blend." It is a freshly clarified champagne demonstrably improved by long contact with the sediment in the bottle. For this blend,

Bollinger uses only vintage wines fermented in oak casks, and aged for nine years in corked bottles before the sediment is extracted.

### "The old-fashioned way"

Although great champagne-makers may each practice their own special variants, all are united in a meticulous respect for the traditional local customs enshrined in laws which govern the famed méthode champenoise.

First among these is the second fermentation period. In the spring of the first year of fermentation, the

blended wines are drawn from their casks and bottled. Fresh yeasts and a little sugar are added in order to stimulate effervescence, the hallmark of all great champagne. The bottles are then corked and placed horizontally on slatted shelves inside huge limestone cellars dug into the slopes of the Champagne region.

The Ruinart aging cellars, located in disused chalk quarries once used by the ancient Romans for their building projects, are like vast

underground cathedrals. The pits extend deep into the ground in a series of storerooms where the temperature remains constant. Vaulted galleries lead to twenty-four rooms in the shape of truncated pyramids, lit by feeble beams of light. The patient work of converting the fermented wine into champagne is carried out in hushed semi-darkness. As a cloudy deposit gradually forms along the sides of the horizontal bottles, the cellarmen gently and regularly revolve them. This is called "turning" and can continue for three to six years.

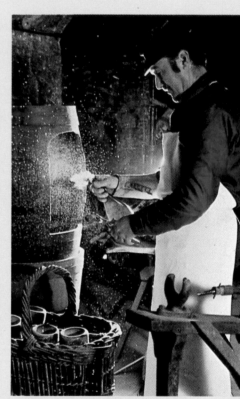

### Slow and steady: tipping

Tipping begins a few months before the cloudy sediment inside the bottles is finally extracted. This operation was invented by Madame Clicquot and involves working the sediment—composed mainly of spent yeasts—down on to the cork. The bottles are placed horizontally in oval openings on a stand, and are gradually revolved and tipped until they are vertical, with the cork pointing downwards.

The tippers are specially trained

*cellarmen who are apprenticed for at least three years in order to learn the exact twist of the wrist required for turning and tipping the bottles, which are given first a quarter, and then an eighth of a turn. The process continues for about two months and can include up to thirty thousand bottles per day.*

*Tipping requires not only an exact twist of the wrist, but also a practiced eye. Cellarmen must be able to judge the sediment's progress through the bottles, which are marked with white at two spots: on the base, to indicate the sediment's original level; and*

*also on the body, to show the location of the air bubble.*

*The tipper must work so that the lightest portion of the sediment, which can only be seen by candlelight, will travel downwards first. The mass of sediment follows, until, little by little, all of it has been worked down the gradually up-ended bottle, on to the cork. At this point the tipper announces to the cellar master that the champagne is ready to have the sediment extracted.*

*In former times extraction was a spectacular sight and a dangerous sport. The bottles were uncorked "on the run" while the sediment shot out under pressure from the carbon dioxide in the wine.*

*Today, the necks of the bottles are placed in a brine solution cooled to a temperature of minus thirty degrees centigrade, which freezes the sediment and the cork, but not the wine. Since the clarified champagne is separated from the sediment by the air bubble, the bottle can then be placed right-side up, and a machine is used to remove both frozen cork and sediment. The champagne in the bottle is then topped up with a liqueur made from wine and cane sugar, in varying proportions depending on the type of champagne desired.*

*At Louis Rœderer, the liqueur wines are blends of the eight best growths from a single year, aged in wood for four to ten years.*

*After the liqueur has been added, the bottles of champagne are recorked and allowed to rest for a few months. The long cellarwork is ended, and so the enjoyment of its product can begin.*

Gaston Latouche (1854–1913).
Le Champagne, *Musée des Beaux-Arts, Rouen.*

From left to right:
*Tipping table at Louis Rœderer.*
*Tipping at Laurent-Perrier.*
*Racking at Ruinart.*
*Magnum storage cellar at Bollinger.*

### Classical antiquity

In the sixth century B.C. the Greeks introduced viticulture in the Marseille region. Five hundred years later the Romans planted extensive vineyards in the Narbonne region of Gaul.

**Roman Gaul:** Two new varieties of grape which were to prove decisive for the extension of the wine-producing regions, were discovered in the first century A.D., the frost hardy *Allobrogica* and *Biturica* which flourish in a wet climate. Wine-producing, no longer dependent on a sunny climate, spread to northern Gaul.

In the year 276, the emperor Probus authorized viticulture throughout Gaul. The majority of the vineyards in the Champagne district, as well as the Loire and Rhone valleys, date from that period.

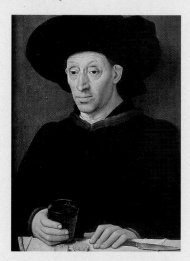

### The Middle Ages

The economic development in the northern countries during the Middle Ages, resulted in the emergence of a new, rich middle-class clientele. The existing wine production proved insufficient and viticulture was considerably developed in the Bordeaux and Burgundy regions, especially in monasteries. Most of *grands crus*, such as Chablis, Meursault, and Pommard date from that period.

*Burgundy wine: Although the first mention of a Côte d'Or wine dates from the year 312, it is to the great Cistercian abbeys of Pontigny, Flavigny, Fontenay, and Moutier Saint-Jean that we owe the development of vineyards. In the thirteenth century wine from Beaune was served at the royal table; Charles V and after him François 1er, confirmed the appellation of Burgundy wine (vin de Bourgogne) for wines originating upriver from Sens, in Auxerre and Beaune. The unification of Burgundy and France in the thirteenth century curbed the development of Burgundy wine until the beginning of the eighteenth century, when its acceptance at the court of Louis XIV gave it a second lease on life. In 1760 the Prince de Conti acquired the Romanée estate and trade developed around Beaune. This tendency was accentuated in the second half of the nineteenth century.*

### The seventeenth century

**Birth of Cognac and Champagne**

As early as the twelfth century, white wines from the Charente region were favored by countries bordering the North Sea. Vineyards were rapidly extended and in the sixteenth century, it had already become the custom to dispose of harvest excess by distillation. In the seventeenth century there was an unprecedented boom in the trade of Charente wines with the Dutch, who, with their powerful merchant marine, supplied the whole of northern Europe in brandy (*brandwijn*) from the ports of La Rochelle and Royan. To meet with this considerable demand, western France optimistically launched the production and distillation of white wines. This activity gave birth to the prestigious alcohol, cognac.

*Two cognacs of international renown, Courvoisier and Rémy Martin*

*Courvoisier: Emmanuel Courvoisier, a wines and spirits merchant, took advantage of his relations with the Empire's military officers to impose his merchandise at the court of Napoleon I. His son opened a cognac distillery in Jarnac in 1835, which earned itself an excellent reputation during the reign of Napoleon III. In 1909 the establishment was bought by an English family of French origin, the Simons, who set up an English company and opened up new foreign markets. Since 1981, Courvoisier is once again a French registered company.*

*Rémy Martin: For two centuries, five generations of the Rémy Martin family, who were both vintners and negotiants, imposed their trademark with its centaur emblem, on the region of Cognac. In 1874, they initiated the use of bottles—the famous Louis XIII carafe—at the time when the grands crus hierarchy*

*was being established in the region. In 1925, André Renaud took over the management and decided in favor of a selective production, VSOP Fine Champagne (matured for more than four years) to meet with the evolution in consumer demand, at the same time developing a distribution network in South-East Asia.*

In the second half of the seventeenth century, the vintners in the Champagne region started to produce a white wine obtained from black-skinned grapes (with colorless pulp and juice) and decided to mature it not in barrels, but in bottles. To their great surprise, this produced a second fermentation, which caused the wine to be effervescent. Champagne was born. At the French court, it encountered immediate success. Legend credits the discovery to Dom Pérignon, cellarer at the Hauvillers abbey. The first sparkling vintage champagne dates from 1698.

The cork stopper made its appearance in 1665 and the corkscrew was invented at the end of the seventeenth century.

### Champagne, from coincidence to *savoir-faire*

**Dom Pérignon** (1638–1715) was in charge of the cellar at the Benedictine abbey of Hauvillers for forty years, and his research was decisive in the development of champagne, even though, contrary to popular legend, it is not to him, that we owe the discovery of the second fermentation process. His activities mainly concerned the assembling of wines, the choice of grape varieties, the degree of maturation of the grapes, and the use of new bottles to conserve the effervescence.

**Ruinart**: For a long time the origin of this company was attributed to Dom Ruinart, a

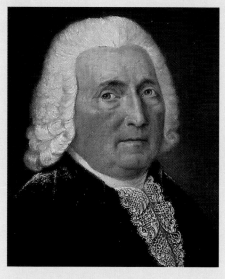

friend and contemporary of Dom Pérignon, but it was his nephew, Nicolas, who, in 1729, founded the first champagne house. In 1764, his son Claude bought chalk quarries in which to install his cellars. The year 1786 marked the opening of the English market and relations were strengthened by a marriage with a Scottish family. Britain, Belgium and Germany have continued to enjoy a privileged situation. After a rapprochement with Moët et Chandon, Ruinart joined the LVMH group in 1984.

**Bollinger:** In 1829 Jacques Bollinger, a wine-broker in Germany for the champagne company Muller Ruinart, entered into an association with and married the daughter of the count of Villermont, a landowner in Aÿ. Circa 1865, his son Joseph was the first to export a very dry champagne, much appreciated by

the English clientele. Bollinger maintained the traditional oak barrel fermentation method, favoring dry, only very slightly effervescent champagne and prestige wines like the recently bottled R.D.

**Krug**: Johan-Joseph Krug, was born in Mainz and subsequently settled in Reims, where he founded a champagne house in 1843. Today it is still a family concern specializing in a selective production with traditional fermentation in oak casks.

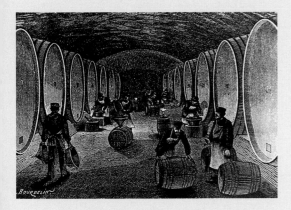

**Madame Clicquot** (1777–1866): In 1798 Barbe Nicole Ponsardin married the wine merchant François Clicquot. She was widowed in 1815 and took over her husband's business, despite the economic crisis due to the English blockade and the Napoleonic wars. As early as 1816, in an attempt to resolve the problem of wine clarification, she invented the tipping stand, whereby the deposit is drawn towards the neck of the bottle and extracted.

**Laurent-Perrier**: Alphonse Pierlot, a cooper who descended from a long line of vintners, founded a champagne house in Tours sur Marne in 1812. At his death in 1881, Eugène Laurent, who was the cellar master, inherited the business, extended the domain, had more cellars dug and renovated the storerooms. Mathilde Emile Perrier, his widow, took over the management in 1887 and through her association with Paul Lebègue in London, trade also flourished in the United Kingdom. In 1939 the company was bought by the Nonancourt family who continues to run it today.

**Louis Rœderer**: In 1833 Louis Rœderer inherited the champagne house belonging to his uncle, Louis Schreider, and opened up markets in Europe and the United States. It is considered to be a reserve champagne, 90% of the production being supplied by owners themselves, and is traditionally matured in oak tuns.

### The eighteenth century

#### The boom in Bordeaux wines

The refinement of the European courts in the eighteenth century favored the production of high quality wines. Champagne was very much in vogue with the aristocracy. As for the Bordeaux wines they soon acquired a prestigious reputation. The vintners in the Bordeaux region were anxious to recuperate the English clientele, who had developed a preference for port, and started to manufac-

ture higher quality wines. From 1720 the new French clarets outclassed port.

### The banes of the nineteenth century

The second half of the nineteenth century was a somber period for French vineyards. In 1845, a parasite known as *oïdium*, a microscopic fungus of American origin, was discovered on the vines. A treatment with sulfur proved very effective.

Circa 1863 *phylloxera*, also originating from America, made its appearance and by 1900 it was widespread. As of 1871, in an attempt to save the vineyards, Planchon and Bazille organized systematic grafts on the more resis-

tant American plants. The *phylloxera* crisis caused the ruin of thousands of vintners, the disappearance of numerous local grape varieties and a standardization of plantations, as well as a veritable scientific revolution involving research into grafting, hybridization, and cultivation of vines.

Finally a third American parasite, mildew, attacked the vines in about 1878. A copper sulfate treatment, known as *bouillie bordelaise* discovered by Millardet, was successfully applied as of 1885.

### The twentieth century

The first half of the twentieth century was marked by the problem

of combating overproduction and fraud. After various attempts to regulate the situation, the Comité national des appellations contrôlées was founded on 30 July 1935, and subsequently became the I.N.A.O. (Institut national des appellations contrôlées) in 1947.

In 1968 a veritable sociological phenomenon was born: Beaujolais Nouveau. Thereafter, every third Thursday in November, the festive wine has arrived on bar counters throughout the world.

In 1971, mechanical harvesting took place for the first time. The "horizontal slapper" is the most widely used of harvesting machines.

The end of this century is witnessing a modification in wine consumption and consequently in its production The consumer has become a connoisseur who drinks wine for pleasure and favors quality over quantity.

## Crystal

**AGATE**: Term applied to glass which has been given a marbled effect resembling agate. This technique was practiced in sixteenth-century Venice and revived in 1827 at the Bohemian glassworks owned by Count de Buquoy in Georgenthal. The term is also applied to an opaque white glass similar in appearance to quartz and manufactured at Baccarat by François-Eugène de Fontenay in 1842. The suitability of this technique for curved pieces in subtle colors accounted for its popularity during the Romantic period and up until about 1870.

**ARCH**: The dome of a glass kiln. The fire is kindled inside the domed kiln, and the glass fused in clay pots inserted around its base.

***BOULE***: Generic French term for all types of paperweight.

**BOUQUET**: Floral motif inside a paperweight. Bouquets can be flat and one-dimensional or vertical and three-dimensional.

**CHAMOTTE**: Fire-clay. An extremely heat-resistant (up to 1,650 degrees Celsius) mixture made of crushed brick, high-silicon sand, and clay, which is pulverized and then baked at high temperatures until it hardens. Fire-clay is used to make the pots in which glass is fused.

**CRYSTAL**: A type of glass made from sand, potash, and lead oxide. The 12 to 30 percent lead-oxide content in crystal makes it transparent, exceptionally brilliant (hence the name), and resonant. *See also* **Glass**

**CRYSTAL, MOUSSELINE**: An exceptionally thin crystal developed in 1850 and used for particularly costly pieces.

**CRYSTAL, ROCK** (or **MOUNTAIN**): Quartz hyalin, an extremely hard, transparent substance.

**ENAMEL**: Colored glass with a low fusion point, applied cold to crystal and fixed by firing. Enamels—metallic-oxide pigments mixed with a solvent—are applied by brush or serigraphy and can be transparent or opaque, depending on their composition. Enamel decoration was popular during the Middle Ages and the Renaissance, but since then has tended to go in and out of fashion.

**GLASS**: Hard, brittle, usually transparent or translucent substance made by fusing soda or potash, sand, and lime. *See also* **Crystal**

**GLASS, BOHEMIAN**: Very clear glass made with quartz, lime, and potash. A type of glass developed in Bohemia at the end of the seventeenth century.

**GLASS-CUTTING**: The technique of using lapidary tools to incise the surface of an object made of crystal or glass. Cut-glass designs include beveled lines, flat ribbing, dots, lozenges, ovals, stalks, etc.

**GLASS, FERN**: A type of glass made with the ashes of burnt fern leaves, which contain a variety of potash. Fern glass is associated primarily with France (fourteenth and fifteenth century).

**GLASS, RHINE WINE**: A glass, often made from a colored parison, for the service of Rhine Wine. Nineteenth-century German-style Rhine-wine glasses were usually hollow-stemmed, but most of the modern stems are solid.

**GLASS, VENETIAN-CRYSTAL**: Type of glass, also called *cristallo*, developed in fifteenth-century Venice using manganese as a bleaching agent. Also known as Bohemian-style or Venetian-style glass.

**GLASSMAKERS**: A term designating all the artisans (master glassmaker, glass-blowers) employed in the manufacture of objects made from molten glass. In ancient Rome glass-blowers and molders were called *vitrearii*, and glass cutters and engravers *diatretarii*. Today the distinction between glassmakers (who work with the molten glass) and glass cutters and engravers (who work with the cooled pieces) is still made.

**GLASSWARE**: Practical objects made from glass and used as tableware, for perfumery and pharmaceuticals, in laboratories, and as lighting fixtures.

**MILLEFIORI**: Type of glass design made by annealing multicolored "canes" or rods together, cutting them into sections, and flattening them. The fused cane sections are then inserted into paperweights, bottles, vases, bowls, jewelry, etc. The millefiori technique was known to the ancient Romans and revived in the middle of the nineteenth century when round paperweights became popular.

**OPALINE**: Translucent or opaque glass made with metallic oxides that give it a milky-white or tinted hue. The term was coined in the seventeenth century and is derived from this material's resemblance to opal, a mineral in the silica family.

**OVERLAY, COLOR**: The technique of applying a second layer of molten glass to a piece, usually in a contrasting color. Overlaid glass is particularly suitable for cutting or engraving, which reveals both colors within the design.

**PARISON**: Tubular-shaped blank of molten glass from which the final piece is made. Forming the parison from a shapeless gob of molten glass is the first task of the glassblower.

**PIEDOUCHE**: Small pedestal for glasses, cups, etc.

**POT**: Receptacle made from fire-clay for insertion into glass kilns. Kiln pots hold the ingredients that are fused into molten glass.

**ROD**: Tool used for extracting gobs of molten glass from a glass kiln.

***SULFURE***: French word designating a high-fired, filtered, and compressed ceramic decoration made to resemble ancient cameos carved from hard stones and intended for insertion into, or under, glass. Also used to designate the glass paperweight in which this type of decoration is contained. The term is probably derived from the fact that early examples tended to resemble silver sulfide due to the small amount of condensed air trapped between the crystal and the ceramic. The first modern instances of ceramic decorations enclosed in glass date from 1796. D'Artigues used the technique at his Vonèche glassworks between about 1810–15.

**TUMBLER**: Unstemmed, relatively stout drinking vessel used for alcoholic and non-alcoholic beverages, as a toiletry accessory, for informal meals, picnicking, and travel.

## Faience and Porcelain

**BISCUIT**: Unglazed, low-fired porcelain paste with a porous texture. Biscuitware was once fired twice (hence the name) but today Sèvres biscuitware is only fired once.

**BRUSHING**: Applying pointillist strokes of pigment with a brush made of badger hair.

**BUFFING**: Final polishing given to porcelain pieces in order to smooth tiny flaws and bring out their brilliance. Biscuit-fired pieces are buffed with aluminum rods.

**CHUCK**: Plate on which unfired porcelain or pottery is turned while being shaped.

**DIPPING**: Immersion of an unfired piece in a glazing solution.

**EARTHENWARE**: Objects (tableware, containers, etc.) made of glazed or unglazed pottery. *See also* **Faience**

**FAIENCE**: From the Italian *Faenza*, the place where it was originally made. Glazed pottery. *See also* **Earthenware**

**FILLING**: The use of modeling-clay to smooth irregularities occurring when models (particularly for figurines and similar intricate pieces) are removed from the initial mold. *See also* **Flaw**, **Molding**

**FLAW, MOLDING**: Flaws, especially in small pieces such as figurines, that occur when the model is extracted from the initial mold. These flaws are corrected by smoothing them with modeling-clay filler. *See also* **Filling**

**FRIT**: A blend of sand, soda, and various oxides fired to a temperature just below the fusion point. Frits are used for some glazes (Sèvres Blue, for example) and soft ceramic pastes.

**GLAZE, ENAMEL**: Metallic-oxide pigments that vitrify at high temperatures. They are applied to porous ceramic pottery for decorative purposes.

**GLAZE, PORCELAIN**: A feldspathic composition used for the manufacture of porcelain which vitrifies at high temperatures, giving the finished pieces their lustrous appearance.

**HIGH-FIRING**: The final firing, conducted at temperatures of 1,100 to 1,400 degrees Celsius, during which the paste acquires its definitive color and hardness. The glaze vitrifies and the colors develop their definitive shades. High-firing also fuses the colored enamel glazes with the transparent underglaze.

**IMPRESSING**: The process of pressing porcelain paste into a mold.

**KAOLIN**: A type of clay that vitrifies when fired. *See also* **Glaze**, **Porcelain**

**LOW-FIRING**: Initial firing of porcelain, conducted at temperatures of between 200 and 600 degrees, which burns off the oils in the glaze pigments.

***MARLI***: Raised rim (of a plate). At Sèvres, this term designates the upper surface of the plate rim.

**OVERGLAZE**: The vitrified, transparent glaze that covers faience pieces after the second firing.

**POURING**: The process of filling plaster molds with liquid slip. The plaster absorbs the excess liquid in the slip, and the residue covers the contours of the mold with a hard film.

**PROFILE**: An automatic or semi-automatic device for turning clay objects as they are molded.

**ROLL**: Tubular roll of ceramic paste, formed mechanically or by hand, from which porcelain pieces are then molded.

**ROTTING**: The seasoning of raw porcelain paste by storing it for several months in a humid atmosphere, which stimulates the growth of acid-secreting micro-organisms that make the paste more malleable.

**SEAM**: The ridge left on fired porcelain pieces by the join between the two halves of the mold.

**SHRINKAGE**: The amount by which an unfired piece will be diminished when subjected to the intense heat of firing. Shrinkage for porcelain is approximately 15 percent.

**SLIP**: A solution of clay and water used to make molded porcelain pieces or to mask the natural color of ceramic paste.

## Fragrance

**ALDEHYDE**: A colorless, volatile fluid with a strong odor that extends the staying-power of compounds in which it is used. In perfumery, fatty aldehydes generated by the oxidation of alcohol are the primary ones used. The discovery of these highly powerful synthetic substances gave perfumers a revolutionary palette of scents to work with, creating an entirely new category of perfume, called the "Aldehydes."

**AMBER**: A category of perfume also known as "Oriental," featuring subtly spicy notes of vanilla, rock-rose, labdanum, and musk.

**AMBERGRIS**: A secretion formed in the intestine of the sperm whale and used as a scent fixative.

**ANOSEMIA**: Diminution or loss of the sense of smell.

**ARCHIVE, SCENT** see **Osmothèque**

**BALM**: A fragrant substance secreted by some plants in the form of gum, resin, or sap. A term used (by extension) in the cosmetic industry to designate an oily emulsion containing little or no alcohol. *See also* **Resin**

**BOUQUET**: A blend of fragrances with no predominant note. A term once common in perfumery but now obsolete.

***CHYPRE*** (Cyprus): Name of a perfume created by François Coty in 1917. The success of *Chypre* led to the creation of an entire family of perfumes based primarily on notes of oak moss, rock-rose, labdanum, pachouli, bergamot, etc.

**CONCRETE**: The viscous, sweet-smelling residue left in the bottom of the vat after flower petals (jasmine, rose, oak moss, etc.) have been heated in volatile solvents.

**DETERIORATION**: Fragrances are subject to deterioration affecting the original color or odor when exposed to the physical and chemical effects of air, light, heat, and age.

**DISTILLATION**: The extraction of natural essences steeped in alcohol by heating the solution until it turns into steam, cooling the steam until it re-condenses in concentrated form, and collecting the final reduced liquid drop by drop.

**EROTIC**: Adjective applied to a perfume that causes specific arousal in the person exposed to it.

**EXHALATION**: The spontaneously generated scent of a given fragrance blend.

**FERN**: A compounded dominant note actually unrelated to natural fern. The "Fern" note is usually obtained by blending notes of lavender, wood, oak moss, cumarin, bergamot, etc.

**FRAGRANCE**: Word derived from Latin and used to designate odors that are positively pleasing, rather than merely good or bad.

**HARMONIUM, FRAGRANCE**: A cupboard in which the various ingredients used in blending fragrances are stored.

**HEADY**: Adjective used to describe a fragrance or perfume that stimulates the senses or the imagination.

**HESPERIDES** (from "Hesperid," in Greek mythology, the garden where Hera's golden apples grew): Name designating the group of essential oils obtained from citrus fruits such as bergamot, lemon, orange, green mandarin, etc. The earliest products in this category were eaux-de-Cologne for both men and women.

**HYPEROSMIA**: An exaggerated sense of smell.

**INFUSION**: In perfumery, an unheated and undistilled solution of flower or plant essences. Examples: infusions of musk, amber, civet, oak moss.

**JUICE**: An alcohol-based fragrance concentrate.

**LEATHER**: An unusual category of perfume differing from the more familiar flower fragrances. Dry—sometimes very dry—notes are used in an attempt to duplicate the characteristic odor of leather. These notes include smoke, charred wood, birch, tobacco, etc., and are combined with floral accents.

**MEMORY, OLFACTORY**: The ability of the brain to retain a memory of smells perceived at an earlier time.

**NOTE, BASE**: The final note in a perfume blend, and the one that persists after the top note and middle note have evaporated. This is because it is made up of less volatile ingredients than the other two.

**NOTE, DOMINANT**: The strongest perceptible note in a fragrance blend. For example: the vetiver note in a floral blend.

**NOTE, MIDDLE**: The term "middle note" is used in perfume laboratories to designate the note that develops on the skin after the top note, and before the base note. The middle note conditions the overall impact of the perfume.

**NOTE, TOP**: The initial scent perceived by the senses following application of a perfume. The top note is made up of the most volatile ingredients in the total blend.

**OSMOLOGY**: The science of smell.

**OSMOTHÈQUE**: An archive of odors, scents, and perfumes (registered trademark S.T.P.F.). Address: 36 rue du Parc de Clagny, 78000 Versailles. Tel: (33) 39 55 46 99.

**PAROSMIA**: a sensory hallucination involving false odor perception.

**PHEROMONE**: A chemical substance, secreted externally by certain insects, which conveys information to and produces specific responses in other individuals of the same species.

**REDOLENT**: Having a specific, easily-identifiable scent.

**RESIN**: A generic term designating any of the solid or semi-solid substances exuded from various plants and trees. *See also* **BALM**

***RUSSIAN LEATHER***: Name given to perfumes duplicating the odor of Russian boots treated with birch oil.

**SOLIFLORE**: Perfumes with a single floral note, the development of which signaled the beginning of modern perfumery. For these fragrances, an effort is made to imitate nature through the creation of stylized scents based on rose, jasmine, violet, lilac, lily of the valley, etc.

**STILL**: An apparatus used for distilling fragrance essences from flower blossoms and other ingredients steeped in alcohol.

**STRIP, DIP**: Highly absorbant, glue-free paper cut in small strips and used by perfume-industry professionals (chemists, perfumers, retailers, etc.) for sampling scent ingredients or blends in order to evaluate their quality and impact.

**VOLATILE**: An adjective describing scents that evaporate rapidly (fleeting fragrances).

**WATER, ROSE; ORANGE BLOSSOM; ETC.**: Mild scents made from distilled flower essences.

## Fabrics and Textiles

**ARTS AND CRAFTS MOVEMENT** *see* **Movement, Arts and Crafts**

**BASIN** *see* **Damask, Cotton**

**BATISTE**: Variety of cambric named after a Cambrai (France) weaver named Jean Batiste. *See also* **Cambric**

**BROCADE**: From the Italian *broccato*, "embroidered." A silk fabric woven with patterns in silver and gold thread. Brocade is a direct descendent of the sumptuous Sassanian, Byzantine, and Muslim fabrics of ancient times. Brocade was used in the Renaissance as an upholstery fabric, and Colbert later supported its manufacture in Lyon.

**BROCADING**: A weaving technique for making patterns in silver and gold thread on a plain background.

**BROCATELLE**: Originally designating a small-patterned brocade, this term was subsequently extended to include varieties in cotton and even wool (Flanders).

**CAMBRIC**: Very fine, thin linen named after Cambrai (France), where it was originally made. *See also* **Batiste**

**DAMASK**: A fabric featuring matt/lustrous contrasts reminiscent of the shimmer of light on Damask steel (after Damascus, capital of Syria). The fabric is usually woven from a combination of lustrous and matte satin threads.

**DAMASK, COTTON**: A blended linen and cotton fabric. Cotton damask was first manufactured in Lyon, in 1580, but the finest cotton damask was ultimately made in Holland and Bruges.

**DRUGGET**: A fabric characterized by small geometric or floral patterns framed by lozenges.

**HANGING, WALL AND/OR DOOR**: Large decorative tapestries used during the Middle Ages and the Renaissance in Europe as insulation in drafty buildings.

**LAMPAS**: Probably originating in Persia, lampas is a silk fabric with large patterns woven in colors contrasting with the fabric's background. Lampas was especially popular during the reign of Louis XV.

**LAWN**: A sheer, almost transparent linen or cotton fabric similar to batiste.

***MÉTIS***: French term for a linen-and-cotton blended fabric.

**MOIRE**: A shimmering, iridescent fabric produced by inserting the untreated fabric between two heated rollers.

**MOVEMENT, ARTS AND CRAFTS**: "The Arts and Crafts Movement" designates a decorative style developed in England during the late nineteenth century. This school emphasized simplicity in furnishings and the kind of "honesty" advocated by Philip Webb, William Morris, and Charles Eastlake.

**ORGANDIE**: Very sheer cotton fabric deriving its name from Urgench, a tenth-century town on the Arabian-Chinese trade route.

**SATIN**: A silk fabric that is lustrous on one side and matte on the other. The name "satin" comes from the Chinese town of Tsia-Tung (Zaitun, in Arabic).

**SERGE**: One of the oldest woolen upholstery fabrics.

**WARP**: The threads strung lengthwise on a loom. *See also* **Weft**

**WEFT**: The pick-fill threads inserted horizontally through the warp threads on a loom. *See also* **Warp**

**VELVET**: From the Latin *villosus*, hairy. A fabric in which the warp is made up of dangling threads. The many varieties of velvet include: ribbed (alternating strips of cut and shorn velvet), Genoa (silk velour); Utrecht (mohair and frappe velvet), frappe, and printed.

## Gems and Precious Metals

**BRIDGE**: In watchmaking, the stem around which a wheel revolves.

**CASTING, CUTTLEFISH-BONE**: Technique for casting small objects in one piece. A cuttlefish bone is split down the middle and the separate halves of the model carved out of either side. The two sides are then clamped together to form a mold, and the molten metal poured into it.

**CHECKERING**: Engine-turned engraving of metal pieces with a series of lines for a light-and-shadow effect. A technique generally employed for backgrounds.

**DAMASCENING**: The technique of inlaying a metal surface with metal filaments or strips in order to obtain a polychrome design.

**DIE, RIVETING**: A tool with a rounded head used by silversmiths and goldsmiths to cut bezels into gems. Gem cutters use them with emery powder to cut cameos and intaglio patterns.

**ENAMELING**: A traditional technique employed in jewelry-making. Enamel is a type of opaque or transparent glass that can be colored through the addition of salts or metal oxides. Enamel can be cloisonné (enamels of various colors separated by slender raised metal rods that form a pattern) or chased (same technique as the previous one, except that the metal is recessed instead of being raised). Chasing was used between the twelfth and the fourteenth centuries around Limoges (France). Painted enamel techniques, developed at the end of the Middle Ages, are similar to those used for porcelain: the metal is entirely covered with enamel, with no separations.

**GRAVER**: Small chasing tool used by engravers and metalsmiths.

*GUILLOCHAGE see* **Checkering**

*MAILLECHORT see* **Silver, German**

**MARLI**: The raised rim of a plate or dish.

**PIERCING**: A delicate technique, generally performed by women, that involves perforating delicately engraved patterns.

**RAISING**: Shaping a sheet of metal on a metallic mold using various hammers and mallets.

**RIFFLER**: A generic name for metal files of various shapes and sizes.

**SILVER, GERMAN**: A nickel, copper, and zinc alloy patented in 1827 by Maillot and Chorrier. German silver is used as the base for Christofle tableware. It was used in its unplated form during the nineteenth century to make cheap tableware for restaurants, cafés, and spirit shops.

**STAKE**: Wooden chuck used to steady objects during chasing and molding.

**STAKE, CREASING**: A lapidary tool in the form of an anvil with a variety of tips—pyramidal, conic, cylindrical, rounded, grooved—used for different purposes. Creasing stakes are also used to emboss hallmarks on metal.

**TAP**: Hand or machine tool used to bore screw holes.

## Leather

**BOX-CALF**: Chrome-tanned calfskin.

**BOX-MAKER**: Traditional term for artisans who make leather-covered trunks, boxes, and cases.

**CARROTING**: Using a mixture of vinegar and nitric acid to condition animal pelts prior to dyeing.

**CHAMOIS**: A polishing leather used to bring out the surface shine on objects of various kinds.

**CORKING**: A technique for softening and graining leather using strips of cork glued to a piece of wood.

**FULLER**: Wooden trough in which leather is mechanically softened with mallets.

**HANDLE**: The handle of a fur is as important as its physical appearance, and must correspond to the initial visual impression. Terms describing the handle of fur pelts include: natural, full, oily, round, smooth, silky, velvety, flat, waxy.

**ICHTHYOCOL**: A glue-like preparation made from sturgeon bladders, pioneered by Parisian furrier M. Richard in 1876 for lacquering gold-colored and silver-colored powder on to fur. Richard also used this preparation in combination with "oriental essence" (a solution of fish scales from Lake of Geneva bleak fish) which gives a better sheen, producing the appearance of costly fur at a lower cost.

**IRON, SMOOTHING**: Square tool made of glass or hardwood, used for smoothing leather.

**LAST**: Wooden model used shaping shoes or boots.

**MARBLING**: A technique employed in bookbinding. A briar broom dipped in dye is shaken against a wooden pole, splattering the dye on to the binding to produce an "antique" mottled effect.

*NAPPA*: German term designating the lambskin used in luxury apparel.

**OILING**: In the fur trade, the use of a castor-oil and alcohol solution to soften the hairs on a pelt and eliminate matting. The same solution was pioneered in the early twentieth century as the first brilliantine for human hair.

**PLANE** *see* **Iron, Smoothing**

**SERIGRAPHY**: A print-transfer process frequently used for textiles. The use of serigraphy for leather is extremely difficult and today is practiced only by two leather-dressers, one in Santa Croce (Italy) and another in Graulhet (France).

**SHEARLING**: Freshly-sheared lambskin.

**TAB, RING**: Strip of leather used to attach metal rings to a finished leather piece such as a handbag.

**TAMARIN**: A nut gall affecting the tamarisk tree and caused by insect stings. Tamarin is considered one of the best tanning agents.

## Hotels and Gastronomy

*ABAISSE*: A strip of rolled pastry.

*ASSOCIATION DES CLÉS D'OR*: An international association of over 3,000 concierges from grand and luxury hotels throughout the world.

*BRAISE*: To cook in a small amount of liquid over low heat.

*BRUNOISE*: Vegetables cut into small dice.

*CHASSEUR*: A liveried employee of a hotel, café, or private club whose function is to deliver messages and run errands.

*CHEF DE PARTIE*: A divisional chef (Pastry, Salads, etc.) working under the orders of the Executive Chef and assisted by an under-chef and sometimes an apprentice.

*CHEMISER*: To line the inside of a mold with a thin layer of gelatine or a sheet of paper.

**CONSOMMÉ**: A strong, clarified meat bouillon.

**DEGLAZE**: To add hot liquid to caramelized pan juices, making a thin sauce.

**GROOM** *see Chasseur*

**JULIENNE**: Vegetables cut into thin strips.

*MIREPOIX*: Diced-vegetable garnish.

**PALACE**: Term often used to designate a luxury hotel.

**POACH**: To cook (fish, eggs, etc.) in simmering liquid.

**REDUCE**: To simmer a liquid until it has diminished in volume. Liquids containing a thickener will also become thicker as volume is reduced.

*VANNER*: To cool (custards, sauces) by stirring gently with a flat wooden spoon or spatula to release the air. This technique also prevents a skin from forming on the surface of the preparation.

*VOITURIER*: Valet-parking attendant.

## Haute Couture

**BREECHES**: Garment covering the lower part of the body, the legs, and the feet. First worn in the late Middle Ages, the size and cut of breeches evolved over the centuries. Full or paneled breeches had separate leg pieces, and stirrup breeches were a held down by a strip of cloth running under the instep.

**Esparto**: Type of long, coarse grass used to make rope, baskets, and shoes.

**Muslin, Modeling**: Lightweight unbleached, undyed cotton cloth used to make patterns for *haute couture* clothing.

**Piece-Worker**: The assistant tailor who sews together jackets and coats for the master tailor.

**Sizer**: The worker who adds sizing (starch stiffening) to certain parts of a garment.

## Vineyards

**Aromas**: Volatile organic substances that appeal to the sense of smell. The *primary* aromas in wine come from the grape itself, the *secondary* aromas develop during alcoholic fermentation, and the *tertiary* aromas develop during aging. Some connoisseurs use the term "aroma" for olfactory sensations perceived through the retronasal passages from the mouth, and "odor" for those perceived directly by the nose.

**Astringent**: Describing anything that contracts body tissue (and thus the taste buds), particularly tannins. Astringent wines produce a characteristic sharpness on the tongue.

**Blending**: Mixing wines from the same vintage in order to obtain a homogeneous product (not to be confused with cutting, the admixture of inferior wines).

**Botrytis**: A fungus that produces mold on grapes.

**Bouillie Bordelaise**: A liquid solution containing copper sulfate and quick lime, used since the end of the nineteenth century as an anti-mildew treatment for grape vines. Today it is being replaced by synthetic compounds.

**Cellar**: Place where wines and spirits are aged in the cask. Although the word "cellar" is commonly used to designate these storehouses, not all of them are actually underground.

**Cep**: Rootstock (grapes).

**Cepage**: Variety of rootstock.

**Chaptalization**: The addition of sugar to new wine prior to fermentation. The word is derived from that of a chemist named Chaptal, who advocated the technique at the beginning of the nineteenth century as a method for extending the shelf life of wine. Chaptalization is regulated under European Union legislation and can only be practiced legally during certain years, in certain wine-growing regions.

**Château**: Word applicable only to wines designated "d'Appellation d'Origine Contrôlée" (Officially-Recognized Wine-Growing Regions). A "château" is an independent production unit possessing the vineyards, facilities, and personnel necessary for the production and storage of wine.

**Clairet**: A lightly-fermented, light-colored, crisp, pleasant wine that was highly popular under the Ancien Régime. It is made from white grapes grown in the south of France (Aude, Hérault, Gard, and Drôme).

**Clarifying**: The addition to wine of a substance, usually a natural protein (gelatine, albumin, casein, fish glue), that attracts and precipitates suspended matter.

**Climat**: A French word used synonymously with "growth" by vintners in Burgundy to designate a specific area (the boundaries of which are frequently established by official survey) that produces a wine with unique qualities. *See also* **Cru**, **Cuvée**, **Vintage**

**Clos**: In Burgundy, a term designating wines "d'Appellation d'Origine Contrôlée" produced on lots once or currently enclosed by a wall or a hedge.

**Congé**: An official notice certifying that the taxes on wines or spirits have been paid. This notice is sometimes stamped directly on to the overcap of the bottle.

**Coupage**: Cutting wines by combining vintages of varying quality from different regions. For inexpensive table wines, cutting is used to obtain a uniform product.

**Cru**: The word *cru* (vintage) designates both a particular area (although the term *climat* is also used in Burgundy) and the wine produced by it. In Burgundy, a single *cru* may be worked by several vintners; in Bordeaux, each *cru* belongs to a single producer. *See also* **Climat**, **Cuvée**, **Growth**, **Vintage**

**Cuvée**: The product of a single vineyard, particularly in Burgundy (where the term *climat* is also used), a region in which separate growths are stored in separate casks in order to retain their respective characteristics. In Burgundy, for example, *cru* and *cuvée* are synonymous. For white wines, the term *cuvée* refers to new wine from the first pressing. *See also* **Climat**, **Cru**, **Growth**, **Vintage**

**Domaine**: A property representing a single wine-producing area. The term is applicable to both *Vin d'Appellation d'Origine Contrôlée* and *Vin de Pays*. *See also* **Château**

**Elevage**: The series of processes (clarification, stabilization, maturating) carried out following fermentation of the grape juice in order to produce an optimal final product.

**Fermentation**: A process during which yeast acts as a catalyst to transform sugar into alcohol. Fermentation turns grape juice into wine.

**Growth**: A single wine-growing area and also the wine produced by it. *See also* **Cuvée**, **Cru**

**Maceration**: The phase of vinification during which the solid portions of the grape are left to steep in the juice, embuing it with their color, aroma, and tannin.

**Millésime**: The year in which the grapes for a specific wine were harvested. By extension, used to refer to the entire harvest in a given year. *See also* **Vintage**

**Mold**: A disease attacking grapes and caused by the *Botrytis* fungus, which penetrates the grapes as they mature. This mold is exploited by the makers of certain heavy wines such as the Sauternes because, if it is not allowed to advance too far, it intensifies the bouquet of the wine by concentrating the sugar in the grapes.

**Must**: Unfermented grape juice.

**Pressing**: The exertion of pressure on grapes in order to extract the juice.

**Primeur**: Wines designated *d'Appellation d'Origine Contrôlée* that are marketed during the same year the grapes are harvested (usually starting on the third Thursday in November).

**Stalking**: Removing the stems and stalks from grapes in order to prevent red wine from acquiring a bitter taste. For some types of vinification (Beaujolais method; carbonic maceration), stalking of the grapes is not necessary.

**Tannic**: Term applied to a wine rich in tannin or highly astringent to the taste.

**Tannin**: Tannins are contained mainly in the seeds, stalks, stems, and skins of grapes. Tannins are also found in other organic substances (tree bark, citrus fruit). They are bitter and astringent to the taste, giving wine a special character and extending its lifespan.

**Topping**: Adding wine to a cask as the contents evaporate in order to expel air and prevent oxidation.

**Vintage**: The region or year in which a specific wine was produced. *See also* **Climat**, **Cru**, **Cuvée**, **Growth**.

## Crystal

**BACCARAT, A.**, ed. *Baccarat: The Perfume Bottles: A Collector's Guide*. Paris: Henry Addor and Associates, 1988.

**BACRI, C.** *Daum*. Paris: Michel Aveline, 1992.

**BAROIS, L., M. DE FERRIÈRE and J. MOUCLIER.** *Le cristal et l'orfèvrerie*. Paris: Armand Colin, 1994.

**BELLANGER, J.** *Verre d'usage et de prestige, France 1500–1800*. Paris: Editions de l'amateur, 1988.

**CURTIS, J.-L., J. BOULAY, and J.-M. TARDY.** *Baccarat*. Paris: Editions du Regard, 1991.

**INGOLD, G.** *Saint-Louis, de l'art du verre à l'art du cristal de 1568 à nos jours*, Paris, Denoël, 1986.

**MANNONI, E.** *Classic French Paperweights*. Paperweight Press, 1984.

**MARCILHAC, F.** *Lalique, catalogue raisonné de l'œuvre de verre*. Paris: Editions de l'amateur.

**MAYER LEFKOWITH, C.** *The Art of Perfume*. London: Thames and Hudson, 1994.

**NEWMAN, H.**, ed. *An Illustrated Dictionary of Glass*. London: Thames and Hudson, 1987.

**SELMAN, L.H.**, ed. *The Art of the Paperweight*. Paperweight Press, 1989.

**UTT, M. L.** et al. *Lalique Perfume Bottles*. London: Thames and Hudson, 1991.

Exhibition catalogue: *René Lalique*, Musée des Arts Décoratifs. Paris: RMN, 1991.

## Faience and Porcelain

**ALBIS, J. d' and C. ROMANET.** *La porcelaine de Limoges*. Paris: Sous le vent, 1980.

**BERNARD, R. and MAÎTRE J.-C. RENARD.** *La faience de Gien*. Paris: Sous le vent, 1981.

**BLOIS, M.** *Trois siècles de porcelaine de Paris*. Paris: Hervas, 1988.

**BRUNET, M. and T. PRÉAUD.** *Sèvres: des origines à nos jours*. Fribourg: Office du livre, 1978.

**FAY-HALLÉ, A. and B. MÜNDT.** *La porcelaine européenne du XIXe siècle*. Paris: Vilo, 1983.

**MATHIEU, J.**, ed. *La porcelaine de Sèvres*. Paris: Chêne/Hachette, 1982.

**SAVAGE, G., H. NEWMAN, and J. CUSHION.** *An Illustrated Dictionary of Ceramics*. London: Thames and Hudson, 1992.

Exhibition catalogue: *Le Musée National Adrien Dubouché, Limoges*, Paris: Musées et Monuments de France, RMN Albin Michel, 1992.

## Fragrance

**BARILLÉ, E. and C. LAROZE.** *The Book of Perfume*. Paris and New York: Flammarion, 1995.

**COLARD, G.** *Le charme secret d'une maison parfumée: Caron*. Paris: J.-C. Lattès, 1984.

**DEMORNEX, J.** *Lancôme*. Paris: Editions du Regard, 1986.

**ELLENA, J.-C., M.-C. GRASSE, J. and J.-P. LE MARQUET.** *Sous le signe du parfum, Edmond Roudnitska compositeur-parfumeur*. Paris: Editions de l'Albaron, 1991.

**FELLOUS, C.** *Guerlain*. Paris: Denoël, 1987.

**MORRIS, E.T.** Fragrance, *The Story of Perfume from Cleopatra to Chanel*. New York: Macmillian, 1984.

**PARRY, E.J.** *Encyclopedia of Perfume*, 2 vols. New York: Gordon Press, 1992

**PILLIVUYT, G.** *Les flacons de la séduction, l'art du parfum au XVIIIe siècle*. Paris: La Bibliothèque des Arts, 1985.

*Classification des parfums*, Comité Français du Parfum, C.F.P., 1990.

Exhibition catalogue: *Trois mille ans de parfumerie, parfums, savons, fards et cosmétiques de l'Antiquité à nos jours*. Grasse: musée d'Art et d'Histoire, 1980.

## Fabrics and Textiles

**ALGOUD, H.** *La Soie: art et histoire*, Lyon: La Manufacture, 1986.

**BONNEVILLE, F. de.** *The Book of Fine Linen*. Paris and New York: Flammarion, 1994.

**BRÉDIF, JOSETTE.** *Toiles de Jouy: Classical Printed Textiles from France 1760–1843*. London: Thames and Hudson, 1989.

**CALLOWAY, S.** *Twentieth-century Decoration: The Domestic Interior from 1900 to the Present Day*. London: Weidenfeld and Nicolson, Ltd., 1988.

**CANOVAS, M.** *Le guide des tissus d'ameublement*, Paris: Hachette, collection Les grands du style, 1986.

**CARLANO, M. and L. SALMON**, eds. *French Textiles From the Middle Ages to the Second Empire*. Hartford: Wadsworth Athenuem, 1985.

**CLOUZOT, H. and F. MORRIS.** *Painted and Printed Fabrics: The History of the Manufacture at Jouy and Other Ateliers in France (1760–1815)*. New York: Metropolitan Museum of Art, 1927.

**DÉMÉRY, J.-P.** *Souleïado*. Paris: Michel Aveline, 1990.

**HARRIS, J.** *5,000 Years of Textiles*. London: British Museum, 1994.

**LEBEAU, C. and P. CORBETT.** *La grande histoire des tissus*: Paris: Flammarion, 1994.

**MUSÉE OBERKAMPF.** *Christophe-Philippe Oberkampf et la manufacture de Jouy-en-Josas*, Colmar, 1987.

**SCHOESER, M. and K. DEJARDIN.** *French Textiles from 1760 to the Present*. London: Laurence King, 1991.

**SCHWARTZ, P. R. and R. MICHEAUX.** *A Century of French Fabrics: 1850–1950*. Leigh-on-Sea, 1964.

**SCOTT, P.** *The Book of Silk*. London: Thames and Hudson, 1993.

Dictionnary: *Les étoffes. Dictionnaire historique*. Paris: Editions De l'amateur, 1994.

## Gems and Precious Metals

**ARMINJON, C. and N. BLONDEL.** *Objets civils domestiques*. Paris: Imprimerie nationale, 1984.

**BLAIR, C.**, *The History of Silver*. London and Sydney: Macdonald Orbis, 1987.

**BONNEVILLE, F. de.** *Jean Puiforcat*. Paris: Editons du Regard, 1986.

**BOUCHERON, A.** *Le guide des pierres précieuses*. Paris: Arthaud, 1987.

**BOUILHET, H.** *150 ans d'orfèvrerie Christofle*. Paris: Editions du Chêne / Hachette, 1981.

**BOUILHET, H.** *L'orfèvrerie française aux XVIIe et XIXe siècles*, 3 vols. Paris: H. Laurens Librairie éditeur, 1908.

**BURY, S.** *Jewellery, 1789–1910*, 3 vols. London: Antique Collectors' Club. 1991.

**CERVAL, M. de.** *Mauboussin*. Paris: Editions. du Regard, 1992.

**CHAPIRO, A.** *La montre française*. Paris: Editions De l'amateur, 1991.

**DENNIS, F.** *Three Centuries of French Domestic Silver*. New York, 1960.

**FORGET, C.** *Dictionary of Jewellery and Watchmaking*. London: Elsevier, 1984.

**FOUQUET G., E. SEDEYN, J. GUÉRIN, J. LANLLIER, and P. PIEL.** *La bijouterie, la joaillerie, la bijouterie de fantaisie au XXe siècle*. Evreux: Imprimerie Hérissay, 1934.

**GRUBER, A.** *L'argenterie de maison du XVIe au XIXe siècle*. Fribourg: Office du livre, 1982.

**HALL, C.** *Gemstones*. London: Dorling Kindersley, 1994.

**HERNMARCK, C.** *The Art of the European Silversmith and Goldsmith 1430–1830*. London and New York: Sotheby Parke Bernet, 1977.

**MABILLE, G.** *Orfèvrerie française des XVIe, XVIIe et XVIIIe siècles, catalogue raisonné des collections du musée des Arts décoratifs et du musée Nissim de Camondo*. Paris, 1984.

**MAURIES, P.** *Jewelry by Chanel*. New York: Bullfinch, 1993.

**MOREL, B.** *Les joyaux de la couronne*. Paris: Albin Michel, 1988.

**NADELHOFFER, H.** *Cartier: Jewellers Extraordinary*. London: Thames and Hudson, 1984.

**NERET G.** *Boucheron: Four Generations of a World-Renowned Jeweler*. New York: Rizzoli, 1988.

**NEWMAN, H.**, ed. *An Illustrated Dictionary of Jewellery*. London: Thames and Hudson, 1987.

_____. *An Illustrated Dictionary of Silverware*. London: Thames and Hudson, 1987.

**PERRIN, C.** *François-Thomas Germain, orfèvre des rois*. Saint-Rémy-en-l'Eau, 1993.

**PUIFORCAT, J.** *L'orfèvrerie française et étrangère*. Paris: Garnier frères, 1981.

**RAULET, S.** *Van Cleef & Arpels*. New York: Rizzoli, 1987.

**SNOWMAN, K.** *Master Jewellers*. London: Thames and Hudson, 1990.

**VEVER, H.** *La bijouterie française au XIXᵉ siècle*, 3 vols. Paris: H. Floury, 1906–1908.

Exhibition catalogue: *L'Œuvre d'Abraham-Louis Breguet, 1747–1823*, Musée International d'Horlogerie. Text by Georges Daniels, 1976.

Exhibition catalogue: *Les français et la table*, Musée des Arts et Traditions. Paris: RMN, 1985.

Exhibition catalogue: *Versailles et les tables royales en Europe, XVIIᵉ XIXᵉ siècle*, Musée National des châteaux de Versailles et de Trianon. Paris: RMN, 1993.

## Leather

**CAUNES, L. de and J. PERFETTINI.** *Galluchat*. Paris: Editions De l'Amateur, 1994.

**CUMMING, V.** *Gloves*. London: Batsford: 1982.

**DOONER, K.** *A Century of Handbags*. New York: Schiffer, 1993.

**JOUBIN, A.** *La selle Hermès*. Paris: Editions du Collectionneur, 1993.

**MOSELY, G.C.** *Leather Goods Manufacture: Methods and Processes*. Albert Saifer, 1986.

**VUITTON, H. L.** *La malle aux souvenirs*. Paris: Editions Mengès, 1984.

**WILSON, E.** *History of Shoe Fashion*. New York: Chapman and Hall, 1974.

Exhibition catalogue: *Le gant*. Couvent des Cordeliers. Paris: Editions Métiers d'art de Paris, 1994.

## Hotels and Gastronomy

**ARNOLD, W.** *Historical Hotels of Paris*. London: Thames and Hudson, 1990.

**BODE, W.K.H.** *European Gastronomy: The Story of Man's Food and Eating*. London: Hodder Fawcett, 1994.

**BOXER, M.** *The Paris Ritz*. London: Thames and Hudson, 1991.

**ELLWANGER, G.H.** *The Pleasures of the Table*. Gordon, 1972.

**ENNES P., G. MABILLE, and P. THIEBAUT.** *Histoire de la table*. Paris: Flammarion, 1994.

**ETIENNE, B and M. GAILLARD.** *Great Hotels of Paris*. Vendome, 1992.

**GAIN, R.** *Les plus beaux restaurants de Paris*. Paris: Gallimard, 1993.

**GUY, C.** *Histoire de la gastronomie en France*. Paris, 1985

**GUY, C.** *Vie quotidienne de la société gourmande au XIXᵉ siècle*. Paris, 1971.

**MENNELL, S.** *All Manners of Food: Eating and Taste in England and France from the Middle Ages to the Present*. Oxford: Basil Blackwell, Ltd., 1985.

**WALTER M.** *Palaces et grands hôtels d'Europe*. Paris: Flammarion, 1984.

Exhibition catalogue: *La racine et ses feuilles*. Paris: Editions Hermès, 1986.

Exhibition catalogue: *L'Art culinaire au XIXᵉ siècle: Antonin Carême*. Paris: Orangerie de Bagatelle, 1984.

## Haute Couture

**ALAUX, J., F. BAUDOT, S. de CHIRÉE, and P. MAURIÈS.** *Jeanne Lanvin*. Franco-Maria Ricci, 1988.

**BENAIM, L.** *Yves Saint Laurent*. Paris: Grasset and Fasquelle, 1993.

**BOUCHER, F.** *A History of Costume in the West*. London: Thames and Hudson, 1987.

**CHENOUNE, F.** *A History of Men's Fashion*. Paris and New York: Flammarion, 1993.

**DEMORNEX, J.** *Madeleine Vionnet*. New York: Rizzoli, 1991

**DEMORNEX, J.** *Un siècle en chapeaux, Claude Saint-Cyr, Histoire d'une modiste*. Paris: Editions. du May, 1991.

**DESLANDRES, Y.** *Paul Poiret*. London: Thames and Hudson, 1987.

**DESLANDRES, Y. and F. MÜLLER.** *Histoire de la mode au XXᵉ siècle*. Paris: Hachette, 1985.

**DU ROSELLE, B.** *La mode*. Paris: Imprimerie Nationale, Collection Notre Siècle, 1988.

**ETHERINGTON-SMITH, M.** *Patou*. Paris: Denoël, 1984.

**GINSBURG, M.** *The Hat throughout the Ages*. London: Studio, 1987.

**GIROUD, F.** *Christian Dior*. London: Thames and Hudson, 1987.

**KRAATZ A.** *Lace: Fashion and History*. London: Thames and Hudson, 1989.

**MONTUPET, J. and G. SCHOELLER.** *Fabuleuses dentelles*. Paris: R. Laffont, 1988.

**PICOT, G. and G.** *Le sac à mains, histoire amusée et passionnée*. Paris: Editions du May, 1993.

**POCHNA, M.-F.** *Nina Ricci*. Paris: Editions du Regard, 1992.

**RACHLINE, M.** *Le livre du sac: des siècles d'élégance*. Paris: Albin Michel, 1991.

**REMAUNY, B.** *Dictionnaire de la mode du XXᵉ siècle*. Paris: Editions du Regard, 1994.

**RENNOLDS-MILBANKS, C.** *Couture: The Great Designers*. London: Thames and Hudson, 1985.

**STEELE, V.** *Paris Fashion: A Cultural History*. London: Oxford University Press, 1985.

**TOUSSAINT-SAMAT, M.** *Historique technique et morale du vêtement*. Paris: Bordas culture, 1990.

**VAUDOYER, M.** *Le livre de la Haute Couture*. Paris: V & O, 1992.

**WHITE, P.** *Haute Couture Embroidery: The Art of Lesage*. Lacius, 1994.

Exhibition catalogue: *Modes en dentelle*, musée de la Mode et du Costume, Palais Galliera. Paris: Editions Paris-Musées,1988.

Exhibition: *Givenchy, 40 ans de création*, musée de la Mode et du Costume, Palais Galliera. Texts by C. Join-Dieterle, M.-J. Lepicard, A. Sagalow, and S. Train. Paris: Editions Paris-Musées, 1991.

Exhibition catalogue: *Au Paradis des Dames, nouveautés modes et confections, 1810–1870*, musée de la Mode et du Costume, Palais Galliera. Texts by C. Join-Dieterle, P. da Silveira, and F. Tétard-Vittu. Paris: Editions Paris-Musées, 1992.

Exhibition catalogue: *Artisans de l'élégance*, musée des Arts et Traditions Populaires. Paris: RMN, 1993.

## Vineyards

**ARCACHE, J. and C. MONTALBETTI.** *Le guide Hachette des vins 1993*. Paris: Hachette-Guides de voyage, 1992.

**BIÉVILLE, D. de and J.-P. GODEAUT.** *Châteaux*. Paris: Ramsay, 1991.

**COATES, C.** *Grands Vins: The Châteaux of Burgundy and their Wines*. Berkeley: University of California Press, 1995.

**COLLOMBET, F. and J.-P. PAIREAULT.** *Grands et petits vins de France*. Paris: Hatier, 1992.

**CRESTIN-BILLET F, and J.-P. PAIREAULT.** *Veuve Clicquot la grande dame du champagne*. Paris: Editions Glénat, 1992.

**DION, R.** *Histoire de la vigne et du vin en France des origines au XIXᵉ siècle*. Paris: Flammarion, 1990.

**JOHNSON, H.** *The Story of Wine* London: Mitchell Beazley 1989.

**JOHNSON, H. and H. OUIJKER.** *Wine Atlas of France*. London: Mitchell Beazley, 1987.

**FAITH, N.** *Château Margaux*. London: Mitchel Beazley, 1991.

**FÉRET C. and M.-H. LEMAY.** *Bordeaux et ses vins, classés par ordre de mérite dans chaque commune*. Paris: Editions Féret, 1991.

**GHÉLINE D. de.** *Ruinart, la plus ancienne maison de champagne de 1729 à nos jours*. Paris: Stock, 1994.

**KRUG, H. and R.** *L'art du champagne*. Paris: Robert Laffont, 1979.

**LEPRÉ, G. and H. AMIARD.** *Le Ritz, magie d'un palace et ses vins*. Paris: Olivier Orban, 1991.

**OLNEY, R.** *Yquem*. London: Dorling Kindersley, 1985.

**WALTER, M.** *Rémy Martin, l'esprit du Cognac*. Paris: E.P.A., 1991.

## IN FRANCE

### Crystal

**Cristallerie Daum,**
rue des cristalleries, 54000 Nancy. 83.32.14.55
**Musée Baccarat,**
30 bis rue de Paradis, 75010 Paris. 47.70.64.30
**Musée Baccarat,**
rue des Cristalleries, 54120 Baccarat. 83.75.10.01
**Musée cristalleries de Saint-Louis,**
Saint-Louis Les Bitche, 57620 Lemberg. 87.06.40.04
**Musée des Arts Décoratifs,**
107 rue de Rivoli, 75001 Paris. 44.55.57.50
**Faience and Porcelain**
**Musée National de la céramique,**
Place de la Manufacture, 92310 Sèvres. 45.34.99.05
**Faïenceries de Gien,**
78 place de la Victoire, 45500 Gien. 38.67.00.05
**Bernardaud,**
27 rue Albert Thomas, 87000 Limoges.
55.77.40.80

### Fragrance

**Musée international de la parfumerie,**
8 place Cours, 06130 Grasse. 93.36.80.20
**Musée du flacon de parfum,**
33 rue du temple, 17000 La Rochelle. 46.41.32.40
**L'Osmothèque,**
36 rue du Parc de Clagny,78000 Versailles.
39 55 46 99
**Musée de la parfumerie Fragonard,**
9 rue Scribe, 75009 Paris. 47.42.93.40
**Cinquième sens,**
2 rue Bouchoir, 60490 Marest-sur-Matz. 44.76.47.18
and 18 rue de Moutessuy, 75007 Paris. 47.53.00.86

### Fabrics and Textiles

**Musée de la dentelle,**
31 rue du Pont neuf, 61000 Alençon. 33.26.27.26
**Musée du tissage,**
rue Jacquard, 42150 Bussière. 77.27.32.33
**Musée de la toile de Jouy/Musée Oberkampf,**
Château de (l'Eglantine) Montebello,
54 rue Charles De Gaulle, 78350 Jouy en Josas.
39.56.48.64
**Musée Crozatier,**
Jardin Henri Vinay, 43000 Le Puy en Velay.
71.02.01.68
**Maison des Canuts,**
10 rue d'Ivry, 69004 Lyon. 78.28.62.04
**Musée historique des Tissus,**
34 rue de la Charité, 69002 Lyon. 78.37.15.05
**Musée des Beaux-Arts et de la Dentelle,**
25 rue Richelieu, 62100 Calais. 21.46.62.00
**Musée Charles Demery Souleïado,**
39 rue Proudhon, 13150 Tarascon. 90.91.08.80
**Musée Victor Charreton,**
15 rue Victor Hugo, 38300 Bourgoin Jallieu.
74.28.19.74
**Musée de la dentelle et de la broderie,**
rue République, 59540 Candry. 27.76.29.77
**L'Atelier de Soierie,**
33 rue Romain, 69001 Lyon. 27.07.97.83

### Gems and Precious Metals

**Christofle,**
9 rue Royale, 75008 Paris. 49.33.43.00
and 112 rue Ambroise Croizat, 93206 Saint-Denis.
49.22.40.00
**La Monnaie de Paris,**
11 quai Conti,75006 Paris. 40.46.56.66
**Musée des Arts Décoratifs,**
107 rue de Rivoli, 75001 Paris. 42.60.32.14
**Musée du Louvre,**
Département des Objets d'Art, 34 quai du Louvre,
75001 Paris. 40.20.50.50
**Musée Calouste Gulbenkian,**
avenue de Berna 45A, 1093 Lisbonne. 765061

### Leather

**Musée du gant et de la peau,**
Hôtel de Pegayrolles, place Foch, 12100 Millau.
65.59.01.08
**Musée Louis Vuitton,**
18 rue du Congrès, 92600 Asnières.
47.91.00.13
**Musée du cuir et de la tannerie,**
105 rue république, 37110 Château-Renault.
47.56.03.59
**Musée Hermès,**
24 rue du Faubourg Saint-Honoré, 75008 Paris.
40.17.48.36

### Hotels and Gastronomy

**Maison régionale des Arts de la table,**
15 rue Saint-Jacques, 21230 Arnay-le-Duc.
80.90.11.59
**Musée de la Gastronomie,**
Château de Thoiry, 78770 Thoiry. 34.87.52.25
**Musée de l'Art culinaire,**
Fondation Auguste-Escoffier, 3 rue Escoffier,
06270 Villeneuve-Loubet. 93.20.80.51

### Haute Couture

**Musée de la Mode et du Costume,**
Palais Galliéra, 10 rue Pierre Ier de Serbie,
75016 Paris. 47.20.85.23
**Musée des Arts de la Mode,**
Pavillon de Marsan, 109 rue de Rivoli, 75001 Paris.
42.60.32.14
**Musée du chapeau,**
16 route de Saint-Galmier, 42140 Chazelles-sur-
Lyon. 77.94.23.29
**Musée de la Mode,**
11 rue de la Canebière, 13001 Marseille.
91.14.92.20
**L'Opéra de Paris,**
8 rue Scribe, 75009 Paris. 40.01.17.89

### Vineyards

*Paris*
**Musée du Vin,**
caveau des Echansons, 5 sq. Charles-Dickens,
75016 Paris. 45.25.63.26

*Alsace and Eastern France*
**Musée Unterlinden,**
1 rue Unterlinten, 68000 Colmar. 89.41.89.23

*Bordeaux*
**Musée du Vin et de la Vigne dans l'art,**
33250 Pauillac. 56.59.22.22

*Burgundy*
**Musée du Vin de Bourgogne,**
rue d'Enfer, 21200 Beaune. 80.22.08.19

*Champagne*
**Musée municipal d'Épernay,**
13 av. de Champagne, 51200 Épernay.
26.51.90.31
**Musée d'Hautvillers,**
51160 Ay. 26.59.40.01

*Jura and Savoy*
**Musée de la Vigne et du Vin,**
Hôtel de ville, 39600 Arbois. 84.66.07.45
**Musée de la Vigne et du Vin,**
Route d'Athose, 25930 Lods

*Languedoc and Roussillon*
**Musée du vieux Bitterois,**
7 rue Massol, 34500 Béziers. 67.28.44.18
**Musée de la Vigne et du Vin,**
1 rue Neckerand Caves Saury-Serres,
3 rue Turgot, 11200 Lézignan-Corbières.
68.27.37.02

*Provence and Corsica*
**Musée international des Vins,**
île de Bendor, 83150 Bandol. 94.29.44.34

*The South-West*
**Musée du Vin et de la Batellerie,**
5 rue des Conférences, 24100 Bergerac.
53.57.80.92

*The Loire Valley and Central France*
**Musée des Vins de Touraine,**
Celliers Saint-Julien, 16 rue Nationale,
37000 Tours. 47.93.25.63
**Musée du Vin,**
4 bd Arago, 49000 Angers. 41.87.41.06

*The Rhône Valley*
**Muse du Vigneron,**
Route de Vaison, Rasteau, 84110 Vaison-la-
Romaine. 90.46.11.75
**Musée des Outils de vignerons,**
Le Père Anselme, 8 av. d'Avignon,
84230 Châteauneuf-du-Pape. 90.83.70.07

*Cognac*
Bd Denfert-Rochereau, 16000 Cognac.
45.32.07.25
**Salles-d'Angles,**
Le Bourg, Salles-d'Angles, 16130 Segonzac.
45.83.71.13
**Courvoisier,**
2 place du Château, 16200 Jarnac. 45.35.55.55

## IN THE UNITED STATES

**Art Institute of Chicago,** 111 South Michegan
Avenue, Chicago, IL 60603. (312) 443-3600
**Chrysler Museum,** 245 West Olney Road,
Norfolk, VA 23410. (804) 664-6200
**Cleveland Museum of Art,** 11150 East Blvd.,
Cleveland, OH, 43620. (216) 421-7340
**Cooper-Hewitt Museum, National Museum
of Design, Smithsonian Institution,** 2 East 91st
Street, New York, NY 10128. (212) 860-6868
**Los Angeles County Museum of Art,** 5905
Wiltshire Blvd., Los Angeles, CA 90036.
(213) 857-6111
**Metropolitan Museum of Art,** Fifth Avenue at
82nd Street, New York, NY 10028. (212) 879-5500
**Museum at the Fashion Institute of
Technology,** Seventh Avenue at 27th Street,
New York, NY 10001. (212) 760-7708
**Textile Museum,** 2320 "S" Street, Washington,
DC 20008. (202) 667-0441
**Wadsworth Atheneum,** 600 Main Street,
Hartford, CT 06103-2990. (203) 278-2670
**Walters Art Gallery,** 600 North Charles Street,
Baltimore, MD 21201. (301) 547-9000

## IN GREAT BRITAIN

**The British Museum,** Great Russell Street,
London WC1B 3DG. 0171 636 1555
**Victoria and Albert Museum,** Cromwell Road,
South Kensington, London SW7 2RL.
0171 938 8500
**The Wallace Collection,** Hertford House,
Manchester Square, London, W1M 6BN.
0171 935 0687
Finest UK collection of Sèvres porcelain.
**Holburne Museum and Crafts Study Centre,**
Great Pulteney Street, Bath, BA2 4DB.
01225 466669
**Museum of Costume, Bath,** Assembly Rooms,
Bennett Street, Bath. 01225 477752
**Brighton Museum and Art Gallery,** Church
Street, Brighton, BN1 1UE. 01273 603005
**Blair Castle,** Blair Atholl, Pitlochry, Tayside, PH18
5TL. 01796 481207
**Ragley Hall,** Alcester, Warwickshire, B49 5NJ.
01789 762090

# MEMBERS OF THE COMITÉ COLBERT

**BACCARAT 1764**
*Crystal*
30 bis, rue de Paradis. 75010 Paris

**BERNARDAUD 1863**
*Porcelain*
27, rue Albert-Thomas. 87000 Limoges

**CHAMPAGNE BOLLINGER 1829**
*Champagne.* B.P. 4. 51160 Ay

**BOUCHERON 1858**
*Jewelry and Watchmaking*
26, place Vendôme. 75001 Paris

**BREGUET 1775**
*Watchmaking and precision instruments*
7, place Vendôme. 75001 Paris

**BUSSIÈRE 1924**
*Graphic design and printing*
21, rue de Châtillon. 75014 Paris

**CARON 1904**
*Perfumes and cosmetics*
3, avenue Percier. 75008 Paris

**CÉLINE 1946**
*Prêt-à-porter and accessories for men and women*
38, avenue Montaigne. 75008 Paris

**CHANEL 1912**
*Haute couture, prêt-à-porter, accessories, watchmaking, jewelry*
31, rue Cambon. 75001 Paris

**PARFUMS CHANEL 1924**
*Perfumes and cosmetics*
135, avenue Charles de Gaulle
92521 Neuilly sur Seine Cedex

**CHARLES 1908**
*Bronze casting for light-fittings*
18/20, rue Soleillet. 75020 Paris

**CHÂTEAU CHEVAL BLANC 1832**
*Saint-Emilion wines*
33330 Saint-Emilion

**CHÂTEAU LAFITE-ROTHSCHILD 1855**
*Médoc wines*
33, rue de La Baume. 75008 Paris

**CHÂTEAU D'YQUEM 1593**
*Sauternes wines*
33210 Sauternes

**CHRISTIAN DIOR 1947**
*Haute couture, prêt-à-porter for men and women, accessories*
30, avenue Montaigne. 75008 Paris

**PARFUMS CHRISTIAN DIOR 1948**
*Perfumes and cosmetics*
33, avenue Hoche. 75008 Paris

**CHRISTOFLE 1830**
*Silversmithing and cutlery in solid silver and silver-plate*
9, rue Royale. 75008 Paris

**COURVOISIER 1835**
*Cognac*
Place du Château
B.P. 59. 16200 Jarnac

**D. PORTHAULT 1924**
*Linen*
6, rue Collange. 92300 Levallois-Perret

**DAUM 1875**
*Crystal and glass*
32, rue de Paradis. 75010 Paris

**DELISLE 1895**
*Precious metal light-fittings*
4, rue du Parc Royal. 75003 Paris

**DIDIER AARON 1923**
*Interior design, antiques objets d'art, paintings*
118, rue du Faubourg Saint-Honoré. 75008 Paris

**ORFÈVRERIE D'ERCUIS 1867**
*Silversmithing and cutlery in solid silver and silver-plate*
9, rue Royale. 75008 Paris

**FAÏENCERIES DE GIEN 1821**
*Faience*
78, place de la Victoire. 45500 Gien

**FLAMMARION BEAUX LIVRES 1875**
*Publishers*
26, rue Racine. 75006 Paris

**GIVENCHY 1952**
*Haute couture, prêt-à-porter, accessories*
3, avenue George-V. 75008 Paris

**PARFUMS GIVENCHY 1957**
*Perfumes and cosmetics*
74, rue Anatole-France. 92300 Levallois-Perret

**GUERLAIN 1828**
*Perfumes and cosmetics*
68, avenue des Champs-Elysées. 75008 Paris

**GUY LAROCHE 1957**
*Haute couture, prêt-à-porter, accessories*
22, rue de La Trémoille. 75008 Paris

**HÉDIARD 1854**
*Production and distribution of fine foods, catering*
Centre d'Affaires Colombia
146, boulevard Valmy. 92707 Colombes Cedex

**HERMÈS 1837**
*Leather-goods, silk, prêt-à-porter, watchmaking, jewelry, tableware, accessories*
24, rue du Faubourg Saint-Honoré. 75008 Paris

**PARFUMS HERMÈS 1948**
*Perfumes*
23, rue Boissy d'Anglas. 75008 Paris

**HÔTEL DE CRILLON 1909**
*Hotel and restaurant*
10, place de la Concorde. 75008 Paris

**HÔTEL GEORGE V 1928**
*Hotel and restaurant*
31, avenue George-V. 75008 Paris

**HÔTEL PLAZA ATHÉNÉE 1911**
*Hotel and restaurant*
25, avenue Montaigne. 75008 Paris

**HÔTEL RITZ 1898**
*Hotel and restaurant*
15, place Vendôme. 75001 Paris

**HÔTEL ROYAL ÉVIAN 1909**
*Hotel and restaurant*
Château de Blonay
B.P. 8. 74500 Evian-Les-Bains

**JEAN PATOU 1919**
*Fashion and accessories*
7, rue Saint-Florentin. 75008 Paris

**PARFUMS JEAN PATOU 1925**
*Perfumes*
7, rue Saint-Florentin. 75008 Paris

**JEAN-LOUIS SCHERRER 1971**
*Haute couture, prêt-à-porter for men and women, accessories*
51, avenue Montaigne. 75008 Paris

**JEANNE LANVIN 1889**
*Prêt-à-porter for men and women, accessories, tailoring*
15-22, rue du Faubourg Saint-Honoré. 75008 Paris

**JOHN LOBB 1899**
*Made-to-measure shoes, prêt-à-porter*
23, rue Boissy d'Anglas. 75008 Paris

**CHAMPAGNE KRUG 1843**
*Champagne, prestige cuvées*
5, rue Coquebert. 51100 Reims

**LA CHEMISE LACOSTE 1933**
*Clothes, shoes and specialist products for tennis and golf, perfumes, eye-wear, watches, luggage*
8, rue de Castiglione. 75001 Paris

**LALIQUE 1910**
*Crystal*
11, rue Royale. 75008 Paris

**LANCÔME 1935**
*Perfumes and cosmetics*
2/60, avenue Armand- Petitjean. 94152 Chevilly-Larue

**PARFUMS LANVIN 1925**
*Perfumes*
15, rue du Faubourg Saint-Honoré. 75008 Paris

**CHAMPAGNE LAURENT-PERRIER 1812**
*Champagne*
B.P. 3. 51150 Tours-sur-Marne

**LENÔTRE 1957**
*Catering, pâtisserie, confectionery, traiteur*
44, rue d'Auteuil. 75016 Paris

**LÉONARD 1943**
*Couture, prêt-à-porter, accessories*
36, avenue Pierre-I er de Serbie 75008 Paris

**LESAGE 1870**
*Embroidery, haute couture, prêt-à-porter*
13, rue Grange-Batelière. 75009 Paris

**CHAMPAGNE LOUIS ROEDERER 1776**
*Champagne*
21, boulevard Lundy. 51100 Reims

**LOUIS VUITTON 1854**
*Travel goods, trunks, leather goods and accessories*
54, avenue Montaigne. 75008 Paris

**MANUEL CANOVAS 1963**
*Textiles for interior design*
125, rue de la Faisanderie. 75116 Paris

**MAUBOUSSIN 1827**
*Jewelry, watchmaking*
20, place Vendôme. 75001 Paris

**MELLERIO dits MELLER 1613**
*Jewelry, goldsmithing*
9, rue de la Paix. 75002 Paris

**RESTAURANT HÔTELLERIE MICHEL GUÉRARD 1965**
*Hotel and restaurant*
Les Prés d'Eugénie. 40320 Eugénie-Les-Bains

**NINA RICCI 1932**
*Haute couture and prêt-à-porter*
17, rue François-I er. 75008 Paris

**PARFUMS NINA RICCI 1945**
*Perfumes and cosmetics*
17, rue François-I er. 75008 Paris

**OUSTAU DE BAUMANIÈRE 1945**
*Hotel and restaurant*
Les Baux de Provence. 13250 Maussane-Les-Alpilles

**PIERRE BALMAIN 1945**
*Haute couture and prêt-à-porter, accessories*
44, rue François-I er. 75008 Paris

**PIERRE FREY 1935**
*Textiles and accessories for interior design*
47, rue des Petits-Champs. 75001 Paris

**PUIFORCAT 1820**
*Objets d'art in solid silver and silver-plate*
2, avenue Matignon. 75008 Paris

**RÉMY MARTIN 1724**
*Fine Champagne Cognac*
20, rue de la Société Vinicole. 16100 Cognac

**RÉVILLON 1723**
*Fur, leather and accessories*
42, rue La Boétie. 75008 Paris

**ROBERT HAVILAND & C. PARLON 1924**
*Porcelain*
23, rue Hyacinthe-Faure. 87100 Limoges

**ROCHAS 1925**
*Perfumes and cosmetics*
33, rue François-I er. 75008 Paris

**CHAMPAGNE RUINART 1729**
*Champagne*
4, rue des Crayères. 51053 Reims Cedex

**CRISTALLERIES DE SAINT-LOUIS 1767**
*Crystal*
8, rue Royale. 75008 Paris

**SOULEIADO 1780**
*Printed fabrics for clothes and interior design*
39, rue Proudhon. 13150 Tarascon

**S.T. DUPONT 1872**
*Luxury personal products: lighters, writing instruments, leathergoods and accessories*
Tour Maine Montparnasse
33, avenue du Maine. 75015 Paris

**TAILLEVENT 1946**
*Restaurant*
15, rue Lamennais. 75008 Paris

**VAN CLEEF & ARPELS 1906**
*Jewelry, watchmaking*
22, place Vendôme. 75001 Paris

**PARFUMS VAN CLEEF & ARPELS 1976**
*Perfumes*
20-26, boulevard du Parc. 92521 Neuilly sur Seine

**CHAMPAGNE VEUVE CLICQUOT PONSARDIN 1772**
*Champagne*
12, rue du Temple. 51100 Reims

ASSOCIATE MEMBERS

**AIR FRANCE 1933**
*Air transport*
45, rue de Paris. 95747 Roissy Cedex

**LA DEMEURE HISTORIQUE 1924**
*Professional association for the owners of listed, historical monuments and buildings*
57, quai de la Tournelle. 75005 Paris

**MANUFACTURE NATIONALE DE SÈVRES 1738**
*Porcelain*
4, Grande Rue. 92310 Sèvres

**LA MONNAIE DE PARIS 864**
*Medals, cast metal, objets d'art, jewels, special edition coins*
11, quai Conti. 75006 Paris

**L'OPÉRA NATIONAL DE PARIS 1669**
*Opera and ballet*
8, rue Scribe. 75009 Paris

**ORCHESTRE NATIONAL DE FRANCE ADEMMA 1925**
*Publicity for the Orchestre National de France and the Théâtre des Champs-Elysées*
18, avenue Charles-Floquet. 75007 Paris

**CRYSTAL** p. 8: C.C. p. 9: VU/M. Vanden Eeckhoudt/Saint-Louis. p. 10 : C. C. p. 11: Dagli Orti. p. 12: VU/M. Vanden Eeckhoudt/Saint-Louis. p. 13: C. C./A. Muriot. p. 14: C. C./A. Mertz. p. 15: (top) C. C./J. Boulay; (bottom) C. C. p. 16: VU/M. Vanden Eeckhoudt/Saint-Louis. p. 17: VU/M. Vanden Eeckhoudt/Saint-Louis. p. 18: C. C./J. Boulay. p. 19: (right) C. C./A. Mertz; (center) VU/M. Vanden Eeckhoudt/Saint-Louis. p. 20: (left) C. C./R. Veigas; (top) C. C.; (bottom) Dagli Orti. p. 21: C. C. p. 22: VU/M. Vanden Eeckhoudt/Saint-Louis. p. 23: VU/M. Vanden Eeckhoudt/Saint-Louis. p. 24: (all pictures) C. C./A. Mertz. p. 25: (left) C. C./A. Mertz; (right) C. C./G. de Laubier; (center, top and bottom) C. C./M. Colomb. p. 26: (all pictures) C. C. p. 27: C. C. p. 28: (all pictures) C. C./A. Mertz; (drawing on border) C. C. p. 29: (top) C. C./J. Boulay; (bottom) C. C./A. Mertz. p. 30: Dagli Orti. p. 31: C. C. pp. 32–3: (from top to bottom, left to right) Dagli Orti; Dagli Orti; Dagli Orti; C. C.; C. C.; Dagli Orti; C. C.; C. C./Y. Galerne. **FAIENCE AND PORCELAIN** p. 34: (left) C.C. p. 35: (top) Dagli Orti; (right) C. C./D. Cohas. 36: (top and bottom) RMN; (left) C. C. p. 37: C. C./B. Edelhajt/Gamma. p. 39: C. C./B. Edelhajt/Gamma. p. 40: G. Bouchet/Gien. p. 41: VU/S. Mohdad/Bernardaud. p. 42: B. Bouchet/Gien. p. 43: (left) G. Bouchet/Gien; (right) G. Bouchet/Moustiers. p. 44: C. C. p. 45: C. C. p. 46: (left) D. Thierry/DIAF; (right) B. Régent/DIAF. p. 47: C. C./D. Cohas/Bernardaud. p. 48: L. Sully-Jaulmes/RMN/Musée des Arts Décoratifs, Paris. p. 49: (right) L. Sully-Jaulmes/RMN/Musée des Arts Décoratifs, Paris; (top) RMN/Manufacture Nationale de Sèvres. p. 50 : C. C./Robert Haviland & C. Parlon. p. 51: (all box) C. C./B. Edelhajt/Gamma; (right) C. C./L. Herail. p. 52: RMN. p. 53: (center and right) C. C. p. 54: (top) C. C./B. Edelhajt/ Gamma; (center) C. C./Neyens; (bottom) C. C./J. Petit. p. 55: C. C./Hermès. p. 56: Dagli Orti. p. 57: G. de Laubier/Manufacture Nationale de Sèvres. pp. 58–9: (top to bottom, left to right) Giraudon; Musée des Arts Décoratifs, Paris/L. Sully-Jaulmes; Musée des Arts Décoratifs, Paris/L. Sully-Jaulmes; Koninklijk Museum voor schone Kunstent/Antwerp; RMN/M. Coppola; Manufacture de Sèvres; Dagli Orti; C. C. **FRAGRANCE** pp. 60–1: Dagli Orti. p. 62: C. C./Chanel. p. 63: Pierpont Morgan Library, New York. pp. 64–5: (all double page, except photos Guerlain and Givenchy) C. C./Chanel/Cyril Le Tourneur d'Ison; (photos Guerlain and Givenchy) C. C. p. 66: C. C./Chanel/Cyril Le Tourneur d'Ison. p. 67: DIAF/D. Lerault. pp. 68–9: C. C./Chanel. p. 70: (top) Magnum/D. Stock; (center and bottom) DIAF/T. Leconte. p. 71: DIAF/J.-C. Gérard. pp. 72–3: (drawings) C. C./Chanel/Loustal; (center) Osmothèque. p. 74: C. C./Nathalie Soye. p. 75: Osmothèque/B. Jarret. p. 76 : Magnum/S. Salgado. p. 77: Magnum/D. Stock. p. 78: C. C. p. 79: C. C. p. 80: (top) C. C./Valéry Assénat/Chanel; (bottom) G. de Laubier/Hermès. p. 81: C. C. pp. 82–3: C. C. pp. 84–5: C. C. pp. 86–7: (from top to bottom, left to right) Dagli Orti; C. C./Givenchy archives; C. C.; C. C.; Keystone; C. C. p. 88: (left) Sygma/M. Rosenstiehl; (right) G. de Laubier. pp. 89–90: VU/H. de Wurstemberg/D. Porthault. pp. 90–91: (center) Dagli Orti. p. 91: C. C./I. Rey. pp. 92–3 : (top and bottom) C. C.; (center) C. C./J. Petit. p. 94: C. C./C. Crié. p. 95: (top) C. C./G. Nencioli; (bottom) C. C.; (background) C. C./F. Dumas. p. 96: C. C./G. Nencioli. pp. 98–9: C. C./R. Landin. p. 100: C. C./G. Nencioli. p. 101: (background) C. C./Givenchy; (right) Sygma/T. Orban. p. 102–5: G. de Laubier/D. Porthault. pp. 106–7: C. C./M. Hosnyder. pp. 108–9: (top to bottom, left to right) British Library; The National Trust/J. Bethell; Dagli Orti; Bridgeman-Giraudon; Archives Bianchini Férier; C. C./Irving Penn. **GEMS AND PRECIOUS METALS** pp. 110–11: VU/Boucheron/Puiforcat/P.-O. Deschamps. p. 111: Explorer/S. Costa. p. 112: Lauros-Giraudon. p. 113: Dagli Orti; C. C./Mellerio dits Meller. pp. 114–15: (background) Lauros-Giraudon; C. C./D. Sucheyre. p. 116: (left) C. C./Studio Arcadia/E. Lemarchand; (background) C. C. p. 117: C. C./Studio Arcadia/E. Lemarchand. pp. 118–19: (left) C. C./D. Sucheyre; (center) G. de Laubier/Christofle; (right) VU/Puiforcat/P.-O. Deschamps. p. 120: G. de Laubier/Christofle; (bottom) C. C. p. 121: VU/Puiforcat/P.-O. Deschamps. p. 122: (engraving) Musée Bouilhet/Christofle; G. de Laubier/Christofle. p. 123: C. C./D. Sucheyre. pp. 124–5: (left to right) C. C.; C. C./J.-C. Marlaud; Fondation Calouste Gulbenkian. pp. 126–7: (left to right) RMN/National Museum of Ancient Art, Lisbon/

RMN. p. 128: VU/Puiforcat/P.-O. Deschamps. p. 129: C. C./Studio Arcadia/E. Lemarchand. p. 130: G. de Laubier; (bottom) C. C. p. 131: (left) C. C./M. Trois; (right) C. C. p. 132: (top to bottom) Explorer; Explorer; Sygma/Campbell. p. 133: C. C.; C. C./M. Fernandez. p. 134: C. C./M. Fernandez. pp. 136–7: C. C.; VU/Boucheron/P.-O. Deschamps. p. 138: (top to bottom) DIAF/J.-C. Pratt and D. Pries; C. C. p. 139: VU/Boucheron/P.-O. Deschamps. pp. 140–1: C. C. pp. 142–3: (top to bottom, left to right) Metropolitan Museum of Art, New York; C. C.; C. C.; C. C.; C. C.; C. C.; C. C.; C. C. **LEATHER** p. 144: VU/Hermès/G. Favier. p. 145: J.-L. Charmet. p. 146: (left) G. de Laubier; (right) Sün Evrard/D. Foubert. p. 147: C. C. p. 148: G. de Laubier/Hermès; (background) Explorer/Le Toquin. p. 149: G. de Laubier/Hermès; (background) Explorer/Le Toquin. pp. 150–1: C. C. pp. 152–3: (gloves) Métiers d'art de Paris/Givenchy/Léonard/M. Klein-G. Laroche/Pétronille Norval; C. C./Hermès/M. Kishino. p. 154: (top to bottom) VU/Hermès/G. Favier; G. de Laubier/Hermès; C. C./G. Nencioli; G. de Laubier/Hermès. p. 155: Hermès/J.-P. Godeaut. pp. 156–7: C. C./P.-A. Decraene. pp. 158–9: (top to bottom, left to right) Dagli Orti; Dagli Orti; Dagli Orti; J.-L. Charmet; C. C. **HOTELS AND GASTRONOMY** p. 160: VU/Paulo Nozolino. p. 161: (top) Dagli Orti, (bottom) C. C. p. 162: Keystone; (luggage labels) C. C. p. 163: C. C. p. 164: Sygma/R. Mellou. p. 165: VU/P. Nozolino/Crillon. p. 166: C. C./J.-J. Liégeois. pp. 167–9 : VU/P. Nozolino/Crillon. p. 170: (top to bottom) Tara Bard/C. Garo; Tara Bard/C. Garo; Terres du Sud/P. Giraud; Tara Bard/C. Garo; Tara Bard/C. Garo; Tara Bard/C. Garo. p. 171: C. C./Bernard Charlon. pp. 172–3: P. Rival; (box) C. C./Rousseau. p. 174: C. C./M. Elibrik-Delecluse. p. 175: C. C. pp. 176–7: (top to bottom and left to right) C. C.; RMN; C. C./Christofle; C. C.; C. C.; C. C.; C. C./Ritz/Raymond de Landin; C. C./G. de Chabaneix. **HAUTE COUTURE** p. 178: C.C./Muriel Dovic. p. 179: (left) C. C.; (right) Bibliothèque Nationale, Paris. p. 180: (top) L'Illustration-Sygma; (bottom) C. C. p. 181: (top) C. C./W. Maywald; (bottom) C. C./M. Hispard. p. 182: G. de Laubier/Dior; (bottom) W. Maywald/Dior. p. 183: C. C. p. 184: VU/Agnès Bonnot. p. 185: C. C./C. Rouart. p. 186–7 : (top to bottom, left to right) G. de Laubier/Chanel; G. de Laubier/Christian Dior; G. de Laubier/Chanel; C. C./Bellini; G. de Laubier/Christian Dior; G. de Laubier/Nina Ricci; C. C./JFP-Bruno Pellerin; G. de Laubier/Chanel. p. 188: G. de Laubier/Christian Dior. p. 189: C. C./Chanel/M. Dovic. p. 190: (left to right) G. de Laubier/Christian Dior; C. C./Givenchy; C. C./F. Carol. p. 191: (top to bottom) C. C. p. 192: (left) Sygma; (right) G. de Laubier. p. 193: (left) G. de Laubier; Imapresses/N. Mac Ines. pp. 194–5: (left to right) C. C./A. Blanch; G. de Laubier/Nina Ricci; G. de Laubier/Christian Lacroix; C. C./J.-D. Lorieux. p. 196–7: C. C./Y. Yamamoto. pp. 198–9: (top to bottom, left to right) RMN; Dagli Orti; C. C.; C. C./Horst; Keystone/Christian Dior; C. C.; C. C./B. Pellerin; Magnum/Christian Lacroix. **VINEYARDS** p. 200: VU/J.-L. Chapin. p. 201: VU/J.-L. Chapin; RMN. p. 203: Flammarion. pp. 204–5: C. C. p. 206: C. C. p. 207: (top to bottom) Sygma/P. Toutain Dorbec; C. C.; C. C. p. 208: (top to bottom) drawings by Guyot (D.R.); C. C./Scope/M. Guillard; VU/J.-L. Chapin. p. 209: C. C.. p. 210–11: (left to right) Sygma/P. Caron; Magnum/F. Sciamma; C. C.; C. C./C. C./Krug. pp. 212–13: (left to right) Sygma/P. Giraud; C. C.; C. C./Scope/M. Guillard. p. 214: G. de Laubier. p. 215: C. C. p. 216: (left to right) Sygma/P. Caron; Magnum/Harry Gruyaert; Sygma/P. Caron. p. 217: C. C. p. 218: C. C. p. 219: C. C. p. 220: (left) C. C.; (top) Magnum/F. Mayer; C. C.; C. C.. p. 221: DIAF/P. Somelet p. 222: C. C.. p. 223: VU/J.-L. Chapin. p. 224: G. de Laubier. p. 225: C. C. p. 226: C. C./Krug/M. Rougemont. pp. 226–7: (center) C. C. pp. 228–9: (left to right) C. C.; DIAF/Patrick Somelet; C. C.; C. C.; Musée des Beaux-Arts, Rouen. pp. 230–1: (top to bottom, left to right) Artephot/Faillet; C. C.; C. C.; C. C.; C. C.; Artephot/P. Perrin.

OVERVIEWS CAPTIONS, top to bottom, left to right: **CRYSTAL** *Glassblowers.* Bas-relief after Kaemhreou's mastaba (Egyptian stone tomb) in Saqqara. Ancient Empire. Fifth dynasty. Egyptian Museum, Cairo. Glass paste mask. Third century BC, Carthage Museum, Carthage. Drapery scene, washing and wringing. Fifteenth-century Bourgogne-style stained glass window. Church of Notre Dame, Semur-en-Auxois. Saint-Louis royal glassworks. Baccarat crystalworks; view of part of the sales area, nineteenth-century engraving. Young woman wearing a clinging dress and a hat, (detail)

1901–2. Stained glass window by Georges de Feure. Private collection. The first products at the Lalique workshops in Wingen-sur-Moder, c. 1925.
Athamas jug, blue glass with gold decoration. Created by Daum from a design by Jean Cocteau, January 1995. **FAIENCE AND PORCELAIN** Large Kouan vase with lid, decorated in painted blue flowers, 1271–1368, Hai-Tien, China. Fountain jug and bowl. Faïence de Moustiers, eighteenth century. Musée des Arts Décoratifs, Paris. James Ensor, *The Lunch of Oysters*, 1882. Koninklijk Museum voor schone Kunstent, Antwerp. Cordelier vase, nineteenth century. Design for a Compiègne vase, catalogue no. 204. Manufacture Nationale de Sèvres, Paris. Emile Wattier, *Portrait of Alexandre Brongniart*, c. 1830. Manufacture Nationale de Sèvres, Paris. Plate from Manufacture Nationale de Sèvres, decorated with female bust and foliage. Albert Damouse c. 1904. Musée National Adrien Dubouché, Limoges. Model for "Rosebud" service, 1928. Robert Haviland & C. Parlon. **FRAGRANCE** Woman pouring perfume into a bottle, first century. Fresco from a villa in Farnesina. Museum of the Thermae, Rome. *La Parfumeuse*, nineteenth-century lithograph. "Bees" flacon for the Imperial eau-de-Cologne, created for the Empress Eugénie in 1853. Guerlain. Guerlain boutique and factory at Colombes, 1889. Poster by Karliowsky. Grasse perfumery. Lancôme poster. Caron flacon for 'Bellodgia'. Poster. Design. **FABRICS AND TEXTILES** Jean de Wavrin, *Banquet at the Portuguese court*, *Chronicles of England*, Bruges, fifteenth century, London, The British Library. *Les Amours des Dieux*, Tapestry Room, Osterley Park, Middlesex, Nineteenth-century alcove decoration, alcove cast in one piece, French First Empire. Bibliothèque des Arts Décoratifs, Paris. William Morris, textile design, Victoria and Albert Museum, London. Raoul Dufy, Paris, 1930, Bianchini-Férier archives. Léonard kimono Lacoste polo shirt photograph by Irving Penn. **GEMS AND PRECIOUS METALS** *The Struggle of David and Goliath*, silver plate in tooled relief, c. 630, found at Lambossa, Cyprus, 50 cm diam. Portrait of Abraham-Louis Breguet, 1827. Engraving after Girardet. Brooch designed by A. Falize for Mellerio dits Meller, 1863. Christofle silver-smithing in the French Second Empire. The sheep. Engraving. Portrait of René Lalique. Advertising poster for Boucheron, Fonseca c. 1900. Advertisement for Van Cleef & Arpels, by Charles Martin, *Harper's Bazaar*, 1930. One of the models wears a necklace of pendant emeralds, baguette diamonds, trapezoids, and brilliants set in platinum, with assorted earring motifs; the other wears a necklace of pendant and square-cut sapphires, with baguette diamonds, trapezoids, squares and brilliants; a bracelet in cabochon sapphires and baguette diamonds decorates her wrist. Cup designed by Jean Puiforcat in silver and glass on a black marble stand, c. 1925. **LEATHER** Pair of leather sandals with gold and turquoise disk. Chimu art. Gold Museum, Lima, Peru. *The burning of the camp of Syphax.* Historical scene by Scipion. French, early seventeenth century. Panel in painted leather. Musée de la Renaissance. Ecouen. A librarian-bookbinder's boutique. Sixteenth century (restored in 1761). Correr Museum, Venice. *Boot makers.* Engraving c. 1810. Musée Carnavalet, Paris. Seventeenth-century armor and trunks. Louis Vuitton. Checkerboard design by Louis Vuitton (detail), 1888. **HOTELS AND GASTRONOMY** View of the restaurant Oustau de Baumanière, Aix-en-Provence. Peter Binoit, *Still Life*, Germany, c. 1630, Louvre, Paris. Three table settings in French, Russian, and mixed styles. Engraving. Luggage label. "Grand Hôtel du Louvre." English advertisement for the Hôtel George V, by J.M. Noël. Portrait photo of César Ritz.
New Year's Eve menu at the Ritz, 1908. Portrait of M. Guérard. **HAUTE COUTURE** Wool-producing beside the Loire, c. 1500. *Suite des nobles pastorales.* Louvre, Paris. Dresses by Paul Poiret, Watercolor by Georges Lepape. Bibliothèque des Arts Décoratifs, Paris, 1911. Le Coin des sports. Poster by Boutet de Monvel for Jean Patou, 1925. Mademoiselle Chanel, photograph by Horst, 1937. The classic New Look suit by Christian Dior. Portrait of Pierre Balmain at his work-table. Givenchy, *haute couture* collection 1993 Christian Lacroix, haute couture collection, Winter 1989. **VINEYARDS** Master of 1456, *L'homme au verre de vin.* Louvre, Paris. Rémy Martin label. Cognac Fine Champagne, c. 1907. Portrait of Nicolas Ruinart, the founder of the Maison Ruinart. The cellars at Veuve Clicquot Ponsardin at the end of the nineteenth century. Engraving by Bourdelin. Château Cheval Blanc magum label, 1983. "Buvez du vin...." Poster by A. Cappiello, 1933. Private collection.